After Vasari

After Vasari

History, Art,
and Patronage in Late
Medici Florence

EDWARD L. GOLDBERG

Princeton University Press
Princeton, New Jersey

Library of Congress Cataloging-in-Publication Data
Goldberg, Edward L., 1948-
After Vasari: history, art, and patronage in late
Medici Florence / Edward L. Goldberg.
p. cm.
Bibliography: p.
Includes index.
ISBN 0-691-04066-4
1. Baldinucci, Filippo, 1625-1696. 2. Art historians—Italy—Biography.
3. Medici, House of—Art patronage. 4. Art—Collectors and collecting—
Italy—Florence—History—17th century. I. Title.
N7483.B28G6 1988
709'.45'51—dc19 88-22453

To Christine Ivusic
with affection

Contents

CONTENTS

List of Illustrations

Abbreviations

ASF	Archivio di Stato, Florence
ASF/CDA	Carteggio d'Artisti, Archivio di Stato, Florence
ASF Med. Princ.	Medici del Principato, Archivio di Stato, Florence
ASF Misc. Med.	Miscellanea Medicea, Archivio di Stato, Florence
BNCF	Biblioteca Nazionale Centrale, Florence
BNCF Magl.	Manoscritti Magliabechi, Biblioteca Nazionale Centrale, Florence

Practical considerations have led me to avoid citing lengthy Italian texts that are readily available in published form. I frequently refer the reader to four sources:

Diario	*Diario spirituale di Filippo Baldinucci*, in *Zibaldone baldinucciano*, Vol. 1, ed B. Santi (Florence, Studio per Edizioni Scelte, 1981).
Notizie	Filippo Baldinucci, *Notizie de' professori del disegno* . . . , 7 vols., ed. P. Barocchi (Florence, Studio per Edizioni Scelte, 1974–1975).
SPES	The documents in the Appendix (Vol. 6) of the *Notizie*.
Vita di F.B.	Francesco Saverio Baldinucci's "Notizie della vita di Filippo Baldinucci," in *Zibaldone baldinucciano*, ed. B. Santi, Vol. 2, pp. 3–35.

Preface

GIORGIO VASARI (1511-1574) was the most creative propagandist ever to serve the House of Medici. As a painter and as an administrator of artistic projects, he gave visible form to the political and dynastic pretensions of the new Grand Dukes of Tuscany. As author of the *Vite de' più eccellenti architetti, pittori e scultori* (Florence, 1550), the first encyclopedic compendium of artists' biographies, he proposed a brilliantly mythologized history of Italian art; painting, sculpture, and architecture were reborn in Tuscany through the genius of its people, and then rose to perfection in the city of Florence under inspired Medici patronage.

At the Florentine court, the Medici promoted an explicitly Vasarian culture, identifying themselves ever more closely with the artistic achievements of the Tuscan race. However, by the middle years of the seventeenth century, this construction of history was facing serious challenges at home and abroad. Vasari's unremitting Tuscan prejudices angered the proponents of other artistic traditions. His license with fact proved no less exasperating when measured by newer standards of historiographic responsibility.

In Florence these attacks elicited grave concern, since they impugned the prestige of both the city and its rulers. Hoping to substantiate Vasari's art historical claims, Cardinal Prince Leopoldo de' Medici (1611-1675) sponsored an ambitious series of scholarly and curatorial projects. Filippo Baldinucci (1625-1696) emerged as Leopoldo's chief collaborator, and he struggled for many years after his patron's death to realize their plan for a great new Florentine edition of artists' lives.

In casting himself as the second Vasari, Filippo Baldinucci chose a troublesome role, and one for which he was ill-prepared. Baldinucci's birth was insignificant; his education was mediocre; and his artistic expertise was uncertain. Since his search for patronage was continually frustrated, he was forced to attempt increasingly aggressive and ingenious schemes of self-promotion. Filippo also suffered bouts of chronic depression and was prey to destructive religious obsessions.

In the vociferous art historical disputes of the 1670s and 1680s, the chief antagonists were Carlo Malvasia in Bologna, Gian Pietro Bellori in Rome, and Giovanni Cinelli, Ferdinando Leopoldo del Migliore, and Filippo Baldinucci in Florence. Though there were substantial scholarly issues at stake, the controversy was also propelled by no less insistent personal motives. Baldinucci and his colleagues had careers to make, often at each others' expense. In tracing this early development of the art historical profession, we can reflect on the antiquity of so many of our habits and customs.

Acknowledgments

I TAKE great pleasure in recalling the many friends and colleagues who assisted me with this book. During the project's long evolution, I benefited from the constant advice and support of James Ackerman, Malcolm Campbell, Elizabeth Cropper, and Francis Haskell. Dennis Crowley's enlightened criticism proved invaluable in helping translate my often disorganized ideas into a coherent text. Thanks are also due to Eric Van Tassel and Cynthia Parsons at the Princeton University Press, and to Deborah del Gais Muller, who was both a rigorous and a sympathetic editor.

Paola Barocchi and Bruno Santi of the Studio per Edizioni Scelte in Florence kindly shared their transcriptions of Filippo Baldinucci's diary long before its publication. Anthea Brook directed me to the Archivio Bartolommei in the Florentine State Archives, and Anna Teicher helped me evaluate this rich fund of information on Baldinucci's professional life. Laura Giovannini, David Howarth and Adam Manikowski called my attention to other important archival sources.

Sabine Eiche, Linda Pellechia, and Silvia Meloni Trkulja came to my rescue in obtaining photographs under challenging circumstances. Claudine Decostre undertook the translation of some problematic Portuguese documents. Miles Chappell, Marco Chiarini, Lawrence Dowler, Michael Nolan, Donna Salzer, and Thomas Willette were all generously forthcoming with assistance and advice. Edward Pearlman brought order to my complex and barely legible manuscript.

I enjoyed the hospitality of numerous research institutions in Italy and America. My colleagues at the Houghton Library and the Pine Arts Library at Harvard were always welcoming and supportive. I have many happy memories of the kindness I encountered at the Archivio di Stato Fiorentino, the Biblioteca Riccardiana-Moreniana, and the Kunsthistorisches Institut in Florenz. Most of all, I remember the warmth and good fellowship of the Harvard Center for Renaissance Studies at Villa I Tatti in Florence, where I spent a year completing research for this book through the generosity of the National Endowment for the Humanities. November 1987

After Vasari

INTRODUCTION

Vasari and the Medici

THE HISTORY of the Medici family can be read with both admiration and cynicism. By the mid-seventeenth century, Cardinal Prince Leopoldo could look back on a hundred years of sovereign rulers who had married into the first houses of Europe and note popes, French queens, and Austrian empresses of his blood. Behind these stretched a diminishing line of Florentine political bosses, merchant bankers, medium and small businessmen, and peasants from the Mugello.

Leopoldo and his family enjoyed a glamor that was well deserved but hard earned. By the fifteenth century eulogists had already begun to focus on Medici protection of the arts and letters, finding evidence there of a nobility of spirit less apparent in other areas of their activity. With the elevation of the house to a sovereign dynasty under Cosimo I, the Medici invested their patronage with new deliberation and seriousness of purpose. Through ceremonial elaboration and courtly splendor, they sought to enhance the legitimacy of their rule. By recasting the history of Tuscan culture, they sought to demonstrate the appropriateness of their ascendancy.

The Medici were precocious in their application of the arts to the business of state. Over the years the system of granducal workshops grew more extensive in scope and sophisticated in organization. The palace collections came to reflect the tastes of successive princes and the personalities of the artists whom they attracted to their court.

The family culture grew richer from generation to generation, although the Medici state declined in military, political, and economic importance. By the mid-seventeenth century, when the Medici *granducato* had achieved moral legitimacy through its long survival, a new kind of compensation was becoming apparent. It was only as patrons of the arts that they could strive for a place among the rulers of Europe,

and it was in this role that they particularly sought to define themselves.[1]

Giorgio Vasari was perhaps the most creative propagandist ever to serve the House of Medici. In the opening years of the *granducato*, he played an essential part in shaping the family identity. In later generations his formulas often achieved doctrinal authority through tradition and dynastic usage.

GIORGIO VASARI was born in Arezzo in 1511 to a modest artisan family. In his early youth he enjoyed a provincial humanistic education and received irregular instruction in the art of painting. Through a fortunate chain of circumstances, at the age of thirteen Giorgio was made companion to the young Alessandro and Ippolito de' Medici. Had the political and military upheavals of the late 1520s not brought a temporary dispersal of the Medici court, he would probably have been launched on a respectable Florentine career as secretary or tutor.[2] Instead he fell back on his artistic training and began to work as a painter.

Vasari's scholarly and courtly skills greatly advanced him in his new profession. While awaiting the opportunity to reaffirm his Medici connections after an eventual restoration, he travelled widely and cultivated an impressive range of acquaintances. According to Vasari's own account, the idea for the *Vite de' più eccellenti pittori, scultori, ed architetti* arose in Rome during a conversation with Paolo Giovio at Cardinal Farnese's table.

The first volume of the first edition of the *Vite* appeared in 1550. By this time Vasari had reestablished his Florentine ambitions. In the work's dedication to Cosimo I, the author voiced his hope that this endeavor might win him a place at the Medici court. Though burdened for several years with the unwanted patronage of Pope Julius III, he was at last named *pittore stipendiato* by Duke Cosimo in the early days of 1554, with the substantial monthly salary of twenty-five *scudi*. Vasari executed important decorative schemes in the Palazzo Vecchio in Florence and the Palazzo de' Cavalieri in Pisa and eventually assumed a magisterial role in supervising Medici artistic interests throughout Tuscany.

Cosimo de' Medici forged a crown for himself through the application of brutal force to shrewd policy, and his regime fostered a compelling union of the pragmatic and the mystical. Seeking to clothe a military fait accompli with the trappings of legitimacy and higher

inevitability, he caused artistic production to be organized with unprecedented care and comprehensiveness.

The awesome splendor of the Medici court was given explicit meaning through a calculated iconography. With Cosimo's active sponsorship, in 1562 Giorgio Vasari and Giovanni Angelo Montorsoli recast the old Compagnia di San Luca as the Compagnia ed Accademia del Disegno,[3] the first institution of its kind in Europe. The grand duke's academy lent formal structure to his protection of the artists within his realm. It also stood as an impressive monument to this relationship. For the new sovereigns of Tuscany, their dynastic image as patrons of the arts was no less crucial than their actual patronage.

In his dedication to Cosimo I of the 1550 edition of the *Vite de' più eccellenti pittori, scultori, ed architetti*, Vasari discusses his task in chronicling the rebirth and subsequent perfection of the arts.

> Nearly all the protagonists were Tuscans and for the most part your own Florentines. Many of these were protected, encouraged, and rewarded by your most illustrious ancestors. It can well be said that the arts were reborn in your state, nay in your own most happily favored house. Thus it is to the members of your house that the world owes the benefit of these arts, restored, embellished, and ennobled as they are in our present day.[4]

Beyond the terms of conventional flattery, the Medici assumed the *rinascità* as a dynastic property. In the expanded 1568 edition of the *Vite*, Vasari elaborates the theme of inspired Medici patronage into a dominant motif.[5] Over the years their identification with the cumulative achievement of Tuscan culture came to be enshrined virtually as an article of faith. The myth of the Florentine rebirth of art was crucial to this reading of history; its central fixture was Vasari's account of the painter Cimabue.

IN THE "PROEMIO" to the biographies in his *Vite de' pittori*, Giorgio Vasari describes the course of the arts in the ancient world from their inception in Egypt to their perfection in Corinth, Athens, and Rome, through their eventual decline in the latter city during the reign of Constantine. The symbolic embodiment of this "ultimate ruin" is the Emperor's removal of the arts from Rome to Greece. This stands as the watershed between the *antico* and the *vecchio*, respective periods of good and corrupt use.

Vasari represents this decay as so grave that the inundation of Italy by barbarian nations, trampling asunder the arts and subverting the language, laws, and customs of the Romans, might well seem a superfluous second deathblow. Any lingering trace of good antique practice was then ruthlessly smothered by Christianity, with Pope Gregory the Great cast in a strikingly sinister role. Works continued to be produced with a certain magnificence or grandeur of scale, but in the German or Lombard manner, thus clumsy and crude, without grace, design, or reason. Also to be considered are the Greeks who exercised their particular manner throughout Italy. Though not to be confused with the excellent Greek masters of the antique past, within the limitations of their style they created conspicuous works that could serve as examples to the native Italians.

A slight stirring was felt towards the year 1250, when an "increasing subtlety in the air" of certain Tuscan localities allowed the inhabitants to benefit from the antique remains around them. Vasari then leads to the "Vita di Cimabue" with a resounding statement of his central theme.

> Our artists . . . have seen how this art propels itself from a small beginning to the greatest heights, then from so noble a grade hurls itself down to ultimate ruin. By their nature this and other arts resemble human bodies, which have their birth, growth, aging, and death. Thus you will understand more easily the progress of its rebirth (*rinascità*) and the very perfection to which it has risen in our own time.[6]

In summarizing the "Proemio delle vite," we have given only a cursory reading to what is in fact a lengthy and subtle exposition. Vasari demonstrates an impressive awareness of the forces at work in the artistic culture of postclassical Italy, though with little understanding of how these elements relate to each other. He also manifests an acute, if largely negative, comprehension of the principles of Byzantine style and recognizes works of significance even in the Dark Ages. Far more boldly mythologizing, however, is the "Vita di Cimabue" which follows immediately on the "Proemio."

> Due to the infinite flood of evils which cast down and submerged this wretched Italy, such as could be called real buildings were destroyed, and of yet graver import, the complement of artists was totally obliterated. Then in the year 1240, according to the will of God, Giovanni

surnamed Cimabue, of the then noble family de' Cimabuoi, was born in the city of Florence to kindle the first lights of the art of painting.[7]

Vasari describes how Giovanni Cimabue's father recognized the child's intellectual capacity and sent him to learn grammar at the Monastery of Santa Maria Novella. The boy, however, neglected his studies in favor of drawing pictures in his books.

Fortune chose to smile on this waywardness. At that time, "Those who governed the city summoned some Greek painters to Florence for no less purpose than to reinstate the art of painting, which had been utterly lost and not merely left to wander off the track. Among other works in this city, they began to paint the chapel of the Gondi family . . . in Santa Maria Novella."

Cimabue frequently escaped his studies to watch them work in their awkward modern Greek manner. His father eventually bowed to the inevitable and assigned him to them for instruction. By imitating these masters and then "adding perfection to perfection," he was able to remove much of the clumsiness and crudeness of their style. Cimabue made such a name for himself that Dante recorded his fame in the eleventh canto of the *Purgatorio*.

> Credette Cimabue nella pittura
> Tener lo campo, ed ora ha Giotto il grido
> Sicchè la fama di colui oscura.
>
> [In the art of painting Cimabue once was thought
> to command the field, but now Giotto has the cry,
> casting a shadow over the former's fame.]

And so, after the "Vita di Cimabue," Vasari leads us through the lives of Arnolfo di Lapo, the Pisani, Andrea Tafi, Gaddo Gaddi, and Margaritone of Arezzo to Giotto and the next major increment to Cimabue's "small beginning." The renowned elder master, Vasari claims, discovered Giotto as a young shepherd drawing on a rock. Through Cimabue's tutelage and an unequalled imitation of nature, the disciple completely discarded the Greek manner and eclipsed the fame of his mentor.

Following the initial impetus of Cimabue, as Vasari demonstrates in his *Vite de' pittori*, greater and greater achievements were made in ever shorter spans of time. Therefore, the three ages in the progress of the arts run respectively for one hundred and fifty, one hundred, and fifty years.

7

Vasari's first age stretches from approximately 1250 to 1400. If we extend the author's image of human development, this parallels the tentative gropings of childhood, weak and awkward but turned in the right direction. The second age corresponds to the quattrocento and represents the more firmly directed education of youth. The rules that structure nature are then acquired, most particularly the principles of anatomy and perspective and of classical usage in architecture. This period of Masaccio, Donatello, and Brunelleschi is characterized by immature dryness of style, reflecting such rigid learning by rote.

Leonardo, Raphael, and Michelangelo preside over Vasari's third age of full development, which occurs during the first half of the sixteenth century. Their "perfect manner" surpasses even that of the ancients and is founded on an absolute mastery of the rules of design. The artist is thus free to approach nature with a certain license, opening the way to an unparalleled grace and variety. Michelangelo is the culminating figure of this culminating age, uniting in himself the ultimate perfection of all three arts.

As a literary conceit Vasari's scheme is clear, clean, and forceful. Its elegance must have been dazzling when the first edition appeared in 1550, precisely three hundred years after that initial rarification of the atmosphere. As an exercise in historiography, however, the *Vite* presents a number of difficulties quite apart from its factual reliability.

Built into Vasari's cycle was another inevitable decline of art. Indeed, by the second edition of 1568, Michelangelo was dead and the "mannerist" excesses of style feeding on style were becoming increasingly apparent. With shrewd insight Vasari anticipated many of the criticisms that were later levelled against his own art and that of his fellows. Nonetheless, the *Vite* offered a closed scheme that could not be extended easily by subsequent writers.

In the *Vite* Vasari's great progress of artistic development is implicitly unilateral. The author was Tuscan by birth, and even more, a practicing artist rooted in the Romano-Florentine tradition of firm drawing and grand-style figure composition. For him, art was reborn in Florence and, in its higher forms, never left central Italy unless exported by a Tuscan. Other artists, other schools, and other traditions were either ignored or denigrated.

Notwithstanding such ideological simplification, the *Vite* is a richly complex piece of literature drawing on a considerable range of sources and precedents. The motif of cyclic development, for example, already

8

had a venerable pedigree, first in the ancient world and then among Renaissance humanists. Ghiberti had previously applied it to the rise and fall of art.[8] In its entirety, however, the *Vite* was a brilliantly original achievement that marked the beginning of a great tradition of art historical writing.

Giorgio Vasari commanded remarkable powers of literary invention and a genius for casting historical concepts in their most concrete and memorable form. In the realm of art historiography, he introduced the term *"rinascità"* and also the memorable theme of "the barbarians." His formulation of Cimabue's career represents a conscious and highly successful exercise in legend making, giving a powerful mythic form to the activity of the "Greeks" in medieval Italy.

However impressive these virtues, there are others that cannot be claimed for the *Vite*, most notably consistency and factual accuracy. Considering the novelty of the genre and Vasari's conception of his task, such qualities were scarcely essential, particularly in regard to remote artists of the due- and trecento. Later historians, however, were not so forbearing. By the mid-seventeenth century Vasari's lapses could trouble even his admirers and give easy opportunity to critics and detractors. His elaboration of myth and anecdote might be dismissed as old-fashioned and self-indulgent. When Vasari offered more than one version of an event, subsequent generations felt free to take their choice.

Though Vasari conceived his *Vite* as instructive, his Tuscanophile stand was not polemical since no discordant views had as yet been voiced. Whether or not the Florentines did in fact reinvent art, they were remarkably precocious in their cultural self-awareness and quick to give their presumed supremacy articulate expression. For the author of this first compendium of artists' lives, there were few comparisons to be drawn or criticisms to be anticipated. It is notable that even the most apparent of these criticisms were so very long in coming.

FILIPPO BALDINUCCI, in his *Notizie* on the painter Livio Mehus, evokes a train of associations regarding the history of art as viewed from the Medici collections in Florence: "For the late Cardinal Leopoldo of Tuscany, Livio created a picture intended as the cover for a systematic table noting all the paintings in his royal gallery. The artist here represented Giorgio Vasari writing his *Vite de' pittori*, with various things to explain the concept, all marvelously executed."[9]

Though Leopoldo never realized this catalogue-chart of his gallery,[10]

it was only one of several projects that he sponsored with his eye on the authoritative figure of Giorgio Vasari. The prince also founded a great drawing collection organized on Vasarian principles,[11] and encouraged several schemes for bringing the *Vite* up-to-date.

Filippo Baldinucci was the most important collaborator in Leopoldo's art historical endeavors.[12] In the spring of 1681, five years after the prince's death, Baldinucci published the prospectus of the *Notizie de' professori del disegno*, an encyclopedic compendium of artists' lives. A few months later, Mehus's art historiographic icon was displayed at the Saint Luke's Day exhibition of the Florentine Accademia del Disegno.[13]

Though Filippo Baldinucci cast himself as the second Vasari, by 1681 the writing of artists' lives had ceased to be a strictly Florentine affair. New collections of artists' biographies had been issued in Rome by Baglione (1642) and Bellori (1672), in Venice by Ridolfi (1648), in Genoa by Soprani (1674), and in Bologna by Malvasia (1678).

In these years any attempt at writing artists' lives was defined by its relationship to Vasarian precedent. More concretely, much of this activity was linked directly or indirectly to the belated republication of Vasari's *Vite de' pittori*. After Vasari's expanded version of 1568, the *Vite* had to wait seventy-nine years for another printing. The Bolognese publisher Carlo Manolessi reissued the work in 1647, then brought out yet another three editions in Bologna in 1648, 1663, and 1681. Following this remarkable surge of interest, the *Vite* did not see print again until 1759.[14]

Carlo Manolessi was keenly aware of the significance of his initiative. In the preface to the 1647 *Vite*, Manolessi informs the reader that a "most virtuous and qualified individual" has agreed to continue Vasari's lives up to the present day. To this end he requests information concerning painters, sculptors, and architects active after 1567.

The "virtuous and qualified individual" is most probably the Roman antiquarian Gian Pietro Bellori,[15] who composed the edition's lush dedicatory ode to Grand Duke Ferdinando II of Tuscany. Bellori's own *Vite de' pittori, scultori, ed architetti moderni* (Rome, 1672) did not appear for twenty-five years and then contained only twelve carefully formulated biographies. While falling short of a comprehensive updating of Vasari's work, it offers a sympathetic translation of the values of Romano-Florentine *disegno* into seicento terms. On several occasions Bellori also restates or parallels the theme of the Cimabuan *rinascità*.

The middle decades of the seventeenth century witnessed an active

resumption and reappraisal of art historiographical issues, and thus a variety of responses to Vasari's example. As early as 1642, Giovanni Baglione in Rome published his *Vite de' pittori, scultori, ed architetti*, also with an introductory poem by Bellori. Baglione's preface begins with the resounding statement, "That which is lacking to Giorgio Vasari and Rafaello Borghini in their *Lives* . . . is offered in supplement by my present work." This is accurate, in so far as he presents a modest addition of Roman material with few literary or methodological pretensions.

Far more significant and controversial was the appearance in Venice in 1648 of Carlo Ridolfi's *Le Meraviglie dell'arte*. The first great anti-Vasari of a rival pictorial tradition, Ridolfi corrects specific factual errors of his Florentine predecessor, offers fuller biographies of the Venetian painters whom Vasari neglected or slighted, and lauds his school's triumphant mastery of *colore*. In his introduction, Ridolfi goes directly to the point and repudiates the fundamental assumption of Vasari's book: "In modern times the art of painting renewed itself in Venice, before it was brought to Florence as Vasari asserts. He claims that in the year 1240 the Florentines summoned painters from Greece to re-establish this art in their city. With great ostentation he then describes the works of Cimabue and Giotto . . . and other of his painters."[16]

Ridolfi knew well that the Greeks had been active in Venice long before that date and he drew the obvious implications. Vasari's transparent literary inventions and blatant contradictions of fact left him easy to defeat on his own terms. Working within a recognizably Vasarian framework, Ridolfi needed only to substitute Venetian names and dates.

In Florence, Vasari's construction of history had become essential to local pride and to the public image of the House of Medici. The growing foreign competition could therefore hold serious implications. On Saint Luke's Day of 1646 (18 October), the Florentine ecclesiastic and jurist Lionardo Dati[17] wrote to the Accademia del Disegno formally proposing a continuation of Vasari's *Vite*.[18] Though Dati had considered such a project for several years, he recognized that he must delay no longer. With the death of more and more elderly practitioners of the arts came the loss of crucial sources of information. Dati was also troubled by the progress of rival initiatives: "I hear that in Venice and Bologna they have substantially realized this idea which I have just formulated. In Rome, Signor Giovanni Baglione already treated succinctly

the works executed there between 1572 and 1642. Giorgio Vasari won a premier place for our city, which we will lose should his work be carried on by foreigners."

Lionardo Dati offers his services in coordinating a group project. Members of the Accademia del Disegno are to pool their knowledge with whatever they can learn from friends in Florence and abroad. This information concerning artists active after the time of Vasari will be submitted in writing, according to a standard model which he encloses. Dati particularly hopes that colleagues will not abstain from the enterprise for fear that he might profit from their labors. All contributors are to receive full credit, and the work could be published under the name of the academy rather than his own. Finally, his written proposal will serve to guarantee his good faith. "Should you find that I default on my promise, you can publish this letter in my face. All the world will thus recognize the felony."

Shortly thereafter Lionardo Dati approached Ascanio della Penna in Siena for historical material.[19] He also forwarded a copy of his Saint Luke's Day letter to a Signor Paolo in Venice, probably Paolo del Sera,[20] a Florentine merchant with close Medici connections. Dati explains that "the Most Serene Patron has heard my idea and indicated his satisfaction in my carrying it out, since he would view the work with pleasure. In regard to the Most Serene Patron Leopoldo, he has caused me to enjoy every protection."[21]

Dati appeals to Signor Paolo as a compatriot and as an amateur, asking him to investigate rival projects and to approach the Venetians for biographical information. Since Vasari's *Vite* had come to be considered a classic of the Tuscan language, foreign imitations raised a set of special problems.

> Since this work is being composed in the vulgar tongue, we can generally assume that here it would be written more correctly. Leaving aside my own failings, it would appear with the assistance of our professors of that good Florentine idiom in which we read Giorgio Vasari's distinguished work. . . . It is therefore reasonable and incontrovertible that Florentines should follow each other on this path.

Shortly after his overture to the Accademia del Disegno in 1646, Lionardo Dati was raised from a canonship in the cathedral to the vicarship of Florence, and finally to the see of Montepulciano. This rapid ascent of his ecclesiastical career, followed by his death in 1652, appar-

ently left little time for literary pursuits. Elements of Dati's proposal, however, continued to surface in later Florentine projects, particularly those of Giovan Battista Brocchi and Filippo Baldinucci. Indeed, it is Baldinucci who left the fullest account of these successive initiatives.[22]

Some years after Lionardo Dati's death, Abbot Giovan Battista Brocchi, master of grammar and humanities to Francesco Maria de' Medici, decided to take up the lives of the artists where Vasari left off. Word reached him that the late bishop had already made considerable progress towards this end. Among Dati's papers, however, Brocchi could find only a draft of the letter to the Accademia del Disegno and blank questionnaires.

Disappointed but undaunted, Brocchi persevered with his plan, making special progress with the lives of Giovanni Manozzi da San Giovanni and Ludovico Cardi il Cigoli. For the latter he had privileged access to a previous biography of Cigoli, written by the painter's nephew and preserved in manuscript in Francesco Maria de' Medici's library.

Leopoldo de' Medici showed an interest in Brocchi's undertaking, as he had previously in Dati's. Once again, application was made to knowledgeable individuals with Medici connections. In 1667, on Brocchi's behalf, Prince Leopoldo approached Cavaliere Lodovico de' Vecchi for information concerning Sienese painters not discussed by Vasari.[23] At about this same time, Brocchi also obtained an important series of Genoese biographies from Rafaele Soprani, who was then writing the *Vite de' pittori, scultori, ed architetti genovesi*.[24]

Following Brocchi's death in 1683, Filippo Baldinucci learned that the abbot had collected masses of information which might benefit his own researches. Baldinucci gained access through the patronage of various distinguished personages,[25] only to discover that the results fell short of his expectations. In addition to Brocchi's valuable life of Cigoli, there was Soprani's manuscript material, a few notes on Gian Lorenzo Bernini, and an assortment of insignificant jottings. By this time Soprani's fuller *Vite de' pittori . . . genovesi* had been available in print for nearly ten years, and Baldinucci's own *Vita del Cavaliere Bernino* was already published. Baldinucci took great pains to emphasize his personal admiration for Giovan Battista Brocchi while rendering negligible his actual debt. "Never have I wished to adorn myself through the efforts of others, but have always sought to give virtue its due recognition."[26]

In one regard, Baldinucci's candor appears somewhat less exemplary. While discussing Dati and Brocchi's projects, he chose not to mention Leopoldo de' Medici's patronage of these earlier schemes. Especially after the prince's death in 1675, it was of immediate importance to Filippo Baldinucci that he be recognized as the unique partner in Leopoldo's art historical endeavors.[27]

In seventeenth-century Italy the circle of art writers was notably small in compass. If they did not know each other personally, they shared friends, acquaintances, and correspondents. Opportunity abounded for both cooperation and antagonism, as we see in the web of connections between Carlo Manolessi's reprinting of Vasari's *Vite*, Rafaele Soprani's *Vite de' pittori . . . genovesi*, and Filippo Baldinucci's *Notizie de' professori del disegno*.

Manolessi approached Soprani for information on artistic activity in Genoa after the time of Vasari. Soprani obliged the Bolognese publisher, though a friend of the Genoese writer was dismayed that these efforts should appear under another's name. By 1665 Soprani had brought a book of his own near to completion, but involvement in other literary pursuits led him to postpone printing.[28]

The Florentine Giovan Battista Brocchi also contacted Rafaele Soprani in 1668, soliciting material for his edition of artists' lives. Soprani courteously sent Brocchi notices on seven Ligurian painters, though this rival initiative spurred the Genoese, however inconclusively, to put his own work in publishable form. After Brocchi's death, the compendium of Genoese material passed into Baldinucci's hands.[29]

Filippo Baldinucci appears as heir to two successive Florentine schemes for bringing Vasari up to date. In these endeavors Dati, Brocchi, and Baldinucci all enjoyed the support of Leopoldo de' Medici. There are other connections, less direct though no less real, between Baldinucci's *Notizie* and Manolessi's 1647 edition of Vasari's *Vite*.

In the chapters that follow we will trace the later development of Filippo Baldinucci's great project for the *Notizie de' professori del disegno*. When we observe his relations in the 1670s and 1680s with Giovanni Cinelli and Ferdinando Leopoldo del Migliore in Florence, with Carlo Malavasia in Bologna, and with Gian Pietro Bellori in Rome, this small world of the art history writers will come to look even smaller.

ONE

Leopoldo de' Medici

LEOPOLDO DE' MEDICI is a man about whom we know both too much and too little, one of the most celebrated members of a family whose virtues and vices still occupy a strange middle ground between history and mythology. By all accounts a remarkable figure, he is one of those rare personages of whom evil is never spoken and whose praise seldom descends below the hyperbolic. We must begin as broadly and as simply as we can, in separating the ordinary from the extraordinary, in distinguishing what belongs to the individual and what belongs to the family, what belongs to his period and what belongs to his class.

Leopoldo was an Italian prince, a scion of the House of Medici, and a gifted, forceful individual. As a prince, he often seems a remote and stylized figure moving against an unremittingly splendid background. Like religion and etiquette, art was so essential to courtly existence that its meaning can become elusive through its very ubiquity. As a Medici, Leopoldo inherited a unique family culture that brought him both a special range of artistic obligations and exceptional opportunities for creative innovation. As an aristocrat, he cultivated the arts as an adornment of life and a private source of pleasure and recreation.

LEOPOLDO DE' MEDICI was born on 6 November 1617. He enjoyed a privileged education in the humanities and was tutored in the natural sciences by disciples of Galileo. Demonstrating a precocious interest in music and literature, he began in his youth to compose poetry and comedies.

The young prince grew up amidst the Medici art collections and received practical instruction from the painter and architect Sigismondo Coccapani.[1] He participated in rural sketching trips and drew acquaintances at court from life.[2] Seven pictures are attributed to Leopoldo in

15

the inventory of his estate. These include oil portraits of a musician and a captain, a still life of flowers with dogs, a sleeping *amorino*, two landscapes in tempera, and the head of a man in fresco. Many of his private papers feature casual drawings of some talent.[3]

Grand Duke Ferdinando II divided the duties of government among his three brothers, charging Mattias with military affairs, Gian Carlo with finance, and Leopoldo with political matters. In 1637, at the age of nineteen, Leopoldo assumed the governorship of Siena during the absence of Prince Mattias.[4]

Leopoldo first travelled outside Tuscany in 1639, when he visited his sister, Duchess Margherita of Parma, and accompanied her to the court of Modena. The prince also called at Bologna, Ferrara, and Venice, gaining valuable experience in public comportment and enjoying extensive sightseeing.[5] In 1646 he journeyed to Innsbruck in great state with his other sister Anna on the occasion of her marriage with Archduke Ferdinand Karl of Austria.[6]

Shortly after his return to Florence in 1639, Leopoldo obtained a superb *Cleopatra* from the elderly Guido Reni, the most eminent representative of the Carracci tradition in Bologna. The picture was acquired through the mediation of Ferdinando Cospi, the Medici representative in that city and Leopoldo's host on his recent visit.[7]

The Prince's long and fruitful correspondence with Paolo del Sera, a Medici agent in Venice, began at about this same time. Del Sera's letters from the 1640s discuss an aristocratic miscellany of jewels, lace, tapestries, and pictures of various kinds. Leopoldo showed special interest in the great Venetian painters of the sixteenth century. This was imaginative and open-minded for a Florentine but increasingly characteristic of princely collecting in these years. More noteworthy than the purchase of small works by Titian, Tintoretto, and Veronese was his close attention to questions of value and quality. On a few occasions Leopoldo undertook ambitious acquisitions, paying the substantial sum of two thousand ducats for a *Raising of Lazarus* attributed to Veronese.[8] His youthful patronage of Florentine artists was probably significant as well, but more difficult to document.

In addition to such enthusiastic early collecting, Leopoldo began to assume his natural role in his family's protection of the arts. By 1640 he had offered repeated financial assistance to the elderly and destitute painter Jacopo Chimenti da Empoli.[9] In 1643 Leopoldo lent Pietro da Cortona a litter for his return trip to Rome and demonstrated a contin-

uing interest in the artist's Florentine projects.[10] He also advised on the great octagonal table in *pietre dure*, created in the 1640s for the Tribuna of the Uffizi.[11] In 1644, while serving again as interim governor of Siena, Leopoldo intervened in a dispute between the authorities of the Hospital of Santa Maria della Scala and the painter Angelomichele Colonna.[12]

As Leopoldo's inclination to the arts and scholarly disciplines became increasingly evident, he undertook the responsibilities for which he was best suited. In the late 1650s plans were under way to extend the exhibition space in the Uffizi, and Ferdinando II assigned him the task of overseeing the decoration of the south and west corridors. The ceiling was conceived as a pantheon of the greatest Tuscan exponents of the arts, sciences, letters and politics, and the program supervised in turn by three of Leopoldo's librarians and *gentiluomini di camera*. Ferdinando del Maestro was succeeded in 1665 by Lorenzo Panciatichi, followed by Alessandro Segni in 1676.[13]

We can observe Leopoldo in the double role of prince and amateur during his three trips to Rome. He made the first visit at the age of thirty-two, in the company of his brother Prince Mattias, to attend the Easter celebrations for the Holy Year of 1650.[14] This pilgrimage was undertaken rather suddenly, and hasty negotiations ensued between representatives of the Medici and the household of Innocent X Pamfili. The most pressing demand was that the two princes exclude unresolved issues from their conversations with the pope.[15]

A more troublesome problem was that of etiquette and precedence. In these years Roman society was caught in a spiralling inflation of ceremony, as the relatives and favorites of successive papal regimes appropriated ever more pompous courtesies.[16] Though the Medici were prepared to make some concessions to Roman ceremonial usage, they could not receive and return calls without careful advance planning. Mattias and Leopoldo chose to travel *incogniti*, and accommodation was arranged at the Villa Medici at Trinità de' Monti, a splendid garden retreat that provided few of the requisites for a state visit. For these princes of a sovereign ruling house, relations with the papal nephews Ludovisi and Giustiniani were especially problematic. On 6 April Innocent X forced the issue, as recorded in the official travel diary.

> That evening the pope ordered his Master of Ceremonies Signor Febei to come arrange the visits of these *Signori Nipoti*. Thus Their High-

nesses condescended in order to please His Holiness, though they had resolved to see no one at home. This was in spite of the fact that the Tuscan ambassador had fitted out two apartments with his own hangings and decorations. Prince Mattias's apartment made a fine show in crimson velvet and cloth of gold, and that of Prince Leopoldo in crimson damask with gold lace.[17]

Interviews were effected with the greatest personages in Rome in less ceremonially encumbered "third places," usually churches. As noted in their travel diary: "Hardly a day passed when they did not have discourse with cardinals or princes in some church, not addressing anyone as 'Excellency' except Spanish grandees or nephews of the pope. There is scarcely anyone, it seems, whom Their Highnesses did not meet, whether they be cardinals or titled gentlemen."[18]

In a joint letter to their brother Ferdinando II, Leopoldo and Mattias describe one of many such meetings: "On Monday morning [25 April], we went in a carriage with six horses to San Pietro in Vincoli, where there was Duke Ceserini to see us. He accompanied us while we were shown the chains of Saint Peter, Michelangelo's *Moses*, and the other things to be admired in that church. After the duke saw us to our carriage and allowed us to depart, we went on to the churches of the Madonna di Monti and San Marco."[19]

Relics or art objects often formed the background or pretext for these meetings. On 5 April Mattias and Leopoldo "attended mass at Santa Maria Maggiore, where Prince Borghese was waiting to receive them. He had them shown the Cappella Paolina and all the precious objects in the sacristy."[20]

Prince Borghese did not receive them four days later, when they went to admire the treasures in his palace. "Signor Agostino Maffei had all the *guardaroba* shown to the entire household. Signor Agostino, however, showed the jewels only to the two princes."[21]

During their month in Rome Mattias and Leopoldo participated in the most significant religious celebrations, toured the major churches, and visited many of the principal palaces and gardens.[22] On Easter Sunday they held the basin for the pope as he washed the feet of the pilgrims and, a few days later, accepted his offer of an apartment at the Vatican. They also met the greatest magnates in the city, although the Medici princes could not be welcomed with full ceremony.

Though Mattias and Leopoldo carried out their visits *incogniti*, considerations of etiquette and politics were never left far behind. After

admiring a palace or villa, they were usually offered lavish refreshments by their deputy host. One palace the Florentines did not see was that of the Barberini, against whom the Medici had allied themselves a few years earlier in the War of Castro. When the two princes attended the consistory, Cardinal Barberini pointedly refused to acknowledge their presence.[23]

During their privileged excursion through the wonders of Rome, Mattias and Leopoldo's frame of reference often must have been a personal one. Pieces were compared with similar examples in Florence, assessed as the possessions of friends and rivals, and appreciated as elements in rich or innovative schemes of decoration. Especially in the last days of their Roman sojourn, Leopoldo alone paid a number of calls on scholars and private collectors and saw objects in smaller houses and in the stock of dealers. These visits were even less formal in tone, and a *carrozzino* was substituted for the coach drawn by six horses.

On 26 April, "In a small carriage of Duke Salviati's, Prince Leopoldo saw pictures and statues in various places, returning to Trinità de' Monti with the duke." The next morning Leopoldo went to the Medici palace in Piazza Madama "to see some pictures of Piermattei and then to the house of the Cavaliere dal Pozzo to see more paintings, sculptures, and objects of curiosity." That afternoon, "He stopped at the house of the Jesuit Father Kircher, mathematician and great *virtuoso*. He also saw some small pictures and devotional objects brought by merchants." Again on 29 April the prince went out with Duke Salviati "to see to various affairs."[24]

Carl'Antonio dal Pozzo and Athanasius Kircher were celebrated virtuosi, accustomed to the respectful attention of the great world. Piermattei was presumably a dealer whom Leopoldo could not honor with a personal call, though the prince might allow him to bring his merchandise to one of the more centrally located Medici residences. For the most part, Leopoldo's contacts with private collectors, antiquarians, and merchants are summarily noted if at all. From Salviati's correspondence with the prince after his return to Florence, we know that Leopoldo commissioned a reliquary and purchased statues and a classical bust. In Roman antiquarian circles he also formed important acquaintanceships that were to shape his interests for many years to come.

Leopoldo made his next appearance in Rome nearly twenty years later, in circumstances very different from those of his youthful pleasure trip. After prolonged negotiations and visits to Florence by two sets of

papal relatives,[25] he was named as cardinal on 12 December 1667. Celebrations were enacted in Florence on 14 and 15 December "in the same form as those for the promotion of the late Cardinal Gian Carlo de'Medici. . . . The festival bells were rung for two days. There was a public illumination for two nights, also at the houses of the magistrates. On two nights the fortresses fired their guns. The bell of the Uffizi was rung and the shops opened."[26]

On 17 December an illumination was held at the Tuscan embassy in Venice and, probably with equal dispatch, at Florentine legations throughout Europe. A state visit to Rome was indicated, so that Leopoldo might accept his biretta from Clement IX Rospigliosi and establish his position in Roman political circles.

In only three months a remarkable variety of arrangements in Rome were effected for the cardinal and his *famiglia*. Lodging and board needed to be provided for some hundred and thirty retainers, in addition to the permanent staff of the Tuscan legation. Lists of the inhabitants of the three Medici palaces in Piazza Madama, Campo Marzo, and Trinità de' Monti were quickly drawn up to assist in the reassignment or eviction of extraneous tenants. Since Rome saw the constant coming and going of large households, a class of domestic outfitters called *furieri* had arisen to supply their short-term needs.

The Palazzo Madama was the traditional seat of Medici cardinals. A week after Leopoldo's nomination plans and measurements of the state apartments were dispatched to Florence so that the artistic administration could consider projects for redecoration. In early February Diacinto Maria Marmi journeyed to Rome to direct the final installation.[27]

Diacinto Marmi served the Medici for half a century. Trained as an architect and draftsman, he began his career as assistant to his uncle Biagio Marmi, *Guardaroba* of the Granducal Palace. By the 1660s he assumed this post in his own right. While holding ultimate responsibility for the contents of the Palazzo Pitti, maintenance and record keeping were only part of his job. Marmi also showed himself to be a brilliant designer and executor, assembling permanent and temporary decorative schemes with breathtaking efficiency and comprehensiveness. He was still active in 1697, when Cosimo III rewarded his long efforts with the title of *Gentiluomo di Corte*.[28]

In refitting the Palazzo Madama, Marmi deftly combined the resources of the granducal workshops in Florence with those of the specialized Roman firms that produced the requisites of state at short no-

tice. Tapestries were sent from Florence and a rich suite of velvet hangings appropriated from the Tuscan embassy. The Florentine workshops made up chairs to complete sets, while additional ones could be rented locally. Displays of silver were shipped from Florence, as were trimmings to refurbish textile decorations.

Though splendor was of crucial importance, it was not an isolated consideration. Furnishings needed to be calculated according to the ceremonial function of each room. Particular attention was given to chairs, since variations in form signalled conventionalized messages of status and relative formality. Proposed designs were thus sent from Florence to be evaluated in terms of Roman style and Roman decorum.[29] Two portraits of the pope were commissioned from Giovanni Maria Morandi, one of these to go under the baldachin in Leopoldo's audience chamber.[30]

Ugo della Stufa, the cardinal's *Maestro di Camera*, arrived in Rome on 27 February and reported the satisfactory results, "The decoration of the palace is truly majestic, there being eighteen rooms all richly hung, demonstrating the diligence of Marmi's service."[31] A week later the French ambassador and ambassadress called to assess the effect, accompanied by Donna Cristina Paleotti, daughter of the recusant duke of Northumberland.[32]

Leopoldo made his entrance into Rome on 12 March 1668.[33] In the Quirinale five days later, he received his cardinal's hat from Clement IX Rospigliosi with full ceremonial compliment. Afterwards, the *nipoti* offered him a lavish banquet.

> Don Camillo Rospigliosi and the pope's nephews awaited my arrival at the table and were then seated with suitable order. A sumptuous *banchetto* was served, the initial display being splendid with statues and *trionfi*. Fruits and confections were arranged in pyramidal form with great richness and profusion, according to the style practiced here. There was music after we ate, the words alluding to my arrival in Rome. The whole ceremony lasted three hours and I was exhausted by the heat.[34]

In one of many letters sent from Rome to his brother Ferdinando II, Leopoldo details the magnificent elaboration of his reception by the pope. The grand duke's response was brief and to the point. He is pleased that everything went according to program, that nothing was omitted, and that due regard was shown at every stage. This attitude,

both attentive and matter of fact, is often expressed in regard to works of art and schemes of decoration.[35] After his installation Leopoldo was expected to pay formal calls on all fellow cardinals residing in Rome. On 24 March he offered a running tabulation after his first round of visits.

> In recent days I visited Cardinals Cibo, Sforza, Gualtieri, Spinola, Gabbrielli, Odescalchi, Savelli, Dongo, Santa Croce, and Pio. In regard to number and variety of pictures by old and modern masters, Pio is generally best supplied. Savelli seemed the most magnificently housed. In his palace at Monte Savello, he enjoys a grand apartment with noteworthy furnishings, as well as gardens and fountains that rise to the height of the first floor due to the advantages of the site. Similarly, Santa Croce keeps a commodious habitation, boasting fine furniture and many praiseworthy statues. I have not as yet seen others that equal these or merit special comment.[36]

Three days later, Leopoldo updated this evaluation after further visits.[37] As emblems of prestige and requirements of state, such incessantly magnificent interiors might seem to form a dazzling blur behind the figure of the cardinal prince. His eye remained sharp, however, for the unusual and remarkable, as he noted on 8 May.

> To repay the courteous attention of Cardinals Vidoni and Gualtieri, I called on them yesterday morning at their residence in the Palazzo Pamfili in Piazza Navona. While passing quickly through the apartments, I saw the celebrated gallery painted by Pietro da Cortona. Due to the multiplicity of figures and vastness of the area, it can be considered one of his most notable achievements. No less splendid and noble is the Church of Sant'Agnese joined to the palace. Judging from the bas reliefs and ornamental framework, it seems well on its way to completion.[38]

Leopoldo could be expected to demonstrate a personal interest in the work of the recently deceased Pietro da Cortona. The artist had long been associated with the Medici and his decorations in the Palazzo Pitti were completed only three years earlier by his follower, Ciro Ferri. On another occasion the cardinal expressed pleasure in Cortona's frescoes in the Chiesa Nuova, which he admired while hearing mass.[39]

In regard to ceremonial etiquette, nothing was left to chance on Leopoldo's 1668 visit. Distinctions of the greatest subtlety were deduced from precedents set by his late uncle Cardinal Decano Carlo de' Medici and his late brother Cardinal Gian Carlo. All courtesies that Leopoldo

received or offered were duly recorded for future reference.[40] It was also noted for Leopoldo's instruction:

> Whenever His Eminence [Gian Carlo] went publicly to a church, he wore the habit and rigorously observed all ceremony.
>
> In going to gardens or to see a *vigna*, His Eminence normally went in a carriage with six horses, followed by another similar one for the service of his court, as well as a page on horseback with the *valigia*, and guardsmen.
>
> When it pleased His Eminence to see pictures, statues, or other curiosities in a private house, he went privately in a closed carriage.[41]

Leopoldo made frequent dilettante excursions of the latter description, but these took second place to more official obligations. On 27 April he commented to the grand duke, "In such hours as I have free from these occupations, I gratify myself by going to see medals, pictures, and statues in the most famous cabinets and shops."[42]

Leopoldo noted on 8 May: "This morning I was unable to find any cardinals who were not busy, so I went to the palace of Cardinal Antonio Barberini at the Giubbonari. It is truly filled with an abundance of pictures and statues."[43]

Since the Medici had reinstated relations with the Barberini, Leopoldo at last visited their great family palace at the Quattro Fontane on 4 June, after repeated invitations from Cardinal Francesco. "He accompanied me himself while I inspected the pictures, the statues, and the library, and was tireless in showing me the greatest courtesies."[44]

Leopoldo left for Florence on 12 June 1668, after a conspicuously cordial farewell from the papal family and the gift of "a fine picture from the hand of Annibale Carracci" from Cardinal Giacomo Rospigliosi.[45] Many of the displaced tenants moved back to their quarters, and the state apartments in Palazzo Madama were at least partially disassembled. The state coach, which had been bought from a French prelate for Leopoldo's visit, was resold to the ambassador extraordinary from Bologna.

During Leopoldo's Roman sojourn, Diacinto Maria Marmi was busy in Florence redecorating a suite of reception rooms for him on the ground floor of Palazzo Pitti. The audience chamber and *antecamera* were frescoed by Jacopo Chiavistelli. The cardinal's business manager Ottavio Barducci played a central role in administering these activities and corresponded regularly with him during his absence.[46]

Leopoldo's obligations in Rome did not end with his departure. As

titular cardinal of the Church of Santi Cosma e Damiano, he was responsible for the feast of its patrons on 27 September 1668. The Tuscan Resident Torquato Montauti commissioned the arms of Pope Clement IX and the Cardinal de' Medici from a gilder and had Romanelli paint an inexpensive representation of the two saints to be placed over the door. The rest of the decorations were contracted out to a *festarolo*, who rented them plain silk hangings. Santi Cosma e Damiano was an out-of-the-way church, and the preparations were undertaken with stringent economy. Even so, it was possible to make an acceptable showing with the very modest expenditure of sixty-three *scudi*, including music and a gift of food to the monks. Somewhat less was spent the following year, since Romanelli's picture and the armorial devices were available for reuse.[47]

Another consideration for the cardinal was the public availability of his portrait. In addition to satisfying general curiosity, such images could be used by those enjoying Medici connections to demonstrate their privileged status. Ten months before Leopoldo's nomination, his correspondent in Venice, Paolo del Sera, had already ordered a portrait in sacred regalia from the Florentine court portraitist Justus Sustermans.[48] Five days after the formal announcement, the Tuscan resident wrote from Rome: "Many here desire a portrait of Your Highness from which to make copies. If you could favor me with a recent one, I will circulate it among them, and the sooner the better. Otherwise, these *pittorelli* will fill the shops with their usual bad stuff."[49]

Shortly after Leopoldo's return to Florence in 1668, problems arose concerning a suitable source for his authorized engraved portrait. The young Flemish engraver Albert Clouet refused to work from the one offered him and insisted that a better example be sent from Florence. He eventually issued a print taken from an original by Sustermans.[50] Leopoldo's most vibrant and attractive likeness was rendered by the painter Giovanni Battista Gaulli,[51] who called on him in Florence in the spring of 1669 with a letter of introduction from Cardinal Chigi. The next year they saw each other in Rome on at least one occasion.[52] Leopoldo shared his family's long concern with the formulation of their dynastic portraiture. In the 1670s he initiated an ambitious scheme to publish engraved portraits of all the Medici princes beginning with Cosimo I.[53]

Leopoldo's third visit to Rome followed closely on the second. As a Medici and a ranking cardinal, he was responsible for many of his fam-

ily's interests in that city. On 30 November 1669 Resident Montauti reported on Clement IX's gravely deteriorating health. With little transition, this slipped into a discussion of interior decoration. "Considering the risk of new reverses and His Holiness' extreme weakness, it is well that you lose no time in preparing for your trip and seeing to all that is necessary. Available here for your use, we have tapestries for four good rooms, as well as the *parato* with the fountain motif."[54]

Clement IX Rospigliosi survived until 9 December, and Leopoldo could not leave Florence before receiving official word of his death. Arrangements, however, were immediately begun, though on a lesser scale than those for his previous visit. At the exequies for Clement IX and conclave to elect his successor, Leopoldo would be only one of the more visible participants. Considering the prevailing state of upheaval, an element of improvisation would not be unseemly.[55] The ceremonial apartments in Palazzo Madama were already in good repair and additional furnishings were quickly borrowed from the Tuscan ambassador and the princess of Rossano.[56] The cardinal's household was outfitted with mourning livery, and a magnificent cell constructed for his lodging at the conclave.[57]

Leopoldo arrived in Rome on 16 December 1669. On the evening of the nineteenth, shortly after the conclusion of the pope's funeral, he was closed in the exhausting and tumultuous conclave which took four and a half months to elect Clement X Altieri. On 29 April 1670 Leopoldo returned to the Palazzo Madama and began to receive and pay the usual formal calls. As on his previous trip, he filled the space between these with tours of palace galleries, sculpture gardens, cabinets of antiquities, and excavation sites. In the last weeks before his departure for Florence on 17 September, Leopoldo visited the three most eminent painters in Rome: Ciro Ferri, Giovanni Battista Gaulli, and Carlo Maratti.[58]

Gian Carlo de' Medici died in 1663, Mattias in 1667, and Ferdinando II in 1670. Throughout the early months of 1671 Leopoldo and Paolo Falconieri discussed the etching in Rome of two plates representing the late grand duke's funeral apparatus.[59] Leopoldo's already impressive career gathered further momentum in the last years of his life. In the Roman conclave of 1670, he emerged as a considered force in the College of Cardinals.[60] During the opening years of the reign of his nephew Cosimo III, he figured as the last surviving Medici prince of his generation. In addition to the prestige and authority of an elder states-

25

man, he probably enjoyed an augmented income.[61] Though Leopoldo's interest in natural philosophy was less conspicuous than it had been a decade earlier, he became increasingly involved in several innovative and specialized artistic projects. On 21 December 1674 he finally took priestly orders, after five years as a cardinal.[62]

Leopoldo died on 10 November 1675, at the age of fifty-eight. Grand Duke Cosimo III sponsored the state funeral in the family church of San Lorenzo. The facade was hung in black, with four emblematic skeletons alluding to the cardinal's chief virtues of piety, justice, fortitude, and wisdom. This four-part theme was developed further with chiaroscuro paintings and eulogistic inscriptions in the nave of the church. "In addition to these virtues, His Reverend Highness was much esteemed for his continuous patronage and great intelligence in the liberal arts and most noble sciences. This is suitably expressed by epigrams in the far end of the temple." The catafalque bore prominent references to the cardinal's connection with the literary Accademia della Crusca.[63]

ON 14 NOVEMBER 1675, four days after Leopoldo's death, an inventory of his furnishings and household goods was begun. The list took three and a half months to compile and fills two hundred and thirty-eight manuscript pages.[64] The cardinal left behind all the normal outfittings of a princely establishment and the personal accumulation of an exceptional career. There were pots and pans; mattresses and state furniture; carriages and saddlery; relics in jewelled reliquaries and unlabelled cardboard boxes; hunting rifles, exotic weapons, and the arms of his household guard; secular clothing, sacred vestments, and carnival costumes. In addition to domestic crockery and glassware, there were over eight hundred pieces of porcelain and more than a hundred of fine majolica "painted, they say, by Raphael of Urbino."[65]

Leopoldo owned approximately sixty classical statues and busts,[66] a hundred works in ivory,[67] a hundred objects in rock crystal,[68] six hundred portrait miniatures,[69] eight hundred cameos and intaglios,[70] and seven hundred coins and medals, mostly antique.[71] Six hundred and ninety-seven paintings were carefully catalogued, and a few dozen others left out of the numbered series. Included among the paintings were a hundred and thirty-five artists' self-portraits.[72] There was an extensive library,[73] engraving plates left from the published experiments of the Accademia del Cimento,[74] and a variety of scientific, mathemat-

ical and geographical instruments,[75] including the telescope through which Galileo first sighted the Medicean Planets.[76]

Leopoldo's main apartment in the Palazzo Pitti was both a lavish museum and a decorous setting for affairs of state. He occupied fourteen rooms on the third principal floor and a number of others in the attic above.[77] The second largest room in the apartment was the Stanza degli Appimondi, named for a terrestrial and a celestial globe set on ebony tables.[78] Preceded by two anterooms,[79] it served as the lobby to Leopoldo's audience chamber and bedroom. These rooms functioned as a semi-independent reception suite and boasted the most sumptuous textile furnishings in the apartment. The Appimondi was hung with alternating panels of green and purple velvet joined by patterned bands of gold and purple, with a coordinated treatment of doors and windows. There were eight classical busts on carved and gilded stands, four *torcieri* supported by tritons and three ebony tables. The paintings were mostly large and mostly modern, including subject pictures by Ciro Ferri, Vincenzo Mannozzi, and Domenico Cerrini and landscapes by Salvator Rosa, the Abate Lanci, and Monsú Montagna.

The audience chamber had a *paramento* of green damask and the baldachin over the chair of state was of yellow cloth-of-gold and red velvet. Dominating the room were six life-size portraits of seated figures by Justus Sustermans representing Leopoldo's parents Cosimo II and Maria Maddalena of Austria, his late brother Ferdinando II and his sister-in-law Vittoria della Rovere, his nephew Cosimo III, and the Grand Duchess Marguerite Louise of Orleans. Two smaller portraits of Leopoldo's creator, Pope Clement IX, and the reigning Clement X were also on view. There were two additional pictures, a *Mucius Scevola* by Livio Mehus and an unidentified *Cavalry Crossing a River* "di maniera antica."[80]

Leopoldo's bedroom was hung with alternating panels of yellow and green damask and his carved and gilded bed curtained with yellow cloth-of-gold and red velvet trimmed with fringe and gold lace. There was a large depiction of Leopoldo in sacred regalia by the copyist Romolo Panfi, who also executed many of the family portraits that filled the room. Of higher artistic quality were an *Ecce Homo* by Giovanni Bilivert, a *Magdalen* by Carlo Dolci, a *Charity* by Luca Giordano, and a *Prudence and Love* by Vanni. There were cupboards and chests in wood and simulated ebony, four *sgabelletti* upholstered in red velvet, two small tables, table covers in red leather, and other table covers in red damask and in red velvet "con tre cascate alla romana."[81] Possibly in

the bedroom as well were two complicated ebony cabinets. One contained three thousand carefully ordered antique coins and medals in bronze and silver, and the other nearly five hundred painted miniature portraits.[82]

Adjoining Leopoldo's bedroom was a small chapel[83] with an altarpiece of *Saint Zenobius* by Livio Mehus. The rest of the cardinal prince's apartment was devoted primarily to the display of pictures and other curiosities. Most of these rooms were hung in rich, if less costly, unpatterned red silk, though little of the wall surface was probably visible. The absence of tapestries must have been conspicuous.

The largest room in the apartment was the Salone de' Quadri.[84] Ninety-three paintings were displayed there, mostly Venetian works of the sixteenth century and a few Florentine and Emilian pieces of the same period. The celebrated "Giorgione" *Concert* was surrounded by numerous other pictures from the collection of Paolo del Sera, acquired by Leopoldo in 1654.[85] Several canvases ascribed to Tintoretto and Veronese, including the expensive and probably overattributed "Veronese" *Raising of Lazarus*,[86] were conspicuous for their large size. Guido Reni was the preeminent modern master, with his late *Cleopatra* and two other pictures.[87] Amidst seventeen "busts of emperors and senators" on carved wooden stands were the two most impressive classical statues in the cardinal's collection, the *Venus of the Casa Palmieri-Bolognini* and the *Dea Vestale*.[88] The Salone de' Quadri was furnished with a *paramento* of plain red silk, nine gilded wooden *panche* upholstered in red damask, and four gilded *torcieri* supported by tritons.

The Stanza de' Pittori[89] took its name from its hundred and thirty artists' self-portraits. There were also some two dozen small portraits, religious images, and genre scenes on panel, copper, and slate, as well as a variety of classical marbles. In 1667 the Stanza del Buonaccordo[90] was described as "a gallery of landscapes and statues," though the 1675 inventory also lists subject pictures by Guido Reni, Pietro da Cortona, and the Volterrano. The windowless *Camera Buia*[91] hosted a plentiful assortment of primitives, copies, and minor pieces, often unattributed and sometimes unframed.

The Stanza dell'Anticaglie[92] featured items of a calculatedly refined and curious nature. These included small still lives, ten framed miniatures under glass, two *Parables* by Domenico Feti, two Della Robbia *Madonnas* in terra cotta, and a fragment of ancient fresco showing *putti* and animals among grapes and vines. Possibly echoing the private tone

of this room, there were five portraits of Leopoldo's close and esteemed friend Princess Olimpia Aldobrandini Pamfili di Rossano and her daughters.[93]

On the floor above, in the attic or mezzanine rooms, Leopoldo housed various collections of a scholarly or specialized kind, including his extensive library.[94]

> The Most Serene Cardinal Leopoldo divided his library between two locations. . . . In a mezzanine room some fourteen *braccia* wide were shelves running from the floor up to the matting, sustained by winged bats holding the ropework. . . . These shelves were entirely filled with folios and books of other size, not to mention numerous books kept on the center table. This was known as the Libreria di Sopra to distinguish it from the so-called Libreria di Sotto. Next to this upper library, in a room . . . known as the Stanza dei Bronzi, were great wardrobes measuring over two *braccia*, facing each other above and below. Large books of drawings and prints were kept there. The lower library . . . was in a very large mezzanine room, next to the room of mathematical instruments. This library was shelved from the floor to the rafters. . . . All of these shelves, even the ones over the door and windows, were full of books, as was the table in the middle.

Also on this upper floor were the armory, a variety of storage rooms, and the living quarters of his *Guardaroba* Paolo Cennini, who was responsible for the contents of the apartment.[95] Compiling the 1675 inventory was Cennini's final act of stewardship of the late cardinal's movable possessions.

The breakup of Leopoldo's estate was orderly and uncontested. In the years before his death, he had already made over several important landholdings to his younger nephew Francesco Maria de' Medici.[96] His resources appear to have been managed judiciously, without the massive residual debts that forced the liquidation of the estate of his brother Gian Carlo in 1663.

The cardinal made many bequests of a special or keepsake nature. His sister-in-law, the Dowager Grand Duchess Vittoria della Rovere, was left a *gravicembalo* inlaid with ebony and ivory, an elaborate silver centerpiece, and the contents of his chapel.[97] Grand Duchess Marguerite Louise was remembered with a silver-mounted ebony cabinet, sent to the Parisian convent where she retired after the breakdown of her marriage.[98] Leopoldo set aside his thousand-piece collection of ceramics

for the crown prince, his twelve-year-old great-nephew Ferdinando.[99] His sister, Duchess Margherita of Parma, received a *Madonna and Child* by Pietro da Cortona and his other sister, Archduchess Anna of Austria, a *Miracle of Saint Zenobius* by Ciro Ferri.[100] Cardinals Sforza, Rospigliosi, Nini, Pio, Delfino, and Chigi were favored with modern pictures by Baldassare Franceschini, Carlo Dolci, Guido Reni, and Willem van de Velde.[101]

As his closest male relative and the chief representative of the family, Cosimo III was Leopoldo's natural heir. Though his uncle's estate was in many ways remarkable, the grand duke's household administration was well-equipped to absorb this massive influx of objects. Under Cennini's supervision the late cardinal's possessions were carefully listed. Through systematic annotations to the inventory, they were reassigned to the appropriate functionaries in the granducal household.[102] The shorthand annotations of the inventory are often cryptic without a close understanding of the roles of the various domestic managers. Leopoldo's clothing was distributed among his personal servants[103] and some of the less luxurious carriages sold off. Weapons were consigned to a certain Tofani and many items, particularly yard goods, handed over to Ubaldini. Most art works were divided between Diacinto Maria Marmi, *Guardaroba* of the Granducal Palaces, and Giovanni Bianchi, *Guardaroba* of the Granducal Gallery.[104]

Fine objects in ivory, crystal, and gemstone were destined for the gallery, as were the coins, medals, and intaglios. Bianchi was also entrusted with the portrait miniatures, the artists' self-portraits, the best scientific and mathematical instruments, and the antique bronzes. A few notable classical statues were assigned to Bianchi and about thirty paintings, mostly medium-sized Venetian works. Nine drawings were sent to Lorenzo Gualtieri, the late cardinal's *bottigliere*, "to be put in the books of drawings" then being assembled.[105] Leopoldo gave the lifetime use of his library to Francesco Maria. On his younger nephew's death it was to revert to the reigning grand duke, thus insuring its inalienability from the family.[106]

The furniture, classical busts, and about five hundred paintings were made over to Marmi, though a transfer might have been effected only on paper. By 1680 Leopoldo's former audience chamber was recast as a museum of the art of Justus Sustermans.[107] This tribute to the elderly painter was presumably constructed around the six life-size state portraits already hanging there.

At the time of Leopoldo's death, the stage was set for a major expansion and reorganization of the granducal gallery in the Palazzo degli Uffizi.[108] An important aspect was to be the incorporation of the late cardinal's collections into the dynastic patrimony. Leopoldo's bequest to Cosimo III of his carefully assembled treasures was conceived as a bequest to his family in perpetuity. He had always shown a keen sense of responsibility, both as a Medici patron and as a great prince.

LEOPOLDO DE' MEDICI was recognized as a remarkable figure in his own lifetime and across three centuries still appears an attractive and dynamic individual. To his exalted social position he brought personal gifts of the first order and was uniquely successful in integrating the public and private aspects of his character.

We can observe Leopoldo at close range in many passages of his correspondence with friends and relatives and in his own poetic writings. There is a heterogeneous body of literary papers associated with the cardinal. Several of his poems are preserved in relatively clean copies and many others in rough drafts, beyond which they may or may not have progressed. A few are accompanied by the critical opinions of court *letterati*. Mixed in with these papers is a variety of pieces privately circulated by Leopoldo's intimates.[109]

Most of Leopoldo's compositions are love sonnets in varying degrees of conventionalization. One poem is titled "Beautiful Turk, Impassioned Lover" and another, more convolutedly, "For a Beautiful Woman, Who While Going across the Sea on Galleys, Is Saluted by Them with Artillery."[110] There is also an intriguing, if barely legible, draft of a piece about the amorous agonies of "royal personages."[111] On the reverse of this sheet, he sketched three studies of a soulful seated figure and a curious image of an anguished male head perhaps surrounded by flames. Leopoldo covered the scratch copies of his poems with caricatures, landscape drawings, designs of scientific instruments and elaborate calligraphic flourishes.

Throughout his life Leopoldo delighted in female company, to which he made frequent gallant reference in his letters. In general he demonstrated a highly developed social nature, enjoying musical gatherings and gambling parties, hunting and other sports.[112] In 1671, he was involved in a program to revive the ancient Florentine *gioco del calcio* under aristocratic auspices.[113] In the 1640s and 1650s, he composed

comedies that were performed in private by members of his family. A few fragments are preserved of such theatrical writings.[114]

Leopoldo lent his pen to weightier themes as well. He produced several *sonetti morali* and an edifying religious piece, "Learning the Upward Path to Heaven from the Humility of Santa Maria Maddalena de' Pazzi."[115] He was also involved in drafting the quatrain that appears under the portrait of his brother Ferdinando II in the Accademia del Cimento's book of experiments published in 1667.[116] For the Accademia della Crusca, he undertook verses warning its members of the dangers of adulation.[117] In 1669 Leopoldo addressed a carefully considered eulogy to the Empress Eleonora in Vienna, who had requested a sample of his poetic expression. Both the sonnet and the accompanying presentation letter were closely reviewed by Carlo Dati and perhaps other academicians of the Crusca.[118]

Two years earlier, Leopoldo had labored over another sonnet possibly intended for public circulation. The poem apparently comments on the response of various Christian princes to the Turkish menace, and during its composition it went back and forth between Leopoldo and Dati, who also consulted Canon Lorenzo Panciatichi. These courtiers did not allow ceremony to blunt their criticism. "To speak with the sincerity Your Highness customarily desires, we did not think it equal to others that you imbued with more poetic felicity." The images are strained, the collision of consonants is intolerable, and one verse "falls to the ground." "I am overly daring, but in your benevolence you commanded me to proffer my sentiments freely, though I do so with humility and reverence." Leopoldo annotated their critique and accommodated most of their suggestions.[119]

Leopoldo's accessibility and dislike of flattery were remarkable for a ranking member of an autocratic regime. He was a prince with whom many thought they could speak freely and he had a demonstrated gift for human relationships. Among his papers we find souvenirs of a vigorous personal exchange with a distinguished and cultivated circle of acquaintances. He wrote a sonnet on the death of Giulio Sacchetti,[120] the Romano-Florentine cardinal who had been instrumental in the career of Pietro da Cortona. To the Bolognese Conte Annibale Ranuzzi Leopoldo directed a lengthy philosophical "Invitation to Inner Peace, Laying Aside All Pomp and Worldly Pleasure."[121] More whimsically, he offers amorous advice in verse to Cavaliere Ottavio Rucellai[122] and addresses the Marchese Pier Francesco Vitelli with a "Moral Sonnet on

a Sinner Who Turns from Wine to Virtue."[123] In a vein of high face-tiousness the prince headed his own response to a friend's compositions, "This Sonnet Is by the Greatest of the Greatest of All Living Poets."[124] On other pages Leopoldo experiments with risqué anagrams based on the name of Lorenzo Magalotti.[125]

Leopoldo's colleagues could sharpen their wit on the extravagant pietism that was becoming increasingly prevalent in contemporary Florence. Though the prince wrote devout religious verse and maintained an interest in theology, he was distrustful of extremism in all its forms. Among his papers he kept satirical poetry ridiculing "the *bacchettoni* who make themselves out to be saints and are sad, as they go singing through the streets with their heads bowed, gesturing in a hundred different ways."[126] More subtle and incisive is a sonnet addressed "To Your Serene Highness." The lines alternately end with the words "saint" and "madman," and the poet allows the greater difficulty in succeeding as the former.[127]

In his eulogy to Leopoldo de' Medici Lorenzo Magalotti observed, "In addition to his studies, it can be said that all his pleasures and interests were of a studious nature."[128] Leopoldo's greatest contribution, however, was not his private scholarship. As a patron of studies he added a keen sense of organization to the power and prestige of his position.

In Siena in the summer of 1636 the eighteen-year-old prince "opened an Academy here in the palace. It will meet every two weeks, presenting lessons, problems, poetry, and the most beautiful music."[129]

In 1638 Leopoldo and his brother, Ferdinando II, convened the "Accademia Platonica" in Florence and four years later instituted the "Conversazione Filosofica del Palazzo." Though the scope and nature of these gatherings remain unclear, the two princes probably sought to emulate the "Accademia Platonica" of Lorenzo the Magnificent and perhaps wished to establish a new forum for intellectual exchange under secular auspices.

For many years Leopoldo was the chief representative of the granducal family in the Accademia della Crusca, the authoritative guardian of Tuscan language and literature. The Crusca functioned on several levels and Leopoldo figured prominently on all of these.

This so-called "Academy of the Chaff" codified a ritual that was intricate and arcane even in the seicento context, basing its titles, emblems, and ceremonies on allusions to grain, with particular reference

33

to the processes of selection, separation, milling, and refinement. Leopoldo became an academician in 1641, assuming the name of "L'Assonnato" or "The Sleeper," with the impresa of a horse reposing on a bed of straw. The prince soon exchanged this identity for one more expressive of his role in the institution, "L'Adorno" or "The Adorned One," characterized by a crown of wheat ears. In 1651 he reemerged as "Il Candido," "The Pure and Gleaming One," with the device of flour falling from the mill stones.[130] In the miscellany of his estate, Leopoldo left a range of *cruscante* paraphernalia, including two grain shovels, one gilded and the other depicting a horse at a feeding trough, an engraving plate showing a winnowing fan with the academy's emblem, and a curious apparatus in iron, probably a stamp or a seal.[131] The chapel of his apartment in the Palazzo Pitti was dedicated to Saint Zenobius, the academy's patron.

The greatest event in the calendar of the Accademia della Crusca was its annual *stravizio*, a public banquet to mark the succession of officers. Leopoldo took part in the stately exchange of versified toasts that was a characteristic feature of these occasions. At one *stravizio* Canon Lorenzo Panciatichi offered him a *madrigale* on behalf of Cardinal Giovanni Delfino, to which Leopoldo replied in similar form.[132] The prevailing atmosphere of high ceremony is evident in an account of the banquet of 1668.

> The Accademia della Crusca celebrated its solemn *stravizio* with the participation of Signor Cardinal Leopoldo. The archconsuls of the academy also invited Monsignor the Papal Nunzio, who arrived there dressed in a *sottana*, *mozzetta*, and *ferraiuolo*, even though the cardinal came in his *zimarra*. The nunzio's servants said that this was to show greater respect to His Reverend Highness Leopoldo. . . . Having awaited the cardinal's arrival, they went together into the room where the formalities were to be enacted. Here they had equal chairs, though with only a carpet on the floor, no platform. Before going to the table, Monsignor the Nunzio put on his *zimarra*. They sat facing each other and were served equally, with the same gilded tableware, without a breadbasket. On leaving they went as far as the door together, then the cardinal departed first, followed by the nunzio.[133]

Though the etiquette of its regular meetings was often little less stylized, the Accademia della Crusca served several important functions. It helped Tuscan scholars and *letterati* keep in touch with each other and facilitated communication with their colleagues abroad. This network

of individuals with mutual interests made possible a variety of collaborative activities. The Crusca reviewed works of literature for linguistic purity, often giving rise to debates on method and theory. A more demanding and ambitious undertaking was the compilation of Tuscan dictionaries. Between 1648 and 1691 they were occupied with the greatly expanded and revised third edition of their *Vocabolario degli Accademici della Crusca*, considered a milestone in the history of modern lexicography. From its inception Leopoldo was closely involved in this project. On 25 August 1663, in his opening address at their general meeting, he spurred his colleagues to greater diligence. "Where is there a being so flawed in spirit, that . . . he wishes through lack of application to delay for even a moment so much glory to the Accademia della Crusca and to our own homeland?"[134]

Leopoldo personally took part in research for the dictionary, allotted the compilers space in which to work, and channeled many of the academy's enquiries and requests through his own correspondence. Around 1650 Vice Secretary Carlo Dati drafted a memorandum setting out the prince's immediate responsibilities.

> In order to bring the new edition of the *Vocabolario* to a successful conclusion, the "Serenissimo Candido" has undertaken the following, in addition to his many other gracious favors: His Highness will write to Rome, asking permission for four academicians of his choosing to read the writings of Macchiavelli. He will write to Paris for the type. He will write to Genoa and elsewhere for the paper. He will write to Monsignor Nerli to obtain his notes and statements on Dante, particularly those applicable to the *Vocabolario*. He will record observations and research terms relevant to hunting and military architecture."[135]

Leopoldo was also to gather information from other lexicographers. In 1674 the cardinal arranged a special license for Carlo Dati, Luca Albizi, and Vincenzo Capponi to read works on the Index of Prohibited Books.[136]

Though the Accademia del Cimento was a less imposing institution than the Accademia della Crusca, Leopoldo's name is most immediately associated in history with this small body of scientific *virtuosi*. In 1667 the Cimento published their *Saggi di naturali esperienze fatte nell'Accademia del Cimento sotto la protezione del Serenissimo Principe Leopoldo di Toscana*, culminating a hundred years of Medici patronage of such studies. In the later sixteenth century, Grand Duke Francesco was

deeply interested in that age's characteristic amalgam of alchemy, natural philosophy, and progressive technology. The young Cosimo II studied with Galileo. On ascending the throne in 1610, he recalled his teacher from Padua, appointing him *Filosofo e Matematico Primario*. Cosimo II welcomed exponents of the new philosophy to his court, and their influence was notable in the education of his sons. Ferdinando II and Leopoldo developed a profound dedication to the natural sciences, and Gian Carlo also took part in empirical demonstrations.

By the early 1640s Ferdinando II began to carry out "natural experiments" with a cultivated, if heterogeneous, circle of intimates. There was a close community of interest between Ferdinando and Leopoldo, with both brothers devoted to scientific inquiry. After many years of sporadic experimentation, this activity was organized on a more systematic basis in the spring of 1657. The Accademia del Cimento, or "Academy of the Test" or "Risk," had a carefully considered program, leading to the publication of their corpus of *esperienze* ten years later.[137] Though highly serious in tone and intention, such seriousness was defined by the assumptions of princely patronage and seicento virtuosity.

Giovanni Alfonso Borelli and Vincenzo Viviani probably contributed most to the Cimento's method and sense of direction. Though the label is anachronistic, they also appear most nearly "scientific specialists." Lorenzo Magalotti, the Academy's young secretary, was an accomplished aristocratic virtuoso, particularly inclined to polite literature. Francesco Redi was doctor of medicine to the grand duke, as well as a gifted poet and zoologist. Alessandro Segni was Leopoldo's secretary and *gentiluomo di camera*, with a considerable and varied culture. Carlo Dati was an eminent man of letters and an officer of the Accademia della Crusca. Candido del Buono and Carlo Rinaldini were minor scholars, Alessandro Marsili a "rotten and moldy peripatetic," and Antonio Uliva a raffish "adventurer and libertine." Among the most active Italian correspondents of the Cimento was Abbot Ottavio Falconieri in Rome, who also played a decisive role in Leopoldo's antiquarian pursuits and participated in the affairs of the Accademia della Crusca.[138]

This academy usually met in the Palazzo Pitti and Leopoldo assumed responsibility for their expenses. The meetings were relatively unencumbered by ceremony, or at least the academicians did not cultivate ceremony for its own sake. Prince Leopoldo was personally involved in their empirical experiments and must have found these gatherings

stimulating and enjoyable. His energy and perseverance were conspicuous, as was his continuing contribution of observations and ideas.

An ambitious scheme underlay the evident dilettante enthusiasm. Through experimentation the Cimento sought to disprove some of the most obstructive assumptions of Aristotelian scholarship. From an early date Leopoldo and his academy worked with an eye to publication. More than correcting specific errors, their book would offer a prestigious demonstration of method and an implied vindication of their hero, Galileo. Such progressive impulses, however, were qualified by other considerations. Leopoldo and his colleagues stopped short of stating the broader implications of their experimental results and generally did their best to avoid offending ecclesiastical authorities.[139]

However deep Leopoldo's commitment to the new method, his principal business was the business of state. Sessions of the Cimento were suspended for as much as twenty months at a time due to the prince's ill health, the obligations of court life, and the absence of various members of his privileged inner circle.[140] Depending on one's perspective, the Accademia del Cimento can appear either a modern research team or a lively cluster of versatile amateurs.

In contemporary records this small group of scientific virtuosi is most often referred to as "Prince Leopoldo's Academy." Though Borelli, Viviani, and Redi were more distinguished natural philosophers, it was Leopoldo's presence that lent the Cimento its tangible identity. More than material resources, he gave the empirical method the status of official recognition. In his extensive correspondence with scholars throughout Europe, he also gave his academy an official voice.[141] In obtaining access or eliciting results, the name of a prince could function like the letterhead of a modern learned institution. Through the Tuscan post and the various Tuscan agents, Leopoldo could rely on his letters being delivered and answered. In much of his correspondence we see him acting on behalf of a broad sector of the Tuscan intellectual community.

Since channels of communication were often uncertain, prominent individuals might act as central exchanges for ideas, news, and practical information. One of Leopoldo's principal contacts in the north of Europe was Pieter Blaeu,[142] of the great family of Amsterdam publishers and secretary to the burgomasters of that city. Blaeu briefed the prince on political and military developments and acquired pictures for him, particularly sea pieces by Willem van de Velde. He was also conspicu-

ously well-placed to search out books on the great Amsterdam market. Since desired items were usually long out of print, a close eye was kept on upcoming sales and auctions. Like most princely libraries, Leopoldo's was a semipublic institution, serving many scholars and *letterati* at the Florentine court.

Pieter Blaeu was a central figure in erudite circles in the north. Through his hands passed Leopoldo's letters to Christiaan Huygens and Nicolas Heinsius in the Hague and Johan Hevelius in Danzig. To distinguished scholars in the northern and southern Netherlands, Scandinavia, and the Baltic he forwarded complimentary copies of publications by Leopoldo's protégés, Giovanni Alfonso Borelli, Michelangelo Ricci, Valerio Chimentelli, and Nicolaus Steen. Blaeu also distributed many volumes of the *Esperienze* of the Accademia del Cimento[143] and offered his services in blocking a local pirate edition, to be printed in Latin in an economical format.[144]

The exchange between Leopoldo and Blaeu was a reciprocal one. In 1669 the Dutchman wished to publish the first edition of Traiano Boccalini's *Comentarii* on Tacitus. The only complete manuscript was in Venice, and Blaeu requested a copy "through means of your great friend, His Eminence Cardinal Delfino."[145] Considering their nations' social and cultural differences, it is worth noting that the role of an Amsterdam publisher could so often parallel that of a Florentine prince.

LIKE MOST cultivated and thoughtful people of his time, Leopoldo de' Medici was deeply involved with the manifestations of classical antiquity. By the seventeenth century the appreciation of the ancient past had seen a long evolution and had come to fill a broad area of contemporary experience. Rather than representing a clearly delineated field of study, this cumulative classical culture could engage curiosity, taste, imagination, and intellectual speculation on many levels.

Classical scholarship was the most prestigious and best organized category of secular learning. Cutting across boundaries of language and religion, it was also the most cosmopolitan. The ancient past stood as a source and model throughout Western Europe and the principal scholars and antiquarians were linked by an active network of erudite correspondence. Those particularly concerned with the material remains of classical civilization often travelled widely and were likely to meet their colleagues during periodic visits to Rome.[146]

Every remnant of antiquity possessed special value and significance,

whether it be a coin, a fragment of sculpture, a verse of poetry, or a description of the minutiae of daily life. The habits and customs of the Greeks and Romans were meticulously dissected long before much scientific interest was otherwise shown in the apparatus of culture. Modern philology began with the investigation of classical texts and inscriptions. Coins and engraved gems were researched with exhaustive ingenuity to reveal layers of historical and iconographic meaning. Due to their enhanced cash value, these and other antique artifacts also underwent methodical scrutiny to determine their origin, authenticity, and rarity. Though focused on the past, antiquarianism often appears an adventurous and progressive realm of inquiry.

During Leopoldo's first visit to Rome in 1650, he toured the greatest princely collections of classical sculpture at the Vatican Belvedere and the Palazzo Farnese and in the gardens of the Borghese, the Ludovisi, and the Medici themselves. He called at the home of Carl'Antonio dal Pozzo and presumably admired the encyclopedic *Museum Chartaceum* assembled by his brother Cassiano.[147] Though the details are unclear, Leopoldo also made contact with some of Rome's most active antiquarian scholars, including Peter Fytton, Francesco Gottifredi, and Leonardo Agostini. He purchased several pieces of sculpture and might have visited excavation sites and reviewed the stock of selected dealers.

The most influential figure in Leopoldo's early collecting of antiquities was Father Peter Fytton. Born Peter Biddulph at Biddulph Hall in Staffordshire around the year 1600, he was educated in the English colleges at St. Omer, Rome, and Douai. Ordained in 1627, four years later he became agent in Rome for the English Chapter and eventually Dean of the Chapter itself.[148] Like many Catholic expatriates of his nation, Fytton developed a sophisticated Continental culture and appears a highly cosmopolitan figure. He was fluent in French and Italian, a connoisseur of painting, and an accomplished antiquarian scholar. While in Rome in the 1630s, then in Paris in the 1640s, he helped arrange the acquisition of works of art for British collectors.[149] Returning to Rome by the spring of 1650, Fytton was soon busy seeking out antiquities for Leopoldo de' Medici. By the autumn of 1651 he was established in Florence as coordinator of the prince's antiquarian interests.

Father Fytton and Prince Leopoldo fixed their primary attention on the field of coins and engraved gems.[150] This was an exceptionally demanding branch of collecting, requiring an acute sense of organization

and ceaseless attention to detail. The study of numismatics was in a state of constant redefinition, as newly discovered pieces extended or altered the known series of antique coinage. A thorough knowledge of classical history and geography was a minimum requirement for identification and dating, as was a close understanding of cultural usage for the interpretation of emblematic allusions.

Numismatic specialists developed a highly sophisticated expertise regarding material and technique. Many of the seemingly rarest coins on the market were carefully contrived forgeries, and the condition of a genuine piece could greatly affect its value and desirability. The problem of authenticity was even more troublesome in regard to intaglios and cameos since the relevant techniques were easier to duplicate. In addition to the many calculated falsifications, other modern gems were simply too convincing in their antique inspiration. Condition and rarity of material were again crucial considerations, and there were similar problems in identifying and interpreting portraits, subjects, and inscriptions.

Rather than being a miscellaneous accumulation of objects, a cabinet of coins or gems was a carefully structured entity. Coins were normally classified according to type of metal and size and then arranged in series according to date and place of issue. There were numerous further subtleties of organization reflecting technical, geographical, and iconographic variations. Cameos and intaglios could be divided between antique and modern pieces, then according to size. Within these divisions the ordering principle would be that of subject, "that is, Gods, Heroes, Unknown Heads, Barbarian Kings, Philosophers . . . Illustrious Romans, Emperors, and Others Unknown."[151] A further dimension was added by the variety of available materials, including gemstones and glass paste.

In the area of numismatics and engraved gems, the chief scholarly instruments were catalogues and inventories. These ranged from showy illustrated publications to simple manuscript handlists and could record a particular collection or all the known variants in a specific category. Such catalogues and inventories were esteemed as contributions to an important branch of knowledge. They were also invaluable tools for collectors wishing to define the various series of coinage and discover the examples lacking to their cabinets. Close communication between antiquarians was essential, whether they sought to perfect their personal collections or search out items for patrons and customers. The

great published catalogs functioned as standard reference works. Manuscript inventories of individual studios could also serve as the basis for purchases and exchanges.

In addition to his own expertise, Fytton had access to an impressive range of acquaintances throughout Europe. He remained in close correspondence with such distinguished French colleagues as the Abbot Seguin, Tristan des Amant, and Etienne Peruchot, trading many of Leopoldo's duplicate medals with the latter. Soon after settling in Florence Fytton began to exchange inventories with Francesco Gottifredi,[152] who looked after the prince's antiquarian interests in Rome. He probably revisited that city on occasion and in the spring of 1656 went on a buying trip through the north of Italy. In Bologna, he acquired the *Venus of the Casa Palmieri-Bolognini*[153] with the assistance of Fra Bonaventura Bisi. In Venice, relations were strained between Fytton and Paolo del Sera, and the Venetian agent feared that he might return to Florence with unfavorable reports.[154]

After Fytton's death in the autumn of 1656, his position was quickly offered to Francesco Gottifredi. Unwilling to abandon his other interests, Gottifredi agreed to superintend Leopoldo's affairs from his base in Rome.[155] Though the prince maintained a lifelong dedication to antiquarian pursuits, he did not appoint another central administrator in Florence. His acquisitions were now coordinated by a group of Roman antiquarians on whose expertise he also relied for the care and organization of his collection. By the early 1660s Abbot Ottavio Falconieri had become an essential collaborator of Francesco Gottifredi, and they both corresponded regularly with antiquarians north of the Alps. Leonardo Agostini and Francesco Camelli were also active in Leopoldo's service and, in the last years before the prince's death, Pietro Andrea Andreini[156] was emerging as an important figure. Carlo Dati and Lorenzo Magalotti offered assistance on the Florentine end, as perhaps did Leopoldo's secretary Fabrizio Cecini.[157]

With the transfer of responsibility to a committee of antiquarians in a distant city came an increased need for thorough listings of the prince's collection. On 13 January 1657 Gottifredi explained, "Should it please Your Highness to order an inventory of your silver coins, I will be able to serve you more expeditiously in arranging trades and procuring those which you lack, referring both to heads and reverses."[158]

In the years that followed, further inventories were produced for the use of agents, who occasionally sent them back to Florence for updat-

ing. A large portion of Leopoldo's coins, cameos, and intaglios were shipped to Rome in 1670, to be catalogued definitively and installed in specially designed cabinets.[159] A walnut *stipettino* was created for the gems. For the medals, there was an intricate ebony *studiolo* with a hundred and twenty-eight drawers with silver knobs.[160] In 1671 Francesco Camelli went to Florence for some five months, to assemble the new cabinet of medals that he had previously catalogued in Rome.[161]

After realizing these meticulously planned structures, Leopoldo continued to acquire coins and engraved gems. Indeed, it was in this field that the prince demonstrated the longest sustained interest, and also here that he developed much of his unique personality as a patron. In the late 1650s and early 1660s Leopoldo launched a new cycle of projects, setting out to assemble a collection of drawings, a cabinet of portrait miniatures, and a gallery of artists' self-portraits.[162] These schemes appear as the culminating expression of Leopoldo's involvement in the arts. They reflect his dedication to the empirical method, his long antiquarian experience, and his identity as a Medici patron.

In many instances, Leopoldo's fundamental innovation was extending the methods and attitudes of antiquarianism into other areas of collecting. Around 1673 he had four hundred and seventy-seven of his portrait miniatures arranged in a silver-mounted ebony *stipo* with sixty drawers, similar in conception to the earlier *medagliere*.[163] Both cabinets were evidently kept in the same room in the prince's apartment. We know too little about the disposition of these *ritrattini* to discern a scheme of classification. Each velvet-lined drawer held five to nine miniatures arranged symmetrically around a large example in the center.

Though small painted portraits could easily appeal to a collector of coins and gems, Leopoldo adopted antiquarian models in other more profound ways. A studio of numismatics offered a rigorous paradigm of historical progression within geographical divisions, and the essential goals were completeness and precision of organization. The concept of an art historical museum demonstrating the evolution of style within the various schools was still a radical departure, as was the assumed value of historical exhaustiveness in an art collection. Such ideas, however, had long been implicit in the chronological structure of the books of artists' lives. Indeed, a century earlier Giorgio Vasari assembled an extensive drawing collection to illustrate the historical progress of art.[164]

Vasari acquired drawings throughout his life, though perhaps most

actively in the years between the two editions of his *Vite*, 1550 to 1568. In the second, expanded edition, he frequently cites his *libro de' disegni* as offering a visual demonstration of his principal points. Giorgio notes in regard to Cimabue: "In speaking of this painter, it remains only for me to mention the book of drawings I put together, including all those who drew from the time of Cimabue till the present day. At the beginning there are a number of small pieces from Cimabue's hand. To us these may appear more clumsy than otherwise, but we see how much the art of design improved through his work."[165]

Vasari subsequently comments in his life of Giotto: "Considering his period and his style he drew very well, as attested by numerous drawings on parchment . . . in my book. Compared with the masters who preceded him, these seem truly marvelous."[166]

Vasari amassed well over a thousand drawings, which he classified by artist and mounted on heavy paper with elaborate decorative surrounds. Giorgio or his heirs eventually divided these sheets into approximately ten volumes. Pietro Vasari presented one of these to Grand Duke Francesco shortly after his cousin's death in 1574. Seventy-five years later the book was still in the Medici collections.

In the summer of 1658, Leopoldo set out to realize an analogous scheme with the aid of various agents and correspondents in his service. On 18 July Fra Bonaventura Bisi in Bologna pledged his cooperation in helping the prince fill his book of drawings. He notes parenthetically: "By now one must think rather of diverse books, since a single one would be confused and unwieldy. . . . In this way they can be divided by class and by school."[167]

Leopoldo also enlisted the assistance of Bernardino della Penna in Perugia,[168] Paolo del Sera in Venice,[169] and Cavaliere Lodovico de' Vecchi,[170] architect to the Cathedral of Siena. Archdeacon Giovanni Battista Staccoli in Urbino was approached through Jacopo Tolomei, administrator of granducal interests in the Marche.[171] In April of 1659 the prince contacted Giovanni Battista Bolognetti in Antwerp by way of Abbot Lorenzo de' Vecchi, papal internunzio in Flanders.[172]

From the beginning, Leopoldo showed a clear sense of direction in his acquisition of drawings. In Antwerp he particularly required works by northern masters going back to Lucas van Leyden and Albrecht Dürer and in Perugia, by Perugino and Raphael. Staccoli in Urbino was especially busy obtaining pieces by Barocci. On 25 August 1661 Lodovico de Vecchi wrote from Siena: "Till now, I have not come up with

even a single drawing by Baldassare Peruzzi but have not yet given up hope. I will redouble my efforts in seeking out those missing from your most precious books, if Your Highness will advise me of the gaps that break the sequence of periods and schools of painters. This forms a mute history, according to your most noble concept."[173]

By July of 1662, Leopoldo began circulating lists of the artists represented in his drawing collection "so that you will know those of whom I am but meagerly supplied."[174] On 15 September 1663 another list was issued, citing three hundred and eight "Names of Masters of Whom the Most Serene Prince Leopoldo Has Drawings."[175]

In Leopoldo's parallel initiative for a *Galleria di autoritratti*, the impulse was equally strong towards diagrammatic completeness within a historical framework. Begun in the mid-1660s, the project was to assemble examples of self-portraits by all artists of note in the history of art. In a single definitive series, this would offer the most authentic likenesses of these masters and examples of their style at its truest and most characteristic. The self-portrait gallery was both an intellectual concept of cogent power and an exciting challenge to the collector due to the extreme rarity of such items.

Since each drawing or self-portrait was to stand as an art historical document, absolute authenticity was crucial. Questions of attribution were considered with a methodical rigor hitherto reserved for coins and intaglios. Drawings were reviewed by committees, or *consulta*, of connoisseurs in Florence, Siena, Rome, Bologna, and Venice, and application made to experts elsewhere when necessary. The *autoritratti* were doubly problematic, both in regard to the hand of the artist and the identity of the sitter. Potential acquisitions were checked against undoubted likenesses in paintings, drawings, or prints in much the same way that antiquarians sought to attach names to classical busts through reference to coins and other sculptures.[176]

In the last decade of Leopoldo's life, Filippo Baldinucci became increasingly involved in the prince's collecting of drawings and self-portraits, eventually emerging as coordinating secretary. His duties here seem to have paralleled Peter Fytton's earlier responsibilities in the field of antiquities. Correspondence was pursued with agents throughout Italy and occasionally abroad. Lists were circulated, consignments of drawings were sent to Florence on approval, and redundant pieces were traded for needed examples. The same families of Medici correspondents who assisted Leopoldo's search for coins and gems often sought out

drawings and *autoritratti* as well, most notably the Falconieri in Rome and the Cospi-Ranuzzi in Bologna.

Constructing definitive collections of drawings and self-portraits required two stages of research. It was necessary both to define the series and document suitable examples. Due to the paucity of art historical literature, even basic information could be difficult to obtain. Around 1663 Leopoldo received lists from correspondents in Milan and Perugia, of "painters ancient and modern in this city, along with such as can be learned of their works and drawings."[177] Similar lists were later requested from Urbino, Venice, and Naples.[178] Leopoldo de' Medici had long shown interest in the problems of art historical writing and was involved in several schemes to bring Vasari's *Vite* up to date.[179] As we will see in later chapters, Filippo Baldinucci's project for the *Notizie de' professori del disegno* was closely linked to his work on Leopoldo's drawings and self-portraits.

In the last years of the cardinal's life, rapid progress was made on all these undertakings. On 12 June 1673, Baldinucci noted 4,292 drawings in his patron's possession.[180] By 8 September 1673 the number had reached 8,143, as described in the printed "List of the Names of the Painters of Whom We Have Drawings . . . Only to Serve as a Memorandum Since the Collection Is Ever Growing." Baldinucci annotated this list on 1 August 1675, recording a new total of 11,247 pieces.[181] Leopoldo died three months later, at the most intense phase of his collecting.[182] In the years that followed, Filippo Baldinucci continued work on the books of drawings, the self-portrait collection, and the scheme for the *Notizie*, with the sporadic and ambivalent patronage of Cosimo III.

SINCE LEOPOLDO'S identity as a Medici prince was essential to his personality, the line blurs between official responsibilities and personal interests. He inherited an historically complex accumulation of objects, attitudes, and traditions and found many structures in place to help him fulfill the exalted expectations of a Medici.

In collecting, Leopoldo's chief agents came from families within the Medici sphere of influence. During the 1640s and 1650s Paolo del Sera in Venice also acquired pictures for Ferdinando II, Vittoria della Rovere, and Cardinals Carlo and Gian Carlo. Interests overlapped, and it is sometimes difficult to determine precisely for whom parallel purchases were made. In 1649 the Venetian agent obtained for Leopoldo a

small portrait of Duke Ferdinand of Austria and a painting of a *Gypsy Woman*, but mistakenly forwarded the parcel to Gian Carlo.[183] As Leopoldo's collecting became increasingly specialized in the last decade of his life, he organized the best qualified members of these associated families into an efficient network. In close touch with agents, experts, and intermediaries, he often acted on behalf of Ferdinando II and then Cosimo III in acquiring classical antiquities for the granducal gallery.

Among the Medici princes of his generation, Leopoldo was least decisive and innovative in the patronage of living artists. Over the years he acquired works from various painters already established in the Medici circle, including Giovanni Bilivert, Agostino Melissi, Baccio del Bianco, Justus Sustermans, Baldassare Franceschini il Volterrano, Carlo Dolci, and Livio Mehus.[184] Leopoldo's principal artistic protégé was the Nuremberg ivory carver Balthasar Stockamer, whom he kept at the Villa Medici in Rome from 1664 to 1669. Stockamer produced a varied and rather uneven range of works. He realized designs by Pietro da Cortona and interpreted in miniature classical sculptures, often from the Medici collections. Indeed, too little was probably left to Stockamer's invention, as reflected in the overworked and spiritless quality of some pieces. Leopoldo followed his activities closely and personally selected the ivory to be carved. The most ambitious product of this collaboration between Leopoldo, Cortona, and Stockamer is an anemic and technically uninteresting *Crucifixion* group, notable only for its large size.[185]

In regard to contemporary art, Leopoldo's elder brothers emerge as more distinctive patrons. Gian Carlo and Mattias were at the center of semi-independent courts with their own constellations of artistic personalities. The martial Prince Mattias maintained the Jesuit battle painter Jacques Courtois in Florence and Siena for many years. For the prince's villa at Lapeggio, Courtois realized a series of large canvases recording his military feats in Italy and Germany.[186] Volterrano frescoed a room for these, depicting Victory and Fame before a triumphal arch, surrounded by trophies of arms.[187] Mattias also kept Stefano della Bella[188] in his service and played an important part in the early development of the painter Livio Mehus.[189]

Cardinal Gian Carlo was probably most lavish in his patronage, living in conspicuous luxury in the Casino in Via della Scala in Florence and his villas of Castello and Mezzomonte. In 1645 he journeyed to Rome to receive his biretta, accompanied by the portraitist Justus

Sustermans[190] and the sculptor Antonio Novelli.[191] The cardinal returned to Florence with the Neapolitan Salvator Rosa,[192] whose artistic and theatrical efforts he encouraged for nearly a decade. Gian Carlo was an extravagant hedonist by nature, with little evident sense of responsibility to his family's artistic interests. After Gian Carlo's death in 1663, his collections were liquidated to settle his vast debts. From the estate Leopoldo purchased a miniature portrait of his deceased brother, pictures by Carletto Caliari, silver, and three volumes of drawings.[193]

Unlike his brothers Gian Carlo and Mattias, Leopoldo collected for his family and for posterity. His personality was closely linked to the Medici gallery, and it was in this relationship that he developed the remarkable projects immediately associated with his name. After the cardinal's death, Cosimo III sponsored further work on his uncle's collections of drawings and self-portraits. In the course of the 1680s, both were installed in the Uffizi Gallery.

As a prince Leopoldo enjoyed a considerable income but faced heavy financial responsibilities.[194] Though his wealth was limited, he had means at his disposal beyond those of any private person. At the Florentine court he found painters, craftsmen, advisors, and administrators ready to fulfill his artistic requirements. Extending throughout Europe was a network of agents dedicated to his family's interests and linked to Florence by streams of regular correspondence. Through these agents Leopoldo could obtain information, execute orders, disburse monies, and transport objects with exceptional rapidity and precision.

Leopoldo could be sure that the basic necessities of courtly life would be provided whether or not he chose to intervene. Beyond this, he enjoyed unusual opportunities to realize his own values, tastes, and fantasies. Such a prince, decisive in character and inclusive in outlook, could also give direction and focus to broad currents of contemporary culture. Leopoldo de' Medici thus expressed the aspirations of his family, his nation, and his age while fashioning for himself a unique identity as patron.

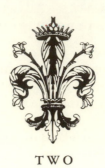

TWO

Filippo Baldinucci: His
Early Career

AFTER FIVE YEARS as cardinal, Leopoldo de' Medici at last took priestly orders in the closing days of 1674. On 21 December, he said his first mass at the altar-tomb of Saint Cosimo in the Florentine Church of the Santissima Trinità.[1] The Prince was titular cardinal of the ancient monastic Church of Santi Cosma e Damiano in Rome, and these saints had long been patrons of the Medici family. Leopoldo was also protector of the Vallombrosani Friars and the Santissima Trinità was their seat in Florence.

The cardinal prince's inaugural mass was observed as a major court ceremony, concluding a full month of ordination solemnities. On 25 November 1674 Leopoldo received minor orders from the Papal Nunzio, in a sumptuous temporary chapel fitted out in his apartment in the Palazzo Pitti. For his mass on 21 December, the crossing of the Church of the Santissima Trinità was hung with textile decorations and the high altar embellished. Two red baldachins were erected for his nephew Grand Duke Cosimo III and his sister-in-law, the Dowager Grand Duchess Vittoria della Rovere. Also in attendance were representatives of the Florentine religious and diplomatic communities and three junior Medici princes. There were Leopoldo's nephew Francesco Maria, who would eventually succeed him to the family cardinalate: his great-nephew Crown Prince Ferdinando, who would not live to reign; and his great-niece and goddaughter Anna Maria Luisa, who would survive until 1743 as the last of the Medici. Though not listed in the official record of the ceremony, Filippo Baldinucci and his son Francesco Saverio were invited as well and found places on the very steps of the altar.

The occasion was a memorable one for the elder Baldinucci, as he

describes in his spiritual diary.[2] While Filippo knelt in rapt adoration of the body of Saint Cosimo displayed beneath the altar, the holy martyr signalled his approbation of Filippo's devotion by miraculously turning his head toward him. This supernatural event was emphasized that evening when Saint Cosimo appeared to him in an inspired dream, in the company of Saint Primitive. The remains of this early Christian martyr saint had made a similar gesture to Filippo a month earlier in the Church of San Firenze.[3]

Filippo Baldinucci had long served the House of Medici and had long maintained a conspicuous interest in religious matters. By the time of Leopoldo's inaugural mass, Baldinucci had come to occupy a privileged place in the cardinal's circle as chief collaborator in his most original collecting and curatorial endeavors. After the cardinal prince's death a year later, Filippo continued work on the gallery of artists' self-portraits and the encyclopedic drawing collection arranged on Vasarian principles. For the rest of his life, he struggled to realize their plan for a great new Florentine compendium of artists' biographies.

Filippo Baldinucci seems a most inapparent heir to the attitudes and ideas of the "Prince of the Cimento." Far from demonstrating anything that could be construed as a scientific mentality, Baldinucci's diary offers a strong self-portrait of a man whose world was so miracle ridden as to leave little room for natural causation. Leopoldo de' Medici, however, was a dynamic individual who drew many kinds of people into his sphere, and his patronage altered the course of Filippo's life.

FILIPPO BALDINUCCI was born in Florence on 3 June 1625, to Giovanni Baldinucci and his wife Caterina da Valle. From the late fourteenth century, the Baldinucci had played a role in Florentine civic and commercial life.[4] Filippo's great-great-grandfather Bernardo Baldinucci held a post in the tax administration during the late republic. His grandfather Giovanni Maria and great-uncle Bernardo were enrolled in the silk guild. His father Giovanni and uncle Jacopo both achieved eligibility for public office.[5]

In the seventeenth century Florence was a moderately large city of some seventy-thousand inhabitants. Like other formerly great Italian manufacturing and trading centers, her economy in these years saw a rapid contraction and redirection. The wool and silk industries had so dwindled that even the domestic market could be maintained only through extreme protectionism. The liquidation or bankruptcy of busi-

ness enterprises was a recurring event, and money that had previously circulated in commerce was invested in land or public funds. The acquisition of land had a particular symbolic value. With the establishment of the Medici *granducato* came the rise of a self-conscious neo-feudal patriciate. These aristocrats frequently relegated the administration of their agricultural holdings to a growing class of factors, estate agents and financial managers.[6]

The professional orientation of the Baldinucci family seems to mirror this retrenchment in the Florentine economy. While Filippo's grandfather took part in the textile trade, and according to one source died in Palermo, his father Giovanni was engaged in overseeing the interests of landed families. The names of Giovanni and Filippo Baldinucci appear in the account books of numerous patrician houses and religious institutions. In 1647, for example, Giovanni Baldinucci wrote Lucrezia Gotti Niccolini, informing her that a debt had been paid to the heirs of Francesco Alessandri in connection with monies invested at interest. In part, he effected this payment out of his own pocket, being unable to collect either the rent owed by Signor Pandolfini or her income from the *monte del sale*.[7] After Giovanni's death, it took Filippo ten years to recover a small sum owed his father by Marchese Rodrigo Ximenes "for his efforts in keeping the books of that gentleman."[8]

For half a century Filippo Baldinucci served the Florentine aristocracy as accountant, estate agent, and financial adviser. The ledgers of the Marchesi Bartolommei offer an impression of the scope and nature of Filippo's activity.[9] From 1650 until his death in 1697 he is cited as "our bookkeeper," with a varying monthly stipend. However, Filippo did not devote all his time to Bartolommei interests and was probably not considered a full member of their household. In addition to keeping their regular accounts, he was available for lucrative free-lance assignments. He must also have had the opportunity to run many of his own affairs parallel to those of the Bartolommei.

Filippo Baldinucci gathered rents from city properties, disbursed large and small sums in his employers' names, collected the income from shares in the *monte del sale* and *monte di pietà*, and supervised the sale of agricultural products from the Bartolommei estates. Until his death in 1656, the elderly Giovanni Baldinucci occasionally assisted his son with such day-to-day responsibilities.[10] Filippo also carried out special audits, assembled documents for legal proceedings, and invested money for his patrons. Though he was often the principal agent serving

the Bartolommei in such matters, other names pass through the account books in similar capacities. The level of Filippo's involvement must have depended on the time he had available and the relative attraction of other prospects.

Filippo began his association with the Bartolommei on 4 June 1650,[11] at the time of a complicated financial transaction. The Bartolommei were acquiring the estate of Montevettolini in the Valdinievole from the Medici. This was to figure as their most significant rural holding. Ferdinando II and Cardinal Carlo de' Medici were evidently both beneficiaries of this sale, which included two-thirds of the estate and its contents, with an option on the remaining third. Until the acquisition was completed some ten years later, the granducal family continued to collect a third of the profits. A thorough and rigorous accounting was needed on which to base these calculations.[12]

On 4 March 1651 fifty florins were credited to "Filippo Baldinucci, *nostro computista*, for his special efforts in organizing the books at Montevettolini, appraising the livestock there, and many other tasks."[13] This supplemented his regular monthly salary of ten florins. On 20 July 1653 he received an unspecified payment for a particularly demanding assignment. In order to define the state of the Montevettolini property and prepare a fiscal projection, Filippo spent a month and a half in the granducal accounts office, working closely with the Medici financial administrators.[14]

Over the years Filippo offered his services to such families as the Ginori, the Alessandri, the Taddei, the Pucci, and the Valori, as well as the convents of San Silvestro and Santa Maria Maddalena de' Pazzi in Borgo Pinti.[15] Other less clear references allude to professional dealings with the Albizzi, Frescobaldi, and della Gherardesca and the estates of Marcialla and Solucci.[16] Filippo Baldinucci's activities seem to have centered in the Arno valley between Florence and Pisa and, more particularly, in the area of Empoli. The Pucci had a villa near Empoli and the Valori, a villa at Empoli Vecchio, while Baldinucci was himself close by at his property of Botinaccio. The Bartolommei's great holding was to the north at Montevettolini and the Alessandri's far to the south at Petroio. In addition to family and social connections, the financial affairs of Baldinucci's employers were often intertwined. In the close world of the Florentine aristocracy, Filippo was probably a well-known subsidiary figure.

Baldinucci, who grew up in the family home in Via Larga, later

moved to a comfortable and even imposing residence designed by Ammannati, situated at the corner of Via degli Alfani and Via della Pergola.[17] It is difficult, nevertheless, to evaluate the precise state of Filippo's personal finances, and even more, the prevailing apprehension of utter ruin which darkened the last three decades of his life. In any case, it is clear that his immediate family was rapidly outdistanced by the offspring of his uncle Jacopo. By the 1650s his elder cousin Alessandro was named Vicario of Borgo San Sepolcro.[18] In the next generation, Alessandro's son Giovanni Maria served for thirty-seven years in the papal administration as treasurer of the provinces of the Marche, earning the hereditary title of *marchese* and a patrician wife.

In interpreting Filippo Baldinucci's personal and family life, one of our principal documents is the biography composed by his son Francesco Saverio. However, he wrote thirty years after his father's death[19] and factual accuracy often fell prey to intellectual vagueness and familial *pietas*. Though we cannot accept Francesco Saverio's statements without corroboration, he describes the kind of thwarted youth that we might have deduced from the conflicts and uncertainties of Filippo's maturity.

Filippo was born in 1625, the only male child of the then forty-eight-year-old Giovanni Baldinucci. Named for the recently canonized Saint Filippo Neri whom Giovanni had met in Rome during his own childhood, the boy was carefully raised in Christian surroundings and educated by the Jesuits. Filippo found his chief recreation in frequenting artists' studios, where he developed a notable facility in drawing and modelling in clay.

Feeling the weight of advancing years, Giovanni cut short his son's studies in order to introduce him to the family business. In his spare time Filippo sought to keep up his reading and maintain a more limited interest in the visual arts. On his deathbed in 1656, the elder Baldinucci once again countered his son's inclinations, commanding that he marry and continue the family. Filippo had resolved to take up a religious vocation in the severe Capuchin order. However, after a profound crisis of conscience, he rendered the dues of filial devotion, wedding Caterina degli Scolari, of an ancient and formerly influential Florentine house.

In his spiritual diary Filippo's principal theme is the continuing conflict between his religious requirements and the demands of family and professional life. Years later his haphazard education emerged as both a weakness and an embarrassment. In the *Notizie* Filippo frequently refers

to his early experience of artistic practice and exposure to the personalities and lore of the Florentine workshops.

At the age of ten Filippo Baldinucci visited Livorno, where he admired Pietro Tacca's *Monument to Ferdinando I.* He especially enjoyed meeting the Turkish slave Morgiano, who served as model for one of the chained moors at the base.[20] In Florence five years later, Filippo saw Tacca lying in state in the Church of the Annunziata.[21]

In his youth he copied drawings in red and black chalk by Andrea Comodi, a technique in which he achieved considerable mastery.[22] Filippo participated in outdoor sketching parties with Baccio del Bianco[23] and called on this artist several times to watch him record the craters of the moon through Galileo's telescope.[24] In his midteens, he observed the blind sculptor Giovanni Gonnelli practice his curious method of modeling in clay. At that time, Gonnelli wished to study Filippo's face as well.[25]

Baldinucci frequented the studios of the competent woodcarver Jacopo Maria Foggini[26] and the distinguished painter Matteo Rosselli.[27] Filippo demonstrated the warmest admiration for Rosselli as a central figure in Florentine artistic circles and as paragon of the good and devout life. He maintained long and close relations with Rosselli's nephew, the painter Father Francesco Boschi.[28]

Filippo Baldinucci often expressed gratitude to his elder contemporary Carlo Dolci for "imparting to me my first precepts of the art of design."[29] The young painter was a daily visitor to the Baldinucci home, and Filippo's sister Maria Maddalena served as his model for an image of the Madonna. This early acquaintance ripened into an enduring friendship. In later years Carlino also portrayed Baldinucci's wife Caterina in the guise of *Peace.*[30]

Throughout his life Filippo cultivated this personal familiarity with art and artists in Florence. In his writings he refers affectionately to the court portraitist Justus Sustermans[31] and to Baldassare Franceschini, il Volterrano, the most celebrated frescoist of that time. While Franceschini was at work on the cupola of the Niccolini Chapel in Santa Croce, Filippo often ascended the scaffolding to admire his progress.[32] Three decades later, he attended the Volterrano on his deathbed.[33]

From his own collection, Baldinucci lent Lorenzo Lippi drawings to copy by Santi di Tito.[34] He knew the Jesuit battle painter Jacques Courtois and acquired pictures by him even before his arrival in Florence.[35] Filippo owned drawings and a notebook from the hand of Salvator Rosa

and saw the Neapolitan perform some of his theatrical compositions.[36] Leonardo Buonarroti, descendant of Michelangelo and devoted guardian of the Casa Buonarroti, stood as godfather to Filippo's children.[37]

Filippo Baldinucci could assemble a highly individual collection from the objects and memorabilia accumulated in the studios and homes of Florentine artists. He obtained a variety of personal papers and put together two successive collections of drawings,[38] including works by Lodovico Cigoli,[39] Andrea Comodi,[40] Cristofano Allori,[41] Sigismondo Coccapani,[42] and Baldassare Franceschini.[43] Filippo also owned two *quadretti* of caricatures by Baccio del Bianco,[44] a *Portrait of the Sculptor Francavilla* by Giovanni Battista Paggi,[45] a copy of Lorenzo Lippi's *Portrait of Salvator Rosa*,[46] a *bozzetto* by Cristofano Allori of the mother of the painter's mistress,[47] and a *Portrait of Giovanni Gonnelli* given to Baldinucci by the sculptor's widow.[48]

Filippo possessed numerous devotional pictures by Francesco Boschi[49] and Carlo Dolci,[50] and from the latter a drawing of the miraculous image of the Annunziata.[51] In his domestic chapel was an *Ecce Homo*, sculpted in wood by Jacopo Maria Foggini and painted by the Volterrano. According to Baldinucci the piece inspired such devotion that he was often called upon to lend it to churches and convents.[52]

In his *Notizie* Filippo Baldinucci cites many works of art belonging to the families he served, as might be expected from the wealth and status of his clients. He could also have exercised his skills as connoisseur while preparing inventories or evaluating estates. In one case Baldinucci notes a fine *modello* by Lodovico Cardi il Cigoli. "The present author happened upon this and other pictures in a villa belonging to the heirs of Marchese Ottavio Pucci, and they subsequently carried it off to their house in the city."[53]

The Bartolommei were a rich and cultivated family. From 1649 to 1655 they were engaged in restructuring and decorating the church of Santo Stefano al Ponte adjacent to their palace in Via Lambertesca. The account books note a few payments to artisan sculptors "by the hand of Filippo Baldinucci."[54] The Bartolommei owned important pictures by more recent Florentine artists, though scarcely any older paintings or classical antiquities.[55] In 1669 Baldinucci was involved in assembling a set of twenty-one Medici portraits for the principal Bartolommei villa of Poggiale. The series ran from Cosimo *Pater Patriae* to Crown Prince Cosimo III and was executed, at least in part, by the painter Giovanni Rosi.[56] The Marchese Girolamo (born circa 1584) and his son Mattias

Maria (1640–1695) were distinguished if conventional poets and dramatic writers, and their library was rich and wide-ranging.[57] At the death of Mattias Maria in 1695, they owned most of Baldinucci's published work, though otherwise little of the literature of art.[58]

Filippo Baldinucci enjoyed more than professional relations with a sophisticated sector of the Florentine aristocracy. Alessandro Valori, last representative of an old and illustrious family, had a number of villas in the region of Empoli. "Several times a year, this *cavaliere* visited one or another of these with a company of most noble gentlemen. . . . In addition to his amiable conversation, he entertained them in all ways with extraordinary liberality . . . and on many occasions chose me, author of these *Notizie*, as his companion."[59]

Francesco Saverio Baldinucci offers a fuller account of his father's participation in the Valori circle, affirming that Filippo was welcomed "al pari d'ogni altro." He also describes how Filippo contributed more than his wit and skills as raconteur. "Almost every day they drew lots to determine which of his companions would sit for a portrait. He executed these in red and black chalk or else in *terra cotta* in full relief."[60]

The satirical writer Lionardo Giraldi and the painter and dialect poet Lorenzo Lippi also frequented these cultivated yet lighthearted gatherings.[61] Filippo Baldinucci was deeply influenced by the forms of Tuscan comic writing. Many of the *Notizie*'s extended anecdotes concerning artistic personalities were conceived as fully developed novelle. Mingling rustic humor and religious instruction, he also composed brief comic pieces performed by the children of the Oratory of San Firenze on their holidays at San Miniato.[62] In 1684 Baldinucci published a defense of his art historical writings in the form of an elaborate burlesque dialogue.[63]

Filippo Baldinucci states that he began his service to Leopoldo de' Medici in 1664.[64] By this time his professional expertise was already known to several members of the granducal family. Prince Leopoldo enjoyed particularly close relations with his sister Anna, whom he accompanied to Innsbruck in 1646 for her marriage with Archduke Ferdinand Karl of Austria. After her husband's death in 1662, the archduchess found herself precariously placed at the Habsburg court and fought to regain control of her dower properties in Mantua. In December of 1663 the Florentine legal expert Giovanni Tamburini was sent to Innsbruck.[65] He wrote Leopoldo on 14 September 1664, summarizing the current state of affairs.

If Your Highness and the Most Serene Grand Duke could stand at a window and see what was passing here, I'm sure that you wouldn't want the archduchess to remain in this place even if she wished it. . . . I was told that the present archduke might soon come to terms leaving your sister not only her possessions in Mantua but also the right to have her agents review the accounts from previous years. . . . A knowledgeable person of good character must therefore be sent to Mantua to effect this review, and she asked me to find someone suitable. I could scarcely choose better than Filippo Baldinucci, whose goodness and expertise is without equal in Florence, and I wrote him asking whether he might take on the task. Though there were difficulties, his dear friend Alessandro Valori and I managed to persuade him, and he will go to Mantua to review these accounts whenever desired. At present he is occupied with some calculations for the grand duke and others for Cardinal Decano Carlo. Since he will need suspend these responsibilities for the month he is away, he wishes to receive an explicit command, making clear that he is moved by duty not whim. According to Her Highness' instructions, I informed Signor Filippo that this would be done and hope you will summon him and give him the command he requires. Ask as well if you can help settle his other obligations by approaching the grand duke or doing whatever else will satisfy him. If Baldinucci is content and free from worry, he will better serve Her Highness in this most urgent matter.[66]

Filippo wrote Leopoldo on 11 December 1664 to announce his arrival in Mantua[67] and again on 20 January 1665[68] to request the prince's help in attaining access to essential records. When Baldinucci returned to Florence on 23 March, he had successfully concluded his assignment[69] and was soon favored by Anna de' Medici with a personal letter of thanks.[70] It would seem that Filippo also made a strong impression on the Gonzaga rulers of Mantua.

Francesco Saverio Baldinucci offers the fullest and most detailed account of his father's sojourn at the Gonzaga court. Duchess Isabella Clara was eager to benefit from Filippo's experience of the arts and had him shown everything of religious and artistic significance in her realm. "Even more, she wished him to execute her portrait and that of her son Prince Carlo III in red and black chalk. These elicited such pleasure that they were adorned with rich frames and placed in Their Highnesses' own apartments."[71]

Filippo Baldinucci refers on several occasions to his Mantuan visit,

which was evidently a considerable personal triumph. He notes a painting by Castiglione[72] and a self-portrait by Sofonisba Angosciola, "which the Archduchess Isabella Clara showed me in Mantua in 1664."[73] Writing to one of Cosimo III's secretaries in 1681, Filippo comments, "I glory in holding *servitù particularissima* with the Archduchess Isabella Clara. I received many honors from her when I went there in the service of Archduchess Anna, on the orders of Grand Duke Ferdinando II."[74]

Baldinucci returned to Florence with a ceremonial flourish, as he described to Leopoldo on 23 March 1665. "When I took leave of Their Highnesses in Mantua, I received strict instructions. They would have me perform gestures of respect in their names, not only to Your Highness, but to all members of your Most Serene House. Having already called on Cardinal Decano Carlo, I will soon call on Prince Mattias as well and am awaiting your own most gracious summons."[75]

Francesco Saverio's description of his father's journey from Mantua is provocative though uncorroborated. "Before returning to Florence, he set off on a trip through much of Lombardy to master the styles and tastes of the great painters of that land. This was by order of Leopoldo of Tuscany, who intended to avail himself of Filippo's services."[76]

Though patrons often sent artists on study trips to perfect their craft, it is exceptional to find such patronage offered a promising connoisseur or art writer. Even if Filippo broke his journey in such great centers as Modena and Bologna, he specifies in his writings none of the works that he admired in those cities.[77] When his credibility was under attack in later years, he would have had many opportunities to cite so conspicuous a demonstration of the Prince's interest and support.

Writing a few years after the cardinal's death in November of 1675, Filippo describes a more modest and gradual beginning to their relationship. "In carrying out my professional affairs, including assignments from the Most Serene House, I was often in touch with His Most Reverend Highness over the course of eleven years. With such occasion, he deigned to admit me to the *consulte* that he held on drawings, paintings and other things pertaining to his virtuous recreation."[78]

In 1658 Leopoldo began assembling an encyclopedic drawing collection modeled on Vasari's celebrated *Libro de' disegni*. Arranged on historical principles, these drawings would trace "the sequence of periods and schools of painters."[79] In the mid-1660s, the prince initiated a parallel project for a gallery of artists' self-portraits. This definitive series of *autoritratti* would offer documented likenesses of all masters of note

in the history of art and reliable examples of their style.[80] Here as well, the plan probably was to divide the self-portrait collection into geographical schools, demonstrating the progression of master to pupil.[81]

Like most of Leopoldo's undertakings, his art collecting was a well-organized collaborative effort. The best-qualified Medici agents throughout Europe were linked into an efficient network, and their activities coordinated by his household administration.[82] Baldinucci's success in Mantua in 1664–1665 must have attracted Leopoldo's favorable attention. In the years that followed, he made a place for himself in the *consultà* which met in Florence to evaluate prospective purchases.

Since the *consultà* pooled the experience of numerous participants, it is difficult to trace the emergence of Baldinucci's role. Considering Leopoldo's curiosity and enthusiasm, he must have kept in close touch with the experts and connoisseurs who served him. Letters to the agents in various cities were normally drafted in the first person from the prince himself, and his artistic correspondence was inseparable from the other duties of his secretariat. Many extant lists, memoranda, and letter drafts have been attributed to Filippo with some plausibility on the basis of handwriting. However, his part in their formulation remains unclear, and we still know rather little about the numerous secretaries, functionaries, and copyists in Leopoldo's household.

In the closing years of Leopoldo's life, the figure of Filippo Baldinucci begins to detach itself from the background of the *consultà* and the secretariat.[83] The cardinal returned from Rome in September of 1670 and remained at the Tuscan court until his death in November of 1675. His collecting of drawings and self-portraits developed from a subsidiary interest to a dominant passion. A special room in the Palazzo Pitti was arranged for the rapidly expanding *Galleria di Autoritratti*. In the last two and a half years of his life, the drawing collection tripled to some twelve thousand pieces.[84]

During this final period, hundreds and even thousands of drawings at a time were arriving in Florence, and the cardinal's collecting needed to be managed with uncompromisingly businesslike efficiency. Dating from 1673 are neat and methodical tabulations of proposed drawings headed "Parere del Baldinucci."[85] Filippo succinctly assesses their attribution and desirability and sets out the sums that Leopoldo should be prepared to offer. In 1673 Baldinucci also published a master list of the prince's drawings, intended for circulation among the agents.[86] It is evident that his voice had gained prominence in the *consultà*, and he was

probably functioning as central coordinator of the cardinal's acquisitions.

Filippo Baldinucci's own correspondence with Leopoldo on artistic matters was addressed to either his secretary Canon Fabrizio Cecini or his *bottigliere* Lorenzo Gualtieri. By the time of Leopoldo's trip to Rome in 1667, Canon Cecini was established as chief of the secretariat with a monthly stipend of twelve *scudi*.[87] His hand is evident in all the prince's affairs, including the collecting of art objects and antiquities. In the autumn of 1674, the rough draft of a letter directed to the painter and connoisseur Giovanni Battista Natali was headed "Ricordi al Signore Canonico Cecini."[88] The following spring three portrait miniatures were sent for appraisal to Baldassare Franceschini, "by Canon Cecini according to the command of the Most Serene Cardinal de' Medici."[89] Several of Filippo Baldinucci's letters to Cecini remain from 1675. Filippo reports his efforts in the cardinal's service and requests books and art historical information "from trustworthy friends of His Most Serene Highness."[90]

Francesco Saverio Baldinucci records an event from the early days of his father's involvement in Leopoldo's collecting.

> To assure himself further of Filippo's ability to recognize the hands of different artists, the cardinal had two hundred drawings selected, these being of unquestioned authorship. The master's name was inscribed on the reverse of each one . . . and they were brought to Filippo's house by Lorenzo Gualtieri, who was cellarer to His Highness and also interested in the arts. Gualtieri set him the task of identifying them one by one, comparing his judgments with the inscribed names.[91]

Filippo proved infallible in his attributions, causing Leopoldo to exclaim: "This is a man worthy of princes. He has everything in order in every way!" Though Francesco Saverio's account seems rather stylized in presentation, it signals the emergence of the connoisseur as a possible artistic hero. In any case, his indication of Lorenzo Gualtieri's role strikes a convincing note.

At the time of Leopoldo's visit to Rome in 1667, Lorenzo Gualtieri was a *staffiere*, or footman, with a modest monthly stipend of five *scudi* five *soldi*.[92] Though Gualtieri's personal background and professional duties are unclear, his expertise in artistic matters must have been considerable. He and Baldinucci worked together for many years on the

drawings and self-portraits. In 1675, Gualtieri stood as Filippo's intermediary on several occasions, in obtaining Leopoldo's assistance for his art historical researches.[93]

After the cardinal's death, Baldinucci and Gualtieri continued their partnership under the auspices of Cosimo III. Lorenzo entered the Granducal household and rose to the rank of *Primo Dispensiere*, maintaining a close involvement with his patron's collection until at least the year 1700. In 1682 Baldinucci wrote Gualtieri a formal presentation letter, discussing whether Raphael or Andrea del Sarto was the greatest painter of the previous century.[94]

However remarkable Filippo Baldinucci's skills as connoisseur, such activity was usually a sideline of practicing artists.[95] For expert opinions on attribution and cash value, Leopoldo's administration relied particularly on two painters long established at the Florentine court. These were the Flemish portraitist Justus Sustermans (1597–1681), who served the Medici for over half a century, and Baldassare Franceschini il Volterrano (1611–1689), the most esteemed Tuscan frescoist of that time. A number of relevant memoranda survive from the cardinal's secretariat,[96] including this one from the early 1670s: "A box is being sent with two portraits, one larger than the other. As far as I can see, it is beyond question that the smaller one is Antonio da Correggio. The other portrait, they say, is Giovanni Bellini, and in truth there is some resemblance. However, Signor Giusto and Signor Volterrano's opinions are desired regarding each of these. They can express their sentiments here on this sheet." Sustermans noted at the bottom of the page, "I, Giusto, affirm that the smaller portrait is from the hand of Correggio as stated above. I believe the larger portrait to be of Giovanni Bellini, but by another hand."[97]

Filippo Baldinucci and his colleagues needed to process massive quantities of objects offered for Leopoldo's consideration. Since the self-portrait and drawing collections were conceived in a specialized scholarly and ideological context, absolute rigor had to be maintained in regard to attribution and authenticity. As funds were limited, care was taken to receive value for money. Therefore, the surviving blocks of memoranda, annotated lists, and rough drafts of letters reveal an administrative structure of awesome complexity. In many transactions we cannot isolate Baldinucci's hand. However, the context of his activity is clear, as is the important contribution of his business experience.

A characteristically intricate mass of paperwork was generated in the

winter of 1671-1672, during negotiations for a small collection of drawings belonging to Cesare Beccadelli in Bologna. Father Giuseppe Maria Casarenghi looked after matters on the Bolognese end, under the supervision of Count Annibale Ranuzzi.

On 5 December 1671 Cavaliere Beccadelli sent thirty-three drawings to Florence for Leopoldo's inspection. At the same time he forwarded an itemized list, stating their authorship, medium, subject, and presumed value.[98] In Florence Beccadelli's drawings were numbered and redescribed in a new list, with a few notations of obvious copies and overattributions.[99] Another concise list was prepared, correlating the drawing numbers and the prices proposed by the owner.[100]

Next, the Florentine administration set out an elaborate table in four columns.[101] The first noted the name of the artist, the second the number assigned the drawing, the third "our price," and the fourth "their price." On the back of the chart, the difference between Beccadelli's demands and Leopoldo's assessments was calculated in both Bolognese and Florentine monies. The relative desirability of the drawings is expressed through a complicated set of symbols and probably represents the consensus of a meeting of the *consultà*. These symbols are described in an accompanying key.

> Two lines signify that His Highness wishes it, whatever the case may be.
> A single line, only if we agree on the price.
> The symbol of a cross indicates no great interest.
> A single line with the addition of two short lines in the margin means that our own offer can be somewhat increased.

This information is recapitulated in another table, where the drawings are grouped together in these four categories.[102] A descriptive list was also prepared, explaining why eight of the drawings were not acceptable on any terms.[103]

On 12 December 1671, only a few days after receipt of the drawings, the cardinal's administration addressed two letters to Father Casarenghi, the Bolognese agent handling the negotiations. One was a "lettera mostrabile," intended for Beccadelli's eyes, which the priest was to pass off as the official communication from Florence.[104] Attached to this was the owner's original list, "annotated in the margin with the prices that seem appropriate to me."

The second, private letter of 12 December was more outspoken.

"Here I have enclosed a confidential list of the drawings I should wish to have and my open intention in regard to how far I am willing to go."[105] This "nota confidenziale" was a copy of the second master list, dividing the drawings into categories of desirability relative to price.[106]

In early January the drawings were sent back to Bologna, and Casarenghi soon showed himself unable to conclude the deal. Negotiations were encumbered by Beccadelli's high birth, "and since he is one of the principal *cavalieri* of this city, he does not wish to be identified as the owner."[107]

Conte Annibale Ranuzzi, Leopoldo's chief agent in Bologna, could deal less circumspectly with the cavaliere and took the matter out of Casarenghi's hands. As Ranuzzi observed to the cardinal, "Beccadelli is a man of position, no doubt, but when it comes to his own interests, he's worse than a Genoese."[108]

On 6 February 1672, the Conte acquired the nineteen most interesting drawings for very nearly the prices set by Leopoldo's administration.[109] He sent a list of these to Florence and also returned the *nota confidenziale* that had been issued to Casarenghi.[110] Ranuzzi advanced the money in order to conclude the deal and asked that it be reimbursed through the bankers Gianozzi and Manetti in Roman coinage, as this was easier to change. The drawings were dispatched to Florence on 8 March, accompanied by a Bolognese customs document.[111]

At about this same time, another monumental pile of lists and counterlists, calculations and annotations, arose during the review of several lots of portrait miniatures also from Bologna. Though such procedural elaboration could achieve extraordinary proportions, these activities were accompanied by a sense of intellectual excitement and dilettante enthusiasm.

Pronouncements by Leopoldo and his collaborators were often highly facetious. It is observed in regard to a portrait miniature by Lavinia Fontana, "The woman must have been beautiful since the picture is nothing much." A feeble pun is turned on an attributed Domenico Feti, "Se fusse anche dell'Odori non vi spenderei se non doppia una."

Questions were raised and hesitations freely expressed, for example, "This is rather fine but I'm not sure it's Guido." Leopoldo and his experts filled the margins of their lists with "*credo*," "può essere," and "si e no." Honest doubts were preferred to facile attributions.[112]

Filippo Baldinucci must have found such an atmosphere stimulating and the prince's attention flattering. New horizons opened for this es-

tate agent and bookkeeper, endowed with only a modest education and some artistic experience. In 1681, in the preface to the first installment of the *Notizie*, Baldinucci describes his development under the aegis of the late cardinal's patronage.

> Finding that he had gathered many thousands of drawings by the most celebrated masters in the world, His Highness honored me by hearing my opinion on how to organize them. The best plan, I held, was to arrange them in books in chronological order beginning with Cimabue, the first restorer of the art of painting, followed by his disciple Giotto, and progressing through their pupils until we reach the masters now living . . . With unimpeachable evidence from the artists' own hands, the progress of art could then be recognized, not from reading but through one's eyes. . . . It will be seen that such an enterprise requires a thorough understanding of this whole order of succession. According to His Reverend Highness' command, I set out to reinforce my studies in this field, applying myself to this for many years. . . . During these labors my basic conviction was strengthened, that the arts were restored by Cimabue and then Giotto and spread by their followers throughout the world. I had the idea of demonstrating this diagrammatically in a tree, extending from the first initiators to our own contemporaries. . . . His Highness approved this fantasy of mine, and what is more, vigorously encouraged me to realize it. . . . Information was obtained, as were many books in diverse languages from Italy and abroad. When I thought it necessary for discovering the truth, works of various masters in distant cities were copied in drawing at great expense.

Baldinucci further explains how this momentum continued in the first years after Leopoldo's death. Filippo thought to supplement his genealogical tree with an *indice cronologico*, indicating the position of the various masters on the chart and succinctly noting their "characteristics, style, period, works, actions and idiosyncracies." Eventually, "my index grew into a literary opus, and my chronology into a chronicle, that is to say, a voluminous collection of *notizie de' professori del disegno*."[113]

Filippo's account is compelling, though overly streamlined. Giorgio Vasari's historiographic drawing collection had been famous for more than a century, and Prince Leopoldo had something similar in mind since the late 1650s. When Baldinucci wrote his elaborate autobiographical rationale for the *Notizie* in 1681, a work of this kind had been

lacking for nearly forty years. In 1646, Leopoldo showed interest in Lionardo Dati's plan for a great new Florentine edition of artists' lives. In 1667, the prince supported Giovanni Battista Brocchi's subsequent initiative.[114]

Baldinucci places himself too near the center of the stage, but nonetheless, he vividly evokes the organic and expansive nature of Leopoldo's patronage. When Filippo began participating in the prince's *consultà*, his potential as an art historical writer could not have been evident. The search for objects, however, was inseparable from the search for information, and it was probably never clear where one project began and another left off. On 22 May 1674 the cardinal's administration returned a mass of drawings to Conte Annibale Ranuzzi in Bologna. "I send you as well a new list of painters, deriving in part from the drawings you recently sent me and in part from others. If possible, I should wish to know their names and places of birth as well as the years in which they were active or died. If you are not thoroughly informed regarding some of these, please tell me where I can learn about them."[115]

In the course of his curatorial duties, Filippo Baldinucci developed an exceptional historical consciousness. In a note from early in 1675, probably written by one of Filippo's sons, he demonstrates a specialized connoisseurship of impressive sophistication.

> Baldinucci does not himself write, since he is unwell and has taken medicine this morning. He says that Ercole da Ferrara was a pupil of Lorenzo Costa, and Lorenzo Costa of Fra Filippo Lippi. Costa worked better than Ercole. Thus there seems to be some error, in that the drawing which is held to be from the hand of Costa is inferior to the one attributed to Ercole. Furthermore, the style of Costa's master Fra Filippo is more evident in the drawing assigned to Ercole than in that given to Costa. Something of this, however, can be seen in both of them.
>
> The price of one *dobla* seems rather high. He suggests that you try to get it for as little as possible and then compromise somewhere in the middle. However, he refers the matter to the prudence of His Most Reverend Highness.[116]

Due to the paucity of art historical literature, even basic chronological data was not easily forthcoming. Without Leopoldo's influence and connections, it would have proved nearly inaccessible. Filippo cites the cardinal's assistance in obtaining books, information, and copies of

paintings. Leopoldo had an extensive and continually growing library and was in touch with many of the principal booksellers in Venice, Paris, Lyon, Basel, and Amsterdam. Among Baldinucci's papers is a "List of Books Thought to Be of Possible Use for the Work," including those of Lomazzo, Zuccaro, Van Mander and Boschini.[117]

The assistance of the grand duke's librarian Antonio Magliabechi was also invaluable. Probably the most brilliant bibliographer of the age, Magliabechi had numerous correspondents throughout Europe. In the spring of 1675, Filippo Baldinucci discussed with Fabrizio Cecini the progress of his researches.

> I received the notices from Modena with great pleasure, and with even greater pleasure your kind offer of the books by Masini and Montealberto. . . . Due to an indication from Signor Magliabechi, I am also thinking of procuring a certain booklet discussing Modenese painters. . . . From what I read in the latest notices, I realize that I was not far behind in my deductions from the things I've seen. At the same time, I recognize the urgency of His Reverend Highness' continued favor. Only by obtaining such material for me from every possible place in Italy will this work be certain and worthy of His Highness.[118]

There was little or nothing in print regarding many schools and periods. Above all, crucial early links were missing in the chain of evolution that Leopoldo and Filippo sought to document. The masters of the thirteenth, fourteenth, and even fifteenth centuries were distant in time, remote in aesthetic values, and usually ignored except by a few specialized antiquarians. In 1675 the cardinal's administration ordered copies from Genoa of works by the mysterious Lodovico Brea.[119] Inquiries were sent to Gian Pietro Bellori in Rome concerning the frescoes and mosaics in Santa Maria in Trastevere.[120] The Florentines also approached Carlo Cesare Malvasia in Bologna for a "list of all the painters, sculptors, and architects you mention in your work, from the year 1200 until 1400, with the precise dates of their activity and the names of their masters and pupils."[121]

Recent artistic production was usually outside the published literature as well. In the spring of 1675 Leopoldo's administration composed a standard questionnaire in the cardinal's name.

> For certain endeavors that I am having carried out relevant to notices on painters, I would like precise information concerning all the paint-

ers, sculptors and architects presently active in your city. I refer to those after 1642, who achieved reputation and accomplished works in public places, also masters who died or went elsewhere, including foreigners who worked here in Italy.

Furthermore, I wish to know who were their masters, and if you can also learn their masters' masters without undue effort, I will be especially grateful. This request refers only to those not named in the books of Baglioni, Ridolfi, and Bellori, since we have already sufficient notice of these.[122]

By late April of 1675 Leopoldo and his collaborators began circulating these questionnaires among Medici agents and correspondents. In the following months replies came in from Marco Boschini in Venice,[123] Carlo Malvasia in Bologna,[124] Francesco Oddi in Perugia,[125] Angelo Maria Ranuzzi in Urbino,[126] and Pietro Andrea Andreini in Naples.[127] Ottavio Falconieri in Rome was approached as well.[128]

The connection between Leopoldo's collecting and Baldinucci's art historical research is expressed most clearly in another inquiry from two years earlier. By 1662, Leopoldo had begun distributing indexes of his drawings, and by 1663, requested lists of "painters ancient and modern" in various cities.[129] In the summer of 1673 Filippo Baldinucci issued a twenty-seven page printed *Listra de' nomi de' pittori di mano de' quali si hanno disegni*. He notes in alphabetical order the masters represented in Leopoldo's collection and records the number of drawings by each. Whenever possible, he includes the dates "in which they flourished or died." "This is the state of things on this day of 8 September 1673. The present list is to serve only as a memorandum, since the collection is continually growing and we are continually accumulating more notices of dates."[130]

On 24 October 1673 Flaminio Borghesi in Siena was given specific instructions regarding the use of the *Listra*.

I am sending you an index of all the painters of whom I have drawings and the number of these that I have. In this way you will better understand my intentions and will know those masters of whom I am in short supply. If you can find them, I would like at least twelve examples of each. Should you discover celebrated painters who have not come to my attention and are not mentioned in the list, I would be pleased to have drawings by them as well. Increasing the number of masters renders the collection more famous. Even if you cannot find drawings by these other masters, don't neglect to note their names

and the time of their activity or death. Then I will at least have this information at hand, should drawings by them come my way.

As you see in the printed list, I lack death dates for many painters. In fact, I have not expended much effort in the search, but only pick up dates here and there when I find them. If you happen to know when some of these lived or died, you would be doing me a favor. Referring again to the list, I have the idea of dedicating individual books to those masters from whom I have very many drawings. I would therefore take pieces by Vanni up to the number of one hundred.[131]

On the first of August 1675 a copy of the *Listra* was updated by hand. The number of drawings had increased from eight thousand one hundred forty-three to eleven thousand two hundred forty seven, and the number of masters from five hundred thirty-five to six hundred fifty-four. A few years after Leopoldo's death, Filippo Baldinucci and Lorenzo Gualtieri completed the organization of the drawing collection on the orders of Cosimo III. The books of drawings remained Gualtieri's official responsibility until 13 May 1687, when he turned them over to Giovanni Bianchi, *Guardaroba* of the Granducal Gallery.

The principal document of this transfer is the manuscript *List of the Books of Drawings, Indicating How Many Are Included in Each Book*. This list records eleven thousand two hundred sixty eight drawings attributed to six hundred forty-six masters. The drawings were disposed in one hundred five volumes cased in red leather with gold tooling. There were twenty-two general volumes containing drawings by various artists and eighty-three others devoted to individual masters. The list is broadly alphabetical and thumb-indexed by letter. Under each letter, the artists are given first in the order in which they occur in the numerical sequence of the general volumes, followed by citations of the relevant individual volumes. The pages of the list are ruled like a ledger and the column at far left carries the number of drawings by each author. A running tabulation is found at the bottom of each page.[132]

The 1687 list served as both an administrative accounting of the grand duke's property and a summary index of the collection. Since the volumes were disassembled in the early nineteenth century, it remains the only substantial record of Baldinucci and Gualtieri's great project, conceived under the auspices of Leopoldo de' Medici. A broad reconstruction is possible, establishing the number of drawings attributed to each master and the order of these masters in each volume.[133] The col-

lection was vast and impressively comprehensive. However, its historiographic structure would not have been self-evident to an amateur paging through the hundred and five volumes in sequence. Baldinucci's genealogical tree and chronological index were probably intended as master keys to the collection.

Eighty-three individual volumes were allotted to seventy-two different artists. These monographic units were often massive. Four hundred twenty-three Barocci drawings filled four books, four hundred ninety four by Poccetti three books, and five hundred five by Stefano della Bella also three books. In the twenty-two general volumes, the compilers' intention is only sometimes apparent. The first *volume universale* begins with the expected progression of Florentine primitives from Cimabue, Andrea Tafi, and Gaddo Gaddi through Giotto, Simone Memmi, and onwards. This order, however, advances by fits and starts, sideward and backward moves, with puzzling lacunae and surprising inclusions. Titian, for example, appears in volume three and Giorgione in volume five. The twenty-second book, containing a hundred seventy drawings by one hundred fifty-five very miscellaneous masters, seems to have been formed only by the pressure of coping with so many objects.

At the time of Leopoldo's death, Filippo Baldinucci was caught up in an expanding cycle of projects closely linked to the personality of his exceptional patron. Their activity in the drawing collection had given rise to the genealogical tree, and they were considering broader applications of these researches. There is no firm evidence that Leopoldo had specifically destined Filippo as author of a new Florentine compendium of artists' lives. Such possibilities, however, were certainly in the air and the momentum of their work was moving them in this direction.

Francesco Saverio Baldinucci describes his father's predicament following Leopoldo's death. "Immersing himself in this laborious undertaking, he set aside his business interests almost entirely, in hope of the substantial assistance promised by the cardinal. Then on 10 November 1675 the Lord God summoned this pious and noble patron, abandoning Filippo under the weight of his endeavor. Even this great loss, however, was not enough to dissuade him."[134]

On 20 July 1681 Filippo Baldinucci addressed a petition to Cosimo III by way of his secretary Apollonio Bassetti. Filippo outlines his "humble services to the Most Serene Princes" and begs "such remuneration as the Cardinal should have wished for me had he lived."

I served the Most Serene Cardinal for eleven years, assisting him assiduously in matters pertaining to his recreation. In order to assemble his books, he graciously commanded me to study the series of masters of the art of design going back four hundred years. I did this for the whole time, giving precedence to obedience over personal advantage. I asked nothing of the cardinal, except his intercession with the grand duke for a place in the tax office (*decime*), and he condescended so to favor me. At his death, he ordered that I be given one hundred *doble* as payment for all of my great collection of drawings. He had these from me a few weeks earlier, and they are now to be seen scattered throughout the grand duke's books. I would gladly take any oath that I never requested nor received other from him. The point could be made that I was given money on rare occasions to pay for a few drawings or artists' portraits, when His Highness wished these to pass through my hands for his greater advantage and assurance. If His Most Serene Highness finds that I took even the merest particle of profit on these few occasions, may he exclude me forever from his favor.[135]

Baldinucci's career as an art historical writer might have been very different had Leopoldo de' Medici lived a few years longer. Unfortunately, their plans for further scholarly and curatorial projects were only half-formulated, and Cosimo III had neither the temperament nor the imagination to follow his uncle's lead. Filippo discovered important new talents within himself during his association with the cardinal. His later struggle to realize them brought economic and emotional strains with which he was ill-equipped to cope.

IN HIS OWN lifetime, Filippo Baldinucci was probably most widely known for his strident opposition to Carlo Malvasia, the great biographer of Bolognese painters. Though Baldinucci and Malvasia were seldom if ever in direct contact, their antagonism took root well before 1678 and the publication in Bologna of the *Felsina pittrice*. During Filippo's years in Leopoldo's service, he and Malvasia were joined by a convoluted web of loyalties and counterloyalties representing the intricacies of political, social, and intellectual life.[136]

Conte Carlo Cesare Malvasia was born in Bologna in 1616 and was related by blood to several preeminent families of that city.[137] In his youth he studied letters under Cesare Rinaldi and Claudio Achillini and began at an early age to compose verse. The young Malvasia collected prints and drawings and undertook a gentleman's instruction in the art

of design with Giacinto Campana and Giacomo Cavedoni. His practice
of the fine arts eventually extended to fresco painting in his own home
and those of friends; he also drew several of the portrait illustrations for
his *Felsina pittrice*.[138] Malvasia evidently received a solid grounding as
well in classical antiquarianism, a field in which he was to demonstrate
an impressive proficiency.

At the age of twenty-two Carlo Malvasia took a degree in law at the
Bolognese university. He soon left for Rome to make a place for himself
at the papal court during the turbulent last years of the Barberini re-
gime and the early Pamfili ascendancy. At the outbreak of the War of
Castro in 1641, the count embarked on a brief military career but dis-
covered a religious vocation the following year in the course of a serious
illness. He received sacred orders, adding theological studies to the
round of his legal activities. Finally, Malvasia returned home to fill
simultaneously the positions of Canon in the Cathedral and lecturer in
law at the university.

Two discordant elements reveal themselves in this brilliant array of
attributes and attainments. The first is Malvasia's mercurial and com-
bative personality, which kept him embroiled for much of his life in
overheated scholarly and artistic controversies. Second is Carlo Cesare's
equivocal position as either acknowledged bastard of Conte Antonio
Galeazzo Malvasia or offspring of a repudiated unworthy marriage.[139]
Though he was raised as a nobleman's son, more strictly legitimate
progeny needed to be considered before him. A prestigious semieccle-
siastical career would have obviated the many problems of marrying and
maintaining a suitable establishment.

For the rest of his life, Carlo Malvasia divided his time between his
duties in the cathedral and the university and his artistic and antiquar-
ian endeavors. His cousins in the Cospi-Ranuzzi family represented
Medici interests in Bologna, and through them he played an important
advisory role in Leopoldo's collecting. In a letter to Prince Leopoldo of
6 September 1663, Marchese Ferdinando Cospi cites Malvasia's opinion
on a drawing, describing him as "knowledgeable in this profession, an
antiquarian, and the person who is currently setting out to write the
'Lives of the Painters' for publication."[140]

Though permanently reestablished in Bologna, Malvasia frequently
wintered in Rome and undertook study trips to further his researches.
Returning from Rome and Loreto in the spring of 1666, he stopped in
Florence to investigate the granducal collections and to hold "various

and diverse meetings and discussions with the first *virtuosi* of painting, antiquities and other matters relevant to his work on the 'Lives of the Bolognese Painters.' "[141] On this occasion the conte canonico approached Leopoldo with a detailed letter of introduction from Ferdinando Cospi.

> This is the person of whom I previously spoke, who is highly knowledgeable in regard to drawings and has some very beautiful ones himself. He is writing the addition to the "Lives of the Painters" and is compiling their most beautiful works, so perhaps Your Highness will graciously allow him to list yours in order to describe them. Since you will surely enjoy dealing with him, I have instructed him to remain in Florence as many days as Your Serene Highness commands. He is a Canon of the Cathedral and the best, most highly accredited doctor of law in this university, with a large salary. He is also a *bel ingegno* and a poet particularly in the burlesque mode, the best in this land though he no longer wishes to compose. He is the natural brother of my nephew the Quaranta Malvasia, in whose house he stays and is treated like a brother because of his great virtues. I am describing him so that Your Highness will know all of his qualities. Should these please you as I expect, you will find no one in this country better qualified to serve you in the area of his expertise.[142]

Filippo Baldinucci might have met the conte canonico in Florence in 1666, or perhaps even in Bologna a year earlier in the course of his own trip to Mantua. While in Prince Leopoldo's *consultà* Baldinucci certainly came to know Malvasia well, as a crucial presence in the letters of the Marchese Cospi and the Conte Ranuzzi.[143] Greatly esteemed as a connoisseur, he was probably the most important source of expert opinions on Bolognese drawings.

In spite of his remarkable gifts, Carlo Malvasia's vagaries did a great deal to disrupt Annibale Ranuzzi's service to Leopoldo's collecting. The canon's own interests could cross those of the prince, and in December of 1673 he made off with a desired collection of drawings, including a prized Raphael.[144]

Years earlier, in the spring of 1665, Ranuzzi was driven to distraction during negotiations for the drawing collection of a Signor Bianco Negri. "In the morning I persuade him and in the evening I find him dissuaded. Those that want them are certain *sensali* for the Canon Malvasia, and they are hard at it all day, driving a thousand suspicions into his head."[145] Two weeks later Ranuzzi flung his hands into the air. "In

regard to the drawings, I can't do anything at all, 'e do in certi cervelli pazzi, pazzi, pazzi.' "[146]

Though outspoken and irascible by nature, Carlo Malvasia's quirks and evasions could spring from yet deeper roots. As a fervent Bolognese cultural patriot, he found himself on the defensive at the very outset. In his city, Rome held both the reins of government and an equivocal artistic hegemony. Annibale Carracci was the first of a series of great Bolognese painters who had manifest varying degrees of allegiance to Roman patronage and Roman aesthetic values. Since the mainstream of art historiography and criticism ran through Florence and Rome, Bolognese painters were esteemed according to their success in assimilating the Romano-Florentine grand style. By writing an intrinsically Bolognese history of Bolognese art, Malvasia sought to validate his native tradition on its own terms. For Leopoldo de' Medici and Filippo Baldinucci, the great literary source and model was Giorgio Vasari. For Carlo Malvasia, Vasari figured as the pernicious root of the problem.

The conte canonico would cooperate with the Florentines up to the point of compromising his own convictions and goals. In June of 1666, after his visit to Florence, Malvasia sent Leopoldo a "list of drawings that I noted during my voyage and in my own collection, as Your Serene Highness deigned to command me."[147]

Writing to the prince in August of 1673, Malvasia apologized for the slightness of his annotations to a *nota* sent him in care of the Marchese Cospi. "This is all that I could extract from my material, which is largely restricted to Bolognese painters . . . but on other occasions I hope that you will not find me so inadequate."[148] This *nota* was probably related to Baldinucci's printed *Listra de' nomi de' pittori di mano de' quali si hanno disegni*.

In May of 1674 Leopoldo sent Annibale Ranuzzi "a new list of painters who are unknown to me." Ranuzzi forwarded this to Malvasia, who furnished basic biographical information.[149]

As Leopoldo's art historical projects grew to maturity, his administration's requests struck Malvasia nearer to home. In the months preceding the cardinal's death on 10 November 1675, Filippo Baldinucci was intensely busy working to perfect his great genealogical tree of the art of design. In April of 1675 Baldinucci composed and circulated a questionnaire seeking basic chronological data concerning artists active after the year 1642, "but only those not cited by Baglioni, Ridolfi, and Bellori, since we already have enough notice of these."[150] Also in April

of 1675, Filippo faced the necessity of approaching Carlo Malvasia for information regarding the early Bolognese school. A clear challenge was in the air, between Malvasia and the proponents of Vasari's old schema for the Florentine *rinascità*.

On 25 April 1675 Filippo Baldinucci wrote Lorenzo Gualtieri to enlist the support of Leopoldo de' Medici.

> Awaiting publication of Signor Conte Malvasia's "Lives of the Bolo-gnese Painters" would delay my beginning the final draft of my chronology. . . . So as not to lose time, I should wish His Serene Highness to procure a list from that *cavaliero* of all the painters, sculptors, and architects mentioned in his work from the years 1200 until 1400. These few are all that I require, as well as the precise times in which they flourished, and who their masters and pupils were. . . . With this information I can begin my final draft and carry on for some months without confusing the dates until 1400. Indeed, this is no slight labor. The Conte Malvasia's work will then appear, along with other information for which His Highness sent to various places, and I will have even more to do.[151]

Beyond the necessity of obtaining Leopoldo's sponsorship lay the delicate problem of eliciting Malvasia's cooperation without raising suspicion. On receiving Baldinucci's request, the cardinal's administration immediately drafted a brief and formal note to the conte canonico. Thinking better of this tactic, they cancelled the draft and tried out an indirect appeal to Conte Annibale Ranuzzi.[152] This paragraph was copied into a letter of 27 April 1675 from Leopoldo to Ranuzzi: "Signify in my name to the Conte Malvasia my desire for the courteous favor of a list of all the painters, sculptors, and architects mentioned in his work from the year 1200 to the year 1400. . . . Though one hopes that his work will soon see the light, in the meantime I would dearly value this information. . . . Do assure him that in no way will my work prove prejudicial to his, since it will not be finished for some years."[153]

A reply came quickly from Bologna. On 30 April Ranuzzi assured the cardinal that his wishes had been conveyed to Malvasia at his villa near the city. In a postscript Ranuzzi briefed Leopoldo on further developments. "Before sealing my letters I saw the Conte Malvasia, who has returned to town. He sent me the enclosed note and told me that he will consider how best to serve Your Highness. If I'm not mistaken, it seems to me that he has little will, perhaps thinking this prejudicial

to his own work since he has circulated some parts of it in a similar form."[154]

In his note Malvasia goes straight to the point. He asks Ranuzzi to tell Leopoldo that his work deals only with painters. His obligations are such that he does not know when it will appear in print, though he hopes to finish in a year at most. Until now, Malvasia has turned his attention only to the most significant painters "who make up the lifeline of art." He specifically cites the great school of the Carracci and various Bolognese masters of the cinquecento. "Until now, I have not seen as significant or worthy of much thought those who flourished around and before the year 1400, such as Jacopo Davanzi, Cristoforo, and Simone. This is all that I can say in haste and without preparation."[155]

Ranuzzi's observation of "little will" on Malvasia's part was to prove a conspicuous understatement. The crucial phrase in the conte canonico's note was evidently the reiterated "until now." As recorded by a Bolognese compatriot, Baldinucci's implied challenge had Malvasia literally climbing the walls.

In his *Cronica*, Giovanni Mitelli wryly observes that requests from Florence have reached Malvasia, for "a list of painters beginning before 1400. In Bologna they have also written the Arciprete Vittorio to this effect, fearing that someone earlier than their Giotto Fiorentino might be found. At [the Church of Santa Maria di] Mezzaratta, Malvasia has gone up the walls with sponges soaked in water to uncover the best ancient painters."[156]

Leopoldo's administration assessed Malvasia's cool response, in a letter to Ranuzzi of 4 May 1675. "My work is general and enters into no detail," the cardinal emphasizes, "and thus has nothing to do with that of the Conte Malvasia." However, he instructs Annibale Ranuzzi to seek out the information elsewhere.[157]

Conte Annibale was caught in the middle, between local and family allegiances and his obligations to the Medici. On 7 May he pledged his best efforts, hoping to serve his great patron at least in part.[158] Four days later Ranuzzi conceded that "these doctors here can't see their way to organizing painters or sculptors back from 1400, beyond what Vasari has already done." By way of compromise, Ranuzzi paged through Masini's *Bologna perlustrata* and Montalbani's *Minervalia Bononiensia*, collating references to early artistic activity.[159]

Ranuzzi was deluded if he thought this bit of editorial work might

win him peace. As he learned by return post, ignorance and personal tension in Bologna were compounded by bureaucratic muddle in Florence. On 14 May the cardinal acknowledged Annibale's list of citations with chilling politeness, regretting that he had expressed himself badly at the outset. Rather than compiling notices from 1640 to the present day as requested, Ranuzzi was working backwards from that date. Therefore he sent Conte Annibale another copy of his instructions.[160]

These "instructions" presumably were the recent, widely circulated questionnaire soliciting material on artists active after 1642. In spite of their intricate discussions of Malvasia and the Bolognese primitives, someone in the administration must have lost track of this more specialized request to Ranuzzi. It would also seem that they had previously neglected to send to Bologna the standard questionnaire on more recent production.

Ranuzzi expressed his bewilderment on 18 May and asked permission "to conduct a hearing in defense of my attention to Your Highness' commands." By way of evidence, he sends back their two letters exacting information on painters before 1400. Ranuzzi also acknowledges the new request concerning artistic activity in Bologna after 1642. He had passed this on to Malvasia, who responded with a slight "scrap of paper" (*cartuccia*) that Ranuzzi forwards to Florence. "Since it does not seem to me that Your Highness has been exquisitely served, I will elicit more diligent application elsewhere."[161]

Compared with replies from other major centers, Malvasia's "note of painters presently working in Bologna" seems a cursory and haphazard affair. The canon emphasizes his past cooperation with the Florentines and infers that there will be no paucity of information "when the 'History of Bolognese Painters' appears, be it pleasing unto God."[162]

Concerning the moderns, Carlo Malvasia was no less defensive than in regard to the primitives. Annibale Ranuzzi's search for information thus dragged on inconclusively for another week. An unidentified person promised Ranuzzi assistance, but soon demurred that he knew nothing about recent Bolognese art beyond what was already published in Masini's *Minervalia Bononiensia*.[163] Conte Annibale then threw a last pitch at Malvasia with definitively negative results. "As if by chance, I again approached the Signor Conte Malvasia. He now stands openly accused as jealous of his work and we need not trouble ourselves hoping for anything at all."[164]

Our final word on this matter comes from Malvasia himself. Some

two months later, in a letter to Leopoldo of 6 August 1675, Carlo Cesare discusses two hundred twenty-one drawings sent him from Florence for attribution. He annotated each piece with the greatest diligence and vows fervent devotion to his prince and patron. Before closing the letter, Malvasia turns his attention to "the other matter." "I have implored the Marchese Cospi to stand as my intermediary and intercessor with Your Serene Highness. He will express my shame and mortification at seeing myself unable to satisfy the repeated appeals of Signor Baldinucci."[165]

This is the first mention of Baldinucci's name in a correspondence that has taken place until now at the double remove of the Cardinal de' Medici and the Conte Ranuzzi. Breaking through these ceremonial and bureaucratic conventions, Malvasia makes clear that it is merely Baldinucci, not his great patron Leopoldo, that he chose to serve less than exquisitely. In regard to the two hundred and twenty-one drawings, Malvasia showed unreserved willingness to share his expertise insofar as this did not impinge on his book. On at least one further occasion in the summer of 1675, Malvasia will "baptize" drawings for the cardinal, who will continue to hold his ability in the highest esteem.[166]

The obvious, though unanswerable, question is whether Malvasia instigated a local conspiracy of silence against Filippo and his researches. The Bolognese probably knew rather little about their own painters of the due- and trecento. It is curious, however, that even the names and dates of artists within recent memory should prove so difficult of access.

While Malvasia was preparing the *Felsina pittrice* for publication, the Florentine challenge perhaps forced an emergency revision of his treatment of the Bolognese primitives. At that moment, the conte canonico was also involved in selling off many hundreds of drawings from his personal collection.[167] Since the author was meeting the printing costs out of his own pocket, the sale might have been timed to defray these expenses. In this case, the sacrifice soon proved an empty gesture. As we will see in later chapters, Carlo Cesare Malvasia could show a perverse genius for complicating his own life.

On 27 September 1675 Filippo Baldinucci wrote from his rural holding of Botinaccio to Leopoldo's secretary Fabrizio Cecini, "I have come down here for a few days with a large case of books and all my bits of paper, in order to straighten out a few difficulties without being disturbed." He enquires about some material from Genoa "because this

school of Genoa along with that of Bologna is keeping everything of mine up in midair."[168]

Leopoldo de' Medici died six weeks later, on 10 November 1675. Baldinucci's research was still in midair, as was his new career as a historian of art.

FILIPPO BALDINUCCI'S years with Leopoldo de' Medici might well appear a golden age of growth and self-realization. Filippo, however, left a personal chronicle that allows us to view this period from another perspective.

During the night of 15 September 1669 Filippo awoke, overwhelmed by an intolerable burden of troubles. Sensing the impossibility of further repose, he recorded the first entry in his spiritual diary.[169]

> On this day, the fifteenth of September 1669, Octave of the Feast of the Nativity of the Blessed Virgin, I found myself in gravest affliction. With little humility or subjection to God, I was anguished by a heavy loss of property and the danger of yet heavier future losses. For many years I had prayed with others for the prosperity of this venture, and now things appear reduced to the extreme. This same pridefulness caused me to turn away from those servants of God who sought to console me, perhaps offering them no little scandal. . . . For the last three days, I have been filled with confusion and inner darkness, affliction and apprehension. Today in particular, I was assailed by my usual mishap of raising blood or vapors or melancholy humor to the head, with discernible danger of unsettling the brain. Today, as I said, I was in the most desperate straits, and I cannot express the inner darkness, and the conflicts within me between faith and disbelief.[170]

For the remaining twenty-seven years of his life Filippo had frequent recourse to the diary in times of crisis. Already in these first sentences, we find the most characteristic elements of his continuing spiritual disorder. For Filippo, all the occurrences of his daily existence were somehow supernatural in their origin or significance. As a result, his physical and emotional state floated unsteadily on the ebb and flow of his business career. More generally, he was dissatisfied with his commitment to a secular life and uneasy concerning his dealings with those in religious life.

On this particular occasion, Filippo tried in vain to make an act of conformity to the will of God. Returning home, evidently from the

place of business where he suffered reverses, he undertook his usual devotions, but these failed to dispel either the mental or physical symptoms. As was his custom, he gave himself the discipline, offering it to the Holy Virgin "in onore de' flagelli del suo santo figliolo." Filled with emotion towards the Virgin and sensing favor in seeking her aid, he applied himself more vigorously to his act of conformity. However, the anguish, inner darkness, and perturbation of the head only intensified. At the peak of this crescendo, he threw himself with redoubled force into his act of conformity. "Then in an instant, these mental and corporeal phenomena dissolved away, leaving me with a serene mind and a near certainty that the Blessed Virgin had liberated me prodigiously. . . . Indeed, this grace seems to me a miraculous grace, since I was raised in a moment from the depths of physical and spiritual sickness to a state of total liberation. What the Lord requires of me, I've thus learned, is more humble subjection to him."[171]

In the calm that followed, Filippo projected a program to root out his flawed submission to divine will.

> First, ask always of God that you may subject yourself to his will and place yourself under his scourge, even if his will be that you fall dead at his feet from the greatness of the blows. . . . Avoid as you would death itself complaining to servants of God with prideful words and little humility. . . . This causes them grave scandal. Even more, it gives license to the Demon and leaves you helpless, as you've often experienced. In such cases the Lord need turn his hand to miracles, as happened this time and as you well know. . . . In the end, whether you wish it or not, God is the master. It is for you to accommodate yourself to Him, not Him to you, even if he should wish to cast you into the depths of hell after a life of intense misery. . . . If this you will do, you can hope that God will console and exalt you when the time comes.[172]

Baldinucci noted a few days later, "I cannot reflect on other than the awfulness (*terribilità*) of God's judgements and cannot conceive of God other than in terms of justice and awfulness. . . . I do not know if this is a sin, but I can give the Lord God only the name of *Terribile* for only as such has he long shown himself to me."[173]

Filippo Baldinucci called on his spiritual advisor Father Emilio Savignani and left these first entries in the diary for his scrutiny. Savignani wrote brief but incisive comments, seeking to calm his charge and set him on the path to a more constructive relationship with God. The

father reminds him that the Lord "is a most loving master of our well-being." He warns that Filippo is "too greatly attached to property, esteem, and so forth." He also advises him to cultivate "greater indifference" in the face of emotional excesses and to recognize merely physical symptoms and treat them as such.[174]

Filippo's distress was generated most immediately by the problem of "divine recompense." If in a state of grace, he expected God to award him worldly success, and indeed, took this as the principal indication. At the same time he struggled to reconcile the rival claims of the way of negation. "As much as I wish to serve God, to that degree must I abandon hope of any good in this world, but always in everything accept every evil. Beneath this lies my awareness that the perfect way is the way of crosses and that misfortune is the prize of good action. So have I read in that pamphlet and have often heard."[175]

When tribulation came to Baldinucci, however, it brought a host of doubts and temptations. "Instead of lending support, these misfortunes sap my every strength."[176] Filippo filled his spiritual diary with the details of business affairs. Often he totalled his receipts and from their import deduced his relative acceptability to God.[177] Since it could be said that Filippo kept his prayerbook and account book bound in the same cover, his devotional language often echoes his professional preoccupations.

> On the thirteenth of this month, I had a clear illumination. All our acts of hope are deposited in the bank of God, with the expectation of interest in due time. All the acts of hope, I say, made in periods of darkness, when there is no one who seems to see or hear.[178]
>
> The coin in which God wishes to be paid for his graces, the father told me, is the rendering of thanks . . . and the recognition of having received these graces.[179]
>
> I should give no consideration to this apparent evil which comes after I specifically prayed to the saint for deliverance from it. God is not obliged to pay every Saturday, and I should have believed that the prayer would have its effect in its own time.[180]

Filippo's thwarted religious vocation exacerbated the strain between the demands of spiritual and worldly life. On Christmas of 1672 he noted that his devotions had long been accompanied by bouts of intense weeping and sought to analyze the causes.

> It touches my emotions when I reflect on the gifts and graces that the Lord bestowed on some great saint or even on the very Mother of

God. . . . I think of the religious calling, the quickening of the will to God's service and the detachment from those cares that so restrict me. The Lord's grace in me then seems like the seed fallen in the public way and among the thorns, because I cannot deny my being as a man in the worldly sphere. . . . I am compelled by necessity and by the spiritual and material provision the Lord requires of me for so large a family, and thus I meet many perils. In a sense, it seems that the Lord spurs me terribly in one direction yet pulls the bridle in the other. Between such extremes, He alone knows what I'm about. Therefore, I weep burning tears, not for envy of the saints but in compassion for myself.[181]

Filippo Baldinucci might have done well to risk filial disobedience in his youth and thus taken sacred orders, since he seems a personality for whom religion needed to be a full-time occupation. More than lending institutional support to his faith and shutting out mundane distractions, Baldinucci saw the priesthood as controlling a range of special powers. We have already heard his conviction that unsuitable behavior towards servants of God could "give license to the Demon" and stand in the way of necessary benevolent miracles. On 18 May 1674 Filippo met with Father Savignani. His account reveals the nature of their discussion. "The father told me that he knew a man with only minor orders who had power over demons and drove them away without being ordained a priest. He effected this merely with faith and a sure belief that God was helping him. With the words 'God help me,' it is certain that he chased the demons away and everything came to pass as he believed it would."[182] Baldinucci then notes Savignani's suggestions on dealing with "nocturnal terrors."

For thirty years a visionary nun of noble birth in the Convent of Santa Maria Maddalena de' Pazzi held a special place in Filippo's religious imagination.[183] Baldinucci served the community in a professional capacity, and the mother conveyed divinely inspired advice on his family and business affairs. Her identity was shrouded in secrecy and their contact evidently progressed through several stages of indirectness. They communicated by letter and through the intermediary of their spiritual advisors, then "according to the usage of the place, I could hear but not see her."[184]

Though Baldinucci had been in touch with the visionary for some time, she does not figure in his diary until 7 November 1673. Filippo laid out a characteristic balance sheet, listing "the many and various

tribulations that the Lord sent me in the last eight years and how these were resolved." With often cryptic abbreviations, he notes investments, law suits, and property disputes. "My chief fear in the world was that the great settlement of accounts might not take place and I would fall into the hands of my adversaries F. and V. This came to nothing, according to the prediction of that *serva di Dio*. Accounts were settled and my adversaries have not been able to get anything on me in all these years."[185]

On 12 June 1675 Baldinucci met with the nun. She assured him that his earthly sufferings would turn to advantage in reducing his interval in purgatory and communicated the Lord's intentions regarding Filippo's five children. Ignazio would become a Capuchin, Isidoro a canon, and Antonio a Jesuit. Giovan Filippo was destined for a business career. Francesco Saverio would be the happiest and most favored, "since it was for him to relieve or raise up or aggrandize the house of Baldinucci. I don't remember the precise words." Her prayers on "the matter of the cardinal's drawings" brought confirmation of a satisfactory outcome.

> It must not be thought that such high and divine things were voiced smoothly and consecutively as if she were telling a story. Rather, she spoke as if she were about to burst with great torment. . . . Frequently she would stop, breathless and sighing, and say, "Have I told you too much? This evening in examining my conscience I should not wish to find that I had told you too much." . . . In regard to purging my sins through suffering, she repeated many times with great affection and humility, "Believe me, Signor Filippo, I will help you to suffer." . . . Finally, she explained how their confessors forbade them hair shirts and such things. Therefore she asked me as a great favor to have made for her a belt of iron five fingers wide. She requested that it be thick, since it would undergo much wear . . . and rough, not one of those that seem made of silver.[186]

Baldinucci sent the iron belt by way of her confessor. "Through him I advised the mother of three grave afflictions of mine, over which she should pray. The first concerned the impending loss of necessary assistance in my business, the second the affair of the drawings, and the third my grave doubts in a business matter."[187]

When Filippo called on the nun in September of 1675, she conveyed the Lord's assurance regarding the drawings.[188] She had also been much enlightened in regard to his sons, and most particularly, the fourth-born Isidoro.

Signor Filippo, you remember what I told you about Isidoro, how he would be a priest and a canon? Later, when you brought him here to me dressed in his habit, I rejoiced saying, "Oh, here is our canon!" . . . I then prayed for him and seemed to find myself in our Cathedral of Santa Maria del Fiore. I saw the Blessed Virgin in majesty on a beautiful cloud high in the choir, with your son Isidoro on her arm. Suddenly, she sent him falling gently to a spot down in the choir. The Virgin said to me, "This is his place," and I understood that Isidoro would be a canon of that church.

Filippo expressed his wonder and amazement. " 'Your Reverence realizes that what you tell me now is a great thing and indeed a miracle. Canons of the Cathedral are surely all *cavalieri*. The most they can give a good Florentine citizen is a canonship in San Lorenzo, since they even let country folk have those.' The mother replied to me, 'How do you know that he won't receive it from some prince?' "[189]

Hopes and fears concerning princely favor constitute a major theme in the spiritual diary. During Holy Week of 1674 Filippo Baldinucci struggled with a crisis of confidence in God. He had reason to suspect that adversaries were intriguing against him with Cardinal Leopoldo. "Various things caused my apprehension to grow, until I saw the imminent danger of losing the protection of such a lord." This raised the deeper question of his state of grace, and Filippo recorded in detail his many days of intense turmoil.[190] On Easter morning, 25 March, his devotions were especially fraught.

Scarcely had I finished my prayers . . . and was about to leave for church to take communion with a fearful and afflicted heart, when there came a knock on the door. A letter arrived from the cardinal in Pisa, full of all that I could have wished and more, that is to say, appreciation, reliance, offers, and promises. . . . My heart opened up, and I was filled with extraordinary joy, since it seems clear that the Lord sent this grace to teach me confidence in him.[191]

Two months later, on the first of June 1674, Baldinucci's doubts returned in full force.

Today the Foe invented a new ploy. I asked the grand duke for a post in the tax office (*l'uffizio delle decime*) and had great hope of obtaining it, due to the cardinal's promise in the letter from Pisa on 25 March. This morning the offices were to be announced. The Foe contrived to convince me, through the statement of a person who should know, that if the post fell to my lot, I would receive word by lunchtime.

Since that hour passed and I heard nothing, I had good reason to lose
every hope and was filled with the usual sadness and disbelief.[192]

Filippo describes the following hours of sorrowful self-analysis.

Suddenly, late in the day, news that the post had been assigned me
was despatched to my house on the cardinal's own order. The Foe's
artifice is noteworthy, in that he took advantage of an exceptional
occurrence. Though offices are normally published early in the morn-
ing session of the magistrature, for once it happened very late after
lunch. . . . These are all manifest signs that the Demon makes use of
my feeble virtue to keep me in perpetual disheartenment and disbe-
lief.[193]

Baldinucci's business career was unsettled and nerve-wracking and
kept him trembling on what he saw as the wrong side of God. His
world was so saturated with the miraculous that if miracles were not
regularly forthcoming, he read their absence as divine rejection.
Though we have heard Filippo deny envy of the saints, he sought to
squeeze the occurrences of his own life into the forms of hagiographic
literature. On 29 December 1674 Filippo Baldinucci narrated a re-
markable series of events.

Thirty years earlier, Father Francesco Cerretani brought the body of
the holy martyr Saint Primitive to the Florentine monastery of the Phil-
ippine Fathers. This relic was at first kept in Cerretani's own cell, then
translated to a private chapel in the adjoining Church of San Firenze,
and finally, given an honored place below the altar of the new oratory.
On one occasion Baldinucci saw these remains in the father's cell and
after maintained a special veneration for the saint. Often he knelt before
the locked door of the chapel or asked the fathers to relay his prayers.[194]

In the early evening of 20 November 1674, Filippo Baldinucci and
a friend were walking towards Piazza della Signoria. As they passed the
Church of San Firenze, Baldinucci was moved to utter the words, "I
want to stop at the oratory to say an Ave Maria to my patron Saint
Philip." Upon entering, they saw the relics of Saint Primitive exposed
beneath the altar, surrounded by clouds of incense or smoking lamps.
Filippo exclaimed, "Oh, this is the body of San Primitivo, let us draw
near!"[195]

Kneeling on the altar steps, Baldinucci was soon locked in combat
between pious sentiment and spiritual aridness, imploring the saint's
intercession with much emotion. The corpse's face was turned to the

beholder, fixing its gaze on the devotee like a living person. This greatly enhanced Filippo's piety, and he later rendered a drawing of the precise posture, with the head "in full face, as the painters say."[196]

Absorbed in prayer, Baldinucci's visual attention strayed from the object before him. Suddenly, with a thrill of terror, he saw Saint Primitive lying with his face in profile, his head aligned with his body. In sorrow and trepidation, Filippo recalled the miracle of the corpse of Saint Maria Maddalena de' Pazzi, who turned her face against a reprobate kinsman.

Both Baldinucci's companion and the sacristan assured him that the present posture in profile was the accustomed one, and no change had been apparent to their eye. Fear gave way to deep consolation. Rather than a sign of disapprobation, the initial gesture of turning towards him was a signal grace.[197]

A few days later Filippo visited Father Savignani to share this momentous development. The spiritual advisor was little impressed and inferred that his charge was seeing things only in the more mundane sense. "I did my best to entertain the father's opinion contrary to the experience of my own eyes. Deep in my heart, however, remained the conviction that this was the Lord's own grace. . . . If such be the case, God need bring other things to pass so that the father will credit it to San Primitivo."[198]

A month later the Lord chose to underline this grace in particularly auspicious circumstances. On 21 December 1674 he attended Cardinal Leopoldo de' Medici's first mass at the altar-tomb of Saint Cosimo in the Church of the Santissima Trinità. Filippo and his son Francesco Saverio knelt in prayer before the body of the saint, whose head "I saw turned towards me, even more than that of San Primitivo I would say."

Having digested Father Savignani's sceptical counsel, Filippo did not imagine that the configuration of Saint Cosimo's remains might be other than usual. That night in bed, however, Saints Primitive and Cosimo both appeared to him. Francesco Saverio, an unidentified acquaintance, and the sacristan of the church all confirmed that the corpse had been, and still was, lying in strict profile.[199] "I recounted all this to Father Savignani, who gave it somewhat more attention, most of all because I told him that thinking them favors and graces from God greatly helped me in my disbelief and faintheartedness. May it please the Lord and these glorious saints that I be not disappointed. If these

are the Lord's graces, may he show what he requires of me and help me fulfill it."[200]

Some months later Baldinucci experienced another failure of miraculous grace. In the summer of 1675 he was at the estate of the Alessandri family at Petroio, presumably for professional reasons. On the night of Saturday 3 August, Filippo had a dream that brought him "great consolation."

> I seemed to find myself in a place where an image of the Madonna was revealed, that is, a beautiful relief of the Virgin, half life-size and painted in flesh color. She had a most lovely face and was seated with her son Jesus on her left arm. Our Lady fixed me with a sweet smile that filled me with great devotion. Meanwhile, I saw myself as one greatly afflicted repeating these words with deepest emotion: "Illos tuos miserecordes oculos ad nos converte. . . ."
>
> That morning [Sunday] I arose to journey to a distant church to hear mass and take communion. For some reason, the steward of this villa told me that I could go to the little church nearby since there were two masses, and that morning they would expose a miraculous image of the Virgin. He recounted some singular graces due to this image and mentioned that it was in relief.
>
> Hearing this under such circumstances, the same sweetness and devotion arose within me as I had experienced the night before. I determined to go there, which I did, and was able to confess and take communion. . . . The image was then revealed. It was a relief of the Virgin, painted in flesh color, a little over half life-size, showing her seated, also with her son Jesus sitting on her left arm. However, she was not turned towards me, nor smiling, but rather looking out at the people. Neither was her face especially beautiful, as I had imagined it last night. In spite of my best efforts, it elicited little or no devotion since it was in the old style (di maniera antica), with the face and other parts poorly proportioned.[201]

In religious painting Filippo Baldinucci demonstrated a predilection for softness, delicacy, and mystical sweetness. In his *Notizie*, he singles out Federico Barocci and Francesco Vanni for "a certain indescribable spirit which moves devotion, compunction, and other pious emotions."[202]

Though Filippo responded only faintly and ambivalently to the stylistic qualities of the primitive *Madonna* at Petroio, he was deeply involved in the cult of ancient devotional images. In his notices on Giotto, he describes a portrait buried with the Blessed Umiliana de'

Cerchi, evidently replacing her head which was enshrined in a reli-
quary. "In past years the present author made many small copies of this
portrait, revising the drapery as much as possible in our softer modern
style without losing sight of the original. The Most Serene Grand
Duchess Vittoria deigned to keep one of these copies. Another was sent
to Rome, where it was engraved in copper by Albert Clouet."[203]

Senator Alessandro dei Vieri de' Cerchi actively promoted the cult of
his early thirteenth-century ancestress. He sponsored publication of the
Clouet engraving, with the inscription "Filip. Baldinucci Delin." By
the spring of 1673 Filippo had personally distributed fifty copies and
suggested that Senator Alessandro undertake a second printing.[204] The
Baldinucci-Clouet engraving served as prototype for a long succession
of printed images.

Paolo del Sera, Leopoldo de' Medici's agent and confidant in Venice,
owned a drawing after the angel in the miraculous fresco of the *Santis-
sima Annunziata* in Florence. On 17 October 1671 he asked the cardinal
to complement this image by ordering a replica of the Virgin Annun-
ciate "from Carlo Dolci or someone else who draws diligently and
well."[205] Leopoldo passed the assignment on to Filippo Baldinucci, who
finished the drawing by the first days of 1672.[206]

Francesco Saverio Baldinucci records another contribution by his fa-
ther to the cult of the Santissima Annunziata.

> His Majesty the Emperor Leopoldo begged the Most Eminent Leo-
> poldo de' Medici to send him an exact copy of the entire image of the
> Virgin Annunciate in the sanctuary of this city. Filippo was assigned
> the task of executing this in red and black chalk, but was reluctant,
> thinking himself unable and unworthy. . . . The cardinal was well
> pleased with Filippo's effort and showed it to the excellent painters
> Baldassare Franceschini il Volterrano and Carlino Dolci, who ap-
> proved it in full measure. It was then sent to His Imperial Majesty,
> who received it with much satisfaction and praise.[207]

Filippo Baldinucci's close friend Carlo Dolci might have seemed a
more apparent choice for a work of this kind destined for so great a
patron. Dolci painted several replicas of the *Annunziata*, and Filippo
owned his preliminary study for the example commissioned by a Vien-
nese convent.[208]

A conspicuous element in Carlino's art is the adaptation and enhance-
ment of old and venerated representations. Filippo Baldinucci could

himself envision the mystical transfiguration of a modest sacred image as a translation into the style of Carlo Dolci. In the spring of 1675 Filippo recorded an incident during one of his tours of aristocratic properties.

> Around the fifteenth of May . . . I was at the villa of Marchese Ottavio Pucci in Empoli. Due to external causes, I found myself in greater travail and mental agony than I have long experienced. God helped me force myself into the bounds of patience, and I offered this tribulation to the Most Holy Madonna. In a room of that house, I saw a little image of Saint Francis Xavier and briefly commended myself to him. In a dream that night the saint revealed himself to me, that is to say, the face and part of the bust. Without altering the likeness, the face appeared so beautiful as to make one fall in love with it. The features were exceedingly white but the beard dark. More than anything, it seemed as if it were from the hand of Carlo Dolci, that is to say, marvelously delicate, composed, and clean.[209]

Baldinucci's revered friend, the painter Father Francesco Boschi, also issued copies of the "Giotto" portrait of the Beata Umiliana de' Cerchi.[210] In their youth Boschi and Baldinucci studied painting in the shop of Francesco's uncle Matteo Rosselli. Later they shared two spiritual advisors, the Jesuits Emilio Savignani and Giovanni Angelo de Benedictis.[211] Father Francesco also enjoyed a long and confidential relationship with the visionary nun. Several weeks after his death on 16 January 1676, he appeared to a sister of her convent.[212] Many other "things of great edification" followed suit, and Filippo nurtured hopes of a celestial career for Boschi no less exemplary than his earthly one.[213]

There are many indications that Filippo Baldinucci figured in a devout circle of Florentine artists or, more broadly, of devout individuals dedicated to the arts.[214] To put his spiritual diary in context, we need know a great deal more about the books he read, the congregations he frequented, and the associations of his confessors and advisors.[215] Francesco Saverio Baldinucci tells much about the home environment that propelled three of the five children into religious life, the Jesuit Antonio Baldinucci eventually achieving beatification.[216]

Filippo and his family lived in one of a block of three houses at the corner of Via della Pergola and Via degli Alfani. While preparing his "Notizie di Bartolommeo Ammannati," he learned that another of these had been an early home of the Blessed Luigi Gonzaga of the Society of Jesus. In 1688 Filippo enlisted Cosimo III's patronage "in affix-

ing a gray stone frame to the front of this house, wherein a painting will be placed of this Beato's sacred image."[217]

In his writings Filippo Baldinucci expressed strong opinions on decency of subject and artistic representation. In 1683 he circulated Bartolomeo Ammannati's century-old attack on licentiousness in the arts, with great expectation of public benefit and granducal approbation.[218] One can only hope that Francesco Saverio was misinformed regarding his father's purchase and immediate destruction of a "chiaroscuro picture of a nude Venus with a satyr and *amorini* in rather indecent attitudes, though a most beautiful work of painting, since it was from the infallible hand of Carracci."[219]

Baldinucci often structures his biographies like moral tracts, with sudden conversions, good deaths, rewards of virtue, wages of sin, and seemingly interminable inclusions of edifying matter. Just as often, he affectionately digresses through humorous tales of artistic eccentricities, family oddities, bizarre patrons, comic rustics, and bohemian pranks. Baldinucci's scholarship can be strong and original or obsessively pedantic, and his style sparkling, turgid, or slapdash. At times he mechanically anthologizes other writers and at times pioneers new fields of inquiry and attitude. The *Notizie de' professori del disegno* is a strange and unbalanced literary concretion. Considering the financial, social, and psychological obstacles that Baldinucci faced, the most remarkable attribute of the *Notizie* is that it exists at all.

THREE

Filippo Baldinucci: 1681

ON 19 APRIL 1681 Filippo Baldinucci arrived in Rome carrying cop-
ies of the prospectus of his *Notizie de' professori del disegno* printed in
Florence only a few days earlier. This was Baldinucci's first visit to
Rome and the *saggio* of the *Notizie* his first publication.[1] Before the end
of 1681 Filippo issued two other works equally charged with implica-
tions for his career, the *Lettera a Vincenzo Capponi* and the *Vocabolario
toscano dell'arte del disegno*.

Baldinucci's debut was bold, decisive, and carefully planned. In the
course of a year his name emerged from relative obscurity and became
familiar to any informed amateur of Italian art or letters. With this
extraordinary effort, he hoped to resolve the crisis of patronage precip-
itated by the loss of Leopoldo de' Medici.

On 19 January 1676, two months after the cardinal's death, Filippo
affirmed his trust in Divine Providence.

> "This year I come to a happy end by way of much adversity. The Lord
> God would thus have me know that he views me with forebearance
> and that I should not lose hope in the face of sinister occurrences. . . .
> The cardinal's death brought sorrow and loss such as I cannot express,
> but it was accompanied by a conspicuous grace. Though I had de-
> spaired in the matter of recompense, it was resolved through means
> both singular and remote from human intervention. Truly the Lord
> chose to show me his hand in a miraculous way. . . . As yet another
> exceptional favor, God set me to this chronological work of mine.
> The work has been well received. What is more, it offers much relief
> and distraction from the worries, responsibilities, and afflictions that
> consume my spirit. Neither can I fail to note the Lord's grace in con-
> tinuing the grand duke's protection after the cardinal's death, in the
> commands received in his service, and many other current signs of
> Divine Providence. Ad laudem Dei et Beatae Mariae Virginis.[2]

89

On 9 February 1676, the visionary nun of Santa Maria Maddalena de' Pazzi added her own guarded optimism. "She received no special enlightenment regarding my chronological work, but hopes it will go well."[3]

Grand Duke Cosimo III inherited his uncle's collections, including the drawings and artists' self-portraits. The originality and prestige of the Galleria di Autoritratti appealed strongly to Cosimo's imagination. For the rest of his life he dedicated himself to its expansion and perfection, continuing to rely on Baldinucci's expertise.[4]

On 12 February 1681 Lorenzo Gualtieri commented to the grand duke's secretary Apollonio Bassetti: "This morning we had a long session on the portraits. With convincing arguments, tests, and comparisons, Signor Baldinucci showed us several discrepancies."[5]

Filippo wrote an explicit account of his efforts with the vast collection of twelve thousand drawings left in disarray at Leopoldo's death.[6] "The Most Serene Grand Duke honored me by commanding that I carry out the late cardinal's wishes. For some years I went to work in the room high up in the palace, three and four times a week or even more, during the summer and in other seasons. At home I also studied the series of artists. Over a hundred books of drawings were then assembled through the diligent application of Signor Lorenzo Gualtieri."

Filippo Baldinucci developed his art historical interests under the aegis of Leopoldo de' Medici. After the cardinal's death, when he reaffirmed his commitment to the "chronological work," financial assistance was only one pressing consideration. For information and advice, Filippo had come to rely on a network of agents and correspondents with his great patron at its center. Baldinucci quickly took stock of the few resources he could command in his own right, and set out to construct a new pattern of communication and support.

During his years with Leopoldo, Filippo Baldinucci frequently applied to the influential Granducal Librarian Antonio Magliabechi. Also, Baldinucci played an important role in the Florentine cult of the Beata Umiliana de' Cerchi, to which Senator Alessandro de' Cerchi was much devoted.[7] Senator Alessandro was secretary to the Dowager Grand Duchess Vittoria della Rovere and evidently related by marriage to Bishop Giuseppe Maria Suares in Rome.[8] Bishop Suares was a distinguished scholar of Christian antiquities and a founding member of the Accademia Reale of Queen Christina of Sweden.[9]

In the spring of 1676, Baldinucci sent Magliabechi a lengthy

memorandum[10] that was frank in both tone and intention. "For greater effect and to assure ourselves of the favor desired from Monsignor Suares, it would be well for Signor Magliabechi to stipulate the worth and esteem he graciously accords the individual under discussion. He might cite him as a friend and confidant, of civil birth, a lifelong student of things pertaining to design and painting, but only as a pastime and recreation."

Baldinucci offers Magliabechi a concise statement of his current project. From his youth, Filippo notes, he took an interest in the works and styles of painters going back to the time of Cimabue. Cardinal Leopoldo saw fit to consult him on paintings and drawings, thus obliging him to study a wide range of printed and manuscript sources. These researches convinced Filippo that the fine arts were restored by Cimabue and Giotto and spread by their disciples throughout the world. He thought to demonstrate this through a tree, "accompanied by an alphabetical index, seemingly an adjunct but in effect the principal part." This table would show the place of each artist on the tree and set out his "dates, style, works, masters, and pupils, in the most clear, brief, and true terms possible, correcting the chronological errors of past authors by reference to manuscripts of undoubted veracity."

Baldinucci's authoritative and probably unwieldy *indice cronologico* had taken precedence over the tree and seemed well on its way to becoming an encyclopedic edition of artists' lives. He had already destined his efforts for publication and needed the advance recognition of a great personage like Bishop Suares.

> Our *virtuosi* consider this a praiseworthy idea and fear that a less expert person might pick it up before the present version appears. It would please this author and these *virtuosi* should someone deign attest this to the world and ennoble it with their pen, publishing some of the notices that will figure in the forthcoming work. This should be accomplished in the form that seems best, giving full particulars of the work, stating that these notices pertain to it, and so forth.

Baldinucci closes his memorandum on a nervous note, begging Magliabechi "above all else to refrain from describing him as proficient in letters. He does not profess letters, and it would prove risky for Signor Magliabechi to propose this."

In Rome on 23 May 1676 Alessandro de' Cerchi's acquaintance Father Porta presented Monsignor Suares with a letter from the Senator.

Father Porta observed: "The bishop read it in my presence, expressing great pleasure in the explanation of Giotto's true name. When he reached the point where you present Signor Filippo Baldinucci's desire to correspond with him, he protested that he would receive his letters more than willingly and would consider himself greatly favored."[11]

Filippo rose to the occasion and Monsignor Suares responded in kind on 11 July 1676.[12] With great ceremony the bishop acknowledges his debt to Senator Alessandro for introducing him to a virtuoso so esteemed by the late Cardinal de' Medici. Suares shared Baldinucci's observation on the etymology of Giotto's name with the scholars of the Roman court, and it was greatly applauded.

Baldinucci received Suares's brief and formal letter after long delay in May of 1677. With the greatest deliberation and calculation, he formulated plans to publish it in a luxurious format and to extract the fullest public relations value. He waited many weeks, until 28 June 1677, to convey his rapture to Antonio Magliabechi.[13] By the end of September Filippo issued it in the name of Alessandro de' Cerchi and evidently at Alessandro de' Cerchi's expense.[14] The bishop died two months later, on 7 December 1677. If Filippo had hoped to extract more from the Suares connection than a brief puff of publicity, it was only one of many disappointments in these years.

Cosimo III soon demonstrated the limits of his interest in Leopoldo and Baldinucci's undertakings. Though the grand duke was fervently devoted to the family gallery, his attention to his late uncle's wishes extended only as far as the stewardship of his property. Beyond this lay an indefinite range of scholarly projects associated with Leopoldo's personality and patronage. Since Lorenzo Gualtieri assumed full membership in the granducal household,[15] there was no evident need to keep Filippo at court in a curatorial capacity. By the spring of 1677 Baldinucci was sent to the village of Vico Pisano near Pisa, as *vicario* or rural administrator.[16] On his return visits to Florence, questions were referred to him concerning the documentation of self-portraits and the copying of pictures.[17]

Around 1678, according to Baldinucci's own account, he came into Florence for a few days from Vico Pisano. While walking from the Cathedral to the Piazza del Granduca, he met his friend Cavaliere Lorenzo Pucci. They discussed Filippo's researches on the professors of the art of design, and Pucci suggested accompanying it with a systematic de-

scription of "the terms and expressions peculiar to the exercise of these arts."

"Returning to my post at Vico Pisano, . . . I applied myself to this *Vocabolario*. At times I alternated this with work on my notices of painters, or else I lay aside the notices altogether. In four months the *Vocabolario* was thus considerably more than half finished."[18]

The scope of Filippo's "notices of the painters" continued to grow, as did his fear of the pirating of his research. On 21 September 1679 he voiced this apprehension to the grand duke's secretary Apollonio Bassetti.

> Before an author can issue his work, he often sees it badly printed by someone else. In order to avoid such deception, experienced people have always held that I should acquire my own printing works. I began negotiations with Gugliantini eighteen months ago . . . to buy a printing outfit from him that includes almost all the type characters I need. Due to the great expense of my work, I was not able to close the deal. . . . If you think it well, please inform His Highness of this development. Two months ago, when I last attended an audience, he graciously indicated that I should not be too quick to ruin my finances by borrowing money at interest. The grand duke hinted that he would soon respond to my appeal for assistance, or else provide remuneration for my efforts and expenses.[19]

In the next few days Bassetti reminded the grand duke of Baldinucci's proposal. The wearying cycle of vague interest and benign neglect had already begun. Filippo replied on 27 September 1679.

> I understand that the Most Serene Grand Duke remains benevolently disposed to help me with my work, though he does not mean to do so at present. The expense of publishing the whole thing is so great that His Highness' favor will always be well received. In obedience to his charitable instruction that I avoid bankrupting my house by taking money at interest, I have withdrawn from the purchase of the printing works. However, to establish myself and to strike a defense against people of ill will (*difendermi da malevoli*), I am forced to publish at least a page as it were. I think of issuing a bit of a sample (*un poco di saggio*), piecing together my few resources and not going into debt. In this way I can fulfill the requirements of my project and accommodate His Highness' suggestion. I will then await his generosity at such time as it pleases him to favor me. This generosity, I repeat, will then appear even more necessary and timely.[20]

After a session with the inspired nun on 24 October 1680, Filippo added a note to his diary. "The Lord said to her regarding my work, 'Tell him to carry on and I will see that he receives recompense.' "[21]

By the end of the 1670s it must have become fully evident that Cosimo III was not to figure as the agent of divine recompense without vigorous action on Baldinucci's part. For years Filippo had proposed nebulous and constantly expanding schemes for chronological trees and chronological indexes. The grand duke needed to be shown something tangible enough to support.

It is difficult to assess the objective state of Filippo's personal finances, though his son Francesco Saverio evokes the atmosphere of impending ruin that characterized their family life.[22] Viewed from any direction, Baldinucci's predicament seems troublesome. At the time of Leopoldo's death in 1675, Filippo was already fifty years of age. Even with generous and sympathetic patronage, his plan for a universal history of art was growing so vast as to exceed the normal expectations of any human life span. "Friends sought to persuade me that those parts already completed should not be concealed and the whole work hidden from sight till it receives the finishing touches."[23]

A few months after the cardinal's death, Filippo showed his preoccupation with mortality and the vicissitudes of old age. On 5 March 1676 the nun of Santa Maria Maddalena de' Pazzi promised him seventy years of life. Filippo asked her to pray that he might enjoy his remaining time with unimpaired health and undiminished faculties.[24] On 22 August she extended her prediction to the age of eighty and assured him that these last years would be especially happy and blessed.[25]

Filippo Baldinucci had cause to fear competitors and detractors, both in Florence and abroad. We will later observe some of the "people of ill will" on whom he kept an anxious eye. Since he was neither an artist nor a scholar, he had few apparent qualifications for the work he was attempting.

Baldinucci's birth was mediocre, his formal education insignificant, and his literary credentials negligible. Even his artistic culture was difficult to characterize. Filippo attended to the art of design "only as a pastime and recreation," not as a profession. His authority rested on the mastery of historical connoisseurship, then a vague and uncodified field of study.

While envisioning a comprehensive treatment of European art from the time of Cimabue, he had personally seen very little outside Tuscany.

In 1664 he journeyed to Mantua to audit the books of Medici proper-
ties. At some point he might have travelled through the Marche to
venerate the Sacred House of Loreto and call on relatives in Macerata.[26]
He visited Rome once in the spring of 1681, as part of a campaign to
set his new career on a firmer foundation.

FRANCESCO Saverio Baldinucci writes:

> There came the year 1681 when Filippo's youngest son Antonio, then
> fifteen years of age and already called by God to the divine vocation,
> determined after much dispute . . . to enter the Society of Jesus.
> With a Christian desire to confirm the Lord's will, Filippo wanted to
> conduct him to Rome in person to deliver him to God and the Soci-
> ety. Thus he took leave of Grand Duke Cosimo III and obtained the
> favor of lodging in his palace in Piazza Madama. . . . Around this
> time, the distinguished sculptor and architect Gian Lorenzo Bernini,
> who was affectionately regarded by Queen Christina of Sweden,
> passed to the other life. Her Majesty had already received particular
> notice of Filippo. Upon hearing that he was in Rome for this pious
> purpose, she wished him to pay his respects and receive her com-
> mands.[27]

As usual, Francesco Saverio tells us too much and too little. Filippo
had several good reasons for going to Rome in 1681 and, at this junc-
ture in his life, showed himself considerably more than a passive vehicle
of Divine Providence. The call on Queen Christina and her commission
for the *Vita del Cavaliere Bernino* were causes rather than effects of the
trip. The grand duke's hospitality was requested only at the last minute
when other arrangements fell apart.

The months preceding Baldinucci's visit to Rome were turbulent and
difficult. Tension mounted in a long and bitter property dispute with a
priest at Botinaccio. This priest was maliciously damaging the Baldi-
nucci villa and estate, while Filippo struggled to reconcile his own
property rights with the other's sacred prerogatives.[28] Conflict also
erupted between Baldinucci's spiritual advisor Father Savignani and the
inspired nun, who responded with a prediction of Savignani's imminent
death.[29]

In the Baldinucci household the chief issue of the moment was the
career of Filippo's youngest son. The Dominicans and the Jesuits both
recognized Antonio as an exceptionally promising candidate for reli-
gious life and courted him assiduously.[30] Though Filippo and the vi-

sionary nun pressed the claims of the Jesuits, Antonio was unable to master his own preference for the Dominicans. In a final attempt to comply with his father's wishes, Antonio undertook a retreat before Christmas of 1680 at the Jesuit noviciate in Borgo Pinti. As he concluded the *Spiritual Exercises* of Saint Ignatius, "he suddenly felt a great internal impulse and a total mutation of his previous inclination. His true vocation was in the order where he could aid more souls, and this seemed to him the Society of Jesus."[31]

At this time Baldinucci was busily preparing the *saggio* of the *Notizie* for publication at his own expense. The grand duke, however, was willing to confer several less costly benefits. Cosimo set the Tuscan bureaucracy to obtaining copyright and distribution privileges for several Italian states and evidently absorbed the relevant administrative fees.[32]

During the winter of 1680–1681 Apollonio Bassetti frequently discussed Baldinucci's publication privileges in his correspondence with Lorenzo Gualtieri in Florence and with Giovanni Battista Mancini, the Tuscan resident in Rome. On 14 January 1681 Bassetti forwarded to Mancini a memorandum, outlining Baldinucci's plans for the *Notizie*. Filippo states that "this work will be accompanied by a *Vocabolario* pertaining to the practice of these same arts."[33] The *Vocabolario* was cited as well in his petition for Tuscan copyright privileges.[34]

Since the *Notizie* were to appear in installments over an extended period, Filippo requested a twenty-year copyright for each part. Though this was granted for Tuscany, in Rome Mancini could obtain only the customary dispensation of nine years.[35] In the midst of negotiations for the privileges of Rome, Venice, and Milan, Baldinucci troubled Bassetti regarding such minor states as Lucca, "since I have some friends there," and Mantua, "since I glory in my *servitù particolarissima* with Archduchess Isabella Clara."[36] Bassetti presented these requests to the grand duke, who expressed a disinclination to pursue them.[37]

Cosimo III granted Baldinucci a second conspicuous favor by accepting the dedication of the *saggio* of the *Notizie*. This choice of honorary recipient must have embodied Filippo's deepest hopes and fears as well as a pressing lack of alternatives. Considering the nature and origin of the *Notizie*, their presentation to other than a Medici patron would have seemed exceedingly odd. However disappointing Cosimo's past support, so public an association would enhance the project's prestige. With luck, it would also strengthen the connection in Cosimo's mind.

As the spring of 1681 approached, the pace of events quickened. On

5 February the grand duke ordered Filippo to prepare a summary inventory of the self-portrait gallery. He completed it a week later, adding a lengthy and subtle analysis of the values and goals essential to this collection.[38]

On 10 March Baldinucci informed Bassetti that the *saggio* of the *Notizie*, treating the four decades of 1260 to 1300, would be printed by Easter. Also, he broke the news of his intended journey to Rome on the Sunday after that festival. "Beyond the desire to see with my own eyes those things I will eventually discuss in my writings, I am moved by my youngest son's resolution to join the Society of Jesus."[39]

In the following weeks Baldinucci answered numerous queries from the palace on artistic matters while working to speed the *saggio* through the press.[40] By 5 April some of his plans for the trip had broken down. As Baldinucci explained to Bassetti, a friend in Rome had offered him "a bit of house space in a spot with good air, so that I could stay a month there with freedom and advantage."

Filippo was dismayed to learn that his would-be host was preparing to leave Rome, allowing him no time to attempt other arrangements. "Friends tell me that in such a case the grand duke might concede me two little corners of rooms and nothing more in the palace in Piazza Madama. I hear that he often is pleased to grant this favor to those who serve him."[41]

On 8 April 1681 Bassetti forwarded Baldinucci's letter of request to Resident Mancini in Rome, with a cover note indicating Cosimo's approval.[42] That same day Filippo briefed the grand duke's secretary on the progress of his plans. "The first part of my work should be ready by the time of my departure, as scheduled for next Sunday. . . . Therefore nothing remains but to have His Highness look at the dedication. . . . I will send it to press as soon as you convey his pleasure and approval. With the help of God, we will then have the first demonstration of my poor efforts."[43]

The dedication that passed before Cosimo's eyes was a masterpiece of ceremonious directness. Baldinucci begins by investigating "the motives that lead writers to destine the dedication of their works. These can be traced either to self-interest, that is to say, the need for protection, or else respect and gratitude, since the work is worthy and due to the recipient of the dedication."[44]

Baldinucci considers Cosimo III eminently suitable on both counts. First, "there is no one from whom I can hope more vigorous and benign

protection." Second, the Medici boast a great family tradition of nurturing the arts. More particularly, "I can claim special privilege in imploring your sovereign patronage as my efforts were conceived under the gracious auspices of your uncle, the Most Serene Prince Cardinal Leopoldo of grateful memory."

By 11 April the dedication was approved, pending revision of one relatively minor phrase. Filippo and Antonio Baldinucci took formal leave of the grand duke shortly before their departure. "He commanded my son to address a special prayer on his behalf, in the act of assuming the sacred habit."[45]

On the morning of 19 April the Baldinucci arrived at the Palazzo Madama in Rome[46] bearing a letter of introduction from Canon Bassetti to Conte Mancini.[47] Their welcome was rudimentary, as Mancini predicted a week earlier.

> I received your order regarding rooms for Signor Baldinucci and have assigned him two in Piazza Madama which should please him. However, I don't know if he will be satisfied, since they are bare and empty and there is no furniture in these palaces to give him. Your order does not specify that they be furnished, and having considered his own letter, I note that he requests only the room and nothing more. I therefore ordered Diogenes to have the Jew ready at their arrival, to provide them with whatever they require.[48]

Filippo Baldinucci stayed in Rome for about six weeks. The details and formalities of settling his son in the Jesuit noviciate probably consumed much time. His own sacred interests were also a major responsibility. According to Francesco Saverio, Filippo attended two papal audiences.[49] Armed with the *saggi* of the *Notizie*, Baldinucci had many visits to pay to friends and acquaintances in the city. These ranged from simple courtesy calls to encounters rich with implications for his new career.

FILIPPO BALDINUCCI must have awaited publication of Carlo Malvasia's *Felsina pittrice* with both eagerness and apprehension. By the summer of 1675 Filippo had already launched a campaign to extract information from him regarding the Bolognese primitives.[50] This moved the conte canonico to raise his defenses and perhaps even plan a strategic attack. When the *Felsina* was at last to appear in print, the

Florentine had good reason to fear difficulties and delays in obtaining a copy of this privately issued book.

In the spring of 1677 Paolo Falconieri went to Florence to organize several artistic projects at the Medici court.[51] On 6 November Falconieri sent a message to his close friend, the grand duke's secretary Apollonio Bassetti. "His Highness the grand duke has graciously condescended to grant Baldinucci the favor he requested of me in the enclosed note, as well as the work of a certain Malvasia containing material on many Lombard painters. Baldinucci expects this to come off the presses in Bologna this week. His Highness commanded me that you write the Signor Abbot Goti and the Signor Balì Cospi."[52]

Bassetti quickly saw to arrangements on the Florentine end. Within the week Marchese Cospi's secretary Teodoro Bondoni responded with the latest drama on the Bolognese side.

Having occasion last week to stop at the house of Conte Carlo Cesare Malvasia, Canon of the Cathedral, he showed me his fine book of the "Lives of the Painters," complete except for the rest of the index which he was doing. He told me that a reply from a certain senator has led him to change his tack and no longer dedicate it to the Bolognese Senate. Instead, he resolved to present it to the King of France, and he read me the dedication. Though he must await the response from France, this will not cause too long a delay. Then he will issue the work with great satisfaction, since the French had requested the matrix, thinking to print it there at their own expense and then give him copies. He drew back from this favor, as I said, wishing to dedicate it to the Bolognese government. Now he has altered his resolution after great expenditure. I recount all of this so that anyone expecting the work soon will know the cause of delay. I will see Conte Malvasia, keeping on the lookout for when we can have it. Thus the Marchese Cospi orders me, in response to the grand duke's command.[53]

Bondoni wrote Bassetti ten days later, on 23 November 1677, advising him of the matter's satisfactory conclusion. "Conte Malvasia is finished with the book, and the Most Serene Grand Duke will have the first copy, as soon as those for Paris have been dispatched. This is according to his own intention, for he acquired service with the Most Serene Prince Cardinal Leopoldo and names him often in the book. Those for the king are now being bound, so Malvasia will have the

pleasure of serving the grand duke towards the middle of next month."[54]

Malvasia was brilliantly resourceful in making problems for himself. Passionate and outspoken by nature, he took evident pleasure in swimming against prevailing currents of attitude and expectation. The conte canonico recognized a gross undervaluing of the Bolognese artistic tradition instigated by Giorgio Vasari and compounded by a succession of Florentine and Roman writers. Malvasia conceived the *Felsina pittrice* as a long overdue counterattack. Such a strategy encouraged his inclination to rhetorical posturing and defensive overstatement.

In the *Felsina pittrice*, Malvasia's value judgments often seem as little likely to add up as Vasari's dates. Malvasia can thus show himself as either the most opinionated or the most open-minded of seicento art historiographers. While his main theme is Bolognese cultural integrity, his arguments frequently appear as loose series of strong reactions to the misstatements and misapprehensions of previous authors.

Malvasia opens the *Felsina pittrice* with a categorical denial that the art of design was reborn in Tuscany or in any single geographical locality for that matter.[55] Though he scornfully dismisses the Vasarian *rinascità* of Cimabue and Giotto, his cursory twenty-three-page outline of early Bolognese art is little more than a fleeting preface to his four-hundred-fifty-page treatment of sixteenth- and seventeenth-century production.

The core of the *Felsina pittrice* is an alternative appreciation of the school of the Carracci. Malvasia responds to Bellori's assumption that their worth was directly proportioned to their willingness to assimilate the Roman grand style epitomized by Raphael. The conte canonico's Bolognese defense included odd, inconsistent, and often gratuitous attacks on both classical and modern Roman authority. In a moment of ill-fated inspiration, Malvasia countered Bellori's apparent slight of Annibale Carracci by labelling Raphael a "mug maker from Urbino" (*boccalaio urbinate*).[56]

Such pronouncements on the exemplary authorities of modern art raised an immediate furor. Most copies of the *Felsina* were subjected to emergency emendation, and "esemplari del boccalaio" eventually became rare collector's items.[57] Malvasia's position on Cimabue, Giotto, and other remote artists of the due- and trecento seems only a peripheral issue. If it were not for Baldinucci's pressing interest, even Malvasia might well have ignored it.[58]

For a Florentine seeking to define himself as the second Vasari, the question of the *rinascità* was more fundamental. For an untried scholar fighting against unfavorable odds to establish himself in a new career, Carlo Malvasia must have appeared an easy and exposed target. Filippo Baldinucci thus developed a relatively minor controversy into a major vehicle for his first public appearance.

Baldinucci's *saggio* of the *Notizie* treats artists principally active between 1260 and 1300. After the copyright privileges, the dedication, the author's preface, and the first diagrammed branch of the art historical tree, Filippo addresses the central premise of his undertaking. This comes in the *Preface to the Work, Including the Notices on the Florentine Painter Cimabue, Who gave the First Improvement to the Art of Design, and to the Style of Painting Then Practiced by the Modern Greeks and Their Imitators.*[59]

With a few exceptions, Baldinucci's *Proemio* represents a shorthand exercise in squeezing Vasari's two prefaces and "Vita di Cimabue" into as compact a space as possible. Perhaps the most interesting of these divergences falls at the very beginning. While Vasari describes his work's reason for being in conventional terms of pleasure and utility, Baldinucci offers an elaborate excursus on mankind's perverse war against truth and the God-given faculty of perfectly understanding all knowable things. This is followed by an encapsulation of Vasari's survey of ancient art from its mythical beginnings through the dark ages and subsequent "Vita di Cimabue." Baldinucci repeats Vasari's story of the Greek painters in Santa Maria Novella and the young Cimabue's decisive improvement of their style. He adds two scholarly display pieces on the history of the Dominicans at that church and on the lineage of the de' Cimabuoi family.[60]

Baldinucci's thundering overture on nature, truth, man, and God sets the stage for the next section of the *saggio*. This is the *Apologia* or, according to its full title, *The Restoration of the Art of Design and by Whom This Was Achieved: Apology Favoring the Glory of Tuscany, as Asserted by the Aretine Giorgio Vasari in Honor of the Florentines Cimabue and Giotto.*[61]

Though the *Apologia* is an unsubtle twenty-two-page attack on Malvasia, Baldinucci refrains from citing his opponent's name in compliance with period custom. Filippo denies any initial antagonism, stating tht he had completed his own writing to that point at which the *Apologia* is inserted. In 1677 a book by a certain modern author then appeared, offering good material on compatriot artists but furiously de-

nouncing Giorgio Vasari and vilifying Cimabue and Giotto. At first Baldinucci considered any reply superfluous, trusting that the author's wild invective would deprive the work of credibility. Later he determined that the erring writer was only misguided and his own duty lay in leading him back to the true path.

"However ingenious and learned a person may be, if he undertakes to write of an art he has not himself long practiced, he may indeed demonstrate his intellectual attainment in regard to history and such ornament as need accompany it. Concerning the profession itself, however, he must rely on information from others and, what is more, frequently subscribe to their opinions." Mingled with good and erudite notices are found ideas thus contrary to the "common sentiment of excellent and experienced *professori* of these arts." In the final analysis, such errors have no substance apart from blind patriotism.[62]

As we have observed, Malvasia's views on the Vasarian *rinascità* cannot have surprised Baldinucci as much as he implies. Also, the Bolognese writer's position on the rebirth of art is far less chauvinistic than the Florentine's. In regard to their relative qualifications, Filippo's condescension seems painfully misplaced. Apart from Malvasia's noble birth and honored position in the Bolognese university, his practical grounding in the arts, personal acquaintance with its *professori*, and experience as connoisseur is at least the equal of Baldinucci's. In fact, we will see that Filippo found the meagerness of his own credentials particularly troublesome at this moment. Though Baldinucci raises the accusation of hollow pedantry, he is far more guilty of this in the *saggio* of the *Notizie* than Malvasia ever was in the *Felsina pittrice*.[63]

After describing the nature of Malvasia's error, Baldinucci sets in motion the heavy machinery of the *Apologia*. His method combines crude rhetoric with ponderous authoritarianism. As witnesses to the "new life" given the art of design by Cimabue and Giotto, Baldinucci presents some ninety texts from over seventy sources. These begin with Dante's famous evocation of the transience of fame, "Credette Cimabue nella pittura tener lo campo ed ora ha Giotto il grido."

Most of Baldinucci's authorities were commentators on Dante or otherwise linked to this literary tradition. In addition to demonstrating how very heavily he wore his own learning, Baldinucci proved only that it was not uncommon for educated Italians to have read the *Purgatorio*. This great and incestuous spiral of quotations is punctuated by the strident reiteration in boldface of offending passages from the *Felsina pit-*

trice. The self-generating paper chase becomes positively dizzying, with quotes within quotes within quotes. Eventually Baldinucci vehemently cites Malvasia's sarcastic citation of Vasari citing Dante.[64]

After the *Apologia*, Baldinucci offers another eleven sets of notices on artists. The most significant is that on Giotto. Baldinucci generally reaffirms Vasari's assertions, presenting massive extracts from published sources and manuscript material discovered during his own research. Filippo takes the reader through an exhaustive genealogy of Giotto's family, ingeniously accumulates circular evidence that Oderigi d'Agobbio was Cimabue's disciple, and investigates the origins of the cult of Saint John at the Florentine Baptistery.

Even by contemporary standards, the *Apologia* must have seemed a graceless overreaction.[65] Baldinucci, however, saw a very great deal at stake. Florentine cultural prerogatives had been threatened by recent attacks on the Vasarian paradigm. In the erudite world, there was a ready niche for an opponent to the distinguished and controversial Carlo Malvasia. The *Apologia* would also stand as a conspicuous demonstration of Baldinucci's scholarly attainments. Filippo recognized the precariousness of his own situation and the *Apologia* was only one instrument in his campaign of consolidation.

THE *saggio* of the *Notizie* (1681) is a shoddy piece of typography, roughly utilitarian in appearance, and often badly printed. This unimpressive pamphlet includes sixty-eight quarto pages of text and twenty pages of miscellaneous matter, dedication, privileges, index, and charts.

Malvasia's voluminous *Felsina pittrice* (1677–1678) is a far richer and more prepossessing work, though perhaps rather provincial in effect. It features some forty vigorous woodcut portraits as well as numerous ornaments and occasional illustrations.[66] Bellori's *Vite de' pittori* (1672) is a Roman product of the greatest luxury and sophistication. Meticulous in planning and refined in execution, it boasts a costly program of engraved decoration and illustration. Baldinucci's *Notizie* was highly conspicuous for its lack of artists' portraits. This must have been an especially humiliating economy, considering the author's long involvement with the Medici Galleria di Autorittrati.

For Filippo Baldinucci, the implications of his prospectus far outstripped its modest presentation. In the preface he offered his credentials before proposing his great project.

I am not a *professore* of this most praiseworthy and noble art of design. It is well known here and elsewhere that I have always exercised a very different profession, though an honorable one appropriate to the civility of my condition. Neither can I assume the title of *dilettante* of the art of design. As I demonstrate in another writing, I do not see in myself any of the merits ascribed to those called *dilettanti*. Through the excellent education obtained for me by my elders, I was involved with these things since my childhood, but merely as a pastime and recreation. I applied myself less to painting and drawing than to acquainting myself with the paintings and drawings of the masters, pariculary those of the past, in this country and abroad, beginning with Cimabue.[67]

Baldinucci traces the origin of the *Notizie* to his experience with Cardinal Leopoldo's drawings. He then describes the scope of his undertaking in practical terms. The *Notizie* have been divided into forty-two decades running from 1260 to 1680. This will allow him to publish his "vastissima opera" in scattered installments without sacrificing chronological coherence. Each volume will include the relevant sections of the great chronological tree. "I dare expose my meager ability to the test of publication (*al cimento delle stampe*) only from obedience to His Serene Highness Cardinal Leopoldo. . . . I have also been encouraged by many noble intellects, most particularly the unequalled Antonio Magliabechi whose fame fills the world."[68]

The "other writing" to which he refers on the issue of *professori* and *dilettanti* is the *Lettera di Filippo Baldinucci a Vincenzo Capponi*. This sixteen-page quarto pamphlet is dated 28 April 1681 and was published in Rome by the Tinassi Press during Filippo's visit.[69]

The Capponi were one of several noble families that monopolized the principal offices in the granducal administration. They also figured prominently in Florentine cultural life. At the time of Baldinucci's letter, Senatore Marchese Vincenzo was the grand duke's representative or *Luogotenente* in the Accademia del Disegno. He had long played a conspicuous role as well in the Accademia Fiorentina and the Accademia della Crusca.[70]

Filippo explains that this great personage frequently visited him at home to discuss his writings. Capponi further "wished me to put my feelings on paper regarding certain matters relevant to the art of painting. Though authors have not yet treated these issues, they still deserve to be proposed and discussed."[71]

Filippo sets four problems in this new area of art writing. The first question is whether "only expert *professori* of painting can render proper judgment of this art or perhaps the ingenious *dilettante* can as well." The second asks "if there is a sure rule for knowing whether a picture is an original or a copy." The third propounds "whether there is a rule for ascertaining if a picture is from the hand of one master rather than another." Finally, he inquires about "the practice of copying pictures and the esteem to be accorded such copies."[72]

Baldinucci begins on a facetious note, asking himself the obvious question. "You who undertake to write about such things, tell us something of the figure you mean to cut! Are you perhaps an expert professional painter (*professore*) or else an ingenious amateur of the arts (*dilettante*)?"[73]

Having raised this query, Filippo lightheartedly brushes it aside. He is not an ingenious *dilettante* because he is not at all ingenious. He is not a painter by profession and his opinions therefore merit from the *professori* "only such acclaim as Alexander was pleased to concede the color grinders of Apelles."

In fact, Baldinucci avoids hard and fast rules throughout his *Lettera a Vincenzo Capponi*. Regarding the relative pronouncements of *professori* and *dilettanti*, he offers a set of subtle qualifications: "Among the great number of dilettantes, I would venture to conclude that there are perhaps a few elevated intellects. With little manual practice but sound theoretical education and wide visual experience, they can sometimes, but not always, be just judges of good and bad pictures. The rule, however, is that only experts with long technical experience can offer valid verdicts, if they have seen an infinite number of the finest works."[74]

In the *Lettera* Filippo demonstrates considerable skill in working around the limitations of contemporary usage. Connoisseurship had been a traditional sideline of practicing artists and a "serious dilettante" could seem a contradiction in terms. Baldinucci evokes the ridiculous spectacle presented by the *dilettanti* of his day, whose judgments were founded only on ignorance and capricious personal taste. "Thus in regard to these arts we hear ideas so new and strange that he who wishes to discern the light of true precept can scarcely make out even a weakly reflected glimmer."[75]

While Baldinucci apparently answers few questions in the *Lettera a Vincenzo Capponi*, his principal point is implicit. Connoisseurship is a

rigorous discipline requiring specific skills and training. The reader also hears Filippo speak in the most attractive of his several voices, that of the witty and urbane gentleman scholar. The *Lettera* is elegant, amusing, and gracefully learned. Though far removed from the shrill pedantry of the *Apologia*, the author shows his long experience of the relevant problems. With adequate emphasis he underlines his service to Leopoldo and Cosimo III de' Medici[76] and cites his own definition of *maniera* from the forthcoming *Vocabolario del disegno*.[77]

The *Lettera a Vincenzo Capponi* was a shrewdly calculated public relations exercise. Baldinucci deftly presented his qualifications, including a prestigious connection with the Florentine Accademia del Disegno. Also, he offered a lively and literate demonstration of personality. We would like to know more about the specific background to this publication and, in particular, who might have helped Filippo with arrangements on the Roman end. The great Tinassi Press also published the *Giornale de' letterati*, a literary newssheet under the editorship of Francesco Nazarri. For fourteen years it served as an international clearing house for newly printed works of erudition. Although 1681 marked the end of the *Giornale's* run, Baldinucci had a publication listed and summarized in each of that year's three issues. The *Lettera* appeared in the first number, the *saggio* of the *Notizie* in the second, and the *Vocabolario* in the third. In terms of public exposure, the initial value of these reviews might have exceeded that of the works themselves.

FILIPPO BALDINUCCI offers an eloquent autobiographical anecdote in his "Notizie di Annibale Carracci." "When the present author was in Rome . . . he was taken to the Galleria Farnese by some knowledgeable Florentine *cavalieri*. When asked his opinion, he knew not what to say, but that he saw Raphael of Urbino reprinted there with additions."[78]

If Filippo did in fact venture this pithy observation, it confirms our expectation that he had gotten Bellori's *Vite de' pittori* (1672)[79] by heart before his visit to Rome. Gian Pietro Bellori was an ubiquitous figure in that city and, indeed, throughout the world of polite erudition.[80] In casting himself as Malvasia's antagonist on the issue of the primitives, Baldinucci would have looked to Bellori as his most apparent and powerful ally.

Bellori was papal Antiquarian and Librarian to Queen Christina of Sweden. Through an opportune association with French interests, he established himself as official spokesman on aesthetic matters in the

Accademia di San Luca and the Academy of the King of France in Rome. A polished writer and codifier of ideas, Bellori in his *Vite* gave clear form to the classical inclinations of an entire age. As doyen of contemporary art writers and theorists he could, if he would, play a crucial role in Filippo's new career.

In the last months before Leopoldo's death in 1675, Baldinucci twice requested information from Bellori concerning art in medieval Rome. These queries were transmitted through the cardinal's secretary Fabrizio Cecini in Florence and Monsignor Ottavio Falconieri in Rome.[81] In the spring of 1681 he approached Bellori in person, with an introduction from Antonio Magliabechi. Filippo's *saggio* would have seemed a most acceptable offering, with its bludgeoning attack on their presumed mutual enemy Malvasia.

If Bellori responded with more than polite praise, he was not willing to put it on paper. On 24 May 1681 the papal antiquarian exchanged compliments with Antonio Magliabechi, librarian to the grand duke of Tuscany.

> The Most Illustrious Signor Filippo Baldinucci graciously considered me worthy of a visit and allowed me to pay my respects to him at my house. He communicated to me his defense of Vasari concerning the origin of painting which rose again in Florence through Cimabue and Giotto, and also the records of those first painters. I thought the work truly commendable for its erudition and force of logic, and later I saw it in print, shared with me by the Most Illustrious Signor Commendatore dal Pozzo. Though my own merit does not allow me to equal Signor Filippo's favors, I adorn myself with borrowed merit in calling myself your servant. To this title I owe the gracious and abundant courtesies shown me in Signor Filippo's learned conversation.[82]

Of the many events of Baldinucci's Roman visit, his call on Queen Christina of Sweden probably bore the heaviest weight of implication. The queen enjoyed enormous prestige and influence, and her recognition alone could open many doors.[83] In fact we know rather little about their meeting. A year later Filippo noted in his dedication of the *Vita del Cavaliere Bernino*, "Your Majesty deigned to honor me, first by indicating your interest in this matter through the correspondence of a most worthy prelate (*degnissimo prelato*), then by seconding it with your own voice."[84]

When Gian Lorenzo Bernini died on 28 November 1680, he had long been the most conspicuous and influential figure in Roman artistic

circles. Though Christina could afford to offer him few commissions, she maintained a lively interest in his work, and they developed a close personal association. As a final gesture of respect, the queen resolved to publish an official account of his life, refuting the lingering accusation of incompetent engineering in his work on Saint Peter's. Christina's librarian Gian Pietro Bellori was the most esteemed contemporary author of artists' biographies. In these years, however, Bellori was emerging as the authoritative exponent of classical-idealist values in art, which banished a commission for a life of Bernini to the realm of whimsical speculation.

The selection of Filippo Baldinucci for this task was little less remarkable. Before visiting Rome in 1681, he can have had only the most general idea of Bernini's work.[85] Though we do not know how Baldinucci came to be considered for the assignment, we can postulate the identity of the "degnissimo prelato" who corresponded with him.

The sculptor's son, Abbot Pierfilippo Bernini, was Canon of Santa Maria Maggiore in Rome and Assessor of the Holy Office. Combining legal and literary interests with a distinguished ecclesiastical career, Pierfilippo composed the libretto for *L'Honestà negli amori*, Scarlatti's opera presented at the Teatro Bernini in February of 1680. The opera was produced under Queen Christina's patronage, and she personally annotated a copy of the libretto.[86] The abbot is frequently and effusively cited in Filippo's biography of Gian Lorenzo Bernini and described on one occasion as "degno prelato."[87] While the text of the *Vita del Cavaliere Bernino* was being published in Florence, Pierfilippo supervised the engraving and printing in Rome of the accompanying portrait.[88]

Much of Baldinucci's six weeks in Rome was given to studying Bernini's works, which he was now seeing for the first time. He also needed to investigate complicated structural problems relevant to the controversial towers of Saint Peters. Bernini's family and students assisted Filippo with his research. After returning to Florence, he "corresponded at length with many people in order to procure good and true information . . . most notably Gian Lorenzo's dear disciple, the renowned Roman architect Mattia de' Rossi."[89]

Filippo Baldinucci was in touch with at least two distinguished members of the Florentine community in Rome, Abbot Francesco Marucelli and Paolo Falconieri. Marucelli lived in Piazza di Spagna and owned a considerable collection, including six pictures by the Dutch *bambocciante* Theodor Helmbrecker. In 1686 Filippo dedicated his *Arte*

dell'intagliare in rame to the abbot, especially acknowledging his hospitality. "You treated me with such generosity as exceeds my power of expression. I particularly valued your introduction into discussions with great *virtuosi* of things related to the art of design . . . which brought no little advantage to my studies." After Baldinucci's return to Florence, Marucelli continued to forward written information. At some point he presented Filippo with a painting by Helmbrecker "of a drinker with a flask in his hand and a full glass."[90]

Paolo Falconieri[91] was long involved with Filippo Baldinucci and his work. They saw each other during Falconieri's visits to Florence and in 1677 Filippo asked his help in obtaining a copy of Malvasia's *Felsina pittrice*. On 24 September 1678, Paolo sent two drawings, considered self-portraits of Polidoro and Guido, to Florence. "In order to make doubly sure, I know that Baldinucci can add further evidence based on the antiquity of the inscriptions."[92]

In a letter to Apollonio Bassetti of 19 April 1681, Paolo Falconieri noted that he was awaiting Filippo's arrival in Rome.[93] A week later he added: "I saw Signor Baldinucci in the Chiesa Nuova on Sunday morning and began to assist him at that time. I will continue in this as much as possible, considering the many things I need finish before leaving here."[94] Falconieri departed for Florence near the end of that month and might well be the friend with whom Filippo had hoped to find lodging.[95]

In his writings Baldinucci makes few direct references to the collections and monuments he admired during his visit. In the "Notizie di Salvator Rosa," he cites works belonging to the artist's close friend Carlo de' Rossi "which I saw in 1681 in his house in Rome."[96] Carl'Antonio dal Pozzo showed Filippo the treasures that he and his late brother Cassiano assembled, including the celebrated "paper museum" of ancient artifacts and lore.[97] He also visited the studio of Bernhard Keilhau, a Danish convert to Catholicism and student of Rembrandt.[98] After returning to Florence, Baldinucci prepared a list of the artists' self-portraits he had seen in Rome, including works in the houses of the Sacchetti, Duke Salviati, the prince of Palestrina, and the Spanish ambassador.[99]

IT WOULD BE gratifying to learn that Baldinucci's trip to Rome marked a brilliant transformation of his fortune. His return to Florence, however, saw a depressing resumption of the old cycle, with Cosimo

III's polite neglect driving Filippo yet deeper into his endemic fatalism. On 8 June Filippo Baldinucci attended the granducal audience and gave Cosimo a copy of his *Lettera a Vincenzo Capponi*. Three days later he sent Apollonio Bassetti a list of self-portraits in Rome, accompanied by a set of pessimistic reflections.

> On this occasion I must share with you a great travail of mine. I have published the beginning of my *Notizie*, dedicated to the grand duke, and have seen my *Vocabolario* halfway through production. Now I find myself compelled to abandon this second publication, to my great discredit and damage, throwing away all that has been accomplished and all there is yet to do. Since embarking on the project, expenses have grown before my very eyes, for paper, printing, and other unimagined things, though people say this is more or less normal. I have withdrawn two hundred *scudi* from investment, which is equivalent to borrowing it at interest, and have rashly consumed every other available resource. Believe me, Sir, that I am in the most dire straits a man can face. Beyond the present disaster that I have brought down on my house looms shame and further loss. Reduced to this state, I dare remind you of the Most Serene Patron's intention to compensate me for my many efforts and expenses in assembling the books of drawings. Otherwise, I would experience his beneficence when he came to look on the array of works commanded me by the late cardinal. So he gave you cause to hope on several occasions two years ago.[100]

In the next six weeks, Cosimo saw no reason to give this appeal more serious consideration than he had numerous earlier ones. On 20 July Baldinucci explained to Bassetti that he managed to cover the inflated printing costs of the *Vocabolario* "in part by begging and in part by liquidating some of my possessions." Filippo then brought another development to the secretary's attention. As the *Vocabolario toscano dell'arte del disegno* neared completion, several Academicians of the Crusca suggested that this work might best be dedicated to them, as it was so closely related to their own endeavors.

> I thought this worthy of consideration, since it would allow me to strike twice with a single shot. Such a gesture would please the academicians while paying homage to the grand duke, who is their leader and patron and to whom I wish all my works to belong. Today I called on His Highness, so as not to hazard a decision on my own. It seems that I would serve him equally well by dedicating it to his academy, and having learned his benign pleasure, I need worry no more. There-

fore I have begun setting out my dedication to the Academicians of the Crusca.[101]

There was obviously a good deal more to this than meets the eye. The Accademia della Crusca's policy was to accept presentations only from its members, and Baldinucci's election must have been in the works for some time.[102]

In the *Vocabolario toscano dell'arte del disegno*, Filippo's address to the academicians parallels his dedication in the *saggio* of the *Notizie*. Baldinucci reviews the motives of authors in offering their writings to "great and worthy personages." The approval of such personages can win patronage and also defend these works "from the tongues of jealous and vituperative men, with whom the republic of letters has always abounded." The *Vocabolario*'s very nature renders its dedication to the Crusca singularly appropriate. As Baldinucci emphasizes with great ceremony, he does not seek the academy's approval, but rather their criticism and correction. "Should you choose to polish a few of the words which I bring here in rough form, reducing them to their natural splendor . . . they may then merit a place among the jewels of your most learned *Vocabolario* that will soon appear to enlighten our century. . . . Do not disdain abasing your most noble intellects by removing all that is useless and erroneous in my feeble work, thus making it worthy of you."[103]

Baldinucci was admitted to the Accademia della Crusca on 3 January 1682 under the name of "Il Lustrato," that is, "The Polished One" or "He Who Has Achieved Added Luster."[104] The dedication was meant to be read against the background of his impending election, and the final paragraphs offered a play on his destined academic persona. Francesco Saverio Baldinucci describes the concept of his father's emblem.

Being obliged to deduce his *impresa* from things pertaining to grain, Filippo chose straw because it is much used in sculpture. He placed a bust of shining white marble on one of those small wooden stands that sculptors employ, surrounded by the small bunches of bound straw with which they impart the final gleam to such figures. He took his motto from the fifth *canto* of Dante's *Purgatorio*, "Gleaming yet more than ever it did before." ("Lucente più assai di quel che l'era.") As the statue attains its highest perfection from the straw, he hoped that through the academy his writings might achieve such esteem as they would neither merit nor receive on their own.[105]

The *Vocabolario* is a one-hundred-eighty-eight-page Tuscan dictionary "explaining the words and terms relevant to painting, sculpture, and architecture, as well as other subordinate arts that have design as their basis. Included are the names and qualities of jewels, metals, hard stones, building stones, rocks, woods, colors, instruments, and every other material used for the construction and adornment of buildings and for painting and sculpture."[106]

As we have heard, Filippo Baldinucci set a very specific scene for the conception of his *Vocabolario*, a meeting in Florence with Lorenzo Pucci around 1678. We also know that Leopoldo de' Medici had been closely associated with work on the great third edition of the *Vocabolario dell'Accademia della Crusca* (1691). There is some evidence that Prince Leopoldo might have shown interest as well in a separate dictionary of artistic terminology. By 1676 the Florentine lexicographers particularly versed in the fine arts had died, and Baldinucci could have inherited both the job and an accumulation of research material.[107]

According to Filippo's statement, he brought his *Vocabolario* near to completion in only four months of part-time work.[108] The dictionary itself reveals many inconsistencies and signs of haste. Though Filippo does not cite literary sources according to the Crusca's practice in their own lexicographic entries, neither are his terms and definitions as close to studio usage as he implies in his introduction. There is no indication that the academy took advantage of Baldinucci's offer to participate in work on their third *Vocabolario*.[109]

The most interesting aspect of Filippo Baldinucci's involvement with the *Vocabolario toscano dell'arte del disegno* is his willingness to assume publication expenses, with a few emergency contributions obtained "by begging." This initiative was closely linked to his achieving membership in the Accademia della Crusca, an impressive demonstration of his otherwise questionable "proficiency in letters." For the rest of his life, Filippo took this dignity very seriously. Subsequent volumes of the *Notizie* bore the academy's emblem on their title page, and he relied heavily on such institutional authority in his struggles with "vituperative and jealous men" and "people of ill will."

At the meetings of the Accademia della Crusca on 29 December 1691 and 5 January 1692, Baldinucci recited a lengthy two-part *"lezione"* on the relative merits of ancient and modern painting. He soon published this lesson with a dedication to the academy's official "Protettore," Gian Gastone de' Medici.[110] Filippo's friend Piero Dandini

portrayed him in an elaborate allegorical painting, "seated in the act of writing his *Notizie*, accompanied by two women representing the Accademia della Crusca and the Accademia del Disegno."[111]

However beneficial the blessing of academic authority on his literary pretensions, it did little to ease Filippo's immediate economic worries. On 9 December 1681, he forwarded a copy of his *Vocabolario* to Apollonio Bassetti.

> I am sending my son to you with a copy of the *Vocabolario toscano dell'arte del disegno*. Availing myself of this opportunity, I should mention that I called yesterday on our Most Serene Prince and briefly described my present urgent need and implored his relief. As usual I found His Highness favorably disposed. Apparently nothing else remains to be done, unless you might be good enough to remind him, for I hear that he is leaving sometime this week. I beg this of you with the greatest fervor. Since His Highness deigns to do well by me at least in regard to my labors, it would be particularly opportune should he do so now. At present, I am publishing the *Vita del Bernino* and could then go to Rome in person or else send my son. Otherwise I forfeit the opportunity for great advantage.[112]

Baldinucci closes his address to Bassetti with a few compliments, only to reopen it with a postscript nearly three times longer than the body of the letter. "After writing and then commending myself to God, it occurred to me that perhaps His Highness does not know the full facts regarding my poor efforts in the service of the Most Serene Princes. Though this refers back to the time of Cardinal Leopoldo of grateful memory, the grand duke should not assume that while honoring me with his kind affection, this prince also remunerated me as he should have wished had he lived."

To help Bassetti present his case to Cosimo III, Baldinucci offers a clear and concise summary of his eleven years with Prince Leopoldo and later work in the granducal drawing cabinet.[113] Even his publications, he emphasizes, were undertaken out of obedience to the late cardinal. Filippo concludes with a demonstration of the pietistic fatalism that waged constant war with his personal ambitions. However ill he might fare at the grand duke's hands, he never lost sight of his prince's place in the chain of divine authority.

> Perhaps in his highest prudence, as absolute master of all that I am and all that I have, His Most Serene Highness might not see fit to

offer me relief. In such case I will declare myself more than satisfied, recognizing the honor of His Most Serene Commands as no small relief in their own right. The disasters that befall me I will then prize as the glory of my house, accepting them out of obedience to God and nature, thereby holding myself, my family, and all that I shall ever possess in perpetual debt.

When Filippo Baldinucci attended the granducal audience on 8 December 1681, he probably referred as well to his dispute over property rights with the priest at Botinaccio. A crisis had been building in recent weeks, and the priest lodged complaints against Baldinucci with both the grand duke and the cardinal archbishop of Florence. Filippo in turn begged Apollonio Bassetti's intecession.[114]

In regard to direct financial assistance from the grand duke, Filippo did well to steel himself with pious resignation. On 19 December 1681 he communicated to Bassetti the latest dispiriting developments. "The *Vita del Bernino* is now being finished, but from this I derive little satisfaction. A weighty consideration, as you know, allows me neither to go to Rome in person nor send someone there to present it. I will thus have to dispatch the book through the post."[115]

On 30 December 1681 Baldinucci offered Bassetti his wishes for the New Year and shared the latest report from Rome of his son Antonio's conspicuous success in the Jesuit noviciate. "I should think that His Serene Highness would not be displeased were he made party to this excellent news."[116]

Though Cosimo III's interest in Baldinucci's writings stopped short of a cash subsidy, his patronage could take other forms. On 6 February 1682 Filippo assured Bassetti of his undiminished faith in granducal providence. "Never will a shadow of doubt fall on my belief that the Serene Patron in his great goodness stands ready to succor my house at such time as he deems expedient. Indeed, these delays can serve only to increase my hopes. Meanwhile, as you know, my expenses hold me in a tight grip. Therefore I dare beg His Serene Highness for one of the offices noted in the enclosed memorandum."[117]

On 27 February 1682 Filippo, by way of Bassetti, sent the grand duke profuse thanks for awarding him the anachronistic sinecure of *Capitano di Parte*.[118] At this time the *Vita del Bernino* was approaching publication. The text had been printed in Florence, but the books could not be assembled until Bernini's engraved portrait arrived from Rome. Baldinucci commented on 6 February, "I can't imagine when the work

will appear, due to all the new cardinals who are having their portraits cut."[119]

On 21 February 1682 Gian Pietro Bellori wrote Antonio Magliabechi. "You ask about the life of the Cavaliere Bernino which is being printed there in Florence. The portrait is being engraved here in Rome and will be seen through production by Monsignor Bernino."[120]

Baldinucci composed an intriguing minor work while awaiting the production of his *Vita del Bernino*. His *Lettera a Lorenzo Gualtieri*, dated 19 January 1682, addresses the issue of whether Raphael or Andrea del Sarto was the greatest painter of the sixteenth century.[121] In Florence, nationalist sentiment tended to enhance Andrea's critical reputation. Baldinucci compares their relative mastery of "the four perfections of painting" and concedes that Andrea is the first painter of Tuscany. Raphael, however, merits the larger honor.

> The title of Prince of Painters is therefore due to Raphael, that very title with which the city of Rome wished to honor his sepulcher. Had I not reached this conclusion through my knowledge of his works in Rome, Florence, Lombardy, and other provinces and cities of Italy, I would have been drawn to it by the authority of Cavaliere Giovan Lorenzo Bernino. . . . Raphael of Urbino, he used to state, was an immeasurable receptacle collecting the waters of all the other sources. This was a way of saying that he possessed together the highest perfection of all other masters.

The *Lettera a Lorenzo Gualtieri* is a formal literary presentation piece, that must have circulated in manuscript, though it was not printed for nearly a century. We would like to know who saw the *Lettera* and, in particular, if it reached Gian Pietro Bellori. Though Baldinucci noted Bernini's appreciation of Raphael in his *Vita*,[122] it is interesting that he should repeat it as the focal point of another work. The *Lettera* offered a courteous acknowledgment of Baldinucci's long collaboration with Lorenzo Gualtieri. It could also be seen as a gesture towards classical-idealist opinion, which was becoming increasingly influential in Rome.

We know very little about Queen Christina's response to Baldinucci's *Vita del Cavaliere Bernino*. In her letter of thanks the queen expresses conventionalized delight and dismisses the lavish praise Filippo directed at her in the dedication. "All the rest seems to me worthy of applause and esteem, and I thank you on behalf of the public for your labor. I assure you that I will keep in mind the service you rendered, and may God preserve you and cause you to prosper."[123]

In retrospect the queen seems to have been content to leave Filippo's prosperity in the hands of God. There is no indication of royal rewards or even further interest in his career. If Christina offered Baldinucci any tangible signs of her regard, he is unlikely to have let this pass without public mention. Though he did not return to Rome to present the *Vita* in person, he must have made some attempt to cultivate his one conspicuous hope in the world beyond Florence. Filippo added another title to his list of publications, and evidently the only one he did not need to finance out of his own pocket. Also, he adorned himself with the outer trappings of the favor of another great patron.

At the end of his year of marvels Filippo Baldinucci found that everything and nothing had changed. In a heroic attempt to launch his career as writer and artistic authority, he published four works, travelled to Rome, and became an Academician of the Crusca. However, his economic preoccupations continued unabated, feeding in turn his emotional and religious obsessions. Filippo's health declined, raising fears of a wretched old age and the impossible vastness of his project for the *Notizie*. On 4 April 1684 he assessed these circumstances in his spiritual diary.

> My condition has substantially worsened. My sight, hearing, and mental acuteness have diminished, that is to say, the natural faculties that allow me to attend to my studies. These form my only pleasure, and there is no other and there is no other and there is no other [*sic*], say what you will. Age has advanced upon me. My expenses have increased. What is worse, I find that more effort and more exertion of heart and mind are required than ever before.[124]

In these years Baldinucci was forced to reconsider many of the basic assumptions of the *Notizie de professori del disegno*. Physical and financial limitations played their part. No less troublesome was the activity of "people of ill will" and "vituperative and jealous men."

FOUR

Filippo Baldinucci,
Ferdinando del Migliore, and
Giovanni Cinelli

FILIPPO BALDINUCCI had achieved minor celebrity by the first months of 1682. Through a shrewd campaign of self-promotion, he made a place for himself in erudite Florentine circles and was establishing a wider reputation as well. With much force and little subtlety, he exploited a timely controversy with Carlo Cesare Malvasia, a man markedly superior to him in both social and scholarly attainment.

Filippo soon found that controversy was easier to start than finish and that his new ambience counted more than its share of eccentric and combative personalities. The most vociferous antagonism came not from patriotic foreigners like Malvasia, but from Florentine colleagues. Their motives could prove as oddly mixed as Baldinucci's own.

Early in 1684 Filippo Baldinucci published a twenty-three-page pamphlet in quarto, *La Veglia: Dialogo di Sincero Veri*. The work was issued anonymously, without title page or dedication, and the proofreading was either hasty or neglectful. Though the publication is inscribed "Con licenza dei superiori," there is none of the usual legal apparatus of copyright and censorship. Indeed, the *Veglia* was printed in Lucca, just beyond the political borders of Tuscany.[1]

In spite of its rudimentary format, the *Veglia* is one of Baldinucci's most complex and carefully considered works. Though his intention was fiercely polemical, he produced an elegant and cultivated piece of writing. Using the literary form of a dialogue, the author combined elements of a one-act comedy and a practical instruction manual for archivists.

After the invocation of "Iesus Maria," the pseudonymous Sincero

Veri describes the background to his piece. "That man is a social animal is a universally known and approved axiom." With refined wit, Sincero reviews the most characteristic expressions of the fundamental human need to share conversation.[2]

The noble and learned frequent universities and academies, where members speak thoughtfully, listen intently, and reply decorously according to fixed rule. Gentlemen of civility also meet in public bookshops and other commercial establishments ("nelle pubbliche librerie e altre officine"). Here their discourse is no less reasoned, though enlivened with amiable jokes and harmless levity. Pleasing informality thus enhances both profit and decorum.

Less pleasurable, less profitable, and certainly less decorous are the "congressi dei crocchioni." Sincero borrows this last word from Lorenzo Lippi's *Malmantile Racquistato*, a mock heroic epic in studied Tuscan dialect. Esteemed as a painter, scholar, and wit, Lippi had been a conspicuous figure in cultivated Florentine circles. Baldinucci knew him from his own days with Alessandro Valori, when he drew Lippi's portrait in red and black chalk.[3] This affectionate reference to the *Malmantile* set the desired tone for Filippo's dialogue.

Baldinucci-Sincero offers an elaborately facetious definition of the noun "crocchione" from the verb *crocchiare*, meaning to raise a raucous cacophony by banging together hollow objects. In their assemblies, the *crocchioni* tumble head over heels in chaotic discussions, compounding stubborn error with capricious invention. Conflict, dissension, and scandal are excited, and everyone and everything disrespectfully knocked about. Such gatherings might be called "academies willfully formed to confound the truth."[4]

The whimsical dissertation on academies and anti-academies and the definition of *crocchione* in the style of the Accademia della Crusca emphasize this aspect of Baldinucci's authority. Having evoked the prevailing climate of hectic controversy, he sets the stage for his "vigil."

Some two years earlier, a recently deceased friend of Sincero's took refuge from a rainstorm in a place of public commerce (*una pubblica bottega*). Though little inclined to such company, he was forced to await a break in the inclement weather in a hotbed of *crocchioni*. With great relish they were pulling to pieces the newly printed *saggio* of the *Notizie de' professori del disegno*.

As it happened, Sincero's late friend was equally intimate with the author of the *Notizie*. Seizing this opportunity, he sorted out their weak

and foolish objections, and the *crocchioni* declared themselves van-
quished. For the sake of clarity, Sincero transformed their vigil around
a charcoal brazier into a dialogue between two characters, *Amico* (friend
of the author) and *Publio* (the public).[5]

The *Veglia* includes many passages of deft comedy, playing with par-
ticular skill on Baldinucci's transparent disguise as Sincero. Amico is
cast as something of a zealot, though tolerantly amused by his compan-
ion's jovial wrongheadedness. The characterization of Publio often
verges on high burlesque. Publio avoids reading the works he criticizes
because studying and thinking raise the melancholy humors of hypo-
chondria.[6] It is necessary, he insists, to attack the words and deeds of
others so that conversation will not prove insipid, like a meal consisting
only of sweets.[7]

As an exercise in the Tuscan comic vein, the *Veglia* is related to Bal-
dinucci's own *Lazzi contadineschi*. These dramatic sketches were con-
ceived as "dialogues with four or five interlocutors . . . representing
daily events among rural workers and their masters and simple country
folk with notaries and judges. The *Lazzi* were composed for the Phil-
ippine Fathers of San Firenze, who long used them as innocent recrea-
tion for the pious and learned lay people who frequented the holy offices
of their oratory."[8]

The *Veglia* offers a witty, literate, and closely calculated response to
a range of general and specific attacks on the *saggio* of the *Notizie*. The
ostensible give-and-take of the dialogue form left Baldinucci free to
maneuver around points of contention. It was not easy for him to strike
a defense, for his position was often indefensible.

Giorgio Vasari founded his claim to Tuscan preeminence in the arts
on a stylized literary scheme for the *rinascità*. This involved the young
Cimabue, a team of "Greek" painters at work in a particular chapel in
Santa Maria Novella, and a mystical rarification of the atmosphere.
Casting himself as the second Vasari, Baldinucci assumed his predeces-
sor's paradigm as crucial to the Florentine interest. In the *saggio* of the
Notizie, he thus shouldered an awkward burden of dubious premises and
factual contradictions. Ridolfi and Malvasia had already documented
artistic activity in Venice and Bologna before the Cimabuan rebirth.
Some Florentines also were beginning to wonder if they were not better
off without Vasari's construction of history.

In the dialogue Publio's first thrust comes gently enough. He praises
Baldinucci's literary style and commends his desire to defend their

homeland. However, Cimabue and Giotto's revitalization of painting is universally acknowledged and some people consider Baldinucci's queries inappropriate. Such people, Amico replies, have not read those recent authors "who seek to draw the trade to their own market." The *Apologia* was written to close this question for all time, "to drive in the nail then bend its head over."

Publio next wonders if Baldinucci is in fact honoring Florence by claiming that painting began to flourish there only in 1260. Painters were certainly active throughout the rest of Europe by that date. Amico explains that good usage began with Cimabue. All other work was in the clumsy Greek style and of negligible value.

Publio asks why Baldinucci did not discuss these pre-Cimabuan artists. Amico notes that the author of the *Notizie* indeed offered examples, and he personally volunteers yet a few more. Considering the derelict state of art, such names merit as little interest as a "laundry list" and can serve only to prove two points. In those days, the art of painting was exercised by men of noble rank.[9] Also, old documents reveal the existence of an ancient painters' quarter in the vicinity of San Bartolomeo del Corso.[10] We can observe that in the *saggio* of his *Notizie* Baldinucci barely implies the first point through allusion to Cimabue's gentle birth. He makes no reference to the *contrada* of San Bartolomeo.

As the vigil progresses, Publio's questioning becomes more intense. He asks how we know that Cimabue rather than another painter redirected the course of art. Amico advises him to keep his doubts to himself. In the *Apologia*, Baldinucci enlisted four hundred years of artists and learned writers who will come swooping down on Publio with hisses and catcalls. Furthermore, if he shared Baldinucci's visual experience, he would recognize this fundamental truth in the works themselves.

In regard to the Greeks, Publio is relentless. If native Florentine painters were so numerous, why did Cimabue need to study with Greeks? For that matter, why were Greek painters summoned to Florence at all? Would it not redound to Florence's greater honor if Cimabue had been taught by his own compatriots?

Amico talks around these issues at great length before dismissing them as irrelevant. Florentine ascendency in the arts began with Cimabue, not Cimabue's teachers. These had nothing of worth to impart, whoever they might have been. Should anyone discover a Florentine painter with whom Cimabue studied, the author of the *Notizie* will tear

the offending leaf from his book. This, however, would add not the slightest glimmer to the sum total of Florentine glory.

With great glee Publio announces that the time has come "to fire the heavy ordnance." Construction did not begin on the present Church of Santa Maria Novella until 1279, some decades after Cimabue was meant to have learned his craft from Greeks at work on the extant frescoes in the Chapel of Saint Luke. Publio summarizes outraged opinion on such jumbling of the facts. "These are inexcusable errors, they say, these are errors in chronology. Before publishing Vasari's assertions, the author of the *Notizie* would have done well to consult an expert in matters of antiquity."[11]

Amico is amused rather than daunted. If his opponent has indeed shot off his biggest gun, he need worry little about future blasts. Amico responds to Publio's personal allegations before determining whether the chapel had been built in time for art to be reborn there. "Let me take up the words of that ingenious critic of yours. These, he says, are inexcusable errors. These, he says, are errors in chronology and so forth. All this, I say, is boldness, even rash temerity, the will to exaggerate, to annihilate, to injure, then to triumph over the injured party. We recognize this and no less from such a manner of speaking."[12]

It is self-evident, Amico asserts, that the author of the learned *Notizie* requires no outside assistance. To illustrate further Baldinucci's antiquarian accomplishments, Amico summarizes his researches on the early history of the Jesuit Church of San Giovannino. This information is extracted from Baldinucci's forthcoming biography of Bartolomeo Ammannati.[13]

More immediately to the point, Amico proposes that the Chapel of Saint Luke is a remnant of the previous Church of Santa Maria Novella. He advances three principal arguments.[14] First, the incorporation of such pre-existing fabric is both feasible and precedented. Second, according to documents cited by Vasari, the cornerstone of the new church was laid during ceremonies held in the Chapel of Saint Luke itself. Vasari's generic reference to "ricordi," he deduces, must imply trustworthy records from Cimabue's own time. Third, the crudeness of the extant frescoes in the chapel prove that they are Greek works predating the Cimabuan *rinascità*. "Thus you recognize that the author of the *Notizie* always tested Vasari's foundations and never erected his own structure unless he knew it to be firmly grounded."[15]

A chastened Publio admits that ill-informed condemnation is as

much to be avoided as facile acquiescence. Nonetheless, he considers "manoscritti privati" to be of uncertain value and still distrusts Vasari's documentary sources.

Such uneasiness is well founded, Amico agrees. He therefore analyzes the relative problems posed by private and public manuscripts. Though he does not define clearly his two categories, "public manuscripts" seem to include institutional account books, official chronicles, and records of corporate deliberations. "Private manuscripts" are then informal letters, personal journals, and historical commentaries by untrained observers. Works in this second category are worthy of credence only when they demonstrate seven essential qualities.

The first test is simple probability, especially the avoidance of the fabulous and exaggerated. Second, private manuscripts must reveal careful organization and a clear sense of historiographic method. Third, they must be truthful in even minor details, since only the most rigorous authors can elicit confidence. Fourth, the researcher should identify the name, profession, and attributes of the writer. Such factors are as crucial as the work's own apparent merits. When such information is not available, one determines if other good authors have accepted this material. On the fifth, sixth, and seventh points, one considers whether the writer is treating subjects within his area of expertise, events from his own time, and matters involving his homeland or places of which he is well informed.[16]

Publio heartily approves Amico's criteria. He obediently recites them one by one, vaguely affirming the suitability of Vasari's sources. In conclusion, he recants his false opinions and voices a string of moral pronouncements on the dangers of hasty denigration.

As a statement of historical method, Baldinucci's program would meet the approval of the most objective modern scholar, apart from his utterly characteristic appeal to authority in point four. With fumbling sleight of hand, he sought to apply such criteria to Vasarian practice. In the intervening century concepts of historiographic responsibility had changed. Baldinucci's own credentials were in dispute, and he needed to refashion Vasari into an object worthy of defense.

The *Veglia* was published with many apparent signs of clandestinity. This, however, was very far from Baldinucci's intention. He had been in close touch with several key members of the granducal regime, and his pamphlet must have had at least tacit approval.

Before New Year's of 1684, Filippo sent Cosimo III's secretary Apol-

lonio Bassetti a preliminary draft of another work and elicited com-
ments from Francesco Redi, *Arciconsolo* of the Accademia della Crusca.[17]
In January he was entrusted with a financial transaction by *Auditore*
Ruberto Pandolfini, the ultimate civil censor in Tuscany.[18] When the
Veglia appeared in March of 1684, Baldinucci used it to mobilize the
highest official opinion. He quickly directed copies to Cosimo III and
Apollonio Bassetti, to Francesco Redi, and to Ruberto Pandolfini.

In his cover letter to Pandolfini[19] Baldinucci describes the context of
the *Veglia*. When the *saggio* of the *Notizie* was in press some two years
earlier, the Captain Cosimo della Rena approached Filippo Baldinucci
on behalf of his friend Ferdinando Leopoldo del Migliore. The captain
asked that he include a reference to del Migliore's forthcoming book,
the *Firenze città nobilissima illustrata*. The printers had yet to run the
notices on Giotto. Filippo therefore inserted del Migliore's opinion on
this painter's honored burial in the old Cathedral of Santa Reparata, as
discussed "in his much desired work, the *Firenze illustrata*, now in the
process of publication."

The perfidious del Migliore repaid this courtesy by denouncing Bal-
dinucci throughout the city. He denied Filippo's right to touch anti-
quarian matters, since this was his province alone, or even to mention
the art of design. "In places of public commerce (*nelle pubbliche botteghe*),
on various occasions he expounded such sentiments with enough petu-
lance to nauseate the most cheerful stomachs and to leave people laugh-
ing behind his back."

In discussions with various *persone letterate*, del Migliore expressed
particular grievance that Baldinucci's book appeared before his own.
The publication of the *Vocabolario toscano dell'arte del disegno* exacerbated
this situation by introducing much antiquarian material unknown to
the author of the *Firenze illustrata*. In any case, del Migliore seized a
trifling pretext for altercation. In his entry for the word "*torre*," Baldi-
nucci lauded the Tuscan antiquarian Giovanni Renzi as worthy of a place
"with the best," that is, "coi Migliori." The printer chose to capitalize
the first letter of the second word, and del Migliore flew into a rage,
taking unfounded umbrage at an undeserved compliment.

Baldinucci's personal inclination, he assures Pandolfini, is to ignore
so petty and insignificant a person. Some months ago, however, he re-
ceived "unimpeachable information" that del Migliore was turning his
Firenze illustrata into a pit of slander. "He names me not to cite my
work nor to praise it as I did his. Rather, he spites me in every place

and in every way that he knows. His invective and disparagement are moved by extraordinary jealousy, and he disclaims that anyone else might have seen anything at all. What is worse, he presents feeble and inconclusive reasons fit only to obscure the truth."

Filippo considers such wholesale defamation of the *saggio* of the *Notizie* doubly regrettable. First, it offends the city of Florence in whose honor it was written and the grand duke who favored it with his patronage. Second, the *saggio* is only the advance sample of a vast work that might be "strangled and torn to shreds in its very cradle." Therefore he sought the counsel of theologians, *letterati*, and men of understanding, who advised him to strike his defense even before the attack.

Baldinucci explains that he published his *Veglia* in Lucca to save expense. In this work he expresses himself with civility and Christian moderation, avoiding mention of del Migliore's name and suppressing all indications of his identity. Filippo hoped that he would come to his senses before publishing the *Firenze illustrata* and render the *Veglia* superfluous by remaining outside its circle of defense. Unfortunately Baldinucci learned from "one who knows" that his charitable intentions served only to speed del Migliore in his reckless course. "And God alone knows how he means to treat me in the few pages yet to be printed."

Filippo asks Pandolfini to read the *Veglia*, where he will see arguments esteemed invincible by the Academicians of the Crusca. If he deems fit, the auditore should cause del Migliore to remove Baldinucci's name from his book and erase the slander directed at him. Pandolfini will thus defend their city and save the *Notizie*, "a labor, so to speak, that has cost my life."

On 23 March 1684 Filippo Baldinucci sent Apollonio Bassetti two copies of the *Veglia*. Since his cover note runs only to a few lines, Cosimo III's secretary must have been conversant with the relevant issues. Filippo asks Bassetti to read the work with a compassionate eye, "remembering that this author cannot hope to make a showing co' MIGLIORI." He asks that one copy be shown to the grand duke and the other forwarded to Francesco Redi.[20]

In the late 1670s Baldinucci made an unsuccessful attempt at acquiring his own printing apparatus. As he explained to Apollonio Bassetti, "before an author can issue his work, he often sees it badly printed by someone else."[21] Filippo's fear of prepublication leaks was perhaps justified, considering how much he managed to learn about del Migliore's book before its official appearance.

In his letter to Ruberto Pandolfini, Filippo Baldinucci traced an in-
tricate human network stretching between the authors of the *Firenze
illustrata* and the *Notizie de' professori del disegno*. Cosimo della Rena
served as formal intermediary. Del Migliore held discourse with *persone
letterate*. In the *pubbliche botteghe*, he allegedly disturbed the sensibilities
of various listeners and was derided for his pains. Baldinucci conferred
with "theologians, *letterati*, and men of understanding." He was kept
informed of del Migliore's actions and intentions by the crucial "he who
knows" and a purveyor of "unimpeachable information." Great public
figures were also involved, including Ruberto Pandolfini, Francesco
Redi, Apollonio Bassetti, and even Cosimo III.

Captain Cosimo della Rena enjoyed a distinguished and varied ca-
reer. "He applied himself to military matters and obtained the com-
mand of two hundred foot soldiers in the grand duke's service. Away
from these martial activities, his every inclination was to letters and,
most particularly, genealogical studies."[22]

The grand duke named Cosimo della Rena *"Soprintendente Generale* of
all the archives both public and private in the city of Florence." In 1673
the captain served as consul of the Accademia Fiorentina. Scholars and
writers frequently lauded his accomplishments. In the *saggio* of the *No-
tizie* Baldinucci cites archival material relevant to Giotto's family "re-
cently discovered and shared with me by Cosimo della Rena, that most
excellent antiquarian."[23] In the *Firenze illustrata* Ferdinando Leopoldo
del Migliore gratefully acknowledges the assistance of "Captain Cosimo
della Rena, gentleman and Florentine antiquarian."[24] Della Rena re-
turned their gracious references in his own principal published work,
*Della serie degli antichi duchi e marchesi di Toscana con altre notizie
dell'impero romano e del regno de' Goti e de' Longobardi* (1690).[25]

The del Migliore were an ancient and distinguished family. From the
fourteenth century they played an important role in Florentine civic and
commercial life, eventually rising to patrician status. Angelica del
Migliore, the last heiress of the house, married Agnolo Ginori in 1618.
In the years that followed a Neapolitan branch sought to assume their
Florentine prerogatives.[26] The outspoken though biased Giovanni Ci-
nelli sarcastically referred to Ferdinando Leopoldo as *"Migliori*, not del
Migliore as he claims, in order to usurp the name of an extinct fam-
ily."[27]

We know remarkably little about this odd yet impressive figure. Fer-
dinando Leopoldo pursued an ecclesiastical career, but evidently

stopped short of taking major orders.[28] In 1664 he was granted a chapel in the Cathedral of Colle Val d'Elsa[29] and later maintained a connection with the Florentine Church of San Jacopo sopr'Arno.[30] By 1685 del Migliore had become a member of the rather diminished Accademia degli Apatisti.[31]

Ferdinando Leopoldo del Migliore published only two works. In 1665 he issued a chronological handlist of the Florentine senatorial families[32] and twenty years later, the more ambitious *Firenze illustrata*. However, he left behind an awe-inspiring accumulation of one hundred and forty volumes of archival material completed during his long researches.[33] At least in his later years, his nephew Giovanni Battista del Migliore participated as well.[34] Such investigations were carried out with methodical rigor. In 1697 he offered his fellow antiquarians a concise manuscript guide to the *Gabella de' contratti*.

> I, Ferdinando Leopoldo del Migliore, have seen almost all the public archives in Florence and the private ones of nuns and monks. Long have I studied that most important archive of the *Riformagioni*, where all the decrees of the *Signoria* are noted and all that pertains to the new municipal law. Nothing, however, has repaid my interest more than the *Gabella*. There I lived, so to speak, for more than ten years, being present both morning and evening.[35]

In his introduction to the *Firenze illustrata*,[36] del Migliore casts the antiquarian as an austere votary of truth, teacher of virtue, and servant of civic glory. Ferdinando writes in order to repay the debt he owes his city. He stresses the long and severe "discipline required if one is to understand the laws, statutes, customs, usages, and modes of the past and discuss them well and with doctrine."[37]

The *Firenze illustrata* is presented as the first volume of an exhaustive survey of Florentine institutions, structured according to the city's traditional *contrade* or neighborhoods. Initially the work was probably conceived as a meticulous guidebook. Through his relentless erudition the author then expanded it with massive inclusions of archival data and historical analysis.[38] Del Migliore cites numerous works of art. However, he considers these and other *anticaglie* primarily as documents of past usage and as signs of former nobility.

Ferdinando Leopoldo viewed society in terms of mystical neo-medievalism.[39] For him the true Florence was characterized by the tower houses of the "nobility of the blood," rich with armorial devices, phys-

ically and spiritually dominating the quarters that bear their names. The time is of the old "aristocratic republic," "before common people of vile or rustic condition stained the candor of the true nobility of the blood, mixing themselves in both the bloodlines and the government."[40]

The title of the *Firenze illustrata* refers not to its scattering of less than mediocre etchings. In his first chapter, "The Origin of Florence and Her Qualities," del Migliore distinguishes the diverse characters of cities. "This difference is induced by their different fundamental principles. On the one hand is a people made illustrious (*illustrato*) by long purification of the blood, who require little industry or artifice to lift them to a greater sphere. On the other hand are men uncouth by nature, whom nothing benefits except banding together in a well-walled city."[41]

Florence is the only city he acknowledges in the first category. Her illustration is thus a "generous breadth of spirit achieved through purification of the blood." He vigorously rejects the ignorant assumption that Florence attained greatness "through the industry of low, mechanic men or through overwhelming riches earned by practice of the arts."[42]

Florence or "Florentineness" is raised to a self-contained mystical entity with its own transcendent processes. Foreign germs present a special problem when they fall into this immaculate and illustrious culture. Del Migliore firmly denies the alleged foundation of Florence by the Romans. Florence was "illustrated by the Romans but not founded by them." The Romans reverently accommodated the indigenous rites and customs, blending themselves with the common people and with the old nobility.[43] The Goths, in contrast, brought a dispersal of energy, subverting native laws, habits, and conditions.

Early in the *Firenze illustrata*, del Migliore notes the portrait bust of Giotto in the Cathedral. "This famous painter and architect merits the laudatory title of *restorer*, having notably improved the art of painting that had dwindled and lay almost extinguished under the ruins of those afflicted times." He offers a selection of relevant literary citations, beginning with Dante's crucial verse. Then he refers to Giotto's honored burial, in the words paraphrased by Baldinucci at least three years before their appearance in print. Finally del Migliore discusses the elegant epitaph composed by Poliziano. This, he observes uneasily, is "worthy of a person of blood, a prince of race and lineage, not Giotto who Vasari tells us was the son of a peasant."[44]

Four hundred pages later del Migliore chronicles the venerable Church of San Bartolomeo. He reveals a document that evidently set the fuse to his collected misgivings on the Cimabue-Giotto problem. A thirteenth-century reference to "San Bartolo chiamato inter dipintores" allowed him to imagine "one of the most populous streets in Florence called *of the painters.*" If his city hosted a flourishing painters' quarter at so early a date, he must reject Vasari's assertion that Florence "was reduced to begging art from Greece. . . . So we discover the misapprehension of Vasari and of he who followed him without better information."[45]

Their error rests on two interlocking assumptions. Early artists in Florence are falsely considered to have worked in the Greek manner. This prompts the specious deduction that Florence was bereft of native talent and compelled to import it from Greece. Del Migliore states that he has devised a series of local painters running from Cimabue back to the time of Frederick II. Since Florence boasts her own continuous tradition, her painters must have exercised a manner different from the "foreign and barbarous style" of the Greeks.

> Indeed, certain qualities esteemed as minutiae are sure indications of works by masters of the Greek nation. Such, for example, are letters of their alphabet across the round diadems on the foreheads of saints, figures represented almost always at half-length, and a certain modesty about these figures. Their clothing is almost always arranged in a way unlike ours and almost always decorated according to the usage of their country.[46]

With somewhat greater clarity and concreteness, del Migliore attacks the Cimabuan myth on yet another front. The Chapel of Saint Luke in Santa Maria Novella was yet to be built at the time of the boy's alleged encounter with the presumed Greek painters. Del Migliore sums up the evidence and its implications.

> For us, these are inexcusable errors that reveal jumbled chronology. Vasari apparently took down his information however it was given to him, without checking the facts or having them examined by someone knowledgeable in matters of antiquity. There is another person who should have done likewise, rather than relying so confidently on Vasari's assurance. On this very point rests Florence's rightful independence in the art of painting. Such negligence has permitted certain uninformed critics the easy denial of Cimabue and Giotto's supremacy.[47]

Del Migliore targets "Carlo Ridolfi, who gives precedence to Venice over Florence in antiquity of painting, and the Conte Carlo Cesare Malvasia, who speaks out against the initial impetus of Cimabue and Giotto, those two most brilliant lights of this art."[48]

Del Migliore promises to resume this discussion when he treats the Accademia del Disegno in a later installment of the *Firenze illustrata*. At that time, he will demonstrate the excellence of Florentine painting achieved by "men of birth, since an intellect purified through noble ancestry is required for mastery of the sciences."

The *Firenze illustrata* is concerned only indirectly with art historical issues. The "attack" that Baldinucci so feared fills barely three of its nearly six hundred pages. Though del Migliore's allusions are unmistakable, Baldinucci is never indicated by name. The author's unflagging seriousness and chilling severity of tone leave little room for "invective and disparagement moved by extraordinary jealousy." Considering Baldinucci's strategic regrouping in the *Veglia*, we can deduce that del Migliore's reasoning was not as "feeble and inconclusive" as he would like to claim.

In view of del Migliore's exalted conception of his scholarly mission, we can well believe that he denied Filippo's competence in antiquarian matters. Their mutual enemy Giovanni Cinelli echoed this sentiment. "Migliori says that writing about antiquity falls only to his lot. He is a master, and others are not to mix themselves up in such things."[49]

Baldinucci equates an attack on his *Notizie* with flawed patriotism. Noting del Migliore's mystical veneration of their homeland, this might seem a bizarre accusation. Filippo's charge, however, struck at the heart of a very complex set of issues.

By the late seventeenth century the concept of "nobility" had become particularly crucial to the Medici regime. The disintegration of Tuscan commerce was nearly complete, and a landed aristocracy had largely replaced the old mercantile patriciate. Such economic and social forces often abetted government policy, which fostered the development of various neo-feudal structures.

Granducal Tuscany saw a proliferation of jousts and carousels, the institution of a crusading order, and the elaboration of ceremonial distinctions. Such neo-chivalric formulae offered more than ideological flourishes and calculated diversions for the courtier class. As the seventeenth century progressed, a few ascendant families appropriated more and more of the functions of government. In practice the principal ad-

ministrative posts were reserved for semihereditary senators and *Cavalieri di Santo Stefano*.[50]

The Medici family identified itself with the cumulative achievement of Tuscan culture. The hierarchic structure and ritual complexity of the academies allowed them to effect this on their own terms. In the Accademia Fiorentina, the Accademia del Disegno and the Accademia della Crusca, the grand duke's connection with Tuscan scholarship, art, and letters was expressed with diagrammatic clarity.

Genealogical studies became a near obsession throughout Europe, as scholars worked to identify and define the nature of nobility. Lineage was as crucial to a city or a state as it was to a single family. With his "Albero universale dell'arte del disegno" Baldinucci sought to document the antiquity and nobility of Tuscan art. The same issues were at stake for Ridolfi and Malvasia in Venice and Bologna.

In Tuscany, power, wealth, cultural attainment, and religious virtue were to be measured by relative access to granducal favor. The Medici themselves were not merely noble but the tangible source of all nobility. History, however, could reveal troubling contradictions. Since the Medici had fought tooth and nail for several centuries to achieve their effortless mystical supremacy, the transcendental propriety of Medici dominion had often been less than apparent to their fellow Florentines.

In the last pages of his *Firenze città nobilissima illustrata*, Ferdinando Leopoldo del Migliore describes the essential distinction between the *"nobile"* and the *"gentiluomo."* Anyone can become a nobleman in an instant through the bestowal of a title. The name of "gentleman" finds deeper significance, indicating "the recognition in oneself of descent from a long and illustrious line . . . without the conjunction of vile and mechanic exercises."[51]

More than questioning the true nobility of the Medici, del Migliore questioned their power to confer it. Though the *Firenze illustrata* is dedicated to Francesco Maria de' Medici, the autocratic rulers of Tuscany are largely besides the point. Del Migliore's romantic vision of the past lends his discourse its only note of human warmth. The world that sparks his imagination was a world before their ostensible rise from the trading classes, when the Medici were at best one influential family among many.

By the late seventeenth century the only acceptable history of Florence was a panegyric to the House of Medici. Again and again in the *Firenze illustrata* such panegyric is conspicuous by its absence. Even in

his lengthy discussions of the Palazzo Medici in Via Larga and their
family church of San Lorenzo, the Medici barely detach themselves from
the long lists of names and dates. With as little inflection, del Migliore
catalogues the dynastic murders and popular insurrections of the later
fifteenth and earlier sixteenth centuries.[52]

On 25 May 1685 Auditore Ruberto Pandolfini resumed a previous
discussion with the grand duke's trusted secretary Apollonio Bassetti.

> As I recently mentioned, I would like to hear your prudent opinion
> on whether or not to approve certain expressions that someone is
> about to publish. More specifically, Signor Ferdinando del Migliore
> is sending to press a work called *Firenze illustrata*. Rather, he says that
> he has already done so with the permission of Signor Mercati. I had
> him remove certain things that were notoriously intolerable, and I
> still have doubts concerning others that I am now passing on to you.
> The first of these seems intentional, ill-timed, and unnecessary in
> refreshing memories of the people's madness and their little respect
> for the ancestors of the Most Serene House in the sublimity of their
> sacrosanct state. Under the second heading is matter perhaps highly
> plausible and decorously expressed, but I do not think that the Most
> Serene Patron's actions are to be restricted to these narrow terms.
> Reverence and admiration for the reigning prince should be blended
> better into the work and impressed on the hearts of the readers, not
> limited to mere details. Most particularly, these deeds are noted as it
> were in passing. The inclusion of some implies the exclusion of
> others, though these seem to me more significant and more worthy of
> enduring memory. I submit my observations to your most prudent
> and exemplary judgment and beg the favor of your most enlightened
> opinion.[53]

Baldinucci's remonstrance must have fallen on sympathetic ears.
Whether or not Bassetti and Pandolfini responded directly to his peti-
tion, they did indeed force at least one set of revisions. The first volume
of the *Firenze illustrata* was also the last.[54] Until his death around
1700,[55] del Migliore continued to file away material from his tireless
archival investigations. He also confided to pen and paper his uncom-
promising views on Florentine history, Florentine art, and Florentine
national identity.

Among del Migliore's later manuscripts is his extensive *Reflessioni e
aggiunte alle "Vite de' pittori" di Giorgio Vasari*.[56] He offers a close run-
ning commentary on the *Vite*, correcting specific factual errors and ad-

dressing the broader issues raised by Vasari, his followers, and his detractors.

Del Migliore here recasts the Tuscan blood myth in yet more stylized and imposing form. Art could not have declined in the late empire because the bloodstock and the culture remained pure until the advent of the barbarians. Like a dark but passing shadow, such adversity could hide but not destroy the deep "science rooted in a people." A mode of painting, sculpture, and architecture persisted in the principal Italian cities, most particularly Florence. "Though bad, barbarous, and deformed, our manner was never Greek nor taken by necessity from Greece."[57]

The Chapel of Saint Luke story is not supported by official documents and del Migliore dismisses it as "a fairy tale recounted by Vasari's grandmother at bedtime." If Greek painters were indeed summoned to Florence, it was only to satisfy a dilettante whim. "One occasionally finds works by foreigners more pleasing than those by fellow citizens. We have seen a Pietro from Cortona, a Giordano from Naples, and many others called here to paint, at this time when Florence so abounds with expert and worthy practitioners."[58]

The arts flourished in the ancient world due to the noble condition of the men who exercised them. Greek youths of good birth were taught design, and such activity forbidden those of menial estate. Ferdinando Leopoldo traces the long history in Florence of the Compagnia di San Luca and its successor, the Accademia del Disegno. It is thus wrong to imagine "San Bartolo inter dipintores" as a bustling street of common artisans.[59]

With a characteristic mixture of sophistry, scholarly rigor, and wishful thinking, del Migliore rejects Cimabue's fabled encounter with the young shepherd Giotto. Vasari's dates are contradictory, and even more contradictory his representation of Giotto as "an agricultural laborer of simple condition." Ferdinando Leopoldo del Migliore offers contrary evidence of noble descent.

> This differs totally from our author's fantastic proposition that Giotto was a vile guardian of flocks and born to Bondone the peasant. Even without noble birth, I concede that a person might achieve generous breadth of spirit and be capable of great things. Such advantage, however, usually matches the gentility of long-refined blood. Excellence is as much to be expected of these as it is deemed miraculous in persons of low birth.[60]

132

IN HIS LETTER to Ruberto Pandolfini, Filippo Baldinucci implied that he had once been on good or at least civil terms with Ferdinando Leopoldo del Migliore. The world of Florentine scholarship was a small one, and they shared important friends and colleagues. Baldinucci, as we have seen, cited the antiquarian's "much desired work, the *Firenze illustrata*," and such courtesies were usually taken very seriously.

Del Migliore, it seems, then showed his true colors. "He names me not to cite my work nor to praise it as I did his. Rather, he spites me in every place and in every way that he knows."[61]

Giovanni Cinelli saw Filippo and Ferdinando Leopoldo as more than acquaintances. In 1681, shortly after the appearance of the *saggio* of the *Notizie*, he sarcastically referered to Baldinucci's "comrade in arms and *fidissimo Achates* Migliori, not del Migliore as he claims, in order to usurp the name of an extinct family."[62]

Cinelli also noted: "Baldinucci goes around boasting that his knowledge of history is superior to mine. In the same way his most faithful Migliori says that writing about antiquity falls only to his lot. He is a master and others are not to mix themselves up in such things."[63]

Cinelli was scarcely a subtle judge of character and motive. By 1681, however, he fully deserved to find hostility if not conspiracy wherever he turned.

Giovanni Cinelli was born in Florence in 1625, the same year as Filippo Baldinucci. In spite of his family's modest circumstances, Giovanni received a solid and even privileged education, with the Scolopians and then at the Florentine university. He studied mathematics with Evangelista Toricelli and occasionally visited the great Galileo.[64]

In 1645 Cinelli obtained a place in the Collegio Ducale at Pisa, where he achieved a degree in medicine five years later. During this time he cultivated a broad interest in philosophy and letters and enjoyed stimulating literary society. At the house of Giovanni Battista Ricciardi, Cinelli found a kindred spirit in Salvator Rosa, the Neapolitan painter, writer, and wit. Many years later Dionisio Sancassani assessed this early influence on his friend's turbulent career. "Our Giovanni deceived himself in frequenting Salvator Rosa, a man of notable learning but even more notably given to satire. . . . He thus contracted the habit of scrutinizing defects in other people and came to overlook defects more properly his own. Unless tempered with discretion, the common fruit of such application is infinite disaster."[65]

A sharp tongue and a satirical temperament were luxuries Giovanni

Cinelli could ill afford. In 1651, with a wife and growing family,[66] he embarked on a meager career as semi-itinerant doctor. Cinelli held a variety of salaried posts, treating humble folk in a succession of market towns and country districts. For the next half-century, he seldom maintained a fixed residence for more than a few years and generally lived on the edge of economic hardship.[67] Such insecurity would have tried more forebearing men than Cinelli. In Borgo San Sepolcro early in his professional life, he was involved in a bloody street brawl with another doctor who dared treat one of his patients.[68]

In the 1660s Cinelli made a concerted effort to establish himself in Florence, piecing together a living through private medical practice and work in charitable institutions. At least one great household availed itself of his services. The ledgers of the Bartolommei from 1662 to 1667 show frequent payments to Doctor Cinelli, authorized by Marchese Mattias Maria.[69] It was perhaps here that he came to know their bookkeeper, Filippo Baldinucci.

While barely supporting himself by his medical skills, Giovanni Cinelli strove to enter an even more precarious trade, that of literary entrepreneur. Cinelli wrote, translated, adapted, extracted, and sometimes published a wide variety of eminently salable works, including saints' lives and devout discourses, treatises on popular medicine, guidebooks, and accounts of exotic lands. Some of his thwarted editorial schemes were highly ambitious. He proposed complete editions of Filelfo and Chiabrera and hoped to offer in Italian a definitive series of Florentine historical writings, including Dino Compagni's unpublished *Cronica*.[70]

Most of all, Cinelli sought out unpublished manuscripts by deceased authors and prestigious works long out of print or yet to be printed in accessible form. In 1671 he presented the first edition of Lorenzo Aretino's *Vite di Dante e del Petrarca*, in 1672 a translation of Horace, and in 1673 an excerpt from the *Polifemo* of Antonio Malatesti.[71] In 1676 he was the first to publish Lorenzo Lippi's *Malmantile Racquistato* in a sloppy semipirated version. This and other of his offerings elicited ill will and even organized opposition.[72] Cinelli added introductions and occasional verse to his literary discoveries and, most essentially, dedications to present or potential patrons. His works were printed in several different cities,[73] and he must have operated with almost no capital.

Giovanni Cinelli made an important contribution in 1677 when he resurrected Francesco Bocchi's *Bellezze di Firenze*, published in 1591.

For nearly a century there had been no new guide to Florentine monuments and treasures. Cinelli doubled Bocchi's work to nearly six hundred pages, meticulously noting "the beauties of the city of Florence, with her paintings and sculptures, her palaces and sacred temples, her precious curiosities and notable works of man."[74]

This guidebook filled an obvious need and went quickly into a second edition.[75] Cinelli offered more thorough and current descriptions and added numerous historical and critical observations. On occasion the doctor could draw on his long medical experience. For example, in Andrea Tafi's mosaic of *Christ in Majesty* on the Baptistery ceiling, Cinelli identified a striking anatomical anomaly. "Andrea here perpetrated the magnificent blunder of representing Christ's hand backwards. He deserves our sympathy, however, since the art of design was but crude and newly reborn, yet to resume its present vigor."[76]

Cinelli dedicated the *Bellezze* to Francesco Nerli, cardinal archbishop of Florence. He calls down as well the blessing of Antonio Magliabechi, in whose house the book was conceived during a conversation with some foreign visitors. Virginio Zaballi and Baldassare Franceschini il Volterrano are thanked for their advice on artistic matters.[77] Lest his own achievement be overlooked, the author included eight pages of laudatory verse, epigrams, and prose commendations from men of distinction.

According to the custom of the time, Cinelli filled his text with courteous references to friends, colleagues, and patrons. In discussing Brunelleschi's then ruinous Church of Santa Maria degli Angeli, also known as the Tempio degli Scolari, he cites two extant drawings. "The Volterrano has one that the architect followed entirely. Filippo Baldinucci has another somewhat different drawing, which he keeps with the greatest care, in memory of the celebrated Brunelleschi and out of respect for the ancestors of his wife Caterina Scolari."[78]

Giovanni Cinelli's most valuable connection was with the granducal librarian Antonio Magliabechi. He composed a vivid, if stylized, character study of this exceptional individual.[79]

Antonio Magliabechi, Librarian to His Serene Highness
the Grand Duke of Tuscany, Living Mine of Erudition
and Fruitful Doctrine.

These days only a rare few study here in our land. Even these, for the most part, glitter only speciously, whether to accumulate money or

to obtain the honors they crave. This is not the case with Magliabechi. He neither desires nor seeks offices. He spends the grand duke's stipend on literary goods and similarly consumes all personal income. Other expense he rejects as superfluous.

Magliabechi may be called a true *letterato* for he talks never of other matter. Care of the person and personal comfort he leaves to others. He is perpetually buried in studies, so much does he pleasure and triumph in leafing through books.

Festivities do not allure him. Spectacles do not attract him. Novelties do not move him, unless they be literary in nature.

He is an inexhaustible mine and deep abyss of science. For counsel, for erudition, for information, for correction, all the pens of lettered Europe have recourse to him. How much could I say in this regard, I who call myself his devoted servant! My tongue is tied only by reverence and respect for those who have assumed the benefits of his labor.

From his noble pen a single book now in press received sixty pages of additions and corrections. Forty pages of censures were conferred on the book of a high prelate whom I must leave unnamed. He produced these censures extemporaneously in only eight days, promising to increase the total to a hundred pages if desired. A great *letterato* sent His Highness a book for review, and His Highness consigned it to Magliabechi for emendation. Magliabechi asked, "How many errors does Your Serene Highness wish me to find? A hundred, two hundred, a thousand?" Our Patron replied, "A hundred will suffice." This number of errors Magliabechi noted in only the first two pages. Without further correction, this book is soon to appear or perhaps already has seen the light.

Magliabechi alone has written more than half the writers in Florence together, though not even one printed sentence carries his name. A friend to true friends, he is always ready to perform his gracious offices. Neither vain nor ambitious, many times he refused mention in the works of Coltellini, Father Boselli, Doctor Toppi, and numerous others. Through him many writings by learned men have enjoyed the advantages of publication. Although he has published nothing himself, he could produce a treatise on any subject in a single day.[80]

Even in Cinelli's aphoristic encomium, Magliabechi seems as remarkable for his obsessive and intractable personality as for his wide learning and scholarly dedication. Other less flattering observers were quick to note his weird physical appearance, squalid living arrangements, and disgusting personal habits.[81] His energy, his memory, and

his single-mindedness inspired universal awe. With these qualities and his place at court, he established an idiosyncratic authority throughout Europe.

Magliabechi corresponded with most scholars of note and enjoyed the best attention of the principal booksellers and publishers. Whatever Cinelli might have thought of his elusive modesty, Magliabechi kept a jealous eye on the barometer of acclamation. In the world of letters his name was perhaps the most frequently and effusively cited.

It is either astounding or inevitable that two such unamiable and eccentricity-ridden men should form an alliance. Cinelli had a career to make and few could serve him so well in effecting introductions or discovering publishable manuscripts. In Magliabechi's own diffidence towards publication, his flatterers saw a noble desire to rise above scholarly controversy. It is possible, however, that the librarian was simply overloaded with undigested factual information.

Cinelli's most ambitious projects would have been unthinkable without Magliabechi's support.[82] In the 1670s he began compiling the *Toscana letterata*, a monumental encyclopedia of Tuscan writers. It came to include four thousand five hundred authors, arranged alphabetically, with concise biographical and bibliographical entries.[83]

Through Magliabechi Cinelli gained free access to the granducal library. "There I wrote my History of Florentine and Tuscan Writers and my other bagatelles. . . . As all the court knows, I studied there every morning for some hours, even when urgent affairs would have had me elsewhere."[84]

Years later Dionisio Sancassani viewed this project with sorrowful admiration. "Cinelli's principal joy was his great collection of Tuscan writers. When Caesar was shipwrecked and awaited rescue, he swam holding his *Commentaries* above the waves. . . . Throughout his great misfortune, Cinelli likewise carried this work with him. Only with death did he entrust it regretfully to the indiscretions of chance."[85]

Had the *Toscana letterata* been published, Cinelli might have enjoyed considerable authority in the scholarly world. In 1705, at the age of eighty and a year before his death, he reflected bitterly on this venture. "He who writes lexicons suffers the torments of hell. I speak from experience, having suffered the same from 1677 till now, due to my work on Tuscan and Florentine writers. Since I cannot publish it at my own expense, I am forced to leave it in God knows whose hands, and this is my chief sorrow."[86]

In the 1670s Cinelli launched another "lexicographic" scheme that was equally enterprising and equally plagued by adversity. With the prompting of Antonio Magliabechi, he turned his attention to the innumerable *"fogli volanti,"* brief and usually ephemeral works that formed a large portion of printed production. "Many small works are printed by great men in loose form. Like flashes of light they vanish almost as soon as they are born. Their authors merit sympathy, since such works slip into oblivion or indeed are never truly known. I was moved to offer this present effort, called the *Biblioteca volante*, in order to bring back to life many nearly lost and to insure those now living against the pernicious dangers of time."[87]

Each installment of his evocatively named *"Flying Library"* was called a *"scanzia"* or "bookshelf." The first was published in Florence in 1677 and was dedicated to Francesco Nerli. It ran to ninety-six pages, listing and often discussing four hundred pamphlets and leaflets of the sixteenth and seventeenth centuries. Nearly all of these came from the granducal library or from Magliabechi and Cinelli's own collections.

A second *scanzia*, issued in Florence that same year, featured two pages of testimonials from esteemed *letterati*. A third and fourth *scanzia* were soon slated for publication in Naples.[88] The *Biblioteca volante* was a shrewd initiative. Beyond the intrinsic merits of the scheme, it allowed Cinelli to set himself up as an arbiter of literary activity. Since many *fogli volanti* were of a timely and even polemical nature, Cinelli could project himself into the vanguard of current trends and controversies. As editor, he found enormous scope to voice opinions, grant favors, settle scores, and promote his own publications.[89]

In retrospect it might seem that the *Biblioteca volante* allowed Giovanni Cinelli rather too much scope for his own good. The fourth *scanzia* appeared in 1682. Twenty-two of its fifty-nine pages were given to an acrimonious dispute between Bernardino Ramazzini, lecturer in medicine at the Modenese university, and Giovanni Andrea Moniglia, an eminent Florentine physician. Their charges and countercharges of medical malpractice engendered a flight of vindictive pamphlets.

Cinelli made no secret of his editorial bias, prefacing the *scanzia* with a dedication to his friend Ramazzini. Moniglia practiced at the Florentine court and was much appreciated as a comic and theatrical writer. The fourth *scanzia* of the *Biblioteca volante* was judged defamatory and libelous. On 11 March 1683 it was "burned by the public executioner in the courtyard of the Palace of the Bargello while the bell tolled." [90]

Cinelli's own fate was somewhat less dire. After three months' incarceration in the Bargello, he fled the city of Florence. This turn of events might have gratified Filippo Baldinucci. Though the Ramazzini-Moniglia affair overshadowed all else, Baldinucci was attacked twice in the unfortunate fourth *scanzia*.

For a number of years Filippo Baldinucci sought to reprint Bartolomeo Ammannati's letter of 1582 to the Florentine Accademia del Disegno, denouncing the perils of worldly and licentious art. Though Baldinucci issued this piece only in 1687, Cinelli did not wait to decry his presumed hypocritical pietism. He addressed a sarcastic verse to "Ser Pippo mio," and further exhorted, "For once and for all, learn modesty and true piety. Don't fake it in order to deceive the world and snatch at a few coins. Take the distinguished and praiseworthy Ammannati as your model, since you evidently wish to ape him in circulating your stupid and pointless letter. Certainly your motives are not those of that upright man and excellent sculptor."[91]

Cinelli also cited Baldinucci's 1673 handlist of Cardinal Leopoldo's drawings, the *Listra de' nomi de' pittori di mano de' quali si hanno disegni*. "This celebrated Academician of the Crusca is so knowledgeable in regard to our language that he errs even in the first word of his feeble and inept little leaflet. I will demonstrate elsewhere his innumerable pompous errors. Where do such ignorant cretins get the nerve to print that it is incumbent on them to correct me?"[92]

Cinelli is telling us a good deal more about his personal relations with Baldinucci than about Leopoldo de Medici's drawing collection. The reference to ignorant cretins correcting him in print is openly autobiographical. In the *saggio* of the *Notizie* Baldinucci discusses Andrea Tafi's mosaic of *Christ in Majesty* in the Florentine Baptistery.

> Here it is incumbent on me to correct the words of a recent writer, who speaks thus in regard to this figure: "Then he alone made the Christ measuring seven braccia, located above the main chapel. Andrea here perpetrated the magnificent blunder of representing Christ's hand backwards. He deserves our sympathy, however, since the art of design was but crude and newly reborn, yet to resume its present vigor."
>
> These are the author's words, and he is sorely misled in such an assertion. Any professor of these arts will recognize that the hand surely is not backwards but the right way around, ingeniously represented by the artist.[93]

Baldinucci then offers an elaborate explanation of the structure of the hand and Tafi's clever play on foreshortening. Doctor Cinelli was little inclined to take instruction on art or anatomy from Filippo Baldinucci. To set the record straight he composed two pamphlets, neither of which was published. The first is an immediate response to the *saggio* of the *Notizie* in 1681 and the second evidently prompted by the *Veglia: Dialogo di Sincero Veri* of 1684.[94] In the latter Cinelli chronicles his long acquaintance with the treacherous Baldinucci.

> I came to know Filippo Baldinucci more than twenty-two years ago, when I was practicing in the house of a *cavaliere* for whom he was bookkeeper and factor as he was for many others. I considered him a friend and a good man and valued him as a confidant, maintaining this opinion until his actions demonstrated the contrary. As a pastime he wished to execute my portrait in red and black chalk, as he had done of various other well-known personages of this city, and keep it at home with these others for study. Seeing myself thus favored, I wanted to make a gesture in return and cited him and his wife on page 493 of my additions to the *Bellezze*. My reward for undertaking the *Bellezze* was many enemies, of whom Baldinucci is one. I first noticed this when I went to his house with the Servite Father Prospero Bernardi,[95] who requested some information concerning the Annunziata. Baldinucci pulled out one of the notebooks of undigested material he was compiling for his work of the *Notizie* and read us a few lines. When I happened to glance confidentially at the notebook he was mumbling over, he covered the writing with his hand so that I couldn't read anything. From this I recognized his diffidence and withdrew, never again wanting to see another thing of his. While I was publishing the *Bellezze*, we discussed the project and he made a great point of warning me not to give opinions. This is because I never went for advice to this man who thinks himself the most knowledgeable in the world in regard to painting. I had good reason since I always took him for a bookkeeper, an accountant, and a business manager in private households, not a painter or sculptor. In such matters, I availed myself of the most knowledgeable *professori*.[96]

Cinelli talks about Andrea Tafi's figure of Christ and the magnificent blunder of the backward hand. He notes that all objective critics recognize the accuracy of his observation, though Baldinucci's partisans vehemently refuse to see it as such.

Baldinucci was then publishing the *Notizie de' professori del disegno*. The day before the appearance of his so-called "vast work," he sent a

confidant to ask if it were true that I intended to write in opposition. Knowing Baldinucci's poisonous heart, we see that like a serpent he also has two tongues. I replied in these words:

"I must confess, my dear sir, that the human race includes spiteful people and disseminators of discord. Not only will I not write such a piece, but the idea never entered my head. I consider Baldinucci a friend and I am indeed obliged to him for not differing with my work on various writers. Mine is broader in scope and certainly not second to his in nobility. Mine will perhaps circulate throughout Europe or at least Italy, helping everyone who writes about such things, while his will never leave Tuscany. I am not like Migliori who goes around grumbling and lamenting that I ruined a work he is still composing by republishing a book produced a hundred years before his birth."[97]

In his *Toscana letterata* Cinelli records a violent argument with del Migliore over their relative rights to the *Bellezze di Firenze*. Ferdinando Leopoldo might well have been dismayed by Cinelli's reissue of Bocchi's guidebook. In one of his unpublished archival commentaries, del Migliore referred in passing to "my discourse called the *Bellezze di Firenze*." He then scratched out this title and substituted *"Firenze illustrata."*[98]

Cinelli continues his tale of trust betrayed.

Baldinucci's work appeared on the following day. Scarcely was it out when three friends informed me that it contained a biting criticism of me. This I didn't believe until I read it with my own eyes and confirmed that my very words had been twisted deliberately. His temerity stunned me, and his shameless behavior, and his rash pronouncements incited by wicked advisers. If previously I had some respect for him in matters of design, I now knew myself sadly mistaken. Either he doesn't understand the human body or else impugned the truth from sheer love of quibbling.[99]

Cinelli bridles at Filippo's assumption that it behooves him to correct the statement of a certain modern writer. He asks with enough acid to bite a copper plate: "Would someone be so good as to tell me when he was appointed public censor of the city, and who imbued him with the arrogant necessity to correct others? I've always known him as an abacus operator and accountant, after having exercised the art of copyist. Never did I realize that he knew how to read, let alone set himself up as a *letterato*."[100]

He builds his case by alternately presenting his own credentials and inquiring after those of Baldinucci. "How can one who has never been

a student dare point out where I need to be corrected? Out of respect, one does not correct masters unless one is a more learned master."[101]

Giovanni Cinelli had a better formal education than Filippo Baldinucci, although a degree from Pisa was evidently no guarantee of prosperity and esteem. Though Cinelli knew the accountant before he had shown much interest in erudite affairs, now they were both struggling against considerable odds to establish themselves as *letterati*. It is not surprising that they followed each other's successes and failures with less than the warmest human sympathy.

The structural accuracy of Christ's hand was fundamentally a subjective issue, based on two different readings of the representational conventions. The point was scarcely essential to Baldinucci's work, and he need not have impugned the doctor's anatomical competence unless he wanted to.

In the *saggio* of the *Notizie* Baldinucci cites Bocchi's edition of the *Bellezze* three times, without a single mention of Cinelli's greatly expanded and more recent version.[102] In his formal and highly literary presentation letter to Lorenzo Gualtieri of 1682, Baldinucci makes clear that this was not an oversight. He refers to "our virtuous fellow citizen Francesco Bocchi in his fine book, the *Bellezze di Firenze* . . . not the one who lately reprinted it with additions, but rather the same Francesco Bocchi who treated this subject with extraordinary application."[103]

Though we do well to question Cinelli's objectivity, he does offer a forceful impression of the prevalent mood of conflict and intrigue. The recollections that we have been considering were set down around 1685,[104] during the first years of his exile from Florence. The publication of the *saggio* of the *Notizie* in 1681 had already inspired a full critique of this work and its author. Cinelli gave his *Lettera dell'Anonimo d'Utopia a Filalete* considerable time and attention, developing it through three drafts. The first of these begins:

> It has appeared, that much lauded work of Filippo Baldinucci, called *Notizie de' professori del disegno*. . . . From the great general acclamation preceding it, I expected a voluminous Calepino if not indeed a *Biblioteca Patrum*. Into my hands then falls a flimsy little leaflet of eight unhappy folios, and I know the truth of the saying, "Minuit presentia famam."
>
> I read the title page and recognize the veracity of what has already been written to me. This person is not a *letterato*, but a bookkeeper

by profession, a plyer of abacuses and account sheets. Formerly, a hundred and forty years ago, this trade was vulgarly called that of eye gouger (*cavalocchio*) or bill collector for other people and their interests. Such a career is now dignified by another name, "keeping contracts," though he still must find it shameful since he wants to claim yet a new profession for himself. While he boasts that his real craft is appropriate to the civility of his condition and highly honorable, everyone knows that keeping other people's books is not the art of a *cavaliere*. . . .

He gives himself the title of "good historian" and says that the Most Serene Cardinal Leopoldo availed himself of his supervision in organizing drawings. Such things are best left to other people to say, unless one is like Narcissus, in love with one's own works. Likewise, there is a big difference between making an entry in a book of debits and credits and writing history. I hear tell that he's a good enough little man (*buono homiciatto*) and adept at his job and that he is also experienced in the styles of drawings and paintings from his hobby of doing portraits in red and black chalk. However, he never wielded a brush, nor most of all, used oil paints. In any case, that he's a *letterato* will be believed by no one who reads the title page of this work of his.[105]

Even the irascible Cinelli must have realized that he was taxing the reader's credibility in premising so sweeping an indictment of Baldinucci's personal and professional habits from a perusal of only the title page of the *Notizie*. Though the chorus of insults rises in the second and third drafts, he withholds the full blast of his torrential sarcasm through several pages of relatively straightforward criticism of the work. He then heaps heightened scorn on Baldinucci's occupation, notes that two of his closest relatives in Prato "exercise the honorable profession of baker and dyer,"[106] and reveals that a convent decided to deprive themselves of Baldinucci's services "since he gave rise to suspicion through overly close dealings with the property agents."[107]

The *Lettera* offers a line-by-line analysis of the *saggio* addressing general and specific points of contention. Often, however, Cinelli descends to an obsessive sifting of Baldinucci's words in search of even the most meager kernels to throw between the heavily grinding stones of his wit. The only positive virtue of the *Notizie*, he informs us, is the wide margins in which to correct its innumerable errors.[108] The advance publication of the *saggio* was the excellent advice of a man of conscience, since it is better to be tricked into buying eight folios than to throw away

many *paoli* on the *"vastissima opera."*[109] Baldinucci might have spared three rulers the bother of granting him copyright privileges, since no publisher is feebleminded enough to consider reprinting it.[110]

There is little to be gained from an exhaustive catalogue of Cinelli's observations since they lack variety, particularly after the third repetition. However, his blatant antipathy was often directed to those very fronts at which Filippo was most open to attack and his objections also tell a good deal about Cinelli himself.

His favorite epithets include the sarcastic *"buono istorico"* ("good historian") and *"nuovo Livio"* ("new Livy"), *"fantaccino"* ("foot soldier" or "low manservant"), "Narcissus," *"omicciato"* ("base" or "little man") and *"mezzo uomo"* ("half man," perhaps in reference to Filippo's short stature).[111] Most often repeated are various plays on "suo cima Bue o capo di bue,"[112] allowing Cinelli to call him ox-headed and to ridicule his obsession with this artist at one go. Though we would hardly expect Baldinucci's manifest religiosity to escape notice, he is awarded the title of "little bigot" only once. "When he writes those words *and all of this work stands in need of correction as well*, it must have been holy week or some other solemn occasion when this *bacchettoncino* examines his conscience. Beyond recognizing the need of correction, no greater truth is registered in this *vastissima opera."*[113]

Cinelli takes particular and very frequent delight in borrowing the phrase "vast work" that Baldinucci applied to the projected scope of the *Notizie.* We can well imagine the mirth in certain quarters when the unimpressive looking *saggio* finally appeared, after much time and presumably much fuss. Cinelli's critique of its content is more difficult to assess, for the only obvious consistency is in his animus to disagree with Filippo's every word. Many of his pronouncements would be of enormous interest, if we could be convinced that they were powered by more than contrariness. He disbelieves in the Dark Ages,[114] for example, and holds that gothic architecture is not crude.[115] However, his arguments tend to become amazingly twisted.

Of Cinelli's personal allegations, the most cutting and the most emphatically reiterated is that Baldinucci is getting above himself in setting up as historian of art. He is neither a trained scholar nor a practicing artist. Even worse, his crime of pride is compounded by a tendency to sing his own praises. As we have seen, the *saggio* of the *Notizie* is often pompous and self-regarding in tone, reflecting the various hopes and fears of its author. Baldinucci sets Cinelli's teeth on edge by incau-

tiously, if indirectly, referring to himself as a "good historian" and the "extractor of the truth." Cinelli comments: "Wishing to be called *buono istorico* is asking rather a lot. To merit such a title, first the work is required, then one leaves it to others to say."[116]

Cinelli finds particularly "stomach turning" (*stomachevole*) the meaningless "nursery rhymes" (*filastrocche*) of authors in "this most odious *Apologia* of his, where he says the same things a thousand times and lets out a braying that any ass knows how to make. By copying the commentators on Dante, which are all together in the manuscript in San Lorenzo, anyone at all can raise the same racket in order to be taken as learned by fools, though never by sensible people."[117]

Cinelli sets out to diminish further the originality of Baldinucci's undertaking. The idea of basing the work on the progression from master to pupil was cribbed from Vasari, while he imitated Livy and Machiavelli in his method of historiographic division.[118] In regard to contemporaries, "It wasn't his own idea to arrange the drawings in chronological order, but rather that of the Volterrano and Lippi, even if he claims that only he has *a complete knowledge of all the order.*"

The critic makes a more serious allegation regarding Baldinucci's debt to Lorenzo Lippi. "He flaunts that *since the concept of the tree is clear demonstration.* It is publicly known that he took it from Lippi, author of the *Malmantile Racquistato*, who not only began the work but carried it out to an advanced point. With subtle policy he extracted these writings from the hands of the heirs and appropriated them to his own use, since they were young charges under the guardianship of women."[119]

The Volterrano was a close friend of Baldinucci's and also assisted Cinelli with the *Bellezze*. The painter and author Lorenzo Lippi died in 1664, before Filippo's involvement with Leopoldo's artistic interests. We can trace too many of Baldinucci's subsequent efforts to credit the charge of fraud and plagiarism at face value. Cinelli was rather more blatantly culpable in 1676, when he published Lippi's *Malmantile Racquistato*, taking advantage of Paolo Minucci's delays in bringing out the authorized scholarly edition.

Baldinucci could certainly be accused of self-aggrandizement and perhaps even of bad faith. Long before Filippo appeared on the scene, Leopoldo de' Medici had begun to organize a historiographic drawing collection and to support projects for bringing Vasari up-to-date. In discussing the evolution of his own endeavors, Baldinucci chose to ig-

nore these earlier schemes.[120] His convenient oversight is unlikely to have gone unnoticed in Florence in 1681.

In his preface to the *saggio* of the *Notizie* Baldinucci comments, "I dare expose my meager ability to the test of publication only from obsequious obedience to the most happy memory of His Serene Highness Cardinal Leopoldo. I have also been encouraged by many noble and erudite intellects of this land and abroad, most particularly the unequalled Antonio Magliabechi whose fame fills the world."[121]

Cinelli's response is a categorical "Endless lies!" He objects strenuously to Baldinucci's claim to illustrious colleagues, mentors, and patrons.[122] At least one of his snider allegations can be dismissed without comment. "Even if it were true that *the most happy memory of Cardinal Leopoldo encouraged him*, it doesn't necessarily follow that this most discrete prince would himself have played such a joke. However, the dead can't reply, and we are permitted to speak of them as we will."[123]

Not surprisingly, Cinelli found particularly unpalatable the relationship between Filippo Baldinucci and his own great ally, Antonio Magliabechi. The granducal librarian had long assisted Baldinucci in obtaining books, and he quickly turned to Magliabechi for support after Leopoldo's death. Cinelli offers an evocative vignette for our consideration.

> I know very well that the exhortation he vaunts from the most learned and erudite Antonio Magliabechi, glory of his homeland, is an outright lie. Shortly before Easter of the present year 1681, I saw a letter from Magliabechi in reply to a friend seeking information concerning this *vast work*. Because he is sincere, he answered with these very words: "I am unable to tell you anything at all regarding Baldinucci's work, since he is hiding it from other eyes with much caution and jealousy. I know well that it is being published in great haste and he has read me a folio already printed. From this, I can't deduce anything that would lead me to venture an opinion since it is necessary to see the whole thing."
>
> Since Magliabechi hasn't seen it, Baldinucci flaunts this exhortation to publish only to gain credit for his work in the penumbra of this brilliant and prodigious intellect. If he had really seen and considered it, he would beyond the shadow of a doubt have persuaded him to let the anchovies have it.[124]

Cinelli rewrote Magliabechi's speech several times.[125] Even in this final form, the librarian might only have been refusing to get involved.

We know, however, that the *saggio* of the *Notizie* was indeed rushed through the press to be ready for Filippo's trip to Rome.

Cinelli insists that whatever recognition Baldinucci achieved was duly bought and paid for. On this score he offers an insider's view of the mechanics of acknowledgment swapping.

> In regard to his ambition of being considered a *letterato*, I need say that by means of a few gifts he got people to write and name him as such in a couple of paltry publications. He kept these carefully hidden here in Florence, but distributed them abroad to those who wouldn't recognize his shrewd method of buying name and fame. Also, by naming a few *letterati* himself, they were compelled to return the favor and name him as well. . . . In regard to fellow Florentines, even if he did receive encouragement, it was only from some *letterato* or other on his own level who nursed the ambition of being named.[126]

If anyone was qualified to recognize such practices, it was Giovanni Cinelli. Again and again in the course of his career, he pieced together intricate structures of courteous obligation, only to blow the fabric sky-high in a fit of temper. Baldinucci played the same game with rather more consistency. In 1676 we saw him engineer exactly the sort of scheme Cinelli alleges. With the help of Antonio Magliabechi and Alessandro de' Cerchi, he obtained letters of commendation from Bishop Giuseppe Maria Suares and Antonio Maria Salvini, then published these with a dedication to Cardinal Francesco Nerli.[127] Hardly less astute was his distribution in Rome of the *Lettera a Vincenzo Capponi* and subsequent citation in the *Giornale de' letterati*.[128]

For Cinelli the most disturbing aspect of Baldinucci's intrigues and subterfuges was their apparent success. He begins the second draft of his *Lettera dell'Anonimo*, "After awaiting it breathlessly for three full years, that much lauded work by Filippo Baldinucci has at last seen the light, and from its great renown he came to be mentioned in the *Giornale de' letterati*."[129]

Cinelli is suitably outraged at Baldinucci's unmerited connection with the Accademia della Crusca.

> I will not criticize his linguistic improprieties nor his expressions that are neither Tuscan nor Florentine, since the job is too big for me. This task I leave to those zealots of his in the Crusca, noting only the unbearable shame. How can the purported Florentine masters of the Tuscan language permit such phrases, ugly enough to earn the ridi-

cule of our fellow Lombards? Whatever can the censors of the academy be thinking? Such latinisms as *dilettante decoroso* are never employed by good writers.[130]

Cinelli composed his two principal attacks at a time when circumstances seemed to be arranging themselves most conveniently for Baldinucci and falling apart most distressingly for himself. Though Baldinucci demonstrated great alarm at del Migliore's opposition, Cinelli's even more violent antagonism evidently elicited little response. In any case, Cinelli was highly effective in neutralizing himself as an enemy.

On 8 May 1683, after his release from prison, Giovanni Cinelli left Florence never to return. Even in adversity he preserved his idiosyncratic sense of style, as he describes in a letter to Antonio Magliabechi. "I lamented. I went up on the cupola of the Cathedral on Easter Sunday to say farewell to my homeland. I fondly kissed the gate tower at Porta a Pinti, since I was really leaving and no joke about it. If I were to return, I would show myself weak. My breast is of stone and it takes a good deal to make me bend."[131]

Through his friend Ramazzini, Cinelli attained but soon lost a lectureship in Tuscan literature at the Modenese university. Otherwise, he was continually on the move through the Emilia, the Romagna, and the Marche, holding a variety of medical posts in towns and villages. In the last years of his life he finally obtained a stable and respected position as resident physician at the Sacred House of Loreto, where he died in 1706.

In 1684 Cinelli and Magliabechi were viciously attacked in a pair of biographical exposés printed anonymously in Siena.[132] Their connection had always been very public and even the granducal librarian was feeling the heat, as he expressed to Bernardo Benvenuti, the prior of Santa Felicità in Florence and a distinguished antiquarian.

I am forced to shield my reputation from the defamatory and even diabolical rumors that I know are being spread continually at the court of the Most Serene Prince of Tuscany. Since I have no acquaintances there nor people to serve me, I appeal to you by the entrails of Our Lord Jesus Christ. When you find occasion, explain to the prince and also to Marchese Albizzi, *that I would willingly submit to the penalty of decapitation if it were ever discovered that I have sent Signor Cinelli material for even a single line* [underlined in text] of his writings or had anything else to do with them.[133]

Fortunately no one took Magliabechi at his word. The librarian worked very hard to help Cinelli pick up the pieces of his life[134] and for the next twenty years remained in close touch with the fugitive in potentially compromising circumstances. Cinelli often wrote fully or partially in code and adopted the pseudonym of Agostino Mazzetti, rebaptizing himself with the initials of his mentor. His letters are seldom dated and rarely offer a return address.[135]

With a tenacity that was either lunatic or heroic,[136] the aging Cinelli persevered with his literary endeavors. He assembled material for another fourteen *scanzie* of the *Biblioteca volante*, ten of which he managed to publish in his lifetime in Rome, Parma, Venice, and Modena.[137] Though his vehemence scarcely mellowed with the years, he never turned his back on established institutional structures. In the course of his career Cinelli claimed membership in the Accademia degli Apatisti in Florence, the Intronati in Siena, the Gelati in Bologna, the Dissonanti in Modena, the Incitati in Faenza, and the Concordi in Ravenna.[138] He must have made a remarkable contribution to the intellectual life of many provincial centers.

Notwithstanding these associations, Cinelli carried out most of his later projects in remote country districts far from libraries, printers, and fellow *letterati*. In these *scanzie* of the *Biblioteca volante*, he cites books from libraries in Modena, Parma, Ravenna, and Fanano. He seems, however, to have relied extensively on notes from his days in Florence and on fresh material forwarded by Magliabechi. Cinelli describes his mode of living in an undated letter to the granducal librarian, dispatched from somewhere in central or northern Italy.[139]

> The *cavaliere* gave me your kind letter and Signor Fellero's published elegy and the notices, for all of which I thank you. I think that you already informed me of this elegy and that I already put it in the *scanzia* that is ready to be printed in Padua. If not, I'll put it in the next one that comes out, which should be soon. I have two that are ready to go except for the dedications, and there will be no delay once I get the information from the patrons. I'm also awaiting information from you about Crasso, to which I'll attend immediately. It will be less bulky if I send it in two or three folders, and I'll copy it as carefully as possible. In regard to doing these on a single subject, it is beyond me here since I have no books and no libraries except the vineyards. These gentlemen are occupied with the land, and they complain about me. [I don't give gifts to the chief people here and

they would willingly see outsiders starve.] I can't carry on like this, for in the last three months, my earnings didn't equal the head of a pin. In December I earned sixteen *giuli*, in September, October, and November four *giuli*. So three cheers for human feeling, particularly when they led me to expect fifty *doppie*. The air here has loosened all of my teeth, and the only advancement I seem to make is advancing my feet out of bed in the morning. Therefore I've given them notice for the end of June, which will complete the year. If there's still time, I'll ask for Fossombrone. If you could get me some recommendations for that city from cardinals, it would be a great favor. However, I must ask that you help me quickly and quietly, so as to avoid nice little rumors arriving there from Florence.

Filippo Baldinucci: His
Last Years

IN HIS *Lettera dell'Anonimo d'Utopia a Filalete* of 1681, Giovanni Cinelli expresses the warmest sympathy for Carlo Cesare Malvasia as a fellow sufferer at Baldinucci's hands.

> As we see, this *omicciato* bears great wrath for the Conte Carlo Malvasia, a *gran letterato* who writes with substance and doctrine. This anger was raised by Malvasia's most learned work, wherein he demonstrates clearly that there was painting in Bologna more than a hundred years before Cimabue. His assertion is so well proven that I need not repeat the arguments and so well-founded that the whole *fatica baldinuccesca* regarding Cimabue is turned topsy-turvy. In reply we see that the Conte Malvasia has offered *nec verbum quidem*. In Baldinucci's chatter this most enlightened intellect recognizes a mere buzzing of insects that can lead at most to their laying the eggs of vermin.[1]

Notwithstanding the force of Cinelli's response, the *Lettera dell'Anonimo* cannot be called a calculated defense of the *Felsina pittrice* (1678). The Anonimo's attack is primarily *ad hominem*, and in disagreeing with every word written by Baldinucci, he can scarcely avoid approximating much of Malvasia's position in regard to the primitives.

The *Bellezze di Firenze* was published in 1677, shortly before the *Felsina pittrice*. Cinelli here espoused the Vasarian line with utmost orthodoxy, as appears in his description of the Chapel of St. Luke in the Florentine Church of Santa Maria Novella. "The ceiling of this chapel is painted in fresco in the old Greek manner. These works are esteemed in spite of their crudeness, for they are by those Greek masters who came here after the art of painting had been lost for more than five

hundred years. Cimabue learned the manner from them, and Giotto in turn from him, and in this way they put the art of painting back on its feet."[2]

Cinelli switched his allegiance from the Vasarian to the Malvasian camp a few years later, after the appearance of the *saggio* of the *Notizie*. Inconsistently enough, while screaming abuse at Baldinucci on this issue of the *rinascità*, the Anonimo breathes not a word of disparagement against Vasari. Indeed he grew vehement when Baldinucci presumed to emend factual and chronological errors in the *Vite*. "If Vasari is a *most worthy writer*, how dare Baldinucci correct him, unless to show himself superior? He calls him *most worthy writer* and scourges him. These are good words but evil actions, the behavior of a hypocrite, not a sincere person. His conceit, and what is more, his ambition are manifest to all in such pretension to vilify and annihilate."[3]

Cinelli's enmity for Baldinucci did not automatically win him Malvasia's approbation. When the doctor turned to him for support, other factors came into play. After fleeing Florence in May of 1683, Cinelli made a brief stop in Bologna. Malvasia's relatives in the Cospi-Ranuzzi family maintained important Medici connections, and the conte himself had long served the granducal house, albeit at times grudgingly. They looked thus with no favorable eye on this strange Florentine renegade.

On 28 August 1683 Marchese Ferdinando Cospi's secretary wrote to the secretary of Grand Duke Cosimo III. "Speaking confidentially, you will discover the esteem, devotion, and respect that the Conte Malvasia bears the house of Medici in his response to Doctor Cinelli, whose writings are now in the hands of the agents of justice. The doctor approached him to write against a certain book, but the conte did not want even friendship from a person who does not enjoy the good graces of the Most Serene Patrons."[4]

Though Carlo Cesare Malvasia was himself scarcely a model of measured scholarly detachment, he had little to gain from an association with the erratic and disreputable Giovanni Cinelli. At this very time, however, the influential Roman antiquarian Gian Pietro Bellori was eager to cultivate just such an association. On 13 May 1684 Bellori wrote Antonio Magliabechi, who was one of the very few people in Italy certain to know Cinelli's whereabouts.

I desire some news of my most illustrious gentleman Doctor Cinelli for I heard that he has left Florence. Speaking confidentially, I re-

cently discussed painting with someone who has great affection for the Lombard school. We touched especially on the beginnings of this art, which they want to transfer from Florence to Lombardy. In Signor Cinelli's favor, it was noted that Vasari erred in tracing the name of Borgo Allegri to the joy (*allegrezza*) elicited by his image when it was carried from the painter's kitchen garden to Santa Maria Novella.

I own as much affection as anyone else for the immortally meritorious Lombard school. Florence and Tuscany, I have said, claim the beginnings of art and also the resurrection of letters. These passed from there to other parts, becoming ever greater, so that Venice and finally Bologna deserve a share of praise. Signor Baldinucci has written very well on this score. However, other more apparent reasons lead us to test this against the evidence of those Lombard writers.[5]

Bellori soon received more news of Giovanni Cinelli than he could possibly have wished. The doctor sent him a copy of his *Giustificazione* (1683), the latest reinforcement of his position in the endemic Moniglia-Ramazzini controversy. On 25 August 1684 Bellori wrote Magliabechi, expressing his sympathy, admiration, and unwillingness to become involved.

At this time, Doctor Giovanni Cinelli's *Giustificazione* has also come from Modena. Having seen nothing else of his, I recognize him as a person of great spirit, erudition, and doctrine. The magnitude of his virtues is equalled by my sorrow at his misfortunes, which I pray God to alleviate. In regard to his writings and his opinions, I was desirous of knowing only those relevant to painting and have begged him to inform me of this.[6]

One of Vasari's more colorful anecdotes involves Cimabue's great *Rucellai Madonna*. This monumental work was joyfully feted by the populace and carried in procession from Cimabue's temporary workshop in the quarter of Santa Croce to its destined place in the Church of Santa Maria Novella.[7] Baldinucci repeated this tale, albeit with some circumspection,[8] and the Anonimo censured his irresponsible fantasy. The street was not called Borgo Allegri until a century later, Cinelli observes, when the Allegri family established themselves there.[9]

Whatever the merits of Cinelli's argument, his unpublished views had reached Rome and were known in some detail. In the letter to Magliabechi Bellori was discreetly noncommittal on all fronts. Discretion was certainly advisable, since the granducal librarian was a chief patron of both Cinelli and Baldinucci. The Roman scholar had been

equally discreet two years earlier, when Baldinucci called on him with an introduction from Magliabechi and sought his support against Malvasia in the Cimabue debate.

Bellori chose not to name the particular colleague "who has great affection for the Lombard school." In period usage, most of northern Italy could be designated "Lombardia,"and Carlo Cesare Malvasia was the most conspicuous spokesman for its artistic traditions. Whether or not Malvasia visited Rome in 1684, his attack and Baldinucci's defense of the Vasarian *rinascità* were central to the discussion Bellori describes.

Gian Pietro Bellori and Carlo Cesare Malvasia knew each other personally, and in the *Felsina pittrice* Malvasia cites drawings from his collection. Particularly in regard to the school of the Carracci, much of the *Felsina pittrice* makes sense only when read as a polemical response to the *Vite de' pittori, scultori, ed architetti moderni*.[10] Bellori's position and prestige were above controversy, and he had little incentive to enter the fray. In any case, the *Felsina pittrice* was drawing enough fire without overt action on his part.[11]

In Bellori's posthumously published *Vita di Carlo Maratti*, he notes this painter's distaste for the facile denigration of fellow artists. Bellori sympathetically chides his friend's excessive, if well-intentioned, ardor and perhaps expresses his own feelings on the Malvasia problem.

> Carlo Maratti advised and admonished one of those who exercised his tongue in condemning the works of even the most excellent and reputed masters. It was easy, he said, for mere children and idiots to go around finding fault and speaking ill of others. The real difficulty consists in knowing how to recognize true beauty, to speak well of a fine work, and to praise it with good reason. Often the worst is praised and the best blamed. Therefore it is not without incitement that Maratti sometimes spoke overharshly of the author who writes that those pictures by the sovereign Antonio da Correggio, universally admired in the palace of the queen of Sweden, seemed to him womanish, by a lady painter. This author also speaks of the *maniera statuina* of antique sculptures and calls Raphael dry and of the humble imagination of a *vasaio urbinate*.[12]

In the history of art historiography and criticism, Gian Pietro Bellori and Carlo Cesare Malvasia can appear as matched opposites. Bellori was the chief spokesman for the emerging system of "academic" or "classical-idealist" values rooted in the Romano-Florentine tradition of *disegno* and grand-style figure composition. Malvasia, on the other hand,

championed a defensive localism, reaffirming the perceived Emilian qualities of color, grace, and expression. In regard to personality Bellori seems cool and measured, Malvasia spontaneous and outspoken. Bellori's writing was clear, flawless, and carefully structured, Malvasia's vigorous, extemporaneous, and often disorganized, with expressive elements of regional usage.

These differences in literary style reflect profound differences in attitude towards the writing of artists' lives. Though Malvasia expounded a particular critical perspective in the *Felsina pittrice*, he emerges most distinctly as an enthusiastic compiler of the traditions, lore, and gossip of the Bolognese studios. Often his biographies read as loose assemblages of anecdotes, dramatic encounters, and pungent epigrammatic pronouncements. Divergences of style and conjunctions of career usually rend the art scene with open civil war and each notable picture represents the personal triumph of one painter over another. Individual characterizations tend to be vivid but fragmented, and these pieces do not necessarily fit together into coherent personalities. Malvasia offers lively reading, but the message is certainly unclear and often unedifying. The heroes of Bolognese painting appear at times as reckless social misfits inclined to hooliganism and vicious pranks.[13]

There are few moments of ambiguity or indirection in the *Vite de pittori, scultori, ed architetti moderni*. Bellori designed his biographies as clear object lessons expressing the aesthetic and moral values of art through the lives of its most exemplary practitioners. Though highly scrupulous in dealing with hard facts and historical documents, Bellori carefully shaped his material through selection, juxtaposition, and interpretation.

In spite of these discrepancies in personality and outlook, Bellori and Malvasia had a good deal in common. Bellori was a classical antiquarian by training, and Malvasia dedicated himself more and more to antiquarian matters in the later years of his life.[14] However different their family backgrounds, they both faced troublesome social ambiguities. Carlo Malvasia was of noble descent but questionable legitimacy.[15] In 1683 the granducal administration was unable to determine the appropriate form of courteous address for a letter to him.[16] Bellori was the son of a small farmer from Lombardy, though taken at an early age into the home of a distinguished antiquarian scholar. Bellori and Malvasia shared access to the highest levels of society but must always have been rather conscious of their relative positions.

Bellori's career was based on a timely association with French interests in Rome. In 1672 he dedicated his *Vite de' pittori* to Jean Baptiste Colbert, prime minister and also chief overseer of cultural affairs. The royal artistic bureaucracy was becoming increasingly structured at home and was rapidly gaining influence abroad. In 1676 the Accademia di San Luca in Rome and the Academy of the King of France in Rome were joined in an honorific union, and the painter Charles Le Brun named *Principe in absentia*. Bellori's lucid codification of classical-academic theory was consonant with French and francophile goals, and he achieved great authority through his institutional affiliations and force of personality. In 1678, Bellori was elected *Primo Rettore* in the Accademia di San Luca and in 1689, named to the Acadèmie Royale in Paris as *"peintre, conseiller-amateur."*[17]

There was a direct correlation between Bellori's critical and theoretical position and his dedication to Colbert of the *Vite de'pittori*. Six years later, however, Malvasia dedicated his *Felsina pittrice*, a work openly hostile to Bellori's premises, to Louis XIV. The king signalled his appreciation in the most flattering style, with the gift of his miniature portrait in a jewelled frame. In 1683 Malvasia published an antiquarian tract, the *Aelia Laelia Crispes*, "so as to express my heartfelt gratitude to Signor Colbert."[18] In 1686 he issued the *Pitture di Bologna* in order to restate and reaffirm the basic assumptions of the *Felsina*. This bore a dedication to Charles Le Brun, "Pittore primario del re cristianissimo."

A writer could not dedicate a book to a great patron without permission, though such permission did not necessarily imply a carefully considered endorsement of its contents. As we have seen, Carlo Malvasia turned to Louis XIV only when exasperated by the Bolognese Senate. The French, on the other hand, had long shown interest in the *Felsina pittrice*.[19] It was clearly destined to be a work of great cultural prestige, written by a distinguished and well-connected scholar who treated definitively a highly regarded school of art. Such conditions must have outweighed the relative orthodoxy or heterodoxy of its views.

In the *Lettera dell'Anonimo*, Cinelli admired the disdainful silence with which Malvasia greeted Baldinucci's *Apologia*. In fact the conte canonico recognized the need for a more substantial response. In the *Felsina pittrice* his principal points could elude even the most sympathetic reader, and his rash overstatements had given the unsympathetic far too much ammunition. In 1686 he published the *Pitture di Bologna*, a meticulous and carefully indexed guide to the most noteworthy paint-

ings in Bologna, including those in churches, palace galleries, and various public buildings. [20] In a brilliantly concise thirty-six-page preface, he sought to clarify his true intentions in the *Felsina pittrice*.

On 1 April 1687 Carlo Malvasia wrote Antonio Magliabechi, explaining why he had not previously favored the granducal librarian with a copy of the *Pitture di Bologna*.

> In the first place, it is really only a disguised reply to that strident *Apologia* directed at me by the frenzied Baldinucci and also that which Signor del Migliore recently wrote against me. Since they are both compatriots of yours and perhaps friends or adherents, it seemed uncivil for me to send you a copy in as prideful a spirit as they would use themselves. Also, I didn't much care whether this work circulated in Florence. I have always had the most reverent esteem for that in all ways distinguished and supreme capital, but according to Baldinucci the city has taken offense at my writings. In the *Felsina pittrice* I wished only to defend myself from the many calumnies and lies that have offended the Bolognese since the time of Vasari. It was almost enough to make me repent when I faced the necessity of replying, even with restraint and modesty, to the bitter recriminations of those two compatriot writers of yours.

Malvasia then draws an important distinction. "In order to publish this preface I threw the rest together. In it you will see the real heart of the matter regarding our blessed controversy over preeminence in painting. I claim antiquity or historical precedence for Bologna and concede, as I have always conceded, greater excellence and merit to Florence. [21]

The conte canonico restates this premise in the opening lines of his introduction to the *Pitture di Bologna*. "It is customary for a person wishing to display his nobility to deduce it as much from the mysterious origins of his earliest ancestors as from those of later date who won fame for noteworthy actions. It seems that a city claiming preeminence in painting need likewise unearth it from those remote times when the brush was wielded but clumsily, though in more recent years she gave the world masters of the first fame."

Malvasia pronounces the standard formula paralleling nobility with antiquity and applies it to the genealogy of art. He also reminds the reader that primitive artifacts are of negligible interest in their own right. Vasari, he notes, was as eager to appropriate the rebirth of art for the Tuscan Cimabue as he was to vaunt the superiority of Michelangelo

over all other modern artists. Malvasia admits that in his own writings he might have been overly partial to Bolognese masters. Unlike Vasari, however, he did not pretend to offer a universal history of art, thereby excluding and damaging others.

Malvasia sarcastically plays on quotations from Vasari, Baldinucci, and del Migliore. He proposes to demonstrate that after the *"infinite flood of evils cast down and submerged this wretched Italy, and the art of painting had been utterly lost and not merely left to wander off the track, it was reborn* in Bologna no less soon than elsewhere."[22]

To prove this Malvasia need not tire the reader's ear with a pointless and wearisome recapitulation of *"most learned,* not to mention *most grave, writers"* endlessly citing Dante. Even Vasari's crucial "poetic text" utterly fails to document the alleged Tuscan *rinascità*. Dante does not claim that Cimabue and Giotto were the first painters but rather that they were celebrated as the best. Malvasia states for the record that he never denied either their fame or their superior skill. At the present time he intends to loose the brisk wind of modern empricism on these remnants of an authoritarian tradition.

> It is enough for me to act as your guide and take you to those places where you can exercise your visual judgment. As judge your evidence today must be only the tangible facts, on the model of those current experiments in distant England and nearby Florence, supremely renowned in this as in all else (leaving aside for now pride in our own compatriots). In this way you can shake fully loose the tyrannical yoke of *ipse dixit*.[23]

The conte canonico stops short, but just barely, of saying that Leopoldo de' Medici would turn in his grave if he could read the *saggio* of the *Notizie*. Malvasia finds his evidence in the visible remains of a continuous tradition of Bolognese painting from 1115 to the present day. His outline is punctuated with suitably risible quotes from his principal antagonists.

Malvasia takes particular pleasure in repeating and then shrugging off the harshest criticisms hurled at him by his opponents. Baldinucci suggested that the author of the *Felsina pittrice* "need avail himself of information from others regarding the profession of painting and subscribe to their opinions."[24] In the *Firenze illustrata* del Migliore branded him a disseminator "of apocryphal and falacious accounts."[25] Malvasia in turn ridicules del Migliore's presumed painters' quarter of San Bar-

tolomeo as "a common alley where all the painters lived together, according to the general usage of vile craftsmen."[26]

In his discussion of the primitives, Malvasia allowed that the Florentines were the best painters in an age of notoriously bad painting. In this way he secures unsurpassed nobility for Bologna while giving up nothing of any value. He concludes, "Let us now pass on to greater things more worthy of your good taste. In the second stage, when art achieved excellence . . . Bologna no longer needed to give pride of place to any other city."[27]

For Malvasia, Francesco Francia was the first Bolognese painter to produce work of intrinsic value. When his survey reaches the time of the Carracci, he presents Lodovico as prime mover in rescuing art from the perils of mannerism. Malvasia offers an inherently Bolognese appreciation of the Carracci and their followers, though he admits pride in those "who abandoned their paternal roofs to become citizens of Rome." In the most conciliatory tone he acknowledges that "these various heroes of painting, equally and without relative superiority, all reached the heights of excellence through different paths."[28]

In his letter to Magliabechi of 1 April 1687, Malvasia voiced his relief at putting controversy behind him. "If the Lord God concedes me that much life, I will see that my *Marmora Felsinea et alia Bononiensium Antiquitatem* appears in its most correct and finished form. All my inclination and pleasure is embodied in this work, and I am especially happy to publish it because it enters into competition with no other city and will thus start no one screaming at me."[29]

Three years later, when Malvasia issued this massive antiquarian treatise, he had become somewhat less confident on this last point. Another clash threatened between the historical prerogatives of Florence and Bologna, based on their relative prestige in ancient Etruria. He wrote Magliabechi on 7 July 1691 explaining why he had not favored him with a copy of his *Marmora Felsinea* (1690).

I can hear the reproaches from my most accomplished colleague Signor Antonio! "What! You just published a book and didn't send it to me?" The fact is that I undertook the work but not the expense, which was entirely assumed by the [Padre Maestro?] Gaudenzio. He let me have but few copies, and these few landed up in the hands of my friends in Bologna and my patrons in Rome. I didn't have even a couple of copies to send to my supporters in Paris. In any case the Padre assured me that you would have seen it, and besides I didn't

much care whether anyone in Florence heard of it. As you realize without my going into detail, everyone there has already taken such umbrage at my works. Who knows what great racket the frontispiece might raise? It shows the figure of Felsina seated on a heap of marble fragments. Above a broken arch appears that eulogy by Pliny so well-known here, "Bononia Felsina vocitata cum Etruriae princeps."[30]

Viewed from Bologna, Ferdinando Leopoldo del Migliore and Filippo Baldinucci could appear as confederates since they were indeed both Florentine partisans. The *Pitture di Bologna*, however, led del Migliore to redefine his own position. In his unpublished *Reflessioni ed aggiunte alle "Vite de' Pittori" di Giorgio Vasari*,[31] he accepts Malvasia's ingenious distinction between Cimabue and Giotto's superior skill and their historical primacy.

Fame has carried the name of Cimabue and especially Giotto throughout the world, and writers both past and present have bestowed the epithet of "most excellent." It suffices to say that Dante, the most serious of writers, commemorated him in the following words, "Cimabue once was thought to command the field but now Giotto has the cry." No one has ever turned against the tide of so many voices. Though Bologna had worthy painters at the same time, none the less she concedes and admits this. Now the Bolognese writer Conte Carlo Cesare Malvasia discourses learnedly on the matter. In the preface to his latest work he states openly that he never denied the right of Cimabue and Giotto to highest honors since they reestablished painting in a better state after its fall, even though it had never been totally extinguished.[32]

In regard to Giotto's fame and excellence, however, del Migliore brings reason to bear on this tradition of unqualified praise, in sharp contrast with "le sue pitture rozze, ammanierate senza disegno."

Hearing Giotto named as most excellent, most worthy, sovereign, and other such laudatory titles, one could imagine that his works were superior to those of Guido Reni, Carracci, Tintoretto, Correggio, Borgognone, and numerous other excellent masters of recent centuries. In fact the difference is as great as that between sun and shadow. Giotto's pictures now elicit respect but not admiration or, at most, admiration for the great advance of this art from so tenuous a beginning. No one can believe that Giotto merits so much praise. He is to be esteemed *ut princeps et reductor artis* and recognized as a great credit to Florence, since one of her own was first able to bring this

fine art to a better state. No one has ever said or written anything to the contrary. Conte Carlo Cesare Malvasia has recently subscribed to this truth since he needed to touch on the point in his most learned book, the *Pitture di Bologna*. Though the conte's words are ample and meaningful, they had been twisted through commentary and interpretation. A certain person thought he could demonstrate that Giotto was the first painter the world had ever seen, by means of a long *filastrocca* of authors who mentioned him. All this heavy labor was thrown away since the Conte Malvasia never wrote nor said anything of the sort.[33]

Though Ferdinando Leopoldo del Migliore revealed a profound attraction to the culture of medieval Florence, this did not lend him special appreciation or sympathy for its artistic production. Here indeed is one of the more striking contradictions in his historical vision. The period of Florence's greatest nobility, when painting was practiced by men of noble blood, preceded the rebirth and perfection of the arts.

A point on which all the combatants would have agreed was the negligible aesthetic value of primitive art. Ten years after his impassioned defense of Cimabue and Giotto in the *saggio* of the *Notizie*, Baldinucci qualified his appreciation of their achievement.

> Turning to the fifteenth century, I find that the art of design had lain prostrate in a miserable state throughout Europe for a good hundred and forty years since its resurgence. In this city, at one and the same time, the three arts at last earned the admiration of men of good taste through the great Brunelleschi in architecture, the renowned Donatello in sculpture, and the worthy Masaccio in painting. . . . In the fourteenth century the work of our painters seemed good but was not so."[34]

The seicento debate over the primitives had far less to do with Cimabue and Giotto than with their implications. Arguments could achieve elaborately stylized form, since they normally began at several removes from the painters and the painting under discussion. Malvasia and del Migliore might also spin mental reservations of almost transparent subtlety, such as their discrimination between historical precedence and primitive excellence.

In the *Reflessioni* del Migliore repeatedly demonstrates his solidarity with "the Conte Malvasia, who has reason to complain of a raging *Apologia* written against him by someone who failed to understand what he said in the first place."[35] However, Ferdinando Leopoldo shows himself

intransigent when it comes to the crucial issue of Florentine nobility. In the *Pitture di Bologna*, Malvasia turned del Migliore's own premise against him and derided the humble origin of Florentine painting in a vulgar artisans' quarter near the Church of San Bartolomeo. Del Migliore restates his evidence for the ancient *contrada* of "San Bartolo inter dipintores," but counters Malvasia's aspersions with a discourse on the long and noble history of the Accademia del Disegno and its parent, the Compagnia di San Luca. He lays particular emphasis on the academy of Lorenzo the Magnificent and the patronage of Cosimo I, seeking perhaps to remedy the *Firenze illustrata*'s deficient enthusiasm for the House of Medici.[36]

More than noting specific virtues and vices of the *Vite*, del Migliore reflects on Vasari's suitability for the task of composing artists' lives. He felt Vasari's efforts to be well intentioned but unprofessional, and his lapses thus led to much fruitless controversy. In the *Firenze illustrata* del Migliore had already bared his split soul regarding this fellow Florentine who was the great ancestor of all art historical writers. "Oh, if only the diligent Vasari had written at the present time and seen these notices on the art of painting that have come to us through good luck and study! With this advantage there is no doubt that he would confound and drive from the field such apocryphal and falacious pretensions, be they of Carlo Ridolfi . . . or of the Conte Carlo Cesare Malvasia."[37]

In the *Reflessioni* del Migliore uses the Vasari problem to open a broad discussion of the necessary qualifications for art historical writing.

> I now touch on the Aretine Giorgio Vasari, who was more than mediocre as a painter and indeed surpassed many of his contemporaries. I turn back to a time when a large-spirited prince was benignly disposed to extend his hand to every person of noble inclination. Such aid allowed Vasari to realize happily an enterprise requiring much study and application. Considering the diverse aspects and numerous demands of such a work, it is evident that he could not achieve it by himself. This is especially the case in respect to historical erudition and appropriate expression in our good Tuscan language and all the more so when facing the test of publication. I do not deny that a painter might possess these attributes, but this occurs rarely and then in defective or inadequate form. In matters of painting he was perhaps equipped with sound rules and precepts, so that one could not tax him with errors. However, the attentive critic finds much contradic-

tion concerning historical method and on points of fact. Notwith-
standing Vasari's intelligence and diligence, I believe that he referred
many points worthy of correction to an ill-informed person who ad-
vised him badly. The results were different in regard to language,
since his work is admirably written with well-structured sentences,
excellent choice of words, and good grammar. Even here, Vasari rec-
ognized his own insufficiency . . . and applied to Abbot Don Silvano
Razzi, a Camaldolese monk and student of Varchi.[38]

Del Migliore put Vasari to three tests, weighing his mastery of artis-
tic precept, his skill in literary expression, and his understanding of
historical method. Filippo Baldinucci used similar language and com-
parable categories in his *Apologia* of 1681, when he held Malvasia's *Fel-
sina pittrice* in the balance and found it wanting.

> It is known that however ingenious and learned a person may be, if
> he undertakes to write of an art he has not himself long practiced, he
> may indeed demonstrate his intellectual attainment in regard to his-
> tory and such ornament as need accompany it. Concerning the profes-
> sion itself, however, he must rely on information from others and,
> what is more, frequently subscribe to their opinions. Fine and learned
> material is often published, as in the present case, mixed with ideas
> and opinions contrary to the common sentiment of excellent and ex-
> perienced *professori* of these arts.[39]

In 1681 Baldinucci also issued the *Lettera a Vincenzo Capponi*, a pam-
phlet considering the relative authority of "expert *professori*" and "in-
genious *dilettanti*" in questions of historical connoisseurship.[40] During
these years there was a lively debate on the matter of who was and who
was not qualified to write on artistic, historical, and art historical mat-
ters. Though personal motives often rose very near to the surface of
these discussions, methodological problems were being addressed with
a new deliberation and seriousness.

Much of the seicento controversy about Vasari reflected newly emerg-
ing criteria of historiographic responsibility. Since the time of Giorgio
Vasari, numerous authors in Florence, Rome, Venice, Genoa, Bologna,
the Netherlands, and France had set out to write artists' lives. Even
more significantly, there had been a full century of intense antiquarian
study and research. Classical antiquarians developed a rigorous schol-
arly apparatus from their wide-ranging investigations of the literary and
material culture of the ancient past.[41] "Modern" or postclassical anti-
quarians were especially concerned with genealogy and local history.

Though medieval civilization lacked much of the glamor and cultural prestige of classical antiquity, scholars could draw on such themes as civic pride, Christian devotion, and the nobility of family or nation. Genealogy was a growing field of great esteem and influence requiring meticulous and objective archival researches of the most demanding kind.

As a modern antiquarian[42] Ferdinando Leopoldo del Migliore dedicated his life to promoting stricter standards of archival practice. These were the standards to which Filippo Baldinucci was held accountable. In 1684 Baldinucci published *La Veglia: Dialogo di Sincero Veri*, in order to demonstrate his uncompromising exactness in handling documentary evidence and, more specifically, to refute del Migliore's charge that he had accepted Vasari's assertions without corroboration. Baldinucci's *Notizie* are often overloaded with semirelevant archival material that serves to demonstrate the author's solidity and professionalism. There are also conspicuous inclusions of strictly genealogical matter, as well as broad references to genealogical method.[43]

Of the writers at this time, Carlo Cesare Malvasia probably remained closest in spirit to Giorgio Vasari. Malvasia was a substantial scholar and also a man of great culture, energy, and originality. However, his methods and assumptions in the *Felsina pittrice* often look back to a belles-lettres tradition of biographical writing that could already seem imprecise, unclear, and self-indulgent. In a period when verifiable documentation was becoming increasingly important, Malvasia showed himself more creative and literary than strictly archival. For example, he often put words in the mouths of his protagonists by constructing passages of "letters" in the first person, expressing what they should or would have said if given the chance.

In the *Felsina pittrice* Malvasia makes a special point of his "homespun and popular" literary style and his close familiarity with the methods and the personalities of the Bolognese studios. In the *Apologia*, perhaps surprisingly, Baldinucci accuses him of hollow pedantry and of voicing "ideas and opinions contrary to the common sentiment of excellent and experienced *professori* of these arts."

In 1681 Filippo Baldinucci could claim only one clear qualification for art historical writing—his long firsthand experience of works of art and of artistic practice. Carlo Cesare Malvasia was a university professor and probably already recognized as an antiquarian scholar. Whatever literary license Malvasia might have allowed himself in the *Felsina pit-*

trice, his last great project, the *Marmora Felsinea* (1690), was rigorously antiquarian in nature.

In his *Apologia* to the *saggio* of the *Notizie* Filippo Baldinucci set out to verify the Florentine rebirth of art by raising a paper mountain of plausible citations from printed and manuscript sources. His method can be interpreted as an obsessive appeal to authority or a caricature of modern historical documentation. By tone and implication, however, Filippo seems to go one step farther. He bears witness to four centuries of unbroken belief in Cimabue and Giotto and reverently acknowledges the "common sentiment of excellent and experienced *professori*." As a Florentine of devout inclination, Baldinucci proposes the Vasarian *rinascità* as a mystical truth inherent in the art of design.

FILIPPO BALDINUCCI died on 1 January 1697, twenty-one years after the death of Leopoldo de' Medici and sixteen years after the publication of the *saggio* of the *Notizie*. Francesco Saverio Baldinucci wrote a moving account of the final period of his father's life.

> In these last years he lost many of his closest friends and saw both the diminishment of his family's income and the increase of their misfortunes and tribulations. Every hope disappeared, be it of comfort or aid from those most high personages who were the sole cause of all the effort and expense he had undergone. He lost heart and fell into an extraordinary melancholy, which brought on a chronic hydropsy in March of 1696. This kept him ill and an invalid until the first of January, when in cruel agony and tormented by retention of urine, he passed to the other life.[44]

The balance of success and failure is usually relative. Baldinucci's most bitter disappointment was probably the grand duke's unrelenting neglect of his art historical writings, compounded by his inability to elicit financial support elsewhere. Filippo, however, published a quantity of major works and achieved a level of official recognition that Ferdinando Leopoldo del Migliore might well have envied and that Giovanni Cinelli certainly did.

Throughout the 1690s the Jesuit Antonio Baldinucci wrote from Rome and elsewhere[45] expressing his deep concern, then growing exasperation with his father's depressive state. On 12 December 1693, Antonio sent a letter to Florence to his brother Isidoro, another of the three priests in the family. "I would write you more often and others of our family as well, but I hesitate because I always hear in reply the same

gloomy news. It is not that I don't sympathize greatly with our father and the rest of them. Since the Lord gives so much patience and strength of spirit, I console myself with the recognition that these tribulations come not as punishments but as glorious crowns bestowed on great merit."[46]

Two years later, on 24 December 1695, Antonio discussed this problem with his brother Francesco Saverio, a lawyer in Florence.

> Our father wrote me in these last few days, concluding his letter with the usual formulas of tribulation, depredation, and disaster, but expressed more strongly than ever before. We've reached a point where I wouldn't be surprised to receive an application to the pope, requesting admission of the entire family to the Hospital of San Giovanni here in Rome, built for the poor who have nothing at all on which to live and no one to help them. Please console this unfortunate old man so that he doesn't die in such affliction. I really don't know what else to do to console him.[47]

After Filippo's death, Antonio sought to break the family ties that he found incompatible with his religious calling. He wrote Isidoro on 15 July 1705, refusing to help Francesco Saverio arrange a marriage. "The reasoning in that long letter leads me to imagine it a prudent decision, although it is the kind of prudence that comes from the heart of a flea or cricket. This is the chief inheritance left us by our father. If faintheartedness and melancholy had not weighed on him so incessantly, our family would have been much better served."[48]

Throughout his life Filippo Baldinucci remained in close touch with the clairvoyant nun of Santa Maria Maddalena de' Pazzi. Until five weeks before his death, he kept his spiritual diary[49] recording the incessant round of personal and religious preoccupations. In the last decade, however, Filippo's formerly pronounced fluctuations of mood gave way to a heavy and seldom varying fatalism. He agonized over his financial affairs, pondered the causes of divine rejection, cultivated pious resignation, and prayed for benevolent miracles. At the age of seventy, on 16 June 1695, he looked back over the past year in a moment of unusual confidence and satisfaction.

> Through inspiration I recognize what really happened last year on the night of 29 August. Overwhelmed by fears, sweating and shivering, I saw myself helpless, unable to continue supporting my family without spending our meager capital. We had little income except what I could collect from my assets which were all frozen. I triumphed by

the grace of God, calming myself with the "In te Domine speravi." Great peace came into my heart, and a double enlightenment of confidence, as I noted the day before. Immediately, on 31 August, I received the Uffizio de' Nove, that of the Arte della Seta; gains in that religious litigation; then the Colleges; and so forth; and also the Innocenti. Thus it is that after ten months of collecting nothing from my debtors, I've kept my house together, I've bought drawings, and I find more money in my coffers than at my time of great fear. . . . The Lord showed me the danger but would not have me experience it and instead improved my affairs greatly. He will do the same in these present dangers . . . if I rely on him and depend on him for all things to the point of expecting miracles.[50]

Filippo looked no less eagerly to miraculous intervention in his art historical endeavors. In 1681 the granducal administration obtained for him copyright privileges for the State of the Church, issued in the name of the reigning Innocent XI Odescalchi.[51] Though this pope was generally disliked during his lifetime, his saintly austerity and undeviating piety won him popular veneration after his death in 1689. Baldinucci had every hope of continued favor from this sacred patron, as he noted in his diary on 5 October 1691. "I have taken that Most Holy Pontiff, my great benefactor Innocent XI, as advocate for me and my family in all my needs, but most of all for help with my chronological work. Since he assisted me while living, might he do so yet, concerning the success of what is already done and the completion of what there is yet to do and the happy outcome of publication."[52]

A few years later, as his health and evidently his financial resources continued to decline, Filippo sought counsel from his spiritual adviser, the Jesuit Father Innocenzio Innocenzi. "He ordered me to carry on with the work, at least as a diversion, and it might come to pass that someone will print it. He was confirmed in his opinion, when he heard that servants of God had said the same and had undertaken prayers for my future needs *iusta promissam*."[53]

On 29 March 1696, less than a year before his death, Filippo shared with Father Innocenzio his hesitations concerning the recent acquisition of a painting. "I recounted all of the most minute circumstances regarding my purchase of the picture by Raphael of Urbino, and he wished me to have no scruples, as indeed I did not."[54]

A year and a half earlier, on 29 October 1694, his scruples were very considerable when he acquired a lot of drawings.

The father approved the purchase of drawings from *Al.mo* and, without obligating me as a matter of conscience, said I would do well to make him a gift. In the case of his death, it would also be praiseworthy to offer a few masses for him. He agreed with me on the question of setting a value for such things as pictures and jewels, raising or lowering the price according to who happens to own them, and considering the diligence of the estimator, not the seller, since he doesn't own it and *vilescunt*.[55]

Towards the end of his life Filippo began assembling a collection of drawings, replacing the one he had either sold or unintentionally donated to Leopoldo de' Medici.[56] Francesco Saverio describes how his father repeated on a smaller scale the Vasarian scheme of the granducal drawing cabinet.

Around the year 1690 Filippo found the burden of his labors somewhat lightened and he conceived the idea of a new collection of drawings. As with the lives of the painters, his intention was to show the sequence from master to master, thus demonstrating with these drawings the various manners as they went from painter to painter. This was the work of some years, and he did not have the chance to finish it, though he did fill four large books in *carta imperiale*. They began with Cimabue and went from school to school up to the masters now living. At the beginning of each school, he noted its origin, development, and relative perfection.[57]

Filippo accumulated approximately twelve hundred drawings. Notwithstanding his encyclopedic conception, they were mostly Florentine and mostly rather recent. The largest group was by Lodovico Cigoli, and there were many studies and designs for festive decorations by Gregorio Pagani, Bernardino Poccetti, Bernardo Buontalenti, and Matteo Rosselli. The piece from Baldinucci's second collection that is now best known is a highly finished drawing of Taddeo Gaddi's *Presentation of the Virgin* in the Baroncelli Chapel in Santa Croce. After Filippo's death the drawings passed to Senator Pandolfo Pandolfini, then to the Strozzi family, and finally to the Louvre in 1803, through the auspices of Vivant Denon. In the course of the nineteenth century the books were disassembled and many of the labels lost.[58]

In spite of his depression and spiritual insecurity, Filippo continued his research and writing. In Florence he seems to have become a conspicuous and even distinguished figure in scholarly and literary circles. In 1687 he republished his *Lettera a Vincenzo Capponi*[59] and in 1690

issued in Florence a corrected edition of his *La Veglia: Dialogo di Sincero Veri*, now without pretense of anonymity.[60] The topical relevance of these pieces must have lessened with the years while their interest as demonstrations of method and personality increased. On 29 December 1691 and 5 January 1692, he recited a lengthy *Lezione* in two parts before the Accademia della Crusca. Filippo's witty, erudite, and very urbane discourse compared the relative merits of the painters of the ancient world and those of the sixteenth century. Almost immediately, he published this thirty-two-page work with a dedication to Prince Gian Gastone de' Medici, *protettore* of the Accademia della Crusca.[61]

In 1686 Filippo issued his second set of *Notizie* treating artistic activity between 1300 and 1400. He had changed printers and this one-hundred-ten-page volume is markedly superior to the *saggio* in both design and production.[62] On the title page he once again dedicated his efforts to Cosimo III, though he did not publish a formal letter of presentation. In his preface Baldinucci sounds rather less confident than he did five years earlier concerning the scope of his project and his opportunities for realizing it.

> Five years have passed, Dear Reader, since I presented you with the first poor fruit of my modest studies. . . . I divided those notices into decades, and I succeeded in completing the first four. In a letter at the beginning of my little work, I remember informing you of the reasons that led me to undertake such a project and of the impetus given me by a person of high affairs. . . . I have not forgotten the reasons I offered you for issuing these four decades with the names and notices of but few of the many artists who worked in that distant time. My friends were pressing me to show something of mine to the public and it did not seem well for me to hide what I had completed until the whole work was finished. Considering my advanced age, there was the danger, indeed the virtual certainty, that it would be buried in oblivion if I were to pass on when the older material was complete but not the more modern. I thus settled on a program of issuing only the initial book of each decade, not just of the first century from 1200 to 1300, but of all subsequent centuries until I reached the end. . . . I could then omit a century or a decade for which I had little information without confusing the overall chronological order. . . . Second, third, and even fourth books could also be added to each decade by myself or others. . . . It was my intention to offer you in every volume a piece of this universal tree that I have here, including nearly two thousand artists beginning with Cimabue.

. . . At the end you would have been able to assemble the various pieces and construct the entire tree from the base of the trunk to the artists presently living. . . . I regret to tell you that I cannot immediately keep such a promise. . . . It did not seem well for me to lose so much time organizing the many small bits of the tree . . . and I decided to await the appearance of more volumes of my notices. At that time, with the help of God, I will issue the whole tree in a single sheet. . . . I am not reneging on my promise but fulfilling it in a different way. My chief undertaking was to write *Notizie*, and since the *professori* of these fine arts seem infinite in number and time seems so precious, I need avoid encumbrances of this sort.[63]

The relationship of the "Albero universale dell'arte del disegno" to the *Notizie de' professori* had become ambiguous at best. Originally, as Baldinucci explained in his *saggio*, these biographical notices were conceived as an explication or gloss on the great genealogical diagram. "My index then grew into a literary opus and my chronology into a chronicle, that is to say, a voluminous collection of *notizie de' professori del disegno*."[64]

Francesco Saverio Baldinucci records the fate of the "Albero."

For Filippo this work proved truly disastrous. No one, however knowledgeable, can imagine the great study and expense needed to perfect it in both form and content. The dilettantes who saw it marvelled and spread its fame widely among discerning people. The late Paolo Falconieri, a gracious and accomplished gentleman known to all, had great affection for its author. He contacted me after Filippo's death, asking that the tree be copied in convenient form and sent to him in Rome for publication at his own expense. Such a copy required much time, effort, and money. When it had been forwarded to Rome and the difficulties of printing all but resolved, the Lord God called Paolo Falconieri to the other life. The tree remained unpublished and the copy was lost, with all it involved. . . . The original remains in Florence, in the hands of he who now writes, who is also the one who copied it. Perhaps the son will have better luck than the father.[65]

There is no further trace of either version of the tree, though we can wonder if Filippo would have regretted its disappearance quite as much as Francesco Saverio implies. By 1686 he was distancing himself from the initial grand design, the ponderous intricacy of which must have begun to look rather less elegant. The original paradigm was projected

before Baldinucci had much experience of historiographic practice, and practical considerations were now coming to the fore.

The scheme of division into *"secoli"* and *"decennali"* was curiously artificial, at once rigid and arbitrary. Every artist was to be classified according to the "decade" in which the appropriate style devolved upon him from his master or, to phrase it another way, the historical moment at which his branch sprang from the tree. This concept makes very good sense in a genealogical diagram but rather less in a corpus of artists' biographies. *Professori* often studied with more than one master, changed styles in the course of their careers, and imitated the style of masters with whom they had never studied formally. In matters of geography artists could show themselves equally uncooperative, and we can imagine the crisscrossing of branches from Antwerp to Paris, from Paris to Rome, from Rome to Naples, from Naples to Madrid, and from Madrid to Antwerp.

The chief problem for Filippo was evidently the sheer quantity of material he needed to process. His research was still a part-time avocation, and it is not clear how much personal and financial assistance he could enlist from his family and friends. He might well have concurred with Cinelli's pronouncement that "he who writes lexicons suffers the torments of hell."[66] It is remarkable how many people in these years undertook encyclopedic projects with little support, few financial resources, and no guarantee of eventual publication.[67]

Filippo Baldinucci set out to write *notizie* rather than *vite*. The implication is that he intended to present factual information in a straightforward manner rather than compose biographies dominated by formal literary considerations. He could also be seen as casting himself in an editorial role, and he did begin rather modestly by collating information obtained in response to questionnaires circulated by Leopoldo de' Medici.[68] Over the years, however, Baldinucci developed talents that neither he nor Leopoldo can have anticipated.

The notices on individual artists range from a few lines to scores of pages. They vary no less markedly in style, content, and originality. Often he did indeed function primarily as an editor, tonelessly recapitulating material from Vasari, Ridolfi, Bellori, Soprani, Malvasia, Van Mander, and others. He also carried out extensive archival research and sometimes felt the need to include every scrap of his findings, whether or not it was immediately relevant to the artists under discussion. Fre-

quently his *notizie* are shapeless accumulations, scarcely *vite* in the cultivated literary sense.

Filippo Baldinucci, however, had decided views on a variety of issues, not least of which was religious observance and its implications for the arts. He could also summon considerable skill as a writer. We hear his voice clearly in many of the *notizie*, particularly those on artists whom he knew personally or by reputation. Often these are carefully structured, with strongly unified themes. He can demonstrate remarkable gifts of characterization, a keen wit, a well-tuned ear for language, and an acute sense for evocative or amusing situations.

Filippo published his third compendium of biographical notices towards the close of 1686, some months after the second installment with its material on the trecento. In the history of art historiographical writing, the *Cominciamento e progresso dell'arte dell'intagliare in rame*[69] appears both a pioneering effort and a pragmatic compromise. This one-hundred-twenty-four-page work is the first book devoted exclusively to the masters of printmaking. It includes notices on seventeen artists, an eight-page preface, and a dedication to Abbot Francesco Marucelli in Rome.

The dedication runs to five pages and goes well beyond the forms of conventional flattery. Filippo cites his long connection with the very eminent Florentine Marucelli family[70] and the many favors he received from the Abbot Francesco and his five brothers.

> When I was in Rome, it pleased you to treat me with such generosity as exceeds my power of expression. I particularly valued your introduction into discussions with great *virtuosi* of things related to the art of design, which brought no little advantage to my studies. . . . Your courtesies, however, did not stop there. After my return to Florence, your gracious letters reached me by almost every post, accompanied by such a multitude of notices on excellent modern artists in Rome that assuredly my best material on them passed through your hands. . . . Though I cannot easily reciprocate such exceptional benefits, they make me eager to offer a small token of my obligation. As it happens, I find that I have much that will seem rather new to us concerning the beginning and progress of the art of engraving in copper. . . . I obtained this through much reading; through translations from Latin, French, German, Flemish and Dutch; through long correspondence with experts from various nations; and through seeing many works of the chief masters of this art.

Even in Italian, Filippo Baldinucci was not the first writer to discuss the art of engraving. Vasari considered it worthy of mention in his treatment of the techniques of incising, inlaying, and enamelling metal.[71] More immediately to the point, Carlo Cesare Malvasia dedicated a sixty-eight-page section of the *Felsina pittrice* to "Marc'antonio Raimondi and other Bolognese *intagliatori*, including their works engraved by others and the works of others engraved by them."[72]

Through implication rather than overt statement, Malvasia could be seen as proposing Raimondi as the father of printmaking. This nationalist strain, however, is very subdued and much of Marcantonio's biography is quoted directly from Vasari. Malvasia observes, modestly enough, "In regard to prints by my countrymen, and I discuss only these, it appears that they were principally responsible for the general familiarity and wide diffusion of the most famous works of the Roman, Lombard, Bolognese, and Venetian schools."[73]

Malvasia is largely correct about the role of Bolognese reproductive engravers in the sixteenth century. His treatment, in any case, is factual rather than thematic and consists primarily of long descriptive inventories of their work and that of more recent local masters.

In his preface to the *Arte dell'intagliare in rame*, Baldinucci reveals somewhat broader ambitions, proposing a Florentine origin for this art. "As we recount elsewhere, it had its beginning in the city of Florence in the fifteenth century through means of Maso Finiguerri, a goldsmith, silversmith, sculptor, and engraver."

Giorgio Vasari mentioned Finiguerri in passing as an accomplished master of *niello* work and the initiator of printing from engraved metal. Baldinucci further states that after the innovation of Finiguerri engraving spread throughout Italy, then to Germany and the Low Countries. Baldinucci's patriotic premise, however, is moderately expressed, and he stops well short of a belligerent, polemical stance. The rather brief *notizie* on Maso Finiguerri were not published until 1728, and the *Arte dell'intagliere in rame* does not provide a coherent survey of printmaking.

In the dedication Baldinucci describes his desire to thank Marucelli and to make use of material on hand, much of it derived from translations and from correspondence with experts. Filippo Baldinucci had rather few opportunities to express gratitude to friends and patrons. His chief project was the *Notizie de' professori del disegno*, and Cosimo III was irrevocably destined as its honorary recipient, no matter how disheartening the prince's response. Filippo could evade a grave breach of eti-

quette by issuing material from the *Notizie* under a different title and directing it to a different patron. In fact, the entries from the *Arte dell'-intagliare in rame* reappeared in their appropriate "decades" in posthumous volumes of the *Notizie*.

Baldinucci was gathering material on the entire history of postclassical European art, and he must have been anxious to get it into print in any more or less coherent form. One of his most valuable properties was a manuscript translation of Van Mander's *Schilderboek* of 1604. For over a century Baldinucci's *Notizie* offered the only substantial body of information on northern painting in the Italian language.[74]

Justus Sustermans, an Antwerp-born portraitist at the Florentine court, was a close friend of Filippo Baldinucci.[75] On 17 August 1675 he passed on a letter from his nephew Giovanni van Gelder, a painter in Modena. Van Gelder responds to a request for information, presumably directed to him in the name of Leopoldo de' Medici.[76]

> If His Serene Highness wishes me to serve him in other respects, I will write to my relatives in Flanders seeking to learn what I do not know. There is a book in the Flemish language naming all the most celebrated painters from the beginning of painting until that time, and we can try to find out about the later ones. I could translate it into the Italian tongue as well as my crude pen permits. Should you desire a copy of this book, you can order it from one of those Livorno merchants who deal with Antwerp. It is enough to specify the book of painters by *Carlo Vermandei*.

It is not clear whether the *Schilderboek* was in fact translated by Van Gelder or by some other Netherlander with Tuscan connections. In any case, Van Mander furnished Baldinucci with material on six of the earlier printmakers, including Albrecht Dürer, Lucas van Leyden, and Hendrick Goltzius. Filippo took information on members of the Sadalaer family from the *Gulden cabinet* (Antwerp, 1661) of Cornelis de Bie.

Baldinucci presented a very personal selection of more recent artists. Antonio Tempesta and Stefano della Bella were Florentine, and Jacques Callot worked long in Florence. Filippo received notices on the Lucchese Pietro Testa from Carl'Antonio dal Pozzo, whom he met during his visit to Rome in 1681.[77] At this time he also made the acquaintance of Bernhard Keilhau,[78] whose recollections of Rembrandt informed Baldinucci's brief and quirky biography. Contemporary Roman reproductive engravers figure very prominently in the *Arte dell'intagliare in rame*.

François Spierre worked extensively for the Medici, as well as for the Falconieri and the Marucelli.[79] Cornelis Bloemart was still alive in Rome and reluctantly conceded biographical data to the Abbot Marucelli.[80] After the death of Robert Nanteuil, his pupil Domenico Tempesti moved to Florence and shared information with Filippo Baldinucci.[81]

In 1688 Filippo Baldinucci published two hundred eighty pages of notices on artists from the sixth, seventh, and eighth decades of the fourth century after Cimabue, that is to say, between the years 1550 and 1580. This was the largest installment of the *Notizie de' professori del disegno* to date and the last to appear during the author's lifetime. The title page bears the name of Cosimo III, though there is no letter of dedication nor indeed an author's preface.

Baldinucci does not explain the gap of one hundred fifty years after the previous set of *notizie* treating the fourteenth century. At least part of his reasoning is readily apparent, since he chose not to duplicate the period covered most thoroughly by Vasari. Though Filippo had a great deal of publishable material on hand, he had yet to compose new biographies of such key figures as Brunelleschi and Michelangelo.[82]

The first fifty-five pages of the 1688 *Notizie* are devoted to Bartolomeo Ammannati, a sculptor and architect with special significance for Filippo Baldinucci. Ammannati and Baldinucci both maintained close ties with the Jesuits, and they both held uncompromising views on morality in the arts. Filippo lived in one of a group of three houses designed by Ammannati. In the course of his research he discovered that another of these had been the home of the Blessed Luigi Gonzaga. Baldinucci appended a "stop-press" announcement at the back of the 1688 *Notizie*, heralding Cosimo III's decision to place a suitable memorial on the facade.[83]

The actual notices on Ammannati comprise thirty-five pages, half of these given to Filippo's archival researches on the history of the Florentine Jesuit Church of San Giovannino. After this, in a separate section of seven pages, he reprints Ammannati's 1582 letter to the Accademia del Disegno, alerting its members to the perils of licentious art. Since Ammannati was one of the early architects of Palazzo Pitti, Baldinucci adds an exhaustive thirteen-page description of Paolo Falconieri's proposal for rebuilding the chief granducal residence. In 1681 Falconieri had completed a great model of this project, with the assistance of the Tuscan Academicians in Rome.[84] When the model was sent to Flor-

ence, it must have aroused interest and curiosity. Baldinucci was probably glad of the chance to honor so distinguished and influential a patron, and Falconieri was probably eager for his project to become better known.

Filippo had long dedicated himself to republishing Ammannati's 1582 letter to the academy. As early as 1682, Giovanni Cinelli attacked this scheme in the ill-fated fourth *scanzia* of the *Biblioteca volante*.[85] On Christmas Day of 1683, Baldinucci sent Apollonio Bassetti a manuscript copy of his life of Ammannati, in expectation of the grand duke's fervent approval.

> Among various edifying things, you will see a letter written by Ammannati to the *Professori del Disegno*, in detestation of lascivious paintings and sculptures. A great servant of God tells me that it might engender a major rebirth of souls in our present age, if God wills me to publish anything more of the great deal that I have ready, that is to say, if I can issue the decade including this biography. Above all else, I think that the Most Serene Patron would wish to hear this letter since it is so much in keeping with his chaste and holy ideas. He would not miss the chance for this letter to confound those many artists who feel that men of talent need not contain themselves within the bounds of decency. I wish to publish it for this reason if for no other.[86]

Filippo should have found an appreciative audience in Cosimo III. The grand duke responded with solemn rigor to problems of sexual conduct and public morality. Later in his life, he removed Bandinelli's indecorously nude *Adam and Eve* from the Cathedral and commissioned metal draperies for Michelangelo's reclining figures in the New Sacristy at San Lorenzo. It does not seem, however, that this approach proved more successful than the others in eliciting support for Baldinucci's *Notizie de' professori del disegno*. Filippo was in any case deeply committed to the issues raised by Ammannati. In 1687 he published the letter in separate form, a year before its appearance in the third volume of the *Notizie*.[87]

In composing his biographies Baldinucci was often troubled by artists of the first rank whose personal lives or choice of subject matter was less than exemplary. The distinguished Florentine painter Giovanni da San Giovanni aroused particularly intense misgivings, since he proved distressingly unedifying on both counts. In May of 1690 Filippo sought counsel from his spiritual advisor. "Regarding the *Vita* of Giovanni da

San Giovanni, I conferred with him on the impropriety of certain elements of sordidness. The father showed little concern about this sin and approved the idea of showing it to the padre rettore."[88]

Baldinucci presents Giovanni da San Giovanni as a negative object lesson on the wages of artistic irresponsibility and a dissolute life. He makes a repeated and conspicuous show of refusing to describe Giovanni's more regrettable works, actions, and statements.[89]

Probably the most gifted but most misguided of worldly artists were Annibale Carracci and, yet more grievously, his brother Agostino. Considering the Galleria Farnese, Baldinucci proposes that Annibale's shamefully low pay was perhaps the judgment of heaven on the lasciviousness of his art. Agostino is taken to task sternly for the obscenities in his prints, "for which he was bitterly rebuked, not only by Lodovico but by every man of conscience in that time."[90] According to Francesco Saverio Baldinucci, his father did not limit himself to verbal criticism of such lapses.

> While going about the city one morning, Filippo saw a beautiful *chiaroscuro* picture in the shop of a secondhand dealer. This showed a life-sized Venus competely nude with a satyr and a few *amorini* in rather indecent attitudes, though a most beautiful work of painting from the infallible hand of Carracci, whose work he loved. He agreed with the owner on a price, bought it, and carried it off to another shop. There he took his penknife and cut it from top to bottom into tiny pieces and then departed, leaving behind the stretcher and frame. The shopkeeper and other observers asked him why he did not take the painting home and keep it covered and thus not exposed to everyone's view. With his usual frankness Filippo replied that only tabernacles are kept covered, from veneration and to foster devotion. Obscene pictures, however, need be removed from the world so that they no longer scandalize anyone. If the perpetrators of such works are in purgatory, their penalties might then be alleviated in some degree.[91]

Until his final moments Filippo Baldinucci remained an uncommon example of devout behavior. Francesco Saverio constructs for him one of the very best of good deaths.

> On the second to last day of December he asked for extreme unction in the presence of many priests and gentlemen who attended him continually. . . . Afterwards he summoned his sons to the bed. Speaking with a clarity and directness totally inconsistent with his

condition, he declared that having three of his sons in the priesthood did not negate his identity as parent and theirs as children. Calling for the last time on the authority and respect due him, he thought it appropriate to give his final blessing. He asked forgiveness for any failings in his example or in their upbringing and promised to pray that God and the Holy Virgin might redress his inadequacies. After many pious pronouncements, he offered his blessing in such potent yet tender words that all were moved to tears and some so overcome that they returned home in deepest silence. One of the pious and learned people in sacred orders spoke out in a loud voice, "So indeed did the holy old man Tubbia [Tobias?] address Tubbia [Tobias?] his son." Father Giuseppe Maria Sottomaior of the Society of Jesus, famed for his rare goodness and holy doctrine, further observed, "The death of this good layman can teach even the wisest and most resigned religious how to die. . . ." Observing Filippo's great pain and torment, it appeared that only through the Lord's grace could he have construed so considered and forceful a final discourse. As soon as he finished speaking . . . he lost command of his faculties and fell into a sudden and terrible agony. Even in such extremity he uttered only his accustomed words when bearing tribulation, "Help me, Most Holy Virgin!" With these words in his mouth, he expired after thirty hours of incoherence. His son Father Antonio then rose. Turning to his brothers, he said with the greatest modesty, "Brothers, let us remember that *'fili Sanctorum sumus.'* Our grandfather was a great servant of God and our father and mother in no way inferior. Let us live our lives so that we may later join them."[92]

Filippo Baldinucci was buried in the Florentine Church of San Pancrazio.[93] Antonio's tribute to his mother's godliness is one of very few references to Caterina Scolari Baldinucci. We know that she descended from an old Florentine family and posed at least once for Carlo Dolci.[94]

Filippo and Caterina Baldinucci had five children, all male, born in a period of slightly more than seven years, from around 1657 to 1665.[95] The eldest, Giovan Filippo, became a Dominican, first at the Monastery of San Domenico in Fiesole, then at San Marco in Florence.[96] The second, Ignazio, ran through a turbulent and disastrous commercial career in Florence, Madrid, and finally Lyon, where he died at an early age.[97] The third, Francesco Saverio, was a lawyer and shared many of his father's business and art historical interests.[98] The fourth, Isidoro, served as a priest in Florence and apparently attracted little attention to him-

self.[99] The fifth, Antonio, became a renowned Jesuit preacher and was beatified in 1893.[100]

In 1681 Filippo delivered Antonio to the Jesuit seminary at Sant'Andrea al Quirinale in Rome. In the first years after his noviciate he demonstrated considerable interest in his father's artistic activities. On 1 September 1691 Antonio wrote to his brother Francesco Saverio in Florence.

> In a letter from our father . . . I learned of his close friendship and many obligations to the Abbot Marucelli. I thus went to his house to thank him and to carry out what was required of me. . . . He and I and many others wish our father to publish what he has written so that this great labor might not be in vain. At present, however, the expense he indicates renders very difficult a successful conclusion. Since the providence of God has always taken care of our family, I do not believe that He can fail to aid so worthy an effort. I am waiting for our father to favor me with the oration he is about to deliver in the public academy.[101]

Antonio arranged to call on "il pittore David"[102] and enlisted Filippo to help sell copies of the Jesuit painter Andrea Pozzo's *Prospettiva de' pittori ed architetti* (1693). "Since this father is setting out to paint our church, we need much money and hope to raise it from this first volume. The second volume will be printed when there is money and when the church is painted."[103]

Antonio required copies of certain images of Saints Ignatius and Francis Xavier and asked Filippo to have them executed as economically as possible.[104] He also suggested that his father's literary talents be directed to the composition of saints' lives.

> In my letters last month I begged our father to offer fervent prayers on my behalf at the altars of the Santissima Annunziata and Saint Maria Maddalena de' Pazzi. . . . I also requested, as it were in passing, that he try writing a separate life of this great saint since his efforts at painters' lives have been so praiseworthy. A life of Saint Maria Maddalena de' Pazzi was read in our refectory with great satisfaction, but it would please even more if he could write a fuller one in his excellent style.[105]

As the momentum of Antonio's vocation quickened, his father's emotional demands became increasingly unwelcome. Antonio taught grammar at the Jesuit colleges in Terni and Rome and developed his

skills as a preacher. His impassioned oratory and dramatic displays of penitence were to win him a great following, particularly among the country folk of the Abruzzi and the Marche.

In November of 1695 Antonio Baldinucci planned a visit to the Jesuit college in Florence, located in Borgo Pinti close by the family home. "When I come, I won't be able to visit our father, since a month of spiritual exercises will begin immediately and this will excuse me."[106]

Years later Antonio was scheduled to preach a series of Lenten sermons in Livorno. He wrote his brother Father Isidoro on 16 March 1709. "In regard to coming to Florence, I experience a repugnance that I do not know how to overcome. It seems so wildly inconsistent, arriving barefoot with my pilgrim's staff, then going off to mama's for a visit."[107]

If Antonio Baldinucci can be seen as realizing Filippo's thwarted religious aspirations, Francesco Saverio inherited his business and family responsibilities. With three of the brothers in sacred orders and a fourth abroad, Francesco Saverio lived much in the shadow of his impressive, admired, exigent, and unstable father.

Until his very last years, Filippo sought patronage jobs in the granducal administration, though with little assurance of support from Cosimo III.[108] Early in 1690 he obtained a post for Francesco Saverio as "assistant to Senator Pandolfini . . . in affairs of the *pratica segreta*."[109] Ruberto Pandolfini was *Auditore delle Riformagioni* from 1682 to 1696, and in this capacity Filippo appealed to him in 1684 for protection from del Migliore's alleged slander.[110] Probably through Francesco Saverio, the senator's son Pandolfo Pandolfini acquired Filippo's drawings.[111]

After Filippo Baldinucci's death Francesco Saverio was entrusted with his papers, including masses of research for the *Notizie* in varying stages of completion. For most of his life he struggled to get this material into print. In 1702 four hundred twenty pages of notices were published concerning artists from the decades between 1580 and 1610. Once again Cosimo III's name figured on the title page, though the immediate patronage came from a younger generation of the Marucelli and Capponi families. The publisher described the background to this initiative.

> Signor Filippo issued the first two volumes of the *Notizie* . . . beginning in the year 1260 when the art of painting was reshaped by Cimabue. He left out the third volume which was already finished in order

to publish the fourth, beginning in 1550 and ending in 1580. With great application and diligence . . . he labored incessantly to complete the work, and thus it might well be said that he died with the pen in his hand. . . . To satisfy *letterati* and *dilettanti* of these noble professions . . . some gentlemen thought to print the remainder of his *decennali*, picking up where the author left off. Canonico Tommaso and his brother Ruberto Marucelli, along with Conte Ferrante Capponi, . . . begged the precious treasure of these writings from the Avvocato Francesco Saverio Baldinucci. A worthy son of Signor Filippo, he also desired that works so dear to him might see the light. These gentlemen assumed this burden at their own expense and gave me the task of printing it.[112]

The remaining notices were issued in 1728 as the third and sixth volumes. The third volume offers three hundred fifty-five pages of biographies from the years 1400 to 1550. The massive sixth volume, covering the decades of 1610 to 1670, runs to six hundred thirty-four pages.[113]

By 1728 Cosimo III had been dead for five years. Neither the third nor sixth volume bears a dedication. Filippo Baldinucci had been dead thirty-one years and Leopoldo de' Medici fifty-three years. Francesco Saverio Baldinucci had reached the age of sixty-five.

Francesco Saverio would go unremarked in history were it not for his dogged devotion to his father's memory. He seems a person of modest gifts and modest aspirations. Apparently he belonged to no academies and published no work under his own name.

Filippo left many *notizie* in rough or incomplete form. Francesco Saverio undertook the exhausting and anonymous labors of copying and editing. Largely on his own, he produced some thirty lives, including a reverent biography of his father.[114] Francesco Saverio's mode of expression is tentative and plodding, with few literary or philosophical pretensions.

The 1728 *Notizie*, like those of 1702, appeared through a group effort.[115] The prime mover was evidently Francesco Maria Niccolò Gabburri. As a young amateur, Gabburri made the acquaintance of the elderly Filippo Baldinucci. At some point he acquired a large book of Filippo's red and black chalk drawings "of men notable for their birth, for their practice of letters, or for their excellence in the art of painting."[116] This wealthy dilettante and collector became a central figure in cultivated Florentine circles of the earlier eighteenth century, when he

welcomed *virtuosi* of every description to his house in Via Ghibellina.[117] By 1719 Gabburri had begun writing artists' lives and around 1740 composed a bright, superficial, and not always well-informed biography of Filippo Baldinucci.[118]

Since the *Notizie* were published with the seal of the Accademia della Crusca, Francesco Saverio Baldinucci's efforts were scarcely acceptable on their own. The last thousand pages of notices were revised by three distinguished *letterati*, Anton Maria Salvini,[119] Anton Maria Biscioni,[120] and Mario Antonio Mariti.

Francesco Saverio Baldinucci assumed the more pedestrian task of compiling the indexes. It does not seem that any lives of his own composition were accepted for publication with those of his father. The third volume of the *Notizie* includes a portrait of Filippo Baldinucci engraved by Pietro Rotari. This is the only illustration in the nearly two thousand pages of the *Notizie de' professori del disegno*. Francesco Saverio probably intended the biography of his father to figure here as well.[121]

IN OUR STUDY of Filippo Baldinucci we have investigated the records of his business affairs, considered the evidence of his published work, followed the correspondence of his friends and enemies, and shared the personal revelations of his spiritual diary. Though we now know more about Baldinucci than any other connoisseur, antiquarian, or *letterato* of his time, he remains a difficult and elusive figure.

Filippo Baldinucci is a man who escapes easy definition. He was a reactionary and an innovator, a bigot and a wit, a hired bookkeeper and a gentleman scholar, an insecure petit bourgeois and a distinguished public figure. His emotional balance was precarious at best. He ran through rapid cycles of religious obsession and secular ambition, vivid enthusiasm and bitter fatalism, energetic achievement and paralyzing despondency. In his writings Filippo advocated rigid authoritarianism, liberal humanism, rational empiricism, and pietistic mystification.

Filippo struggled to establish himself as a writer of artists' lives but was compromised by the vagueness of his qualifications, by the ambiguity of his social position, and by the inadequacy of his personal finances. It is difficult to determine the extremity of his economic predicament and even more difficult to disentangle it from his chronic emotional distress. Though there is no evidence that the Baldinucci family suffered actual want, Filippo's scholarly career was characterized

by thwarted aspirations, strained resources, and incompletely realized opportunities.

Baldinucci initiated his scheme for the *Notizie de' professori del disegno* under the auspices of Leopoldo de' Medici. Cosimo III could have guaranteed the project through a modest subsidy, thereby enhancing the cultural prestige so essential to his family's identity. In retrospect Cosimo's meager support seems irrational and shortsighted and his offhanded treatment of Filippo Baldinucci callous and mean-spirited.

Cardinal Leopoldo and Grand Duke Cosimo were both passionately devoted to the dynastic heritage of the House of Medici. These two princes, however, differed markedly in personality and felt this obligation in different ways. The grand duke probably thought but seldom of Filippo Baldinucci, yet considered himself sympathetic within reason to the project for the *Notizie*. Cosimo III was constantly besieged by supplicants and petitioners of every description. With deadly fairness, he granted some of Filippo's petitions and refused others.

In the small and indeed contracting world of seventeenth-century Florence, Baldinucci's options were painfully limited. He commanded neither the wealth nor the social distinction of an aristocratic *virtuoso*. As a family man with business responsibilities, he discovered his scholarly vocation too late for a career in the church. His intellectual gifts and personal financial resources were considerable, and he required only a committed patron to help him bridge the gaps between his various obligations and endeavors. Filippo Baldinucci found and then lost such a patron in Cardinal Prince Leopoldo de' Medici.

If Cosimo III had shared his uncle's interest in art historical research, Baldinucci might have led a more tranquil and productive life. The *Notizie de' professori del disegno* might have been published sooner and in a fuller, more coherent form.

If the system of aristocratic patronage had not broken down, Baldinucci would not have been driven to such drastic schemes in hope of salvaging his career. If he had not been subject to this acute emotional strain, his psychological affliction might have been less extravagantly expressed.

If Filippo Baldinucci had enjoyed a more satisfactory life, we would know far less about him. As it is his struggles, his successes, and his failures reveal much about the habits, the social customs, and the human possibilities of late Medici Florence.

Appendix I

The Diary of Mattias and Leopoldo de' Medici
from Their Trip to Rome in 1650
(ASF Misc. Med. 94, insert five)

"Diario nella venuta à Roma de' Serenissimi
Principi Mattias et Leopoldo"

Essendosi risoluti li Serenissimi Principi di Toscana Mattias et Leopoldo di venire a Roma per l'anno santo scrissero al Signor Marchese Riccardi Ambasciatore che facesse saputo questa loro volontà a Sua Santità et al Eminentissimo Cardinale Panzirolo il che fu da Sua Eccellenza subito esseguito, et però d'ordine di Sua Santità fu spedito dal Signor Cardinal Panzirolo corriere a Monsignor Bentivogli Nunzio a Firenze che Sua Santità haveva gusto grande di vedere et far servire questi Principi in Roma, dove haveriano havuto ogni sodisfazione purche non entrassero nell'interesse del Signor Marchese Riccardi Ambasciatore di Toscana quale haveva lite con la camera che pretendeva a tutta forza et come lupo rapace levarle centotrentamila scudi, che già Monsignor Tesoriere d'ordine di Sua Santità gli haveva sequestrati nel Monte della Pietà come è notorio a tutta l'Europa con stupore e maraviglia d'ogni invidioso e maligno, non che di tutti gli altri che non havevano notizia di tale ingiustizia. Il che significato alle Altezze Loro da Monsignor Nunzio, risposero che in tale particolare non sariano entrati con Sua Santità.

Et intendendo pochi giorni doppo non solo essere queste Altezze partite per questa volta, ma anche per corriere essere vicino a Roma, Sua Eminenza spedì un suo gentilhomo con due carrozze da campagna ad incontrarle, reverirle et servirle, facendo scusa che l'audienza ordinaria del giorno seguente che haveva già havuta da Sua Santità impediva che non poteva essere Sua Eminenza medesima di persona a pagare questo debito per allora, ma subito che fu licenziato da Sua Beatitudine se ne volò per incontrarle e per ricevere li loro comandamenti.

[Saturday 2 April 1650] Arrivarono la sera medesima di sabato che correva il di 2 aprile et andarono a smontare al loro palazzo della Trinità de Monti, dove senza voler vedere alcuno, ancorche vi fossero molti ad aspetarle, verso le tre ore di notte cenarono et andarono a riposare. Mandarono subito arrivati il Maestro di Camera del Signor Ambasciatore da Monsignor Maestro di Camera a darle parte del loro felice arrivo, acciò lo partecipasse a Sua Santità, come fece la sera medesima,

[Sunday 3 April] quale doppo la Cappella venne a complire per parte del Papa con Loro Altezze significandole il gusto e contento che Sua Santità haveva che fossero arrivati con buona salute a pigliar questa devozione dell'Anno Santo.

Fu trattato detto Monsignore da questi Principi come un Patriarca, dandolo da sedere doppo haverlo incontrato et accompagnandolo nel partire a mezza scala, fu ben servito da altri poi sino alla carrozza.

La medesima mattina s'abboccarono doppo la messa in Sant'Isidoro con il Signor Cardinal Montalto quale hebbe con Loro Altezze discorsi alla lunga.

Fu sparsa la voce in Roma del loro arrivo, et l'istessa mattina mandarono molti Signori Cardinali per complire, et anche li due Nipoti del Papa, Principe Ludovisii et Principe Giustiniani, ma perche allora Loro Altezze non volsero vedere alcuno, il Maestro di Camera del Signor Ambasciatore pigliò le ambasciate et riferiva qualche d'ora in ora succedeva di nuovo.

Il giorno doppo desinare andarono a baciare il piede a Sua Santità al quale per mezzo di Monsignor Gerini era già stata fatta l'ambasciata per parte loro et in anticamera trovarono li due Principi Ludovisii et Giustiniani, con li quali fecero un semplice complimento per non fare aspettare il Papa, al quale baciato che gli hebbero i piedi, li misero a sedere nel solito sgabello, scoperti si, ma con il berrettino di raso in testa, et essendovisi trattenuti quasi due ore si licenziarono, et immediatamente se ne andarono dalla Signora Donna Olimpia, quale ancorche indisposta non volse recusare il favore, continuando il suo solito possesso ad essere visitata come prima Dama, e così finì la sera per essersi la visità dilatata sin a due ore di notte e più.

[Monday 4 April] La mattina seguente andarono publicamente per la solita scala al Concistoro, dove si trattenero fino all'extra omnes, discorrendo con molti Signori Cardinali che di mano in mano venivano, avvicinandosi per rallegrarsi della loro venuta con applauso et gusto di tutto il popolo, non che de Cardinali fuori che il Cardinal Barberino, che si scostò, giache il caso portò che detti Signori Principi si accostassero nell'entrare alla banca, dove era vicina Sua Eminenza, et fatto l'extra omnes, se ne rientrarono nella bussola, dove in anticamera del Papa riceverono molti complimenti da diversi principi et cavalieri et da Monsù Fusars in nome dell'Ambasciatore di Francia, da'quali si licenziarono immediatamente et per la lumaca s'incaminarono verso la Minerva, dove il Signor Duca di Bracciano li stava attendendo per complire e rassegnare alle Altezze Loro la sua devozione, et ivi udita messa tornarono a casa, dove vennero alcuni principi per rallegrarsi della loro venuta, in quali fu risposto essere detti signori in casa, furono però prese le ambasciate, et secondo il solito riferite.

Il giorno doppo desinare andarono a Sant'Andrea della Valle dove si abboccarono con il Signor Cardinal d'Este concertamente con il quale discorsero quasi un'ora.

[Tuesday 5 April] Il martedì mattina andarono alla messa a Santa Maria Maggiore, dove il Principe Borghese si stava aspettando per riceverli come fece facendoli mostrare la Cappella Paolina con tutta la guardaroba della sagrestia.

Il giorno doppo desinare con carrozze da campagna andarono a San Gregorio

per incontrare il Papa che faceva le quattro chiese, et smontati di carrozza si misero in ginocchioni per ricevere la benedizione quale datale mandò un suo palafreniere a complire con Loro Altezze rallegrandosi della buona giornata che havevano in fare le quattro chiese.

[Wednesday 6 April] Il mercoledì mattina andarono a visitare il Signor Cardinale Panzirolo a Monte Cavallo, dal quale hebbero li soliti onori nel ricevimento et nell'accompagnatura, dicendo loro che Sua Santità haveva gusto che si fossero visti con li due Principi Nipoti Ludovisii et Giustiniani.

Il giorno andarono a fare le quattro chiese. La sera il Signor Febei Maestro delle Cirimonie venne a negoziare l'aggiustamento della visita delli sopradetti Signori Nipoti d'ordine di Sua Santità, al che condescesero le Altezze Loro per dare gusto al Papa non ostante che havessero risoluto di non volere vedere alcuno in casa, benche fosse stata dal Signor Ambasciatore con li suoi proprii parata di velluto cremisino et tele d'oro contagliate fatto apparire benissimo un appartamento per il Signor Principe Mattias et un'altro appartamento di damaschi cremesi con trine d'oro per il Signor Principe Leopoldo del che aggiustato.

[Thursday 7 April] Giovedì mattina vennero per il giardino il Signor Principe Lodovisii et il Signor Principe Giustiniani a visitare le Altezze Loro, uno però aspettò che fosse partito l'altro per fare ogn'uno da se questo complimento, et furono ricevuti a capo le scale del giardino dove erano entrati, li fu data la mano et titolo di Eccellenza, et furono nel partire accompagnati fino alla carrozza, et anche lasciati partire, et le Altezze Loro il giorno andarono a visitare le Principesse Nipoti, dalle quali hebbero tutti gli onori che potevano desiderarsi.

[Friday 8 April] Il venerdì mattina andarono alla messa in San Lorenzo in Lucina, dove veddero le reliquie di quella chiesa et particolarmente la graticola dove fu messo il santo sudetto; poi venne il Signor Cardinale Capponi con il quale discorsero fin'all'ora di desinare. Il giorno andarono a Santa Maria degli Angioli, et entrarono a vedere il convento de' Certosini. La sera andarono all'oratorio di San Marcello, dove fece il sermone il Cardinal Capponi, et stettero in un palchetto dove fu anche il Signor Duca di Bracciano con molti altri signori. La medesima sera vi fu anche la Signora Ambasciatrice di Spagna a certe finestre col Signor Duca dell'Infantado et la Signora Donna Olimpia con le figlie in un'altro palchetto fatto per le Eccellenze Loro.

[Saturday 9 April] Il sabato mattina andarono a vedere il palazzo del Signor Principe Borghese, et il Signor Agostino Maffei fece loro mostrare tutta la guardaroba, vedendola tutta la famiglia che andava servendo le Altezze Loro, ma le gioie furono solamente mostrate alli due Signori Principi dal medesimo Signor Agostino.

Non passò quasi mai giorno che non s'abboccassero con qualche Cardinale o Principe di concerto in qualche chiesa, non dando l'Eccellenza se non a Grandi

di Spagna o Nipoti di Papa. Si crede non vi rimanesse quasi nessuno in Roma tanto de' Cardinali come de' titolati che non si abboccasse con Loro Altezza.

Il giorno andarono agli Orti Farnesi in Campo Vaccino.

[Sunday 10 April] La domenica delle Palme andarono a Monte Cavallo a vedere la Cappella, et stettero a vederla in piedi incontro al Papa con tutti quei Signori che li servivono, et finita tutta la funzione il Papa mandò un Maestro di Cerimonia a fare complimento se erano stracchi, et lasciato partire il Sacro Colleggio, come Sua Santità, se ne uscirono per la porta dove erano entrati che fu la porta a capo le scale avanti s'entri nella scala.

Il giorno andarono alla vigna del Signor Cardinale Montalto, dove venne il detto Signor Cardinale in compagnia del Signor Cardinale Colonna, Cesis et la Queva.

[Monday 11 April] Il lunedì mattina fu sentita la messa da questi Signori in Sant'Agostino dove s'abboccarono con Monsignor Lomellino Tesoriere, al quale raccomandarono la causa del Signor Ambasciatore, poi andarono a vedere il palazzo di Piazza Madama. Il giorno dopo desinare andarono a fare le quattro chiese.

[Tuesday 12 April] Il martedì mattina andarono alla Predica della Passione in San Giovanni de' Fiorentini, et stettero a sentirla sull'organo, il giorno andarono a vedere il Papa che andò a San Pietro.

[Wednesday 13 April] Il mercoledì mattina andarono a vedere il Campidoglio, et poi andarono alla messa in Ara Coeli. Il giorno andarono al mattutino alli Cappuccini, dove venne il Cardinale Rocci per abboccarsi con le Altezze Loro.

[Thursday 14 April] Il giovedì mattina andarono a San Pietro a vedere leggere la bolla *In coena domini* et stettero alla benedizione vicino alla sedia del Papa. Nel ritorno che fece Sua Santità si misero per la calca della gente fra le stanghe della sede et andarono a vedere la lavanda degli Apostoli, quale finita vennero a desinare in Campo Marzo con il Signor Ambasciatore, et con tale occasione visitarono la Signora Ambasciatrice et furono 18 a tavola conforme erano quelli 3 tre giorni che Sua Eccellenza gli sposò nel suo arrivo, et il Maestro di Camera di Sua Eccellenza come prima servì di coppa il Signor Principe Mattias et il Signor Tolomei il Signor Principe Leopoldo. Il giorno andarono a visitare i sepolcri.

[Friday 15 April] Il venerdì mattina andarono a San Paolo a vedere il crocifisso et con tale occasione andarono alle quattro Chiese. Il giorno sentirono il mattutino alli Cappuccini e la sera fecero la Scala Santa.

[Saturday 16 April] Il sabato fu fatta la solita communione in casa di Sua Eccellenza et le Altezze Loro la fecero in San Lorenzo in Lucina. Il giorno andarono per Roma con li carrozzini vedendo le mostre dei Coronari del Pellegrino et di altri mercanti.

Il sabato notte s'andò a vedere la festa delli Spagnoli in Piazza Navona in

casa della Signora Donna Olimpia, quale mandò ad invitargli, et stettero in compagnia di dame a vedere alla Ringhiera.

Il Signor Ambasciatore et la Signora Ambasciatrice andarono a vederla in casa del Signor Eugenii.

[Sunday 17 April] La domenica mattina giorno di Pasqua fu tenuta cappella in San Pietro nella cui chiesa celebrò Sua Santità. Questi Signori andarono a vedere in un palchetto fatto per loro apposta vicino all'altare maggiore dove fu tenuta la Cappella.

Il giorno andarono alla trinità di Ponte Sisto a vedere li pellegrini ove venne anche il Papa a lavare li piedi ad alcuni pellegrini, et questi Signori ambidue li tennero la conca mentre Sua Santità fece la lavanda con molto gusto del Papa.

[Monday 18 April] Il lunedì mattina andarono a vedere il Collegio Romano, la libreria et la Chiesa di Sant'Ignazio con la spezieria de' Gesuiti.

Il giorno a vedere la vigna del Signor Principe Borghese quale fece fare loro una bella colazione, ma non fu toccato quasi niente. Il Signor Agostino Maffei fu il direttore.

[Tuesday 19 April] Il Signor Principe Ludovisii fece loro pur fare la colazione quando andarono a vedere un altro giorno la sua vigna e nel mutare carrozze, entrarono la sera in casa del Signor Marchese del Bufalo et visitarono la Signora Marchesa con quell'occasione.

[Wednesday 20 April] Il mercoledì mattina doppo Pasqua andarono con tutta la loro famiglia a San Pietro a desinare, che Sua Santità li reiterò le instanze che fossero andati a Palazzo et li fu dato l'alloggiamento vicino alla Scala Clementina et per trattenitore il Signor Marchese del Bufalo, quale fecero stare a tavola loro, che si fece servire da loro Signori coppieri. Il Signor Principe Mattias dal Signor Conte Strasolto e il Signor Principe Leopoldo dal Signor Balì Ugo Stufa, et furono trattati alla grande dal Signor Cardinale Panzirolo et dalli Nipoti Lodovisii et Giustiniani li furono mandate le carrozze continuamente.

[Thursday 21 April] Il giovedì mattina andarono a vedere benedire gli Agnus Dei nelle stanze di Sua Santità. Il giorno andarono a San Pietro in Montorio con carrozze a sei delli nipoti et di Panzirolo, et si trasferirono a vedere la Vigna del Cardinal Cornaro et poi quella del Cardinal Lanti.

[Friday 22 April] Il venerdì mattina andarono a vedere la benedizione degli Agnus Dei, dove si abboccarono con l'Ambasciatore Cattolico che stava incognito con la Signora Ambasciatrice a vedere la detta benedizione, et il giorno andarono a vedere Castel Sant'Angelo et ivi si trattennero sin a notte per vedere ogni cosa.

[Saturday 23 April] Il sabato mattino andarono in Cappella di Sisto a vedere distribuire gli Agnus Dei, et stettero alla messa nella Cappella di Sisto et alla distribuzione in un palchetto fatto per Loro Altezze, dove salì anche il Signor Cardinale Sforza et il Signor Conte Vitman, et nel ritorno che fecero alli loro

appartamenti Sua Santità mandò loro due bacili di Agnus Dei per distribuirgli alla loro famiglia. Il giorno si andò a vedere la vigna del Signor Principe Lodovisii al giardino di Monte Cavallo, quale fece loro fare la collazione.

[Sunday 24 April] Domenica andarono a vedere il giardino del Papa passando per la galleria. Stettero a desinare da Sua Santità, si fecero servire dalli loro coppieri, finito il banchetto si accostarono li Principi più vicini per discorrere con Sua Santità. Il giorno poi andarono a vedere certe pitture alla Longara et al Palazzo de' Chigi, et poi andarono a vedere il palazzo di Farnese.

[Monday 25 April] Il lunedì mattina viddero la libreria et armeria di San Pietro, dove venne anche il Signor Duca di Bracciano.

[Tuesday 26 April] Il martedì mattina si licenziarono da Sua Santità ringraziandola dell'onore et favore fattoli. Si ritirarono a desinare alla Trinità de' Monti, et non ostante che le Altezze Loro ordinassero che fossero regalati tutti quelli offiziali et ministri che le havevano servite, Sua Santità ordinò a Monsignor Ghislandi quale vi assistè continuamente sotto pena della sua disgrazia che nessuno pigliasse niente come essesguirno, non ostante che si ricorresse a fare ogni instanza, acciò revocasse detto ordine.

[Wednesday 27 April] Il mercoledì non uscirono di casa

[Thursday 28 April] et tutto il giovedi il Signor Principe Mattias mai uscì del Palazzo della Trinità per un poco di dolore di testa. Il Signor Principe Leopoldo andò al Pellegrino in un carrozzino et il giorno medesimamente uscì a vedere alcuni quadri di certi pittori.

[Friday 29 April] Il venerdì andò il Signor Principe Leopoldo a Monte Magnanapoli a vedere il giardino et quadri della Principessa di Rossano. Il giorno andò a San Pietro in Vincula a vedere quelle reliquie et statua di Moisè opera di Michelagnolo Buonarruoti, dove venne il Signor Duca Cesarini per riverirgli.

[Saturday 30 April] Il sabato andarono a Frascati.

Mattias and Leopoldo's letters to their brother Ferdinando II in ASF Med. Princ. 5508 and 5396 supplement this "Diario" but do not always agree strictly on specific points. See Chapter One, notes 14 and 22.

Appendix II

Francesco Niccolò Maria Gabburri's
Vita di Filippo Baldinucci
(BNCF Palatini E.B. 9.5)

Filippo Baldinucci Fiorentino, per suo diletto studiò il Disegno con gran frutto, sotto la direzione del celebre Matteo Rosselli. Disegnava perfettamente bene a lapis rosso e nero, di che ne fanno un'ampia testimonianza, tanti Ritratti disegnati in tal guisa di sua mano, tutti di uomini singolari, in lettere, per nascità, o eccellenza nell'arte della Pittura. Questi ritratti si conservano in una villa del Marchese Rinuccini, detta Empoli Vecchio 15 miglia lontana da Firenze sulla strada di Pisa. La detta villa fu già del Cavaliere Alessandro, ultimo di quella illustre, e antichissima Famiglia. Era quel buon Vecchio il Mecenate di tutti i virtuosi del suo tempo, e di tutti gli uomini di garbo, e di spirito, onde in sua casa era la più florida, e più scelta Conversazione di tal sorta di gente, che fosse allora nella Città di Firenze. Ne si fermava qui, la generosità e il buon quore di quel Dignissimo Cavaliere, ma con dolce violenza, seco conduceva tutta la detta Conversazione alle sue Villeggiature, che erano a Signa nel tempo della Primavera, e nell'Autunno a Empoli Vecchio, dove faceva provare i divertimenti della Caccia, e con una intera libertà, procurava di far gustare ad ognuno la dolcezza del Secol d'oro. Nel numero di questi tali, era sempre Filippo Baldinucci, onde non è maraviglia, se in tempo di quella onesta allegria, facesse tanti Ritratti, e tanti in numero, e in bontà, che adornano una non affatto piccola Galleria di quella Villa. Raddoppiò i medesimi rittrati con sommo amore per averli appresso di se, e godersi i suoi amici, componendone uno intero Libro, coll'inserirvi il Proprio Ritratto insieme con quelle della Moglie, e separatamente, di tutti i suoi Figlioli, con quello del Padre di quegli che queste cose scrive, coronato di Lauro, per essersi dilettato grandemente di Poesia giocosa, nella quale a dir vero ebbe non mediocre talento. Lo stesso Libro, si conserva presentemente da quel medesimo che queste cose scrive, e che fu ancora suo amico, e molto lo praticò nella sua gioventù. La Città di Firenze, anzi l'Europa tutta debbe professare una obbligazione grandissima a Filippo Baldinucci per la bellissima opera sua delle Vite dei Pittori, scritte da Esso, con penna d'oro, per via di Decennali, cominciando da Cimabue, restauratore universale indubitato della Pittura. Accompagnò quest'opera coi Disegni della maggior parte di quegli Artefici dei quali aveva descritta la Vita, distribuandoli in 130 grossi volumi, per la Gloriosa Memoria del Serenissimo Cardinal Leopoldo de' Medici, i quali si conservano presentemente nella Real Galleria di Toscana, come un prezioso Tesoro, che tale si può chiamare con

191

tutta giustizia. E se nei suddetti Libri vi sono per avventura dei Disegni Apo-
crifi, o qualche copia di autori più celebri, come di Raffaello, e altri, non è da
darne carico a Filippo Baldinucci, imperocche egli morì in tempo, che ancora
quel gran numero di disegni lasciati dal predetto Cardinale Leopoldo erano
restati tutti confusi in una gran massa, onde subentrò altro di niuna intelli-
genza che gli pose in quell'ordine, che si vede presentemente. Altra simile
Collezione, non più compendiosa, ristrinse in 4 grossi volumi corrispondente
ai suoi Decennali, cominciando dai disegni di Cimabue, la quale conservò per
suo proprio diletto sino alla morte. Questi passarono poi nelle mani del Sena-
tore Pandolfo Pandolfini, e quindi nei di lui Nipoti e Eredi, dove si trovano
ancora di presente nel loro bel Palazzo in via di San Gallo architettato da
Raffaello da Urbino. Filippo Baldinucci fu Uomo, che oltre all'essere grande-
mente versato nelle belle Lettere, e oltre alla profonda cognizione, e pratica
delle maniere dei Disegni, e delle Pitture, ebbe congiunta una grande illiba-
tezza, di costumi e una somma schiettezza, e sincerità. Fu sommamente amato
dai suoi Sovrani, e di tutta la Città di Firenze per tante sue belle prerogative,
ma con modo più particolare e distinto fu amato dal Serenissimo Cardinal Leo-
poldo, e dal predetto Cavaliere Alessandro Valori. Tale fu la stima, che di lui
fece la sua aurea maniera di scrivere, in un tempo stesso nobile e naturale, che
lo chiamò a Roma per iscrivere espressamente la Vita del Cavaliere Bernino, il
che egli fece con sodisfazione pienissima di quella Maestà. In quella occasione
conobbe molti professori, e fece di propria mano il Ritratto dello stesso Bernino
dal vivo, a lapis nero, somigliantissimo, il quale parimente si conserva nel
sopradetto Libro che si ritrova di presente appresso di quegli che queste cose
scrive. Replicò due volte la Vita dello stesso Bernino, cioe una in Tomo, a
parte per la sopradetta Regina, e l'altra nei suoi decennali. Finalmente morì
Filippo, carico di gloria, e di meriti, il di . . . di . . . dell'anno . . . e fù
sepolto nella Chiesa di San Pancrazio, nella Tomba dei suoi maggiori. L'Av-
vocato Francesco Xaverio Baldinucci suo figliolo aveva intrapreso a scrivere le
Vite dei Pittori, Scultori, Architetti, e Intagliatori in Rame, dalla morte del
Padre, e già ne aveva scritte circa a trenta, quando colpito dalla morte nell'anno
1738 lasciò imperfetta quest'opera, molto desiderabile per le notizie di tanti e
tanti professori diversi.

Notes

N.B. The archival material presented in these notes is often more extensive than the passages selected for translation in the body of the text. Therefore, readers with a specialized interest in the issues under discussion might wish to consult these fuller transcriptions

INTRODUCTION

1. E. Goldberg, *Patterns in Late Medici Art Patronage* (Princeton, 1983), pp. 5–20. For the sixteenth century see the catalogue of the exhibition *Firenze e la Toscana dei Medici nell'Europa del cinquecento* (Florence, 1980). Also J. Cox Rearick, *Dynasty and Destiny in Medici Art* (Princeton, 1984).

2. U. Scotti-Bertinelli, *Giorgio Vasari scrittore* (Pisa, 1905); W. Kallab, *Vasaristudien: Quellenschriften für Kunstgeschichte und Kunsttechnik des Mittelalters* (Vienna, 1908); P. Barocchi, "Vasari pittore," *Atti del V Convegno internazionale di studi sul rinascimento* (Florence, 1957).

3. For the foundation and early years of the Accademia del Disegno see K. Barzman, *The Compagnia ed Accademia del Disegno* (Ph.D. thesis, Johns Hopkins University, 1985), and by the same author, "The Florentine *Accademia del Disegno*: Liberal Education and the Renaissance Artist," *Leids kunsthistorisch jaarboek* (Leiden, 1986).

4. G. Vasari, *Le Vite de' più eccellenti architetti, pittori, et scultori italiani* (Florence, 1550), pp. 3–4.

5. Barbara Mitchell, *The Patron of the Arts in Giorgio Vasari's "Lives"* (Ph.D. thesis, Indiana University, 1975).

6. Vasari, *Vite* (1550), pp. 124–25.

7. Ibid., p. 126.

8. J. Schlosser Magnino, *La Letteratura artistica* (1977), pp. 315–16.

9. *Notizie* 5, p. 535. After Baldinucci's description the picture seems to have disappeared from sight.

10. In the inventory of Leopoldo's apartment after his death, picture 115 is described as "Un quadro in tela alto b. 2¼ largo b. 1½ dipintovi la Pittura che detta a Giorgio Vasari le Vite de' Pittori, et un Putto per aria che tiene la Tavolozza da dipignere di mano di Livio Mehus con adornamento intagliato e dorato, il quale si apre e dentro vi è un registro con cartelline in bianco." ASF Guardaroba 826, fol. 61 v.

11. See Chapter One.

12. See Chapters One and Two.

13. S. Meloni Trkulja, "I due primi cataloghi di mostre fiorentine," in

Scritti di storia dell'arte in onore di Ugo Procacci (Florence, 1977), Vol. 2, pp. 579–85. Evidence is yet to be uncovered specifically linking the display of the Mehus *Vasari* with the publication of the *saggio* of the *Notizie*. Baldinucci, however, was much involved in the Florentine art scene and in contact with the hierarchy of the Accademia del Disegno. In 1681 he published a *Lettera . . . a Vincenzo Capponi* (Rome, Tinassi Press). At this time, Capponi was the grand duke's *Luogotenente* in the Accademia. See Chapter Three.

14. Schlosser-Magnino, *Letteratura*, p. 334.

15. In his introduction to the 1976 edition of G. Bellori's *Le Vite de' pittori, scultori, ed architetti moderni*, eds. E. Borea and G. Previtali (Turin), Previtali offers evidence that the twelve biographies published by Bellori in 1672 represent the abridgment of a larger project that would have been more nearly encyclopedic in scope.

16. Carlo Ridolfi, *Le Meraviglie dell'arte* (Berlin, 1914), Vol. 1, p. 31.

17. In his manuscript *Indice degli scrittori fiorentini* Giovanni Cinelli notes, "Lionardo Dati fratello di Carlo nominato di sopra da me benissimo amendue conosciuti e praticati. Era egli canonico della Cattedrale, e Vicario generale dell'Arcivescovado, fu eletto Vescovo di Montepulciano. Era ottimo legista come si vede dalle sentenze e decreti usciti dalla sua penna in più anni che con decoro esercitò quella carica di Giudice. Fu degno di lode e molto stimato. Era molto accorto. Morì circa l'1670." BNCF Magl. IX 67, p. 1077.

In history Lionardo is overshadowed by his brother Carlo Dati, who figured prominently in many areas of Florentine intellectual life. Carlo served as consul of the Accademia della Crusca. As member of the select Accademia del Cimento, he took part in scientific experiments with Ferdinando II and Leopoldo de' Medici. In 1667 Carlo published the *Vite de'pittori antichi*. In the preface he describes this remarkable piece of speculative antiquarianism as the *saggio* of a comprehensive history of classical art. Carlo Dati's *Vite* was authorized by the Accademia della Crusca as a model of Tuscan language.

18. BNCF Magl. II II 110, fols. 442–43, 18 October 1646, Lionardo Dati to the Florentine Accademia del Disegno (Copy). "Molto Illustri e Virtuosissimi Signori Osservandissimi / Io aveva già tre anni sono destinato di presentarmi alle Signorie Vostre, e palesare l'ardentissimo desiderio che io ho di corrispondere al genio ed all'affetto, con che sono stato sempre tirato all'ammirazione dell'arti liberali, che professate da voi, e dalli egregi spiriti simiglianti a vostri anno resa immortale questa Accademia, e la nostra Città, la Toscana, l'Italia, l'Europa, dirò tutto il mondo cento e mille volte più bello di quel che sarebbe stato senza esse. Ma l'occupazioni diverse dal mio proponimento, che una dopo l'altra in questo tempo, o con la necessità o con l'obbedienza di me impossessatesi anno in modo divertita in qui l'applicazione a questo pensiero, che per cagion loro sono stato si lungo tempo in forse se mi fusse per esser lecito il proseguirlo. Onde più volte sono arrossito nel riscontrare alcuno di loro Signori, con chi io aveva participato questo negozio per riceverne quando io mi fussi messo all'impresa qualsivoglia sorte di indirizo, e di lume per ben condurlo. Pur finalmente (ancorche io sia tra le medesime cure più ingolfato che mai) rendendomi con la morte de loro principali, e più anti-

chi Accademici, e professori smarrire gli aiuti, e sentendo che in Venezia et in Bologna si ritrovasse chi avesse condotto a buon porto il pensiero, che io aveva a pena concepito nell'animo, et avendo le Vite de Pittori scritte succintamente dal Signore Gio. Baglioni dal 1572 sino al 1642 intorno all'opere fatte da essi in Roma, per non peggiorare affatto le mie condizioni nell andare in la, et perche non fusse tolto da forestieri alla nostra città il luogo primiero che ella si è acquistata con l'opera del Signore Giorgio Vasari continuandola essi e non un fiorentino, ho fatto ogni sforzo di comparire in questo solenne giorno nella vostra Accademia per lettera, et publicare alle Signorie Vostre se non altro questa mia buona volontà accompagnandola con una offerta prontissima di af-faticarmi senza rispiarmo in questa a me dilettevolissimo impiego.

E quantunque per confermarmi interamente all'ottimo instituto dell'Accademia con bene adoperata matita, o pennello in un bel disegno, o ritratto io non manifesto l'attitudine proporzionata verso di lei, con tutto spero che le Signorie Vostre in quella ve ne gradiranno ugualmente per l'Accademia la promessa che io le fo di ritrarre con la penna nell'opere le fattezze di quelli, de quali voi stessi per proseguire le vite del Vasari giudicherete che si debba fare elezione.

Al che fare con intero vostro e mio sodisfacimento sarà di mestiere, che le Signorie Vostre si adoperino non tanto per loro stesse quanto per via delli amici della nostra città, e fuori di essa a contribuire in scritto conforme alla nota che io nella presente lettera include tutto quello che de professori illustri dopo al Vasari, de loro Maestri, de loro coetanei, e di loro stessi, averanno che portar di notabile, spaccendosi ciascheduno vari suggetti per non qui affaticare dell'istesso doppiamente.

Così spero che si renderà più facile il mettere insieme questa scrittura nella quale impiegandosi molti, e valenti uomini in meno lungo tempo, e con più perfezione si condurrà a fine quello che maneggiandosi da me solo inesperto et inabile ancorche volontarioso affaticante, quando anche io vi suadesse cento anni a torno, non sarebbe come disse Dante d'un'oncia. Non per questo io starò ozioso riposandomi sopra delle Vostre Signorie no? Anzi il vedere che si con-corra nel modo proposto alla contribuzione mi farà pigliare animo, e coraggio tale, che io non mi quieterò mai, anzi anderò notando e osservando da luoghi privati e publici, drento e fuori della Città tutto quello che io potrò senza perder tempo, e scriverò in ogni luogo dove io possa sperare con qualche cor-rispondenza di amici aiuto e notizie.

Ne vorrei che elleno se ritrovassero dall'applicare a questo negozio pel sos-petto che da loro si potesse avere che avutesi da me le fatiche di loro Signorie io me ne volessi far bello. Imperoche io mi protesto assolutamente del contra-rio, e prometto che saranno scritti con lode sempre i nomi di quelli che avranno operato.

Al che fare quando non fusse altro mi dee muovere l'interesse proprio, poiche avendo intenzione d'onorare ne futuri secoli la memoria di coloro che si meri-tarono l'eternità poi eccitare gli altri con simigliante speranza, e pascere il gusto de curioso spiriti che vagheggiano il mondo, io lo farò con più credito e ne sarò più lodato adducendo per autori quelli che sono maestri nell'arte, che

se io volessi mostrare d'aver fatto il tutto io solo e di mio cervello, e per assicurarnele soggiungo di più che io non intendo che se mi riesce fornire questa scrittura ella abbia a uscir fuora per cosa mia, ma dell'Accademia, alla quale ora per allora ne fo un dono, e mi contento che a loro Signorie stia il mettermi il mio nome o no, e quando elleno troveranno che io manchi a questa promessa stampirrà in faccia questa mia lettera acciò il mondo vegga la fellonia, e qui serbando a discorrere più largamente, in voce con le loro Signorie di molti particolari intorno a questo affare rimarrò delle Signorie Loro molto Illustri e Virtuose / Firenze di Casa il dì 18 Ottobre 1646 / Parzialissimo ed Obligatissimo Servitore / Lionardo Dati."

19. BNCF Magl. II II 110, fol. 445, 26 December 1646, Ascanio della Penna in Pisa to Lionardo Dati (much deteriorated). Della Penna was another contact of Prince Leopoldo's. See ASF/CDA IX, fol. 795.

20. For Paolo del Sera see Goldberg, *Patterns*, pp. 54–78.

21. The sense of the letter is somewhat unclear in regard to the specific identity of the Medici princes who expressed interest in the scheme. It is probable that the "Serenissimo Padrone" cited first and without further qualification was Grand Duke Ferdinando II. It is possible, however, that Dati refers twice to Leopoldo. BNCF Magl. II II 110, fol. 441. 27 November 1646, Lionardo Dati to Paolo [del Sera?] (rough draft). "Illustrissimo Signore e Padrone Osservandissimo / Sono alcuni anni ch'io ò avuto pensiero di continuare le vite de pittori descritte dal Vasari, ed essendomi per la diversità delle occupazioni stato giuoco forza il divertirmi da tal concetto, pure alla fine questo anno spinto dal genio e da altri fini ò scritta all'Accademia del Disegno di Firenze la lettera la quale Vostra Signoria Illustrissima potrà leggere inclusa. E perche da tempi di Santi di Tito in qua e anche in poco innanzi costì in Venezia si vagheggiano l'opere de maggiori e più bizarri ingegni che siano stati per così dire al mondo si di pitture come di architettura, scoltura e simili belle arti e bramando io illustrare la mia scrittura con le memorie gloriosissime di codesti grandi uomini vengo supplichevole a Vostra Signoria acciò ella, come compatriotto, e come quello che non teoricamente e nel discorso gli diletta in estremo di queste virtù ma ancora nell'alto pratico sia contenta di farmi grazia che codesti signori virtuosi di costì mi favorissero di darmi le notizie non solo dell'opere ma ancora di altri particulari de quali fo una nota a parte che pure mando inclusa contenente ciò che mi pare di avere bisogno. Potrebbero codesti signori come faranno qui in Firenze gl'Accademici spartiti la fatica con fare e scrivere le cose chi della vita d'uno, e chi di un'altro.

Ò veduta scritta la vita di Jacopo Robusti detto il Tintoretto scritta da Carlo Ridolfi e stampata costì nel 1642 appresso Guglielmo Oddoni, la quale ardisco di supplicarla che favorisca comprarmela e mandarmela per la prima, e havrà occasione si come se altro ve ne fussero delle stampate, e se vi fussero ritratti di Pittori stampati e se vi fussero ritratti di Pittori stampati avvisandola la spesa perche io la rimborsi." [*added in margin*: Si come sento che è stampata ma non so dove ne quando dubito in Verona la vita di Paolo Caliari Veronese che anche di questa se fusse costì o in Verona riceverei estremo favore che (illegible) mi pervenisse con l'altra.]

Mi è stato accennato, ma non lo so di certo, che sia uno costì amico del Signore Bernardo Giunto libraio Fiorentino, il quale scrive pure anche egli le vite de' Pittori mi sarebbe favore grande avere cognizione si del suggetto che scrive, come an[che] se fusse innanzi in tale scrittura perche io mi esibire a servirlo per ricevere fama a fine che si le di lui come le mie fatiche servissero ad onorare la memoria di questa sorte di virtuosi non avendo io altra mira che questa e potendo dare gusto al Serenissimo Padrone, il quale avendo sentito questo mio pensiero mi à fatto significare che li sarà diletto ch'io tiri innanzi la scrittura perche la vedrà volentieri et il Serenissimo [Padrone/Principe] Leopoldo mi si è fatto esibire di ogni protezione perche io possa avere da più banche comodità e cognizioni da perfezionare questa opera laquale scrivendosi in lingua volgare pare che scritta qui possa riuscire al universale più corretta, che se non riuscisse per difetto mio sortirà con l'aiuto che io [illegibile] da questi professori della buona favella fiorentina nella quale si legge composta l'opera insigne di Giorgio Vasari aiutato dal P. D. Vincenzo Borghini, onde non è disdicevole anzi ragionevolissimo che i fiorentini la seguitino.

Manderei più copie fatte della nota contenente le notizie de quali bisognano acciò ella non avesse a perdere tempo di farne fare più copie ma solamente distribuirle ma per non far maggiore plico mi restringo.

Resta solamente Signore Paolo che avendo preso uno ardire grande grandemente mi scusasse ma sapendo dall'altro canto che ella come gentile potrebbe rimanere più tosto offesa della scusa che dell'ardire reserbiròa impiegare l'allungamento della lettera in quelli ringraziamenti infiniti [illegibile] che per l'obligo il quale contrario con la sua gentilezza consegnandomi per ora a Vostra Signoria Illustrissima / 27 Novembre 1646 / Servitore Obligatissimo / Lionardo Dati."

22. *Notizie* 3, pp. 285–86.

23. ASF/CDA IX, fol. 378, 16 November 1667, Lodovico de' Vecchi in Siena to Leopoldo. "Procurerò con ogni sollecitudine mettere in sieme le notizie de pittori Sanesi che Vostra Altezza Serenissima nomina, parendomi che non ne manchi altri, che il Casolani, Francesco Rustichini, e Lornioli, potendosi nelle Vite di questi più accreditati inserirvesene la notizia di altri di minor credito, come Peruzzi, Astolfo e simili. Scrivo questo giorno a Roma acciò siano fatte diligenze colà appresso i Cavalieri Vanni, avendomi detto che possino havere le vite de moderni pittori Sanesi. Fra tanto farò diligenza anco in Siena, chi possa darmi lume di queste materie, et a suo tempo trasmetterò il tutto a Vostra Altezza Serenissima." ASF/CDA IX, fol. 381, 28 December 1667. "Non tralascio le diligenze per raccorre le memorie de nostri pittori non poste dal Vasari, e già ne ho in buon numero. Ho scritto a Roma per sentire se colà possa ritrovarsi il libro del Baglione nel quale ho memoria haver vedute le Vite del Vanni, Salimbeni, et altri, per fare il confronto se vi sieno notizie vatagiose. Restarei sommamente onorato d'un cenno se basti il semplice racconto della vita et opere de pittori, in confuso o pure deva mettersi al netto il discorso." ASF/CDA IX fol. 382, 12 October 1668. "Non potendomi accertare del recapito di alcune notizie che in esecuzione de reveriti comandi di Vostra Altezza Reverendissima invio al Reverendo Brocchi piglio ardire assicurargli sotto l'in-

dirizzo di Vostra Altezza Reverendissima sperando che egli a sufficienza resterà informato dell'opere di questi nostri pittori da quello che scrive il Padre Azzolini nelle sue pompe e dall'aggiunta che gli mando, havendo stancato molti a poterle havere nelle mani."

24. R. Soprani, *Vite de' pittori, scultori, ed architetti genovesi* (Genoa, 1674), and *Notizie* 3, pp. 285–88. Baldinucci states that Brocchi approached Soprani "per mezzo d'amici." It would be interesting to know if Leopoldo used his influence here as well.

25. *Notizie* 3, pp. 286–87. In particular, Baldinucci approached Consiglio de' Cerchi, *cameriere segreto* to Francesco Maria de' Medici. For Filippo Baldinucci's relations with the de' Cerchi family see Chapter Three.

26. *Notizie* 3, p. 288.

27. See Chapter Three.

28. This information is included in the posthumous biography of Soprani appended to his *Vite*. The painter Giulio Benso was the friend disturbed by Soprani's cooperation with Manolessi's project.

29. *Notizie* 3, p. 287.

CHAPTER ONE

1. Baldinucci, *Notizie* 4, p. 419.

2. G. Pieraccini, *La Stirpe de' Medici di Cafaggiolo* (Florence, 1924), Vol. 2, p. 616.

3. ASF Guardaroba 826. Fol. 36ʳ, "Un quadro in tela senz'ornamento alto b. 1⅙ largo b. 1 dipintovi un giovane con giubbone verde trinciato cherrettino in capo che suona a liuto abbozzato dicono essere il ritratto del S. Cav.re Martelli di mano del S. Card.le."

Fol. 36ᵛ, "Due quadri in tela con adornamento filettato d'oro e fondo nero lunghi b. 2 alti b. 1½ dipintovi fiori e canini, che uno di mano del S. Cardinale." "Un quadro in tela con adornamento di legno tinto di nero e dorato in parte con rabeschi alto b. 1⅔ largo b. 2 dipintovi un amorino che dorme dicono di mano del S. Cardinale." "Un quadro in tela con adornamento di legno tinto di verde e dorato in parte alto b. 1⅛ largo ⅚ dipintovi il ritratto di M. Romolo Reitini Cap.no del Ser.mo S. Card.le fatto di mano di detto Card.le."

Fol. 38ʳ, "Due quadretti in tavola alti s. 7 larghi b. ½ dipintovi a tempera due paesi di mano del S. Card.le." Picture no. 518 "Un quadro di una paniera intonacata tondo di b. 1 diametro dipintovi a fresco una testa con collare da prete con barba nera e panno paonazzo o vinato di mano del Ser.mo Card.le Leopoldo."

For the Martelli portrait see E. Borea, *Caravaggio e caravaggeschi nelle gallerie di Firenze*, ex. cat. (Florence, Uffizi, 1970), no. 65. For examples of his drawings see his poetic composition in ASF Misc. Med. 3, insert one.

4. Adam Manikowski kindly shared with me a very personal and revealing series of letters from Leopoldo de' Medici to Lorenzo Strozzi, mostly written in Siena between 22 May 1636 and 6 December 1645. They offer a vivid

impression of his ready wit and his enjoyment of a wide range of activities, including hunting, music, theatrical events, and *conversazioni*. Although he is usually cited as assuming the governorship of Siena in 1637, he was settled in that city by the spring of 1636. ASF Carte Strozziane V 1121, insert one. See also n. 129 below.

5. ASF Med Princ 5379, Leopoldo to Gian Carlo, fols. 240–43, Piacenza, 15 June 1639; fols. 247–49, Piacenza, 18 June 1629; fol. 238, Parma, 16 September 1629. Leopoldo's letters to Ferdinando II are in ASF Med Princ 1016, insert six.

6. In ASF Med Princ 6381, insert one are two lengthy accounts of the wedding voyage to Innsbruck in 1646 and the festivities occasioned by it. On 12 June 1646 (fol. 28) the party went to Schloss Ambra, where they admired "un' armeria, nella quale sono le armi vestite da molti re e imperatori antichi, vedendosi ancora altre meraviglie e di natura, e di arte."

An important source of material on Florentine life, with especially meticulous and well-informed observations on affairs at court, is Giovanni Battista Ricci's *Diario*. A copy is preserved in ASF Serie Manoscritti 160, with the following colophon: "Qui termina i ricordi sopra citati i quali sono stati descritti da Giovanbattista Ricci cominciati dal 1637 al dì 10 Aprile per in sino a l'anno 1678 per tutto il dì 19 Settembre come sopra si vede et io Giovanni di Piero Chiari staffiere del Illustrissimo Signore Marchese Priore e Balì Niccolò Maria Giugni ho copiato i suddetti ricordi e ridotti in migliore forma . . . 17 Novembre 1713."

In regard to the Innsbruck trip, Ricci notes: "*Capitolo* 60—Adì 20 maggio 1646 in Domenica si partì di Firenze la Serenissima Principessa Anna Maria sorella carnale del Serenissimo Granduca Ferdinando II regnante per andare sposa del Serenissimo Arciduca Ferdinando Carlo di Austria e l'accompagnò in sino a Ispruche il Serenissimo Principe Leopoldo suo minor fratello e andò per suo bracciere l'eccellentissimo Signor Duca Jacopo Salviati e di Ispruche se ne va a Vienna all'Imperatore Ferdinando III per imbasciatore straordinario, in nome del Serenissimo Granduca Ferdinando Secondo di Toscana e per sua maestra di camera messo la Signora Marchesa Maria Strozzi e lei messo il Signore Marchese Bartolomeo Corsini suo genero con ordine ai Sua Altezza Serenissima e andò ancora il Signor Conte e Marchese Rinieri d'Elci, e il Signor Marchese Bernabo Malespina e il Signor Senatore Orazio Strozzi e il Senatore Angelo Acciaioli tutti con grande equipaggio e con superbe livree e con numerosa corte." "*Capitolo* 61—Adì Primo Luglio 1646 in Domenica arrivò in Firenze il Serenissimo Principe Leopoldo che ritornava d'Ispruche con tutti gli altri Signori che andorno seco fuor che il Signor Duca Salviati che andò a Vienna."

7. Goldberg, *Patterns*, chap. 2.

8. Ibid., pp. 67–68.

9. *Notizie* 3, p. 16.

10. M. Campbell, *Pietro da Cortona at the Pitti Palace* (Princeton, 1977), documents 79, 106, 115, and 120.

11. *Notizie* 3, p. 220.

12. ASF Med Princ. 5567, fol. 436, 13 February 1643, Mattias to Leopoldo. "Serenissimo Signor mio Fratello Osservandissimo / Giache tutto il fondamento delle rappresentazioni che fa a V.A. il Docci per rimostrar lo scapito dell'entrate di cotesto spedale della scala consiste finalmente nella difficoltà di ritrarre il prezzo dello smalimento de' grani. Io che non vorrei che con questo pretesto pretendessi di esimersi da gl'obblighi con il Colonna entratti come appare dall'aggiunta copia di sera, della quale riserbo per hora appresso di me l'originale, ho convenuto col medesimo pittore che delle sue operazioni riconoscerà debitore il Serenissimo Gran Duca, il quale dovendo allo spedale il pagamento di 460 moggia di grano non apprezzato sin hora, l'anderà sborsando al Pittore per compenso delle fatiche. Mi honori però Vostra Altezza di operar, che termini il negozio in questa conformità, non meno per che mi pare che non rimanga pretesto il dottore recusarne il partito ma per che mi preme straordinarmente che non si perda la congiuntura di effettuare un abellimento si notabile di cotesta città, e del luogo. E desiderando di sapere prima della mia partenza di qua la resolutione ultima attenderò che Vostra Altezza per tutta domenica prossima si compiaccia di participarmela come la prego. E le bacio affettuosamente le mani, firenze 13 di Febraio 1643, di Vostra Altezza / Affettuoso fratello colendissimo / Il Principe Mattias / Habbiamo fatto una giostra et io ho corso così tutti i cavalieri e li ho vinti tutti." On fol. 437 is a copy of the contract for the work dated "7 di Marzo 1642 in Siena" and signed by Gio. Antonio Scala, Laurentio Docci, Rettore, and Angelo Michele Colonna, Pittore.

13. Giuseppe Bencivenni-Pelli, *Saggio istorico della Real Galleria di Firenze* (Florence, 1779), pp. 227–29. S. Salvini, *Fasti consolari dell'Accademia Fiorentina* (Florence, 1717), pp. 579–80, 587–88.

14. Leopoldo and Mattias's letters to Ferdinando II from this trip are found in ASF Med. Princ. 5508, fols. 50–67 and Med. Princ. 5396, fol. 760f. Their travel diary is in ASF Misc. Med. 94, insert five, "Diario nella venuta à Roma de' Ser.mi Pnp.i Mattias et Leopoldo." These two records supplement each other but are not always in agreement. See Appendix I and n. 22 below.

15. The principal unresolved issue was that of 130,000 *scudi* invested in the Roman *Monte della Pietà* by the Tuscan Ambassador Marchese Riccardi but allegedly sequestered on the pope's orders. See the opening paragraph of the "Diario" cited above and presented in Appendix I.

16. The principal published documents of seventeenth-century Roman etiquette are Girolamo Lunadoro's *Relatione della corte di Roma* and Francesco Sestini's *Maestro di camera*. These works frequently appear together, and I cite the 1671 edition (Venice, Valvasense) that also included Fioravante Martinelli's *Roma ricercata*. In ASF Med Princ 5560 is a document headed "Ragguaglio d'alcune particolarità conveniente all'uso, che si pratica presentemente nella corte romana, per l'accrescimento della cortesia" (fol. 362). On fol. 365 is the observation, "Perche da qualche tempo in qua il termine della corte sia e cresciuto et in un certo modo ha alterato lo stile, e preventito l'ordine consueto, ho stimato bene d'aggiungere a questa relazione alcune particolarità concernente al nuovo stile introdotto per l'accrescimento della cortesia acciò con

queste notizie si comprenda quanto sia per riuscire difficile il praticare il modo usato nella Corte Serenissima mettendosi il tutto con la dovuta et humilissima reverenza in considerazione." This is specifically in the context of Leopoldo's 1668 trip to Rome.

17. ASF Misc. Med. 94, insert five (6 April 1650). See Appendix I.

18. ASF Misc. Med. 94, insert five (9 April 1650). See Appendix I.

19. ASF Med. Princ. 5508, fol. 64. See n. 22 below.

20. ASF Misc. Med. 94, insert five (5 April 1650). See Appendix I.

21. ASF Misc. Med. 94, insert five (9 April 1650). See Appendix I. Presumably Agostino Maffei was *Maestro di Casa* or *Maestro di Camera* to Prince Borghese, though a cursory investigation of secondary sources has not helped elucidate this.

22. The following is a selection of references to works of art and other curiosities in the letters from Mattias and Leopoldo in Rome to Ferdinando II in Florence.

Letter of 4 April 1650, ASF Med. Princ. 5508, fol. 54. "Hoggi siamo stati a vedere la chiesa di San Pietro che c'è riuscita bella e adornata al più alto segno. . . . Speriamo di vedere Roma con gusti di tutti."

Letter of 13 April 1650, ASF Med. Princ. 5508, fol. 56. "Martedì 12 andammo di nuovo a far le chiese ultima dellaquale fu S. Pietro e quivi dopo haver visto dove sono i corpi de due apostoli, e le catacumbe, accompagnati dal Can. Ubaldini, Maffei et Olstenio, che ci dimostrava le memorie più antiche e riguardevoli di quei sepolcri."

Letter of 23 April 1650, ASF Med. Princ. 5508, fol. 63. "Lunedì 18 andammo nella Trinità de' Monti a sentir messa, e vedemmo quivi la sagrestia di quei padri, il giardino, la spezeria et alcune figure in prospettiva che da lontano mostravano una cosa e da vicino un'altra molto differente. Il giorno fu a visitare il Principe Lodovisi, et il Principe Giustiniani, e doppo ci transferimmo a veder la vigna di Borghese, le pitture, le statue e l'altre cose singulari che vi sono. . . . Martedì 19 . . . montati nelle carrozze a due fummo a rendere la visità al Sig. Principe Lodovisi, et al Sig. Principe Giustiniani, che volse mostrarci i suoi quadri e le sue statue . . . Mercoledì 20 . . . Andammo a vedere la vigna del medesimo Principe Ludovisi dove . . . haver visto le pitture, le statue e quello di curioso. . . . Dopo ci portammo a veder il giardino di Montecavallo, e quelli scherzi d'acque. . . . Giovedì 21 . . . Andammo a veder S. Pietro in Montorio e di quivi a veder il casino del Cardinal Cornaro e quel giardino, e la vigna del Cardinal Lanti, e terminammo per il giorno in visitar la Chiesa di S. Cecilia e le reliquie che sono in essa e due altre chiese. . . . Venerdì 22 . . . Andammo a vedere il giardino di Chigi e quelle pitture e poi ci transferimo alla casa del Marchese Patritii che per gran quantità di esserci quadri et assai belli ci trattenemmo più d'un hora, andando di quivi a vedere i pazzarelli, fra quali ne sono alcuni disgustosi, e fra donne particolarmente n'è uno ch'ha del ridicolo assai. . . . 23 Aprile . . . Hoggi siamo stati a vedere la Chiesa Nuova . . . ci siamo transferiti a vedere Castello Sant'Angelo, dove c'è stato mostrato tutto quello si può vedere."

Letter of 25 April 1650, ASF Med. Princ. 5508, fol. 64. "Domenica mattina 24 non uscimmo, ma solo fummo a vedere le statue che sono in Belvedere . . . a 21 hore montammo in carrozza a due et andammo alla Chiesa di Santa Francesca Romana . . . noi ascendemmo a vedere il luogo, dov'è il corpo della medesima santa, e di quivi a piede ci portammo al giardino di Farnese. . . . Lunedì mattina 25 . . . con le carrozze a sei andammo a . . . Pietro in Vincola, dove per vederci era il Duca Ceserini, quale si

trattenne appresso di noi mentre ci venivano mostrate le catene di S. Pietro et andavamo vedendo il Moise di Michelangelo e l'altre cose da vedersi in quella chiesa, e poi avendoci il medesimo Sig. Duca accompagnati alla carrozza ci lasciò partire e noi ci trasferimmo alla Chiesa della Madonna di Monti et a quella di S. Marco dove era la festa."

Letter of 30 April 1650, ASF Med. Princ. 5396, fol. 761. "Martedì 26 per esser il Sig. Principe Mattias travagliato grandemente dal dolore di testa si levò tardi e non uscì di casa, et il Sig. Principe Leopoldo in un carrozzino del Sig. Duca Salviati fu a vedere in più luoghi pitture e statue diverse, e ritornò alla Trinità de' Monti accompagnato dal medesimo Duca. Il giorno andò a Palazzo Farnese a riveder di nuovo le curiosità che vi sono. . . . Mercoledì 27 . . . il Sig. Principe Leopoldo si portò a Piazza Madama a vedere alcuni quadri del Piermattei, e alla casa del Cav. del Pozzo a vedere quivi ancora quadri, statue e molte miscee curiose che vi sono. . . . Il giorno ci trattenemmo in casa del Padre Chircher Gesuita matematico e virtuoso grandissimo, et in veder corone e quadretti portati d'alcuni mercanti. . . . Giovedì 28. Il Sig Principe Leopoldo levatosi assai per tempo andò alla messa nella Trinità de' Monti dove havendo trovato il Sig. Card. Montalto andarono insieme in carrozze a sei a Frascati a vedere le curiosità di quelle ville. Quivi con lautissimo desinare fattoli fare da Sua Eminenza fu poi a vedere il Palazzo di Borghese, di Ludovisi e di Rossano, e tutti li scherzi d'acque che sono in quelle ville. . . . Venerdì mattina 29 il Sig. Principe Leopoldo andò in un carrozzino accompagnato dal Sig. Duca Salviati per suoi negozii per Roma. . . . Il giorno andammo insieme a visitare la Signora Donna Olimpia . . . e nel partire ci fu mostrato tutto il suo palazzo, ch'è molto bello e bene addobbato."

23. ASF Misc. Med. 94, insert five (4 April 1650). See Appendix I. The Cardinal Barberini in question is presumably Francesco, since Antonio was generally referred to as "Cardinal Antonio."

24. ASF Med. Princ. 5396, fol. 761 (26, 27, 29 April 1650). See n. 22 above. In Leopoldo's posthumous inventory (ASF Guardaroba 826), picture no. 535 is a small *Saint Jerome in the Desert* "comprò a Roma da' coronari." For Salviati's involvement in a variety of acquisitions see ASF Med. Princ. 5575a, insert four, fol. 45, Leopoldo to Salviati, 5 July 1650. There is considerable other Salviati correspondence in ASF Med. Princ. 5521, fols. 242–343. Salviati accompanied Anna and Leopoldo Medici to Innsbruck in 1646. See n. 6 above.

25. For these negotiations see W.E.K. Middleton, "A Cardinalate for Prince Leopoldo de' Medici," *Studi seicenteschi* 11 (1970), pp. 167–80.

G. B. Ricci notes in his *Diario*, "*Capitolo 242*—Adì Primo Luglio 1667 in Venerdì entrò in Firenze Don Vincenzo Rospigliosi e Don Tommaso suo fratello che se ne passavano a Roma essendo nipoti paterni di sua santità i quali furno riscontrati fuora della porta al Prato dal Serenissimo Principe Leopoldo con gran numero di carrozze le quali erano state comandate da Sua Altezza Serenissima e gli messe nella sua carrozza e gli dette i primi luoghi. . . ." Leopoldo played a similar role a few months later; "*Capitolo 245*—Adì 30 Settembre 1667 in Venerdì entrò in Firenze il Signor Don Felice, il Signor Don Giovanbatista Cavaliere di Malta come Don Vincenzio Rospigliosi fratelli carnali del Duca. Passati che andavano a Roma e vi era con loro Donna Caterina loro sorella maggiore e il Cavaliere Niccolò Banchieri suo marito e una fanciulla loro figliola di anni 12 la quale a nome. Maria Eleonora e il Serenissimo Principe Leopoldo gli fece il medesimo incontro fuora di porta come aveva fatto alli

altri loro fratelli con gran numero di carrozze e Sua Altezza aveva una carrozza di Sua Altezza Serenissima a sei luoghi e gli fece entrare tutti a cinque dentro in detta carozza. . . ." In both entries Ricci offers fuller descriptions of their receptions and the accompanying series of festivities.

26. In ASF Auditore delle Riformagioni 47, fols. 1088–92, is a gathering headed "Allegrezze fatte per la promozione al Cardinalato del Ser.mo e Rev.mo S.re, Ser.mo Principe Leopoldo. Indì 14 e 15 Dicembre 1667." On fol. 1089 is a letter to Auditor Giovanni Federighi from [?] Tomansi. "Ill.mo Clariss.mo S.re mio P.rone Col.mo / Mi comanda il Ser.mo P.rone di avvisarla acciò dia l'ordine in occasione della promozione del Ser.mo Sig.e P.npe Leopoldo, che si faccia quello che si fece nella promozione del S. Card.le Gio. Carlo come vien notato qui appresso, e si cominci domani. / Due giorni sonarono le campane a festa. / Due sere si sono fatti i fuochi in publico et alle case de' Magistrati. / Et due sere le fortezze hanno tirato. Et sonata la campana degli Offizi e le botteghe sono state aperte. / Et io in eseguire a V.S. Ill.ma faccio humilissima reverenza / di Camera di S.A.S. / li 13 dicembre 1667 / Di V.S. Ill.ma e Claris.ma / Dev.mo Um.mo et Oblig.mo Ser.e / [?] Tomansi."

To execute these orders Federighi sent off three letters, preserved in rough drafts dated 14 December 1667, to the "Proveditore del Monte Comune" (fol. 1090), to Senator Arrighetti, "Procuratore Generale delle Fortezze" (fol. 1091), and to Francesco Covoni, "Operaio alla Chiesa Metropolitana" (fol. 1092). On 17 December 1667 Ambassador Cellesi wrote from Venice to the granducal administration in Florence, "Ho cominciato stasera i fuochi e luminari di torcie alla casa per elezione del Ser.mo Pr.e Leopoldo" (ASF Med. Prin. 3034). In regard to the role of precedent, when Francesco Maria de' Medici was elected cardinal in 1686, the festivities held in Florence on 4 and 5 September were ordered in the form of those for his late uncle Leopoldo. ASF Auditore delle Riformagioni 58, fol. 11 and following.

G. B. Ricci, *Diario* notes "*Capitolo 252*—Adì 12 Dicembre 1667 in lunedì venne nuova come la santità di nostro Signore Papa Clemente IX aveva creato numero 3 cardinali cioè il Serenissimo Principe Leopoldo de Medici, il Signore Jacopo Rospigliosi primo Nipote paterno di Sua Santità il quale si trovava Internunzio a Bruselles e il Signor Don Sigismondo Chigi nipote del Pontefice passato." Also, "*Capitolo 253*—Adì 26 Dicembre 1667 in lunedì. Arrivò in Pisa monsignor Carlo Vaini Cameriere d'Onore di Sua Santità che portava la Berretta rossa a Sua Altezza già eletto nuovo Cardinale il quale fu ricevuto in Palazzo di Sua Altezza Serenissima dove che si trattenne in Pisa in fino al venerdì mattina dove di lì venne a Firenze e mentre che stette in Pisa fu suo trattenitore il Signore Conte Ferdinando d'Elci e da scalco fece il Signor Cavaliere Girolamo Saracinelli e sempre fu servito con dua carrozze di corte e quattro staffieri e il quanciale per tutto dove lui andava si come ancora qua in Firenze ebbe il medesimo trattamento da questi Serenissimi Principi."

27. ASF Med. Princ. 5560, fol. 391. "Nota di quelli che abitano nei palazzi di S.A. S.ma in Roma." There are masses of material relating to Leopoldo's assumption of the cardinalate and his 1668 and 1669–1670 trips to Rome in Med. Princ. 5560. Also relevant is the correspondence of Resident Montauti

in Rome with Leopoldo in ASF Med. Princ. 5539. In ASF Med. Princ. 5565, fols. 285–96 is an important block of correspondence concerning the refurbishing of Palazzo Madama and other arrangements for the 1668 visit. The plan of the state apartments is in ASF Med. Princ. 5539, fol. 119, "La soprascritta pianta è stata fatta dal Sig. Alessandro Cecchini con esatta diligenza." Also Med. Princ. 5565, fols. 292–95. In Montauti's letter to Leopoldo of 7 February (Med. Princ. 5539) he notes Marmi's presence in Rome. Also, "Arrivò domenica sera il Sig. Diacinto Marmi, opportuno per tutti i bisogni del servizio di V.A.R." ASF Med. Princ. 5560, fol. 409 (undated).

28. Diacinto Maria Marmi is one of the most important figures of the Florentine seicento but also one of the most elusive. In the dedication to his *Norma per il guardaroba del Gran Palazzo* . . . of 1666–1667, BNCF Marmi II I 284 (see n. 77 below), D. M. Marmi refers to "miei antenati che per spazio di 130 e più anni resero fedel servitù nella Guardaroba e altri uffici della Serenissima Casa" (fol. 2). In the introduction (fol. 5) he further cites "lo spazio di anni venti in circa, che esercito la carica di Sottoguardaroba in detto Palazzo sotto l'ubidienza di Biagio di Giovanni Battista Marmi mio zio principal guardaroba in detto Palazzo e sotto il comando in oggi dell'Illustrissimo Signore Marchese Cerbone del Monte Guardaroba Generale di Sua Altezza Serenissima."

A good deal of information concerning his later career is found in the *Dichiarazione di Gentilhomo di Corte di Sua Altezza per il Signor Diacinto Maria Marmi*, ASF Pratica Segreta di Firenze 194, fol. 173:

"Cosimo III, per grazia di Dio Gran Duca di Toscana, ecc.

Il lungo e fedel servizio reso a noi et alla casa nostra oramai per lo spazio di anni cinquanta sei da Diacinto Maria Marmi, e la ben grande sodisfazione, che di lui abbiamo per il servizio, che ci ha reso, e ci rende, nella carica di nostro Guardaroba da esso sempre esercitato con somma applicazione e integrità non senza dover rendere al medesimo intera giustizia, ancora per il contento che pienamente ci ha dato pur anco nelli altri impieghi nei quali ci siamo serviti della di lui abilità e talento, come architetto in varie occasioni, e specialmente nelle due solennità celebrate in questa nostra città, et in quella di Pisa, per le traslazioni, nella prima delle sacre reliquie di S. Zanobi vescovo della stessa, e nella seconda di quelle di S. Stefano Papa e martire, et in Roma, dove fu incaricato di preparare, e disporre il nobile addobbamento del Palazzo di Piazza Madama per il soggiorno in esso del Signore Principe Cardinale de' Medici nostro fratello, quando vi si condusse per la funzione di ricevere il Cappello Cardinalizio dalle mani della santa memoria di Papa Innocenzio XI nelle quali congiunture tutte da lui effettuate con pomposa magnificenza et ottimo gusto non lasciò di distinguersi molto onde risultò nell'universale immenso applauso. Avendo a noi dato motivo di riflettere a si distinte et onorate benemerenze di esso oltre la considerazione che non lasciamo insieme d'avere a quelle de suoi antenati che servendo per lo spazio di più d'un secolo li nostri Serenissimi Progenitori non anno trascurato di dar sempre pure tutte le prove di fedeltà e zelo nell'effettuazione delle loro incumbenze. Di qui e che volendo noi dare al sudetto Diacinto Maria Marmi un contrassegno della nostra gratitudine, e dell'affetto con il quale lo riguardiamo, abbiamo risoluto d'ascriverlo per grazia

speciale nel numero di gentiluomini, che colloro attual servizio compongono la nostra corte, vogliamo che con tal prerogativa sia registrato al nostro ruolo, et ammesso a partecipare di tutti gli onori, privilegi e preeminenze che a tal grado si convengono. Per lo che comandiamo che sia da tutti li nostri ministri di qualunque riga riconosciuto, rispettato et distinto nella sudetta qualità, e che il Marchese Riccardi nostro maggiordomo maggiore faccia eseguire nella forma dovuta la presente nostra volontà e perche resti più manifesta la nostra mente abbiamo ordinato, che se ne spedisca questa nostra lettera patente firmata di nostra mano, impresa col nostro sigillo, e contrassegnata col nome dell'infrascritto nostro Primo Segretario di Stato questo dì 15 Agosto 1697 in Firenze."

29. In ASF Med. Princ. 5565, fol. 291 there is a *minuta* from Rome to Florence, "Per tamburetti piccoli si era inteso qui che fossero quei sgabelletti piccoli, che non hanno appoggio alcuno, che non si usano nelle camere nobili. . . . I tamburetti dei quali si è mandato di costà il modello, qui si chiamano sedie senza braccialetti e questi pare, si adoprino nelle camere, dove si gioca, si magnia, et non nelle camere nobili, e se pare a S.A. di farne una dozzina, saranno di servizio." On 27 December 1667, Montauti informed Leopoldo, "Se dovrà far sedie per camere nobili sappia che l'uso più moderno è di farle grandi con la spalliera che passa sotto i braccialetti, et senz'alcuna sorte di chioderia, usandosi in cambio una guarnizione d'oro assai ricca." ASF Med. Princ. 5539, fol. 122.

30. ASF Med. Princ. 5560, fol. 411. "A dì 11 Febbraio 1667. Per Diacinto Guardarobba di S.A.S. . . . Circa i dua ritratti del Papa per quello deve stare nella camera dell'udienza già è stato dato l'ordine dal Sig. Duca Salviati, perche il suo pittore Morandi fa il suo ritratto al naturale, onde bisogna intendersi con il medesimo Duca anco per il secondo, e sua cornice." To the best of my knowledge, these portraits have not been identified.

31. ASF Med. Princ. 5560, fol. 437, 28 February 1668, Ugo della Stufa to Leopoldo. "Giunsi hiersera doppo le 24 a Roma dare in esecuzione de reverti comandi di Vostra Altezza Reverendissima . . . Monsignor Vaini che mi ha favorito in comanda d'inchinarmeli per sua parte e resta molto sodisfatto dell'addobbo del Palazzo che veramente è maestoso essendo 18 stanze tutte parate d'arazi e riccamente è certo che il Marmi ha servito con diligenza."

32. ASF Med. Princ. 5539, fol. 157, 7 March 1668, Montauti to Leopoldo. "Il Sig. Balì Stufa li darà notizia dello stato in che si trova il palazzo e li dirà in che grado sono le carrozze, ond'io rimettendomi a S.S.Ill.ma aggiugnerò solo che hoggi son venuti a vedere gli appartamenti di V.A. l'Imbasc.re et Imbasc.ce di Francia con Donna Cristina Paleotti, quale mi ha dimandato dove dormiva il Sig. Conte Rabatta, e lodando in sommo grado ogni cosa hanno mostrato desiderio di poter presto riverire l'A.V., in nome della quale io ho ringraziato l'E.E.S.S. dell'honore, che hanno fatto a questa casa." For Cristina Paleotti see Giovanni Fantuzzi, *Notizie degli scrittori bolognesi* (Bologna, 1786), Vol. 6, p. 241.

33. ASF Med. Princ. 6388, insert five, 13 March 1668. In Med. Princ. 6388 there are three sets of documents relevant to Leopoldo's 1668 trip to Rome.

Insert four contains *minute* of letters from Ferdinando II and Secretary Pandolfini to Leopoldo in Rome. Insert five contains letters from Leopoldo in Rome to Ferdinando II. The *minute* for these are in Med. Princ. 5508. Insert six contains letters from Leopoldo and G. F. Marucelli in Rome to Lorenzo Panciatichi in Florence.

For the ceremonial aspects of the creation of new cardinals, see Lunadoro, *Relatione* p. 167ff., and Sestini, *Maestro di camera*, p. 20ff. Ricci's *Diario* describes Leopoldo's entourage. "*Capitolo 254*—Adì 5 marzo 1667 in Lunedì. Si partì di Firenze il Serenissimo Cardinale Leopoldo per andare a Roma a pigliare il Cappello Cardinalizzio dove che messo seco una gran corte con numero sei camerate le quali sono le seguenti: la prima Monsignor d'Elci Conte di Frosini, Arcivescovo di Pisa, seconda Monsignor Ruberto Strozzi Vescovo di Fiesole, Terzo il Signor Marchese Antonio Corsi, Quarto il Signor Marchese Luca Albizzi, Quinto il Signor Marchese Francesco Riccardi, Sesto il Signor Donato Maria Acciaioli che in questa congiuntura Sua Altezza lo dichiarò Senatore e per suo maestro di camera messo il Signor Balì Ugo della Stufa, e maiordomo il Signor Fra Bartolomeo Galilei e detto faceva anco da cavalerizzio maggiore, e tutti questi avevano sei staffieri per ciascheduno e tutti e sei Signori che erano di sua camerate avevano la muta a sei fuor che Monsignor Strozzi che aveva solo due cavalli, il quale faceva da Auditore di Camera, e suo Cappellano maggiore Monsignore Filippo Soldani Arciprete e secondo vicario del arcivescovo di Firenze, e primo segretario di Sua Altezza il Signor Abate Filippo Marucelli, e segretario dell' Imbasciata Segreta il Signor Cavaliere Ugo Ugieri senese, il suo coppiere il Signor Cavaliere Alessandro Carducci, scalco il Signor Cavaliere Francesco Martelli e tutti questi avevano quattro staffieri per uno, e i camerieri erano numero otto e ciascheduno con dua staffieri fuor che il signor Lionardo Grazzini che ne aveva tre, i paggi erano dieci con dua maestri, e numero quattro cappellani, aiutanti di camera numero otto, e quattro portieri, quattro mozzi di camera, e staffieri numero ventidue, dua lacche con il Decano, cocchieri numero undici, e garzoni di stalla diciotto, e sei lancie spezzate e cuochi, credenzieri e bottiglieri e cantinieri e altri di più basso servizio." "*Capitolo 255*—Adì 12 Marzo 1667 in Lunedì a hore 21 Sua Altezza fece l'entratura in Roma e al suo arrivo ebbe di riscontro numero centocinque carrozze a sei cavalli e quattro delle sua che aveva condotto a Firenze e cinque delle sua camerate che tra tutte erano centoquattordici carrozze tutte a sei, e queste erano tutte fuora di Porta e dentro in Roma per il corso vi era più di cinquecento carrozze tutte a dua cavalli piene, di dame e cavalieri tutti per vedere l'entratura di Sua Eminenza in Roma."

34. ASF Med. Princ. 6388, insert five, 17 March 1668, Leopoldo to Ferdinando II. "Scesi doppo all'appartamento di Sua Eminenza, fummo da esso presi e introdotti dove già stavano il Sig. Don Cammillo e i Signori Nipoti di Sua Santità attendendo che fusse in tavola, et allora con la conveniente disposizione posti a sedere fu servito il banchetto suntuoso e ricco nel primo apparato di trionfi e statue, e nella magnificenza della confetture e frutte imbandite piramidalmente, e con gran lautezza conforme allo stile e alla moda di quà. Finito il desinare si cominciò la musica con parole che toccavano la mia venuta, ha-

vendo ben durata la cerimonia tre ore con estrema difatigazione a causa del caldo."

Lunadoro, *Relatione* (p. 172) and Sestini, *Maestro di camera* (p. 25) refer to the customary banquet offered new cardinals by the Cardinal Nephew. Ricci's *Diario* describes the occasion. "*Capitolo 256*—Adì 15 Marzo 1667 in Giovedì mattina si fece la cavalcata dalla Madonna del Popolo a Monte Cavallo la quale funzione seguì quando Sua Santità diede il cappello cardinalizio a Sua Altezza Serenissima e a detta cavalcata vi era ventidue cardinali tutti a cavallo su le mule e numero trentadue prelati fra paonazzi e neri vi era ancora molta nobiltà fiorentina e romana con molti camerieri de Signori Cardinali si come di principi, duchi e imbasciatori e di altri signori nobili romani che tutti per obligo ne mandano uno, o due per ciascheduno per maggiormente onorare Sua Altezza Serenissima e in tutti erano coppie centottantadue e quando cominciò la detta cavalcata cominciò a piovere ma durò poco che non impedì la detta funzione e la detta mattina Sua Altezza restò pranzare a Monte Cavallo con l'Eminentissimo Signore Cardinale dominante e il Signore Don Cammillo con sua quattro figlioli assieme l'Eminentissimo Signore Cardinale Sigismondo Chigi che furno creati tutti e tre insieme e doppo pranzo Sua Altezza entrò nella carrozza grande del Signore Cardinale Dominante e dietro a questa viene oltre dieci carrozze di diversi Signori Prelati e cavalieri e il corteggio si formò di numero trentacinque carrozze e da Monte Cavallo si andò a San Pietro e doppo a visitare l'Eminentissimo Signore Cardinale Barberino che come Decano del Sacro Collegio deve essere il primo a ricevere la visità che abitava nella Cancelleria come Cancelliere."

35. ASF Med. Princ. 6388, insert four, 21 March 1667/68, *Minuta*, Ferdinando II to Leopoldo. "Con molto mio gusto ho potuto ravvisare il buon ordine con che era stata adempita la funzione del ricevimento fatto dall'Eminenza Vostra del cappello cardinalizio, in occasione della quale godo che Vostra Eminenza habbia riscontrato i più benigni et affetuosi attestati di cordialità e di stima tanto in Sua Santità che nel Sig. Card. Rospigliosi et che a queste publiche dimostrazioni si aggiunghino quelle, che con i regali reiterati le facevano parimente la Santità Sua et Sua Eminenza."

36. For the obligatory visits of new cardinals, see Lunadoro, *Relatione*, p. 172 and Sestini, *Maestro di camera*, p. 67ff. ASF Med. Princ. 6388, insert five, 24 March 1668, Leopoldo to Ferdinando II. "Soggiungerò all'Altezza Vostra d'havere nei passati giorni visitato i Signori Cardinali Cibo, Sforza, Gualtieri, Spinola, Gabbrielli, Odescalchi, Savelli, Dongo, Santa Croce e Pio, fra i quali, si come in generi e multiplicità di quadri antichi, e moderni, il meglio proveduto è Pio, così il più magnificamente alloggiato m'è parso Savelli, godendo nel suo palazzo di Monte Savello appartamento nobile, cospicuo di arredi, delizie d'acque, e giardini, alzati col benefizio e vantaggio del sito fino al primo piano. Santa Croce parimente tiene una abbitazione comodissima ornata di mobili, e statue, molti e di pregio, non havendo già osservata negl'altri cosa che ecceda, e meriti reflessione."

37. ASF Med. Princ. 6388, insert five, 27 March 1668, Leopoldo to Ferdinando II. "In defetto d'altra materia soggiungerò a Vostra Altezza d'haver visto

assai nobili e spaziosi casamenti nella congiuntura di visitare gli accenati cardinali: più maestoso e magnifico di tutti è quello di Mazarrino vicino a Monte Cavallo tenuto dal Sig. Card. Mancini, godendovisi oltre uno sfogattissimo appartemento doppio d'otto camere accompagnato da recipiente sala, e salita, una luce et aria si aperta e si viva che vi ride ogni cosa. A questo in copiosità di stanze et in delizie di giardino d'agrumi e di fiori succede quello del Card. Chigi, già di Gallicano a S. Apostolo non ha però l'elevazione e la grandezza del primo e a causa del triplicato lutto che porta Sua Eminenza rimane privo d'ogni ornamento di supelletili delle quali però intendo essere molto ben provvista Sua Eminenza a numero e pregio. Può entrare in riga con i due sudetti l'abitazione del Card. Bonelli, anch'essa grande e ben disposta et abbondante di suntuosi arredi. L'altre poi appariscono, e sono più ordinarie, e da non meritare espressa menzione."

38. ASF Med. Princ. 6388, insert five, 8 May 1668, Leopoldo to Ferdinando II. "Hier mattina pure mi trasferii con motivo della medesima urbanità a casa i Signori Cardinali Vidoni e Gualtieri alloggiato in Palazzo Panfilio a Piazza Navona, dove nell'andare scorrendo gli appartamenti veddi la celebre galleria dipinta da Pietro da Cortona la quale per vastità del vaso, e per la multiplicità delle figure, puo passare fra le sue opere più riguardevoli. Magnifica parimente e nobile riesce la Chiesa di S. Agnesa incorporata all'abitazione, e che ne bassi rilievi e negl'ornamenti che compongono il sodo aparise molto avanzata."

39. ASF Med. Princ. 6388, insert five, 30 April 1668, Leopoldo to Ferdinando II. "Hier mattina nell'essere dal Sig. Card. Orsini al quale corrisposi con quell'urbanità, fui alla devozione di San Filippo sentendo messa nella sua capella alla Chiesa Nuova, e ci godei intanto la veduta delle pitture di Pietro da Cortona, che e nel disegno, e nelle figure, e negli stucchi riescono opera riguardevole e degna d'autore." Curiously enough, Leopoldo did not comment on the Cortona decorations in the Palazzo Barberini after his visit on 4 June. See n. 44 below.

40. See n. 16 above. Also in ASF Med. Princ. 5560 is a summary of Leopoldo's public comportment from 13 December 1667 until 6 November 1668 (fol. 346) and various discussions of problems of protocol (fol. 351ff.). On fol. 400 is a list of all the visits made and received by Leopoldo in Rome in 1668. In ASF Misc. Med. 3, insert two is a small tie-bound booklet with an undated note, "Trattamenti fatti in Roma dal Serenissimo Cardinal Leopoldo de' Medici a diversi Prelati, Principi, Ambasciatori et altri Signori di condizione." In ASF Misc. Med. 201, insert two is the "Titolario del Serenissimo Principe Cardinale Leopoldo de' Medici." Evidently a reference manual for the use of Leopoldo's secretariat, this parchment-bound book is alphabetically thumb-indexed, and gives the titles and forms of courtesy suitable for each of the cardinal's more regular correspondents. The work perhaps dates from very shortly after the election of Emilio Altieri in 1670 since it refers to Pope Clement X, but makes no reference to his *nipoti*, listing in detail the courtesies for the Rospigliosi nephews.

41. ASF Med. Princ. 5560, fol. 360. "Del modo nel fare e ricevere visite e nel visitare le dame . . . Ogni volta che Sua Eminenza è andata publicamente

in qualche chiesa è andata in habito, osservando rigorosamente il cirimoniale. / Nell'andare al giardino, o a vedere qualche vigna Sua Eminenza è stata solita andare in carrozza a sei cavalli seguitata da un altra simile per servizio della sua corte, dal paggio di valigia a cavallo e dalle lancie spezzate. / Quando Sua Eminenza è compiacinta d'andare a vedere in qualche casa privata pitture o statue o altre curiosità, sempre è andata privatamente in una carrozza chiusa."

42. ASF Med. Princ. 6388, insert five, 27 April 1668, Leopoldo to Ferdinando II. "In ore poi libere da si fatte occupazioni mi sono appagato d'andar vedendo ne gabinetti e nelle botteghe più celebri medaglie, pitture e statue, havendo tra queste riconosciute per degne di maggior osservazione il Costantino del Cav. Bernino ridotto oramai a segno da dimostrar la sua macchina, e la sua perfezione, si come in genere di singolarità ottimamente provvisto ho trovato il Sig. Abbate Braccesi, che ha mess'insieme una riguardevole raccolta di quadri e di altre belle antichità e galanterie di buon gusto e massime di medaglie, delle quali ha uno studio più che ordinario."

In addition to the examples cited above and below, Leopoldo describes several other excursions in his letters to Ferdinando II in ASF Med. Princ. 6388, insert five. On 1 May, "Io poi havendo desiderato d'essere un giorno alle catacombe per venerare quei santi cadaveri, e con disegno ancora di cavarne uno, ne ho richiesto Mons. Sacrista e ha voluto oggi accompagnarmi egli stesso a quelle di San Lorenzo extra muros di sua iurisdizione, et essendo rimasto d'accordo d'unirmi per la suddetta funzione con il Sig. Card. Cibo, son'ito a levarlo, e giunti sul luogo ci siamo Sua Eminenza et io inoltrati per esse visitati alcuni de sepolcri contrasegnati con l'insegna del martirio, ho scelto due corpi con inscrizione, ma che si sono abbattuti ad essere di quelli che sfarinano, e al contatto son'iti la più parte in polvere." On 15 May 1668, "Sul invito fattomi più giorni sono dal Sig. Card. Orsini d'andare alla vigna ch'egli tiene fuor della porta del popolo e che è quella ch'egli ha volontà di comprare da Vostra Altezza mi vi trasferii per vedervi anche una bella quantità miscee, naturali, e d'anticaglie racoltevi da Sua Eminenza il quale si trovò quivi e vi si spese insieme il resto della giornata." On 9 June he writes, "Io mi trasferii al palazzo della Regina di Svezia con vaghezza di vedervi la decantata richezza singolarità e lindura di tappezzerie d'arredi di medaglie di quadri che in effetto vi sia, e che nella sopranessa casa del Sig. Card. prenominato [i.e., Azzolini] apposta comparsovi mi furono da Sua Eminenza fatte godere con somma mia sodisfazione d'osservare una raccolta di tante pitture preziose et ottimamente conservate di medaglie rare e ben mantenute e di molte altre magnificenze gentilezze che vi si scorgono."

On a loose sheet in ASF Med. Princ. 5508 is a rough draft evidently from mid-April 1668. "Sono andato anche vedendo in hore disoccupate alcune di queste antichità in diverse case fra l'altre di Mons. Patriarca de [blank] E venuto pur da me il Sig. Principe di Palestrina nel ritornare io da vedere le rare antichità di Mons. Patriarca de Massimi gia che fra tante cerimonie non mi scordo in hore disoccupate d'andar anche sodisfacendo tal volta in diversi luoghi alla curiosità."

43. ASF Med. Princ. 6388, insert five, 8 May 1668, Leopoldo to Ferdinando

II. "Questa mattina non havendo potuto incontrar Cardinale non fusse occupato sono stato al palazzo del Card. Antonio a' Giubbonari veramente ripieno di quadri e statue in grand'abbondanza."

44. ASF Med. Princ. 6388, insert five, 4 June 1668, Leopoldo to Ferdinando II. "Mi trasferii al Palazzo delle Quattro Fontane per sodisfarvi all'invito prestante e reiterato dell'infatigabile Sig. Card. Barberino, che nell'inspezione della biblioteca, pitture, statue et altre singolarità che vi si godono, volle pure accompagnarmi indefessamente e con tratti di somma cortesia." In ASF Med. Princ. 5563, fol. 158 is a letter to Leopoldo from Cardinal Antonio Barberini of 10 October 1654, which might possibly have signalled a reopening of communication. Ricci's *Diario* records Cardinal Antonio's visit to Florence on his return journey from France (*Capitolo* 125, 12 November 1657).

45. ASF Med. Princ. 6388, insert six, 12 June 1668, Marucelli to Panciatichi. "havendogli fatto replicare per Monsignor Aquivivi un gentilissimo complimento accompagnato dal regalo di un bel quadro di mano di Annibale Carracci." This description does not allow identification of a specific picture.

Ricci's *Diario* records, "*Capitolo* 259—Adì 17 Giugno in Domenica ritornò di Roma l'Eminentissimo Signore Cardinale Leopoldo con tutta la sua corte e tutti con buona salute e al suo arrivo fu ricevuto in questa dominante con lo sparo del cannone da tutte le fortezze come Principe di Santa Chiesa."

46. ASF Med. Princ. 5560 includes a great deal of correspondence (1659–1672) from Ottavio Barducci, "ministro generale delle possessioni del Serenissimo Sig. Principe Leopoldo." The *andito* and *audienza* to which Barducci refers are presumably in Leopoldo's three-room summer apartment on the northeastern side of the *cortile* on the ground floor of the Palazzo Pitti. In Marmi's description in BNCF II I 284, these are on fol. 217, Camera da Riposo (letter N), fol. 28, Anticamera (letter O), and fol. 29, Bagno (letter P). See n. 77 below. Barducci's letter of 24 April 1668 to Leopoldo in Rome (ASF Med. Princ. 5560, fol. 318) describes the project in particular detail. There are other more cursory references in letters preceding and following. "Serenissimo e Reverendissimo Signore / Domenica passata per mano di questo Gio. Cangioli procaccio ricevei ben condizionata e franca di posto a Vostra Altezza Reverendissima la cassa di disegni ordinati al Sig. Priore Filippini e quando compariranno li tre colli che mandò a questa volta per via di mare gli farò ricevere per tenerli in buona custodia come con l'humanissima sua de 21 ne comanda. / Havevo di già tenuto discorso con il Chiavistelli e Marmi secondo l'accenatomi da questo per l'aggiustamento della camera terrena destinata per il baldacchino secondo il pensiero di Vostra Altezza confermatomi con la medesima lettera, ma si è fatta considerazione, che facendovi il fregio il paramento verrebbe tanto basso che leverebbe la maestà alla camera, quale apparirà molto meglio, quando il parato sarà attaccato più alto, ciò è sotto la fascia della volta, quale non restando tutta dipinta apparirebbe povera come per l'incluso schizzo numero uno però si pensava di pingere tutta la volta senza il fregio, come per l'altro disegno numero due, e nel quadro della volta secondare con la figura et il pensiero da Vostra Altezza accenato, e ordinato nella detta lettera. / Così si è considerato doversi dipingere ancora il [illegible] andito corrispondente alla

camera dell'audienza come per il terzo disegno, già che possendovi tornare bene paramento ne adornamento di quadri con un puro bianco si renderebbe scompagnato da tutte le stanze che [lo zocchi?] vedono dipinte, che a tutto potrà restarne servita l'Altezza Sua di fare reflessione per ordinare più precisamente il suo volere mentre s'apparechieranno per non perdere tempo gli ordinghi all'opera, e [per] che il Chiavistelli promette che il tutto resterà per sua mano terminato in fine del prossimo mese ne lascerò a lui il pensiero de manifattori. / Per un certo poco calculo fatto così in aria già che non puo farsi con fondamento stante che le grasce non hanno esito, mi pare che doverebbe imborsare meglio di scudi 7000 che [illegible] d'avviso all'Altezza Sua, alla quale intanto humilmente m'inchino. / di Firenze li 24 Aprile 1668 / Di Vostra Altezza Reverendissima / Humilissimo, Devotissimo et Obligatissimo Servitore / Ottavio Barducci."

47. ASF Med. Princ. 5539, fol. 183ff, 24 August 1668, Montauti to Leopoldo. On fol. 357 is the "Nota delle spese fatte per servizio del Signor Principe Cardinale nella festa de Santi Cosma e Damiano alla chiesa del titolo di S.A.S. l'anno 1668." On 1 October 1669 Montauti notes, "Il Sig. Monanni ha pagato le doble cinquanta al Priore de Santi Cosma e Damiano in conformità dell'ordine di V.A., e se m'è presa la ricevuta et ha parimente pagato la spesa della festa, che è stata sette scudi meno dell'anno passato, già che servono le due arme del Papa e di V.A., et il quadro dei Santi che si fece l'anno passato" (fol. 375). On fol. 185 is a comparative list of the expenses for the feast as undertaken by the two previous titular cardinals.

48. ASF/CDA VI, fol. 379, 25 February 1667, del Sera to Leopoldo.

49. ASF Med. Princ. 5539, fol. 118, 17 December 1667, Montauti to Leopoldo. "Qui si desidera da molti un ritratto di V.A. per farne copie et s'ella me ne favorisce d'uno dei più freschi, lo potrei comunicare, et sarebbe bene haverlo presto, acciò questi pittorelli, com'è lor solito non empino le botteghe di cosa che non stia bene."

50. The correspondence on the matter of the portrait engraving is very extensive in ASF Med. Princ. 5539, beginning with Montauti's letter of 7 July 1668 (fol. 172) to 5 January 1669 (fol. 240). Also, ASF Med. Princ. 5508, fol. 79, 30 June 1668.

51. Gaulli's portrait of Leopoldo is in the Uffizi Gallery in Florence. The picture is number 584 in Leopoldo's inventory, ASF Guardaroba 826.

52. ASF Med. Princ. 5511, fol. 58, 15 March 1669, Cardinal Chigi to Leopoldo de' Medici. "Eminentissimo e Reverendissimo Signor mio Colendissimo / Incaminandosi di qua alla volta di Venezia il Sig. Giovanni Battista Gaulli pittore maestro accreditato in questa città, e non poco stimato ancor da me per li molti lavori che mi ha fatti, nel passaggio che è per fare per costà non ho volsuto privarlo di questa mia riverentissima lettera per Vostra Eminenza si per dargli occasione di riverirla, conf.e desidera di fare come anche per renderle io medesimo li soliti dovuti ossequii in questa occasione. Supplico con tutto l'animo l'Eminenza Vostra a degnarsi di accogliere l'uno e gl'altri cosi l'innata, et incomparabile benignità sua, e sopra tutto a honorare l'infinità divotione che le professo con li suoi stimatissimi cenni mentre humilissimamente le bacio le

mani / Roma 15 marzo 1669 / di Vostra Eminenza / Devotissimo e Obbliga-
tissimo Servitore / Il Card. Chigi." At the bottom of the page, "Sig. Card. de'
Medici." See n. 58 below.

53. For the *"Serie Aulica"* see K. Langedijk, *The Portraits of the Medici* (Flor-
ence, 1981), Vol. 1, p. 213. Twenty-six copper plates for this series, engraved
by Adriaen Haelwegh, are listed in the inventory of Leopoldo's estate.

54. ASF Med. Princ. 5539, fol. 400, 30 November 1669, Montauti to Leo-
poldo. "I nuovi accidenti hanno ridotto il Papa nel grado che gia Vostra Altezza
ha sentito . . . questa notte Sua Santità ha riposato, e che il polso sta bene, il
che cominciò hiersera doppo esser stato tutto giorno intermittente: nondimeno
è da considerarsi il pericolo di nuovi accidenti, et l'estrema debolezza, et perciò
Vostra Altezza non perda tempo a prepararsi al viaggio, et alle cose necessarie.
Qui ci sono arazzi per quattro stanze buone, et il parato delle fontane, che
possono tutti servire per il suo arrivo."

Ricci's *Diario* observes, *"Capitolo 269*—Adì 12 Dicembre 1669 in Giovedì
mattina partì di Firenze il Serenissimo Cardinale Leopoldo alla volta di Roma
al nuovo conclave per la nuova elezione del nuovo Pontefice dove che il dì 20
detto in venerdì sera gli eminentissimi Signori Cardinali entrorno in conclave
si come è il solito e con i medesimi ordini dell' altri conclavi." According to
Leopoldo's own diary (ASF Med. Princ. 5560 fol. 401), on the evening of 19
December, "serrorno in conclave non si facendo altro che attendere al servizio
del conclave."

55. In addition to the discussion of preparations in Montauti's letters to
Leopoldo in ASF Med. Princ. 5539, there is a scattering of documents in Med
Princ. 5560, particularly fol. 417ff. These are mixed in with the more abun-
dant material relevant to Leopoldo's 1668–69 visit to Rome. In a letter to
Montauti drafted on 1 December 1669, Leopoldo observed, "Dica alla Signora
Principessa di Rossano, che per quello mi possa occorrere in una fretteria, mi
varrò della sua gentilezza. Onde in ordine a ciò le dico che potrà, seguendo la
morte di Sua Santità, far parare le mie stanze dove abitai con i parati d'arazzi
che sono costà e quello che mancasse di portiere o sedie (se bene di queste non
credo che bisogni) e di paramenti, preghi la Signora Principessa in mio nome
a favorirmi. / Circa la carrozza, gia che non è vergogna in queste sorte di fret-
terie, per uno o due giorni che si stia prima d'entrare in conclave, l'accattare o
per quello che mi potessero bisognare farò capitale o del Signor Ambasciatore
o della Signora Principessa. E quando sarò in conclave si potrà vederne et ag-
giustarsi." ASF Med. Princ. 5560, fol. 462.

56. For the career and personality of Olimpia Aldobrandini, princess of Ros-
sano and wife of Camillo Pamfili, see L. Pastor, *La Storia dei papi dalla fine del
medio evo* (Rome, 1932–1933), Vol. 14, pp. 30–36. Her letters to Leopoldo
from 1663 to 1675 are in ASF Med. Princ. 5522, fols. 227–578. Portraits of
the princess and her daughters are listed in the inventory of Leopoldo's estate,
ASF Guardaroba 826, nos. 500–504.

57. ASF Med. Princ. 5560, fol. 370. "Nota di spese che importa tutto
l'adobbo della cella del conclave fatta per S.A.R." These expenses came to over
700 *scudi*.

58. ASF Med. Princ. 5560. fol. 401 contains an exhaustive list of Leopoldo's visits and other official activities. This is headed, "Lunedì 16 Dicembre 1669. Fu l'arrivo in Roma del Serenissimo Principe Cardinal Leopoldo de Medici, venuto per la sede vacante della Gloriosa Memoria di Papa Clemente Nono." Though the function of this record is primarily ceremonial, there are a few entries directly relevant to his amateur interests. On 6 May 1670 he visited the garden at Trinità de Monti and on 13 May went once again "al Giardino." On 13 June, "Fu ancora al giardino di Ludovisio vedendo statue e pitture." On 10 July, "Dopo desinare alla cava delle statue del Duca d'Acquasparta." On 20 July, "Da Monsignor Albergati a vedere galanterie e statue antiche." On 22 July, "Fu poi a vedere statue da due scultori, e poi a Francesco a Ripa a vedere una cava che è del Serenissimo Padrone." On 27 July, "Dal Principe Borghese a vedere pitture." On 24 August, "Da Ciro Ferri Pittore. Da Bacicci Pittore." On 28 August, "Da Carlo Baratta [sic] Pittore." On 1 September, "Dal Marchese Tarsi a vedere galanterie e statue antiche." On 6 September, "Al giardino di Ludovisio." On 11 September he made an informal visit to Ariccia. Most of Leopoldo's dilettante activity was presumably not listed and he saw numerous works of art in the course of his various visits. On 27 June it was noted, "Alla conversazione del Signor Cardinal Chigi, poi dalla Principessa di Rossano, in questi due luoghi si andava tanto spesso che non ne farò più menzione."

Ricci's, *Diario* records Leopoldo's return to Florence. "*Capitolo 285*—Adì 20 Settembre 1670 in Sabato ritornò di Roma l'Eminentissimo Signore Cardinale Leopoldo il quale entrò in Firenze incognito ma il Serenissimo Granduca con il Serenissimo Principe Francesco suo nipote andorno a riscontrarlo a San Gagio e entrorno per Boboli incognitamente come ò detto di sopra."

59. There is considerable discussion of the plates of Ferdinando II's funeral apparatus in ASF/CDA XIX, beginning with an undated letter on fol. 538, evidently from the early part of January 1671. Paolo Falconieri informs Leopoldo, "Questa mattina ho ricevuti i disegni, e subito gl'ho fatti vedere a Gian Jacomo stampatore alla pace, per mettere mano il primo giorno, ma si sono incontrate tutte queste dificultà. . . ." On several occasions Ciro Ferri was approached for advice.

60. Pastor, *Storia dei papi*, Vol. 14, p. 629. Pastor describes Leopoldo as the head of the Spanish faction.

61. An analysis of Leopoldo de' Medici's personal finances is yet to be attempted. In ASF Med. Princ. 5560, fol. 147ff. is a rather miscellaneous block of papers headed *Interessi propri del Serenissimo Cardinale Leopoldo*. He seems to have inherited a number of landed properties from Don Carlo and Mattias de' Medici. On 21 October 1670 he turned over a group of properties to Francesco Maria, perhaps in connection with his nephew's destination for an ecclesiastical career. ASF Med. Princ. 5508, insert three. See also n. 96 below.

62. ASF Misc. Med. 3, insert three and Chapter Two.

63. Lorenzo Magalotti states that Leopoldo's body lay in state in the "salone terreno del suo appartamento." "Elogio del Cardinal Leopoldo" in *Lettere inedite di uomini illustri*, ed. Angelo Fabroni (Florence, 1773), Vol. 1, pp. 1–7. In BNCF II III 500 is an unfinished manuscript account, "Memorie dell'esequie

fatte in Firenze dal Serenissimo Gran Duca Cosimo Terzo, in occasione della morte del Serenissimo e Reverendissimo Signor Principe Cardinale de' Medici." This description ends with a note, "Non si potette dal Sig. Canonico Panciatichi finire stante l'ammalarsi." Panciatichi observes, "Pregio grandissimo hanno apportato all'Altezza Sua Reverendissima, oltre le virtù accennate il continovo patrocinio, e la somma intelligenza di Sua Altezza non meno delle scienze più nobili, che dell'arti, che liberali s'appellano, onde nell'ultima parte del tempio, si leggevano altri epigrammi con simili intitolazioni."

Ricci's *Diario* notes, "*Capitolo 344*—Adì 10 Novembre 1675 in Domenica a hore 21 incerca passò al altra vita il Serenissimo Cardinale Leopoldo Medici e il martedì stette esposto in Palazzo a il suo appartamento e la sera fu portata alla sepoltura conforme al altri principi con le solite compagnie e torcie e fecero la solita gita con i soliti piagnoni e preti e vi era ancora i monaci Valombrosani per che era protettore della detta religione e vi era ancora la Compagnia delle corazze con trombe e timpani scordati e dietro vi era il Serenissimo Principe Francesco suo nipote." "*Capitolo 350*—Adì 3 Aprile 1676 il Venerdì Santo nella Chiesa di Santa Trinità si vedde quella bella lampana all'altare maggiore dove è quel miracoloso crocifisso, la qual lampana a lasciato che sia fatta il Serenissimo Cardinale gia defunto il quale era protettore della religione Valombrosana e si è detto che costi più di cinquecento scudi e per che stia sempre accesa vi a lasciato l'entrata . . ." (The diary entry ends evidently in midsentence).

64. ASF Guardaroba 826. "Adì 14 Novembre 1675. Inventario de mobili e masserizie dell'eredità del Serenissimo e Reverendissimo Signor Principe Cardinale Leopoldo di Toscana, cominciato questo dì suddetto. Stetesi consegnate l'appie descritte robe da Paolo Cennini Guardaroba di detto Signor Cardinale." The last entry is dated 24 February 1676 and is followed by a few pages (fols. 112v–114v) listing those of Leopoldo's possessions sent to Florence from the Palazzo Madama in Rome.

65. ASF Guardaroba 826, fols. 1v–2r. "Dipinte dissero di mano di Raffaello da Urbino."

66. The classical sculptures were dispersed throughout his apartment. See Gabriella Capecchi, "La Collezione d'antichità del Cardinal Leopoldo de' Medici: I Marmi," *Atti e Memorie dell'Accademia "La Colombaria"* 44 (1979), pp. 125–45.

67. The ivories are on fols. 11v–13r. See also C. Aschengreen Piacenti, *Il Museo degli Argenti* (Florence, 1967), pp. 147–53.

68. "Cristallo di Monte" is on fols. 14v–15r.

69. "Ritrattini" are on fols. 101r–103v and fols. 104v–105r. For Leopoldo's interest in such objects see Silvia Meloni Trkulja's discussion in *Omaggio a Leopoldo de' Medici*, ex. cat. (Florence, Uffizi, 1975), Vol. 2.

70. "Cammei e intagli antichi e moderni" are found on fols. 105v–107r. See also M. R. Casarosa, "Collezioni di gemme e il Cardinale Leopoldo dei Medici," *Antichità viva* 15, no. 4 (1976), pp. 56–64.

71. Coins and medals are found on fols. 97r–101r, fols. 103v–104r, and 109r.

72. The self-portraits in the picture listing run from nos. 148–277. Also, nos. 298, 586, 619, 620, 621, and 623.

73. The inventory lists only the pictures in the *libreria* (nos. 444–73). See n. 94 and n. 106 below.

74. On fols. 39ᵛ–40ʳ are various "lastre di rame intagliate," including "36 esperienze matematiche e filosfiche," "4 pezzetti di piastra di rame intagliatovi il frontespizio del libro di sperienze," and "3 strumenti filosofici." On fol. 53ʳ is the plate of a portrait of Ferdinando II, which "serve per il frontespizio del libro delle sperienze."

75. Scientific, mathematical, and geographical instruments are on fols. 42ᵛ–43ʳ. On 35ᵛ are "Mille duegento ottanta due pezzi di cristallo, cioè bicchieri di diverse sorte, ciotole, carafine, ampolle, giare et altre." Many instruments and pieces of apparatus from the Cimento circle are noted in M. L. Righini Bonelli, *Il Museo di Storia della Scienza* (Florence, 1968).

76. ASF Guardaroba 826, fol. 54ʳ. "Un vetro obiettivo che fu già dal celebre Galileo Galilei destinato in dono al Serenissimo Granduca Ferdinando Secondo per mezzo delquale scoperse [tutte?] le novità celesti, e fra l'altre, i quattro pianeti intorno al corpo di Giove, chiamati da esso i Pianeti Medicei, il quale obiettivo vivente il medesimo Galileo accidentalmente si roppe, e così rimase agli eredi da quali a persuasione del Sig. Vincenzo Viviani ultimo scolare del Galileo fu posto nelle mani del Serenissimo Cardinale Leopoldo acciò Sua Altezza si degnasse di farlo conservare, ben che così rotto tra le più salde e preziose gioie della famosissima galleria, o tribuna della Serenissima Casa." There is a marginal notation, "Al Signor Vincenzo Viviani che lo dette a Sua Altezza Serenissima riavuto detto da Sua Altezza Serenissima." See Righini Bonelli, *Museo di Storia della Scienza*, p. 151, n. 3 and pl. 1.

77. The principal document on the appearance of Leopoldo's apartment is Diacinto Maria Marmi's *Norma per il guardarobba del Gran Palazzo nella città di Fiorenza dove habita il Serenissimo Gran Duca di Toscana* (BNCF II I 284). Marmi meticulously records the plan, measurements, allotment of space, frescoes, and semipermanent textile furnishings in Palazzo Pitti as they were in 1666–1667. The 1675 inventory of Leopoldo's estate (ASF Guardaroba 826) describes the contents of the rooms. There were evidently few major changes in the intervening eight years, apart from the installation of the Stanza de' Pittori. (See n. 89 below.) However, we cannot rule out the renovation of wall hangings, and these are only rarely cited in the 1675 inventory. A further problem is that these two sources do not always agree on the number of doors and windows in a particular room, allowing occasional doubt on specific identifications. Also, many classes of items were separately inventoried (i.e., ivories, medals, objects in gemstone, etc.), so that we do not know precisely where they were to be seen.

78. The contents of the Stanza degli Appimondi are inventoried in ASF Guardaroba 826, fols. 78ʳ–80ʳ. It is letter "H" in Marmi's plan and called the Salotto del Appartamento in his description. BNCF II I 284, fol. 194.

79. The contents of the Prima and Seconda Anticamera are inventoried on

fols. 77v–78r. Marmi calls them the Camera de' Portieri (F) and the Antica-mera de' Gentiluomini (G), fols. 192–93.

80. The Stanza dell'Audienza is found on fols. 80r–81r in the inventory and described by Marmi on fol. 195 (letter "I" on the plan). The Sustermans state portraits in the Audienza can be identified with the works cited in *Sustermans: Sessant'anni alla corte dei Medici*, ex. cat. (Florence Palazzo Pitti, 1983), nos. 7, 16, 37, and perhaps 11, 38, 45.

81. The "camera di Sua Altezza Reverendissima dove dormiva" is invento-ried on fols. 81r–82r. Marmi describes the "Camera di riposo del Serenissimo Prencipe Leopoldo" (K) on fol. 196.

82. The numismatic collection and the miniature portraits are inventoried as separate units. In ASF Guardaroba 826, fols. 101r–103v is "Uno stipo d'ebano a sportelli, con mastiettature d'argento contiene dentro numero 60 cassette, con ritrattini. . . . Il sudetto stipo che contiene numero 60 cassette entrovi ritrattini, è restato in camera di Sua Altezza Serenissima." Another ebony chest with one hundred twenty-eight drawers is inventoried on fols. 99r–101r. "Il sudetto stipo si ritrova in camera di Sua Altezza Serenissima con le sudette medaglie descritte." Among various papers relevant to Leopoldo's library in ASF Med. Princ. 5575a, insert two, there is a list of six volumes of numismatic interest with the note, "Questi sono i libri che si mettono in Li-breria di Camera di V.A.R. de Medaglie" (fol. 2). Other rooms in the apart-ment are named as *camere*. However, without further specification, "in camera di Sua Altezza" is perhaps meant to be understood as the bedroom.

83. The chapel is cited in the inventory on fol. 42r–42v. It is letter "N" on Marmi's plan, described on fol. 199. Mehus's "San Zanobio che fa un miracolo d'illuminare un cieco con molte figure" is picture no. 443 in the inventory.

84. The Salone de' Quadri is inventoried on fols. 54v–60r. It is letter "S" on Marmi's plan, and he describes it as the "Salone grande già detto delle guerre, oggi galleria famosissima di quadri e statue del Serenissimo Prencipe Leo-poldo" (fol. 204).

85. The *Concert*, now given to Titian, is in the Palazzo Pitti. It was picture no. 53 in the inventory of Leopoldo's estate. For the del Sera sale see Goldberg, *Patterns*, pp. 56–57.

86. The *Lazarus*, a copy after Veronese or a workshop piece still preserved in the Palazzo Pitti, is no. 3 in the 1675 Leopoldo inventory. See Goldberg, *Patterns*, pp. 67–68 for the controversy surrounding the picture at the time of its acquisition.

87. Guido's late *Cleopatra*, now in the Palazzo Pitti, was no. 60 in the in-ventory. Also by this artist were a *Saint Joseph* (77) and another *Cleopatra* "di prima maniera" (90). See E. Borea, *Pittori bolognesi del seicento nelle gallerie di Firenze*, ex. cat. (Florence, Uffizi, 1975), nos. 100 and 102.

88. See Capecchi, n. 66 above. In G. Mansuelli, *Uffizi: Le Sculture* (Rome, 1958), the *Venus of the Casa Palmieri-Bolognini* is Vol. 1, no. 65.

89. The Stanza de' Pittori is inventoried on fols. 67v–73v. It was not assem-bled until after Marmi's 1666–1667 description of the apartment, but must have been in one of the two larger rooms overlooking the anfiteatro in the

garden, labelled "P" and "O" on his plan. From the sequence of the inventory "O" seems more probable.

90. The Stanza del Buonaccordo is inventoried on fols. 60v–62r. It is "R" on Marmi's plan and he describes it on fol. 203.

91. The Camera Buia is inventoried on 73v–77r. Letter "M" on Marmi's plan, he describes it on fol. 198 as the "Camera della cappella . . . serve per galleria di quadri."

92. The Stanza dell'Anticaglie is inventoried on fols. 84r–86r. This was evidently on the attic level with the library.

93. See n. 56 above.

94. Above the "galleria di varii quadri dipinti a figure piccoli di Pittori famosi" (P), Marmi describes a "Stanza soffitta . . . con altra stanza maggiore a tetto . . . servono per Galleria di varii strumenti matematici del detto Serenissimo Principe" (fol. 201). Above the "camera dell Serenissimo Prencipe Leopoldo che serve per galleria di varii quadri, dipinti e miniati di varie frutte e figure da celebri pittori" (o), Marmi describes a "stanza o mezzanino . . . serve per libreria del Serenissimo Prencipe Leopoldo."

In ASF Med. Princ. 5575a, insert three, document 40 is a deposition by Giuseppe del Nobolo, "Guardaroba del Real Palazzo de Pitti," dated 13 September 1714. He gives information relevant to the transfer of Leopoldo's library to his nephew Francesco Maria. (See n. 106 below.) "Il Serenissimo Cardinal Leopoldo di gloriosa memoria fino che visse tenne la sua libreria in due luoghi del suo appartamento, cioè una ne' mezzanini, ne' quali abita presentemente l'Illustrissima Marchesa Montauti, dove nella camera, in cui essa dorme, compreso anco il sito, che occupa l'andito che fu poi fatto ne' detti mezzanini dal Serenissimo Principe Francesco Maria di f[unesta] memoria per cavarne un passo ad altre stanze; E questo mezzanino che sarà largo circa braccia 14, era tutto circondato da scaffali, da terra fino alla stoia, eccettuato dalla finestra e uscio, retti da certi Pippistrelli, con lor reti d'avanti, quali scaffali erano tutti pieni di libri in foglio, e in altre grandezze, oltre a quelli, che in quantità stavano di continovo sopra la tavola nel mezzo, e si chiamava la libreria di sopra per distinguerla da un'altra libreria detta di sotto; Et a canto a detta libreria di sopra dove di presente sta la Signora Teresa Borgherini, che si chiamava la stanza de' Bronzi vi erano Armadioni altri circa braccia 2, sotto e sopra dirimpetto l'uno coll'altro, dove vi erano libri grandissimi di disegni e stampe. La libreria di sotto si conservava in quel mezzanino, in cui di presente abita la Serenissima Principessa Eleonora, e tornava in vita del Serenissimo Principe Leopoldo sopradetto a canto alla stanza degl'instrumenti mattematici; et anco questo mezzanino, che è molto grande, era circondato da terra al Palco da Scaffali con loro reti, come quelli della libreria di sopra, eccettuate le due finestre, che allora però erano piccole, e la porta, ma tanto gli scaffali attorno a detta stanza, che quelli che rigiravano sopra dette finestre, e porta erano pieni di libri, oltre a quelli che di continovo stavano sopra alla tavola di mezzo. / Item attesto come tutti i predetti libri, e scaffali rimasero alla morte del detto Serenissimo Principe Leopoldo, che seguì l'anno 1675, al Signore Principe Francesco, al quale Sua Altezza Reverendissima gli lasciò, e pochi mesi dopo

la detta morte il prefato Signore Principe Francesco gli levò da' luoghi predetti, e gli fece trasportare nelle tre stanze ove di presente si conservano."

Del Nobolo continues to describe the transfer and subsequent fate of Leopoldo's library. Laura Giovannini kindly brought this document to my attention. She cites it on p. 24 of her *Lettere di Ottavio Falconieri a Leopoldo de' Medici nel Carteggio d' Artisti* (Florence, 1984).

95. Marmi notes a "stanza . . . dove abita il guardarobba" over the Anticamera de' Gentiluomini (G), fol. 193.

96. On 21 October 1670 Leopoldo made over to Francesco Maria the Abbeys of San Galgano and San Turpè in the Pisano, the Abbey of Santo Stefano di Carrara in the Padovano, and the prepositura of Cigoli. ASF Med. Princ. 5508, insert three. At least the first three of these had previously belonged to Leopoldo's uncle Cardinal Decano Carlo. ASF Med. Princ. 5496, fols. 111ff., 351, 422. Also ASF Med. Princ. 5869a, insert one, "Beni fidecommisei passati nel Card. Francesco Maria dall'eredità del Cardinal Leopoldo suo Zio. 1670."

97. ASF Guardaroba 826, fols. 62r, 1v, 2v–4v.

98. ASF Guardaroba 826, fols. 1v, 114v.

99. ASF Guardaroba 826, fols. 1v–2r.

100. ASF Guardaroba 826, pictures nos. 102 and 393.

101. ASF Guardaroba 826, pictures nos. 97, 99, 100, 662, 105, 414, 440, and 659.

102. He attests, "Io Paolo Cennini afermo che il soprannotato è tutto lo spoglio di Sua Altezza Reverendissima di Gloriosa Memoria quali mi trovavo appresso di me per eseguire la mente di Sua Altezza Serenissima. Mano propria." ASF Guardaroba 826, fol. 111v.

103. There is an annotation by Ugo della Stufa, Leopoldo's *Gentiluomo di Camera*, "Il Serenissimo Gran Duca per sua clementissima benignità si compiace che le robe descritte in questa nota, si distribuischino fra gli aiutanti di camera della Gloriosa Memoria del Serenissimo Principe Cardinale de' Medici, eccettuato però i quattro roccetti che così mi ha comandato con la viva voce il Serenissimo Padrone. Ugo della Stufa." ASF Guardaroba 826, fol. 111v.

104. For Giovanni Bianchi see *Notizie* 4, p. 315.

105. ASF Guardaroba 826, fol. 94r–94v. "Tutte le sopradette legate partite e di là si sono consegnate a Lorenzo Gualtieri per metterle ne' libri de' disegni."

106. Leopoldo's library was never inventoried, and on Francesco Maria's death in 1711 there were difficulties in separating his uncle's books from his own, which he left to the Congregazione de' Poveri di San Giovanni. In ASF Med. Princ. 5575a, insert three is a folder headed "Recapiti diversi relativi allo [illegible] azione della libreria del Cardinal Leopoldo dall'eredità del Serenissimo Principe Francesco Maria." A summary of the case on fol. 39 states: "Il Serenissimo Signor Principe Cardinal Leopoldo del Gran Duca Cosimo II di Toscana nel suo testamento de 6 novembre 1675 doppo vari legati fatti a favore de Serenissimi suoi congiunti lasciò la libreria da se raccolta con spesa veramente da Principe al Serenissimo Principe Francesco Maria suo nipote coll'appresso disposizione. 'Al Serenissimo Principe Francesco Maria lascio la mia libreria comprendendo ancora gli scaffali, al quale doppo la sua morte

sostituisco il Serenissimo Gran Duca che sarà allora regnante e prego il detto Signor Principe Francesco Maria a farne fare un'inventario, sperando che la sopradetta libreria possa esser gradita da Sua Altezza più di qualsivoglia altra cosa, come molto proporzionata ad un Principe Ecclesiastico.' . . . Non avendo il medesimo Signor Principe Francesco Maria per quanto si sappia adempito il detto obligo di fare l'inventario. . . ." See also n. 94 above.

107. *Notizie* 4, p. 508. In BNCF II II 110, fols. 350–52 are a list of pictures and an interior elevation drawing, perhaps prepared by Filippo Baldinucci and evidently intended as a plan for the Sustermans "museum."

108. Goldberg, *Patterns*, pp. 231–32.

109. ASF Misc. Med. 3, insert one. These papers are intriguing but highly miscellaneous and need to be subjected to meticulous editing before too many conclusions are drawn. The rough drafts are often very rough indeed.

110. ASF Misc. Med. 3, insert one, fol. 4, "Bella Turca Amante Appassionato" and fol. 32, "Per bellissima dama che andando per mare sopra le galere fu da esse salutata con l'artiglieria."

111. ASF Misc. Med. 3, insert one, fol. 123.

112. Pieraccini, *La Stirpe de' Medici*, p. 612.

113. ASF Med. Princ. 5565, fols. 509–29, Leopoldo to Cavaliere Horatio Capponi.

114. ASF Misc. Med. 3, insert one, fols. 93, 137.

115. ASF Misc. Med. 3, insert one, fols. 22–25. "Imparasi dalla umiltà di Santa Maria Maddalena de' Pazzi la strada di salire in cielo." This saint was canonized in 1669.

116. ASF Misc. Med. 3, insert one, fols. 58–60.

117. ASF Misc. Med. 3, insert one, fol. 111.

118. ASF Misc. Med. 3, insert one, fols. 16–20. This sonnet was eventually published in Giovanni Mario Crescimbeni's *Dell'Istoria della volgar poesia* (Venice, 1731), Vol. 2, pp. 504–50.

119. ASF Misc. Med. 3, insert one, fols. 12–16. In his critique of 13 October 1667 Carlo Dati notes, "Abbiamo letto e considerato il sonetto datoci da Vostra Altezza, il Signor Cavaliere Panciatichi ed io, e per parlare con quella sincerità che suol volere l'Altezza Vostra non ci riesce simile a molt'altri sentiti da lei fatti con più felicità e poesia . . . Son troppo ardito, ma la benignità di Vostra Altezza mi fa tale comandomi il proferire i miei sensi con libertà, ma però sempre umilmente e con ogni riverenza maggiore." Leopoldo annotates their comments and concludes, "La ringrazio ma da vero e replico per risentire con l'istessa libertà il suo parere, e voglio anco sentire altri ma non lasci Vostra Signoria di dire."

120. ASF Misc. Med. 3, insert one, fol. 3. "In morte dell'Eminentissimo Signor Cardinal Sacchetti."

121. ASF Misc. Med. 3, insert one, fol. 8. "Invito al Signor Conte Annibale Ranuzzi alla quiete lasciando le pompe et ogni altro mondano diletto."

122. ASF Misc. Med. 3, insert one, fol. 100. "Al Signor Cavaliere Orazio Rucellai, che non pensi ottener in i versi la [?] della dama."

123. ASF Misc. Med. 3, insert one, fol. 57. "Sonetto morale di peccatore che dal vino ritorna alla virtù. Al Signor Marchese Pier Francesco Vitelli."

124. ASF Misc. Med. 3, insert one, fol. 143. "Questo sonetto si è del maggiore fra i maggiori de viventi poeti."

125. ASF Misc. Med. 3, insert one, fols. 49–50.

126. ASF Misc. Med. 3, insert one, fol. 138. "Ci son certi chiamati bacchettoni / i quai fanno da santi, e sono tristi. / e fanno il collo torto e cento gesti. / e canton per le strade i lazzeroni."

127. ASF Misc. Med. 3, insert one, fol. 164.

128. Magalotti's eulogy is printed at the beginning of Fabroni, ed., *Lettere inedite*, p. 4, "Oltre agli studi si può dire, che anche i diletti e le sue curiosità fossero studiose."

129. ASF Carte Strozziane V, 1121, insert one. On 9 July 1636 Leopoldo wrote Lorenzo Strozzi, "Di quà le do avviso, come giovedì passato s'aprì qui in palazzo l'accademia e si seguirà ogni quindici giorni di radunarla, con lezioni, e problemi, e poesie, e con bellissime musiche." On 16 July 1636, "Intendo che per hoggi saremo invitati ad un festino per trattenimento da Cavalieri, e domani haveremo qui in Palazzo la mia solita Accademia per trattenimento da Accademici. Hoggi pasceremo gli occhi, e domani l'intelletto." On 5 November 1636, "Domani giorno del mio natale si farà qui in Palazzo l'Accademia."

130. See Severina Parodi's catalogue and valuable introduction, *Accademia della Crusca: Inventario delle Carte Leopoldiane* (Florence, 1975). Leopoldo's three successive mottos were: "Da giacer sicuro" ("L'Assonnato"), "Ch'è s'acquista ben pregio altro che d'armi" ("L'Adorno") and "Per lo perfetto loco onde si preme" ("Il Candido").

131. ASF Guardaroba 826, fol. 38r. "Una pala dipintovi un cavallo alla mangiatoia fatta per impresa dell'Accademia della Crusca senza motto." On fol. 47v, are "Un marchio di ferro per l'Accademia della Crusca, o bullettina da commedie" and "una piastra di rame intagliatovi una rosta con impresa della Crusca." On 96v, "Una pala per l'Accademia della Crusca dorata."

132. Crescimbeni, *Dell' Istoria della volgar poesia*, Vol. 1, p. 225.

133. ASF Med. Princ. 5560, fol. 346 (summary of the new cardinal's public comportment from 13 December 1667 to 6 November 1668). "Si celebrò il solenne stravizzo dell'Accademia della Crusca al quale intervenne il Serenissimo Cardinale, e gli Signori Arciconsoli invitarono Monsignor Nunzio, quale si trasferii sul luogo in abito di sottana, mozzetta e ferraiuolo, nonostante che il Serenissimo Cardinale vi andasse in zimarra, e questo dissero i suoi servitori per mostrar maggiore stima verso Sua Altezza Reverendissima. Allo smontar di carrozze fu ricevuto da un Accademico, che fu il Signor Gualtiero Panciatichi, e trattenuto in una camera, sino all'arrivo del Serenissimo Cardinale, con il quale venutosi sotto le loggie, si andò alla sala, ove si devono rendere gli ufizi, quivi stettero sopra due seggiole eguali, ma però in terra piana sopra un tappetto, senza gradino. S'andò a tavola, e prima d'entrarvi, anco Monsignor Nunzio si messe in zimarra. Stettero a dirimpetto, serviti con posate dorate equali, e senza panattiera. Al partire, vennero insieme alla porta, e partò prima

il Cardinale e di poi Monsignore." The ceremonial aspects of two other academic sessions are also described. On 19 January 1668, "Nell'Accademia degli Abbozzati, in via del Cocomero, si recitò un orazione et alcuni altri componimenti in morte del Serenissimo Principe Mattias, dove intervenne Sua Altezza Reverendissima sopra un gradino coperto di velluto rosso, e sedia rossa, in zimarra, ferraiolo e capello." On 30 July 1668, "Il Serenissimo Cardinale intervenne all'Accademia della Crusca in zimmara, ferraiolo e capello rosso."

134. Parodi, *Accademia della Crusca*, p. 10. Particularly intriguing is Leopoldo's reference to "il nostro grande accademico Galileo Galilei con tanta chiarezza dimostrare li filosofici arcani di già scoperti con verità, e li nuovi da lui riconosciuti, e nella terra, e nel cielo riducendo mercè di nostra ricca, e copiosa favella la rozzezza de' termini delle filosofiche scuole, ad una proprietà et gentilezza senza pari."

135. Parodi, *Accademia della Crusca*, pp. 8–9. For Leopoldo's allotment of work space see W.E.K. Middleton, *The Experimenters: A Study of the Accademia del Cimento* (Baltimore, 1971), p. 23. For Leopoldo's correspondence with Ottavio Falconieri see Fabroni, ed., *Lettere inedite*, n. 128 above.

136. In ASF Misc. Med. 3, insert two is a folder headed "Facultà di leggere e tenere appresso di se libri proibiti, e per se, e per altri."

137. My discussion of Leopoldo and the Cimento is drawn largely from Middleton's exciting and thought-provoking *The Experimenters*, pp. 331–46.

138. Ibid., pp. 26–40.

139. Ibid., pp. 72–73.

140. Ibid., pp. 61–64.

141. Ibid., pp. 281–308.

142. Blaeu's letters to Leopoldo from 1666 to 1674 are at the beginning of ASF Med. Princ. 5563. Four are published in SPES, 74, 78, 86, and 89. See also K. Langedijk, "Een Van de Velde—aankoop door Kardinaal Leopoldo de' Medici in het jaar 1672," in *Oud Holland* 76, No. 1 (1961), pp. 97–106. Other correspondence between Blaeu and Leopoldo is in ASF Med. Princ. 5575a, insert 4.

143. ASF Med. Princ. 5563, fol. 20, 1 June 1668, Pieter Blaeu to Leopoldo. "Serenissimo e Reverendissimo Signor Principe Cardinale / Sono finalmente capitati qua in questa settimana li saggi delle esperienze mandatimi da Vostra Altezza Reverendissima, e secondo l'ordine datomi con la sua gentilissima de 28 febbraro. Subito ne ho dato un'esemplare al Signor Einsio, che appunto all'hora stava per partire il giorno seguente per Svecia, come l'altro hieri succedette, onde hebbe molto a caro di riceverlo, come anche il Borelli della Percossa, ch'io pure gli hò consegnato da parte di Vostra Altezza Reverendissima. Mi disse il Signor Einsio, che a Uppsalia si trova un huomo dottissimo e curioso al maggior segno di materie simili, onde io non volsi mancare di presentare, e dargli un'altro esemplare de' sopranominati saggi, già che Vostra Altezza Reverendissima ha havuto la bontà di mandarne Lei per me, e ch'io mi persuado che non potevo meglio impiegare uno di essi per suo servizio, dovendo riuscir grato a Vostra Altezza Reverendissima che li detti saggi suoi restino visti ed esaminati da persone curiose benche tanto lontane. / Ho poi

con l'occasione d'un vascello mandato al Signor Evelio a Dantzica un esemplare de' detti Saggi, et un altro della Percossa per esso lui, et inoltre altro e tanto per il Signor Segretario Tito Livio Burattini. / Il Signor Vossio per causa della stampa che adesso si fa del libro de Idolatria di suo Signor Padre defonto è stato alcuni giorni in questa città onde ho havuto occasione di dargli in mani proprie da parte di Vostra Altezza Reverendissima un'esemplare de' detti saggi. Mi ha detto, come anche ha fatto il Signor Einsio sopranominato, che ne renderebbe le dovute grazie a Vostra Altezza Reverendissima. / Ho mandato a Anversa li duoi esemplari de' detti Saggi per li Padri Papenbrochio, ed Esselenio, e gli ho pregati come anche il Signor Evelio sudetto, che a suo tempo dessero avviso a Vostra Altezza Reverendissima della ricevuta di essi. / Il Signor Grevio è stato qui questi giorni passati, onde ho havuto occasione di consignargli da parte del Signor Dati un esemplare de' gia nominati Saggi inviatomi per questo effetto. / Io da vero sono obbligatissimo alla ineffabil cortesia di Vostra Altezza Reverendissima desiderando li miei sentimenti intorno a detti Saggi, come se fossi habile di giudicare d'una opera si dotta e tanta erudita, tuttavia per farle conoscere la mia ossequiosa e divotissima servitù, e per ubbidire a suoi da me riveriti sentimenti con ogni dovuta sincerità, che per la brevità, che li detti Saggi sono stati nelle mie mani, non posso fare adesso. Intanto le rendo humilissime grazie degli esemplari, ch'ella s'è compiaciuta donarmi e m'accorgo benissimo dalla trascorsa che ho fatta, che questa opera riuscirà di molto contento a' curiosi e virtuosi, e per certo ne' Signori Accademici del Cimento ridonderà grandissima gloria, e principalmente in Vostra Altezza Reverendissima d'haver dato alla luce una opera di tanta vertù, e si degna dell'applicazione d'ogni persona dotta. / Mi scrisse Vostra Altezza Reverendissima d'havermi inviato alcune opere anatomiche del Signore Stenone le quali a me non sono mai pervenute, benche ella me ne scrisse più tempo fa. Scrivo questo solo per farle conoscere, ch'io non trascurò di distribuirli alli virtuosi, ch'ella all'hora mi indicò, forse saranno venute nelle mani del Signor Golio, mentre che nel catalogo de suoi libri fra li sligati se ne trovano se ben mi ricordo 6 o 7 esemplari. / Con la nave l'arma del Principe e Capitano Gio. Pietro, che Dio conduca a buon salvamento ho inviato a Vostra Altezza Reverendissima una balla libri numero due, qui inclusa troverà la fattura che ammonta a 210 fiorini, l'ho indirizzata a Livorno a Signori Gio. van Winckel e Guglielmo van Weerdt con ordine d'inviarla a Vostra Altezza Reverendissima. / Ho preso la libertà di porre nella balla di Vostra Altezza Reverendissima una cassetta per il Serenissimo Principe di Toscana, ch'io humilissimamente la supplico a non pigliare per male, già che non havevo miglior commodità, essendo troppo piccola per mandarla sola. / Se posso servire Vostra Altezza Reverendissima la supplico ad honorarmi come per il passato de suoi comandi, e qui per non attediarla finisco mentre che sono con humilissimo inchino, e con vero affetto / D'Amsterdam il primo Giugno 1668 / Di Vostra Altezza Serenissima e Reverendissima / Humilissimo e Divotissimo Servitore / Pietro Blaeu."

144. ASF Med. Princ. 5563, fol. 21, 27 July 1668, Blaeu to Leopoldo. "Doppo la prima distribuzione d'alcuni esemplari de' Saggi delle esperienze, non voglio fare altra per adesso, fin ch'io sappia da Vostra Altezza Reverendis-

sima s'ella vuole ch'io faccia diligenza per impedire che non si stampi qua in forma piccola ed in lingua latina, perche l'altro giorno un'amico mio mi disse per cosa certa, ch'era bene informato, che c'è qualche uno in questi paesi, che tradurrà subito li detti Saggi delle esperienze in lingua latina, e li stamparà subito poi in forma piccola, quando potrà incontrare qualche esemplare che è da vendere, o ch'egli potrà havere per se. Per parlare schietamente a Vostra Altezza Reverendissima secondo il mio debito, ogni uno che fin ora ha visto e considerato li detti Saggi d'esperienze, ne fa gran stima, e ne resta sodisfattissimo meritamente, perche al parer mio e di tutti passano di gran lunga quelle che sono fatte ed in Inghilterra ed altrove. Vi sono alcune poche parole, che per essre dure o accademiche o termini arti riescono difficili da intendere di quelle che non sono ben prattici della lingua toscana, che non è cosa essenziale ne da maravigliarsene. La stampa, la carta, ed il carattere riescono a sodisfazione. Vostra Altezza Reverendissima scusi per grazia se piglio ardire di parlar seco si liberamente e con tanta familiarità in questo affare, quelle lettere grandi di legno non hanno molto garbo, le figure son bellissime." On 28 February 1669 (fol. 22) Blaeu notes, "Mi pare che quello che voleva stampare il libro delle esperienze in lingua italiana dico latina, non lo tira inanzi per la difficoltà grande che si trova nella traduzione."

145. ASF Med. Princ. 5563, fol. 22, 28 February 1669.

146. See Goldberg, *Patterns*, pp. 91–122. Also L. Giovannini, *Lettere di Ottavio Falconieri*.

147. On 27 April 1650. See n. 22 above.

148. Fytton's letters to Leopoldo are in ASF/CDA III, 9 January 1653–4 April 1656. For basic biographical information see *Biographical Dictionary of the English Catholics* (London, 1886), Vol. 2, pp. 345–47.

149. In his recent book, *Lord Arundel and His Circle* (New Haven, 1985), pp. 1135–36, David Howarth discusses same of Fytton's collecting activities while in Rome in the 1630s. Dr. Howarth very generously shared with me a series of documents from the Dorset County Records Office that shed light on Peter Fytton's later connection with Thomas Weld of Lulworth Castle, Dorset.

150. In a letter to Leopoldo of 5 September 1664, the Abbot Seguyn in Paris refers to the "feu M.r Fitton, Intendant des Antiquités du Cabinet de Vostre Altesse." ASF/CDA IX, fol. 251. For the gems see M. R. Casarosa, "Collezioni di gemme e il Cardinale Leopoldo dei Medici," *Antichità viva* 15, No. 4 (1976), pp. 56–64.

151. In his letter to Leopoldo of 18 October 1670 (ASF/CDA XI, fols. 10–11), Ottavio proposes the following scheme for the prince's cameos and intaglios:

"Serie di intagli grandi antichi.

Serie di intagli grandi moderni.

Serie del resto degl'intagli antichi divisa in:

 teste (secondo l'ordine accennato di sotto)

 figure

 animali

Serie degli altri intagli moderni se ve ne saranno di quelli che meritino di
 esser messi in serie fuori della serie de' grandi.
Serie di cammei grandi antichi.
Serie di cammei grandi moderni.
[Serie di cammei piccoli antichi.
[Serie di cammei piccoli moderni.
 se vi sarà numero che meriti il farle.
Ciascheduna serie sarà disposta con quest'ordine cioè Deità, Heroi, Teste
incognite, Re barbari, Filosofi dove la serie lo richiederà, Huomini illustri
romani, Imperadori, Incerti e nelle serie grandi saranno mescolate le teste con
le buste secondo che richiederà l'ordine."

152. Gottifredi's letters to Fytton are mixed in with those to Leopoldo in
ASF/CDA VIII.

153. See particularly Fytton's letter to Leopoldo from Bologna of 4 April
1656, ASF/CDA III. Also Capecchi, "Collezione d'antichità," pp. 128–29. Fyt-
ton perhaps dealt with Bisi because Ferdinando Cospi, the chief Medici repre-
sentative in Bologna, was ill.

154. See the curious series of letters from Paolo del Sera to Leopoldo, ASF/
CDA V, 8 April 1656 (fol. 133), 22 April (fol. 134), and 23 April (fol. 135).

155. Goldberg, *Patterns*, p. 100.

156. Andreini's letters to Leopoldo de' Medici and his secretary Fabrizio
Cecini are in ASF/CDA XXI. On 2 January 1674 (fol. 129) he wrote Cecini
refusing a position in Florence, probably one like that previously held by Fyt-
ton. At that time Andreini was in Naples arranging a permanent move to that
city for business reasons. He returned to Naples on 24 April 1675, as described
in his letter to Cecini of 7 May 1675 (fol. 143). In the index to the Fondo
Mediceo del Principato of the Florentine State Archives, Andreini is listed as
"Console della Nazione Fiorentina a Napoli" and correspondence from the
1680s and 1690s is cited. In ASF Med. Princ. 5539, fol. 679 (8 November
1673) is a letter from Resident Montauti in Rome describing Andreini's arrival
with an introduction from Leopoldo. Other references are in fols. 682 (18 No-
vember 1673), 781 (5 April 1675), and 782 (13 April 1675). Also Med.
Princ. 3941, 27 January 1673/74, *Diversi* Francesco Camelli to Apollonio Bas-
setti. See also Chapter 2, n. 127.

157. In February 1661 (ASF/CDA VIII, fol. 158) Francesco Gottifredi wrote
Leopoldo, "Il Signor Lorenzo Magalotti ha favorito di farmi vedere secondo il
commandamento di Vostra Altezza Serenissima le tre medaglie portate da
costì." On 7 February 1669/70 (ASF Med. Princ. 5560, fol. 314), Ottavio
Barducci discusses arrangements for shipping Leopoldo's cameos to Rome,
"Con l'assistenza del Signor Lorenzo Magalotti si sono accomodate le cassettine
di cammei in modo da credere che non sieno nel moto per guastarsi." On 9
December 1651 (ASF/CDA VIII, fol. 9), Gottifredi thanks Leopoldo for sending
Carlo Dati to visit him in Rome and refers to the *medaglie* he was shown. In a
letter which is marked 1660, Dante da Castiglione advises Leopoldo that Prior
Antella's medals should be acquired through means of "Signor Carlo Dati o ad
altra persona dependente de Vostra Altezza." ASF/CDA IX, insert five.

158. ASF/CDA VIII, fol. 44, 13 January 1657, Gottifredi to Leopoldo. "Se piacesse a Vostra Altezza ordinare mi fosse fatto un inventario delle sue medaglie d'argento, potrei servirle più prontamente ne cambii et anco provederla di quelle che le mancano, tanto delle teste, come dei riversi, capitandone più spesse volte molte e perche suppongo, che la serie delle medaglie d'argento sia assai numerosa, potria honorarmi così piacendole, di mandarmene la nota di due o tre imperiali per lettera ch'io poi la mettria insieme." On 30 March 1658 (fol. 66), Gottifredi notes in a similar vein, "Mi favorì altre volte Vostra Altezza Serenissima della nota delle sue medaglie d'oro, ma non l'hebbi già di quelle d'argento, della quale hora vorrei valermi per quello di Napoli, che ne ha quantità, ma oltre questa mi giovaria molto per servir meglio Vostra Altezza d'haver la nota distinta delle medaglie di metallo di Vostra Altezza grandi, e mezzane, perche di queste me potria spesso valere anco qui in Roma, et provederla di molte, che capitano alla giornata, e di queste bastaria mandarne una parte per settimana, ch'io poi le andunarei."

159. See n. 157 above. On 6 December 1670 (ASF/CDA XI, fol. 25), Ottavio Falconieri in Rome explained to Leopoldo, "L'inventario de' cammei e degli intagli è già finito et io gli ho già in ordine per potergli inviare ogni volta; onde rimane solamente che Vostra Altezza mi comandi se vuole che si aspetti a mandargli insieme con le medaglie le quali non potranno inviarsi essi presto, rimanendo da ordinare e mettere nell'inventario quelle che si comprano adesso dall'Agostini e se Vostra Altezza vuole che prima di mandare lo studiolo il Cammeli rinetti le medaglie che ne hanno bisogno, ci vorrà del tempo di vantaggio, ma a questo non farò metter mano prima di sentire qual sia la volontà di Vostra Altezza."

160. See n. 82 above. In the inventory of Leopoldo's estate (ASF Guardaroba 826), the medals are cited on several occasions "come nell'indice fatto del Signor Cammelli" (fols. 97r–101r).

161. Goldberg, *Patterns*, pp. 112–13.

162. For the portrait miniatures see Silvia Meloni Trkulja's discussion in *Omaggio a Leopoldo de' Medici*, Vol. 2. For the self-portraits see W. Prinz, *Die Sammlung der Selbstbildnisse in den Uffizien* (Berlin, 1971).

163. See n. 69 above.

164. In *Il libro de' disegni del Vasari* (Florence, 1974), L. Ragghianti Collobi discusses the form and structure of Vasari's drawing collection and traces many extant drawings to this source.

165. Vasari, *Le Vite de più eccellenti pittori, scultori, e architettori* (Florence, 1568), Vol. 1, p. 84.

166. Vasari, *Vite* (1568), Vol. 1, p. 131.

167. See G. Gaeta Bertelà, "Testimonianze documentarie sul fondo dei disegni di galleria," in *Gli Uffizi: Convegno internazionale* (Florence, 1982) pp. 107–21. The Bisi quote is in ASF/CDA III, 16 July 1658, published by A. Poito in *Il pittorino bolognese: Fra Bonaventura Bisi (1612–1659)*, no. 74, pp. 100–102.

168. ASF/CDA IX, insert nine, fol. 106, 31 July 1658, Bernardino della Penna in Perugia to Leopoldo. "Con altrettanta prontezza e felicità, vorrei ub-

bidire e servire a' cenni dell'Altezza Vostra Serenissima in provederle li disegni desiderati, con quanto giubilo, ne ricevo da Vostra Altezza l'honore; dubbito però possa essermene conteso l'effetto per la scarsezza di chi si diletti oggi in questa città di simili galanterie, e perche alcuni anni sono Inglesi et altri oltramontani portarono via quanto poterono havere. Tuttavia starò vigilantissimo et aspetto il ritorno di un gentilhuomo che potrebbe havere qualche cosa di Pietro e Raffaello, con sicurezza che sono originali, d'altri più moderni e buoni sono ricorso ad un Padre Silvestrino."

169. ASF/CDA V, fol. 272, 3 August 1658, Paolo del Sera to Leopoldo. "Intendo dalla benignissima di Vostra Altezza de 27 del caduto che ella vorrebbe dei disegni di questi valent'huomini per poter perfezionare i suoi libri, ma io non saprei propriamente come mi poter fare a poterla servire, perche non capita niente, e tanti quanti ne ho potuti, havere, o cari, o a buon mercato, gl'ho sempre di mano in mano inviati all'Altezza Vostra, come continuerò a fare, se altri me ne capiterranno, havendo io diverse corrispondenze per questa terra ferma aposta, ma di cento disegni che mandino, non ve n'è uno che si possi dir buono." On 17 August 1658 (fol. 273) del Sera wrote, "Ricevei la passata settimana la benignissima lettera di Vostra Altezza insieme con le note delli disegni che ella desidera, destinte in buonissimo ordine, onde ho il tutto pienamente compreso, e di mano in mano, che me n'andranno capitando, non mancherò di servire Vostra Altezza con tutta la dovuta applicazione e con ogni maggior vantaggio."

170. ASF/CDA IX, insert nineteen, fol. 269, 2 August 1658, Lodovico de' Vecchi in Siena to Leopoldo. "Riconosco per singolarissimo l'onore che Vostra Altezza Serenissima si compiace farmi godere, in prevalersi del servizio mio per la scelta de' Disegni che qua possino trovarsi, e di già ne ho parlato con diversi amici e pittori, senza scoprirmi che devino servire per Vostra Altezza Serenissima stimando che in questo modo si possa godere maggiore vantaggio, già che per altro le pretenzioni loro s'accomodarebbero più volentieri alla generosità di Vostra Altezza che al giusto valore de' Disegni."

171. In the inventory of the section "Mediceo del Principato" of the Florentine State Archives, Jacopo Tolomei is described as "segretario della Consultà di Urbino, Auditore della Granduchessa Vittoria [della Rovere] e del Cardinal Carlo" (p. 283). This pattern of communication is clearly expressed in three notes to Tolomei from Leopoldo de' Medici and his *Gentiluomo di Camera* Ugo della Stufa. (1) ASF/CDA IX, insert four, fol. 46. "Illustrissimo Signore mio Signore Osservandissimo / Mi comanda il Serenissimo Principe Leopoldo mio Signore di far sapere Vostra Signoria Illustrissima come sua Altezza haveria caro ch'ella mandasse prontamente quella lettera dove sono le note di quei disegni che dovevono venire di Urbino et io con tale occasione le rassegno la mia osservanza e la reverisco / di Palazzo, 27 dicembre 1658 / di Vostra Signoria Illustrissima / Devotissimo Servitore / Ugo Stufa." (2) fol. 47. "27 dicembre 1658 / Signor Jacopo. Son venuti tanto confusi i disegni di Urbino, e manca nelle descrizioni delle lettere mandate alcune cose, che è necessario che si contenta di esser qua questa sera con *tutte le altre* lettere che si occoresse a tal conto, alle ore 24 per potere adeguatamente riguardare e dio la conservi.

Palazzo li 28 dicembre 1658 / Amorevole di Vostra Signoria / Il Principe Leopoldo." (3) fol. 48. "28 dicembre 1658 / Signor Jacopo. Mando a Vostra Signoria la minuta per rispondere al Signore Staccoli. Se in essa vi fusse qualcosa che non esprimessi bene si contenti di riaggiustarla perche è fatta in fretta. Si contenti bensi di ordinare che gli siano pagati li danari per *li sette pezzi che ha comprato dal Signor Barocci*, che io glieli farò rimborsare dove ella vorrà. E Dio la conservi. Di palazzo, 28 dicembre 1658 / Amorevole di Vostra Signoria / Il Principe Leopoldo."

172. ASF/CDA XVIII, insert one, fols. 457–61, 23 April 1659, Giovanni Battista Bolognetti in Antwerp to Leopoldo (SPES 6). In ASF/CDA IX, insert nineteen, Lodovico de' Vecchi often refers to his brother Lorenzo.

173. ASF/CDA IX, insert nineteen, fol. 297, 25 August 1661, Lodovico de' Vecchi in Siena to Leopoldo. "Fino ad ora non mi è riuscito come credevo il procacciare del medesimo Baldassare alcun disegno, non però ne smarrisco la speranza. Quando Vostra Altezza mi onori avvisare quali manchino per proseguire i libri preziosi et havere interrotta nella continuazione de' tempi e squole de pittori, una muta historia, secondo il nobilissimo pensiero di Vostra Altezza Serenissima ne raddoppierei le diligenze."

174. ASF/CDA IX, insert seven, fol. 143, 10 June 1662, Leopoldo to Bernardino della Penna in Perugia. (SPES 11).

175. BNCF Palatino 1031, fols. 29–33, "I nomi de' maestri de quali il Serenissimo Principe Leopoldo ha disegni," dated 15 September 1663. Published by Gloria Chiarini in *Gli Uffizi: Convegno internazionale* (Florence, 1982), pp. 210–14.

176. Goldberg, *Patterns*, pp. 23–33.

177. ASF/CDA IX, insert eight, fols. 157–58, 24 January 1663, Luca Nistri in Milan to Leopoldo (SPES 14). ASF/CDA IX, insert seven, fols. 148–49, 15 May 1663, Bernardino della Penna in Perugia to Leopoldo (SPES 15).

178. ASF/CDA XVIII, insert five, fol. 15, Domenico Maria Corsi in Urbino to Leopoldo (SPES 47). ASF/CDA XVIII, insert two, fol. 394, Marco Boschini in Venice to Leopoldo (SPES 117). The list from Naples is in BNCF Magl. II II 110, fols. 125–27.

179. See following chapter.

180. "Registro de' disegni per tenere Sua Altezza Reverendissima," dated 12 June 1673, Uffizi III, C. 37, 738. See Paola Barocchi, "Il registro de' disegni degli Uffizi di Filippo Baldinucci," *Scritti di storia dell' arte in onore di Ugo Procacci* (Florence, 1977), vol. 2, pp. 571–78.

181. "Listra de' nomi de' pittori de' quali si hanno disegni." Baldinucci's annotated copy is in BNCF Post. 97 (SPES 52).

182. For the state of the drawing collection at the time of Leopoldo's death see Gaeta Bertelà, "Testimonianze documentarie," pp. 107–45. The crucial document is the *Nota de' libri de' disegni*, dated 13 May 1687. ASF Guardaroba 779, insert nine.

183. ASF/CDA V, fol. 42, 27 November 1649, Paolo del Sera to Leopoldo de' Medici.

184. A very great deal of work remains to be done on Leopoldo's involve-

ment with contemporary artists. There are many pictures in his estate inventory that could equally well have been commissioned directly from the painter or acquired secondhand. Baldinucci cites a number of specific commissions, to Bilivert (*Notizie* 5, p. 307), Melissi (4, p. 318), del Bianco (5, p. 30), Volterrano (5, pp. 174–75), Dolci (5, p. 341), and Mehus (5, p. 535). Dating from the cardinal's 1670 visit to Rome there is considerable correspondence from Ottavio Barducci, Leopoldo's business manager in Florence, concerning two pictures commissioned from Dolci and the Volterrano. The subjects are not specified, but they could well have been pendants because the commissions were parallel and the paintings were both sent off to Rome together by 16 May 1670. They might have been intended as a grand gift. The Dolci is described as octagonal. ASF Med. Princ. 5560, 7 February 1669/70 to 2 September 1670 (fols. 314–283 in a disordered series). Also ASF Med. Princ. 5496, fol. 58, *Minuta* following a letter of 26 August 1670.

185. For Stockamer see n. 57 above. Also, O. H. Giglioli, "Due sculture in avorio inedite di Baldassare Stockamer," *L'Arte* 16 (1912), pp. 451–64, and K. Aschengreen Piacenti, "Le Opere di Balthasar Stockamer durante i suoi anni romani," *Bollettino d'arte* 48 (January–June 1963), pp. 99–110. In ASF Med. Princ. 5539, fol. 12, 3 May 1664 is a letter from Resident Montauti in Rome to Leopoldo describing the arrival of Stockamer and his assignment of lodgings in the Villa Medici. In Rome there was also "il pittore Gio. Giorgio, che Vostra Altezza trattiene in questi palazzi," above and fol. 14, 14 June 1664.

186. *Notizie* 5, pp. 210–11.

187. Ibid., 5, pp. 175–76.

188. Ibid., 4, pp. 609–10.

189. Ibid., 5, pp. 529, 532–33.

190. Ibid., 4, p. 498.

191. Ibid., 5, p. 68.

192. Ibid., 5, pp. 448–52.

193. For the *Creation Series* by Carletto Caliari see S. Mascalchi, "Anticipazioni sul mecenatismo del Cardinale Giovan Carlo de' Medici," in *Gli Uffizi: Convegno internazionale* (Florence, 1982), pp. 41–82. We eagerly await the fuller results of Dr. Mascalchi's important work on this intriguing and elusive patron. For the other items, ASF Med. Princ. 5560, fol. 265, "Robe comprate dal Serenissimo Signor Principe Cardinale Leopoldo dell'eredità del Serenissimo Signor Cardinale Giovanni Carlo."

194. In his funeral eulogy Lorenzo Magalotti made a point of Leopoldo's limited financial resources. See also Goldberg, *Patterns*, pp. 30–31.

CHAPTER TWO

1. ASF Misc. Med. 3, insert three, *Ordinazioni del Serenissimo e Reverendissimo Signore Cardinale Leopoldo dei Medici in Fiorenza 1674*. There are also two bifolios headed *Istruzioni alli tre ordini sacri del Cardinale di S. R. Chiesa*. In regard to the body of San Cosimo, Ricci's *Diario* notes, "*Capitolo 215*—Adì 27 Luglio

1664 in Domenica. Dopo Vespro si fece la processione del corpo di San Cosimo il quale fu mandato dalla Santità di Nostro Signore Papa Alessandro VII ai monaci di Santa Trinità, dove si vedde una gran quantità di torcie a detta processione a honorare detto Santo sicome una gran quantità di popolo." In regard to Leopoldo's connection with the monks of Vallombrosa and the Florentine Church of the Santissima Trinità, see Chapter One above, n. 63. In regard to Anna Maria Luisa de' Medici, "*Capitolo 243*—Adì 11 Agosto 1667 in Giovedì a hore 17 ½ la Serenissima Principessa Margherita Alovisa diede alla luce per la seconda volta una bambina e fu battezzata in Palazzo privatamente da Monsignor Ruberto Strozzi vescovo di Fiesole e gli fu posto nome Anna Maria Aloisa e la tenne al sacro fonte il Serenissimo Principe Leopoldo suo zio paterno del Serenissimo Principe Cosimo III Padre di detta Bambina."

2. Filippo Baldinucci's spiritual diary is preserved in the Biblioteca Riccardiana, Florence, MS. Moreni 18. Paola Barocchi and Bruno Santi took the adventurous step of publishing this important and unusual document in the first volume of the *Zibaldone baldinucciano* (Florence, 1981). This edition will be cited below as *Diario*.

3. *Diario*, pp. 19-24.

4. Francesco Saverio Baldinucci's "Notizie della vita di Filippo Baldinucci" are published in volume two of the *Zibaldone baldinucciano*. *Vita di F.B.*, p. 4.

5. This information is taken, admittedly with a mental reservation, from the genealogical tree of the Baldinucci family in ASF Carte Pucci II, insert twelve. The tree is dated "Domenica 21 giugno 1733" on the front. On the back is the note, "Mercoledì 25 Agosto 1745. In detto giorno fui a parlare al Signore Marchese Alessandro Baldinucci in Via Larga quale venne a Firenze giovedì 19 detto."

Filippo Baldinucci had at least two sisters about whom we know almost nothing. In the *Notizie* 5, p. 342 he refers to Maria Madalena. In his diary he occasionally mentions Letizia, with whom his relations were evidently somewhat strained (*Diario*, p. 67). The genealogical tree in the Carte Pucci records only one sister, who is named Elisabetta. According to this source she married Virgilio di Michelangelo Talenti in 1640. Since this information came many years later, evidently from the other side of the family, "Elisabetta" could easily be a garbled "Letizia." In the *Diario*, p. 147 Baldinucci refers to "mia sorella monaca."

6. F. Diaz, Il granducato di Toscana: I Medici (Turin, 1976), pp. 388-94.

7. BNCF Tordi 540-7. "All'Illustrissima Signora Lucretia Gotti Niccolini, Villa / Illustrissima Signora / Si è pagato alli detti l'eredi del Signore Francesco delli Alessandri ducati cento dodici 3.20 si che resta il debito adetto ducati novecento che tanti si mandano in fiera, et perche per ancora non si è ricevuta la pigione dal Signore Pandolfini ne li danari dal monte del sale ò provisto io quello che me ne potrò rimborsare da quelli mi pagherà il Signore Pandolfini et monte del sale, e se in altro la posso servire mi comandi e gli ricordi che a queste ragazze gli piace le ciliege che le mangerebbono come si suole dire di pinte. Sono stato stamani dal Signore Luttozzo per conto di quel servizio e per fine me gli racomando preghi da nostro Signore Dio ogni bene. Di Firenze li 3

giugno 1647 / Di Vostra Signoria Illustrissima / Osservantissimo Servitore / Gio. Baldinucci."

8. BNCF Tordi 540–7, from Gi[illegible] Ciofi to Averardo Cimenes. "Illustrissimo Signore e Padrone Colendissimo / Il Signore Filippo Baldinucci quale è creditore del Illustrissimo Signore Marchese Rodrigo Cimenes suo Signore fratello di scudi otto di sua fatiche per scritture tenute per il medesimo come Vostra Signoria Illustrissima sa fu. Desidera che io gli atesti detto credito quale lei vedese a medesimi libri, e di più dice che facevo io mesi chiesi molte volte e per non avere noi potuto non havere comodità del denaro non gliene potessi dare e sono persino l'anno 1656, e quanto mi occorre dire per la mena verità e gli fo devotissima reverenza, di Firenze li 25 Agosto 1666 / Di Vostra Signoria Illustrissima / Devotissimo Servitore / Gi[illegible] Ciofi."

Below on the same sheet, Filippo Baldinucci acknowledges receipt of this payment. "Adì 27 Agosto 1666 / Io Filippo di Gio. Baldinucci ho ricevuto dall'Illustrissimo Marchese Rodrigo Ximenes scudi otto di moneta e per detto li ricevo dall'Illustrissimo Signore Averardo Ximenes suo fratello, gli sono per ogni resto di quello era creditore la Beata Memoria di Gio. Baldinucci mio Padre di detto Signore Marchese per resto di sue fatiche di scritture tenute per detto fino all'anno 1656 delli quali appariva creditore a suoi libri e mi chiamo contento anco in nome proprio, e satisfatto interamente quale suo auditore disse pagare di suoi propri danari a contanti scudi 8." This document is sometimes unclear and my readings occasionally problematic. In *Notizie* 5, p. 641 Baldinucci refers to the Ximenes as patrons of Fabrizio Boschi, with whom he maintained close relations as well.

9. I am very grateful to Dr. Anthea Brook who came across these important Baldinucci documents in the course of her researches on Ferdinando Tacca. They are in the Fondo Bartolommei in the Florentine Archivio di Stato. The summary index of the Fondo Bartolommei is chaotic and only sporadically useful. The material from which I work is drawn principally from volumes 200 to 231 of this series. Dr. Anna Teicher kindly looked over some of these and gave me a timely and valuable warning about avoiding facile generalizations from account books.

10. Monies "riscossi per mano di Gio. Baldinucci" are cited in ASF Bartolommei 224, fols. 7v, 12r, and 13r. Also Bartolommei 226, fols. 15v and 17v.

11. ASF Bartolommei 226, fol. 18v, cites payment to Filippo Baldinucci, "dal dì 4 giugno 1650 che venne a servire." See n. 16 below. In ASF Bartolommei 231, fol. 61 is an entry, "A dì 30 maggio 1700 . . . A detti salarii f. 205 buoni al Sig. Ridolfo Mariotti per sua provvisione a f. 5 il mese dal primo Gennaio 1696, che morì il Sig. Filippo Baldinucci nostro computista e subentrò in detto ministero detto Marriotti con detta provvisione."

12. ASF Bartolommei 226, fol. 5vff.

13. ASF Bartolommei 226, fol. 11r, 4 March 1650/51. "A entrate di nostri beni generali f. 50 moneta buoni a Filippo Baldinucci nostro computista, sono per sue fatiche straordinarie di aggiustare scritture retrovarsi a Monte Vettolini, per far le stime de bestiami, e molte altre fatiche fatte (come si e rimasto

d'accordo con detto Baldinucci) dal dì 4 giugno che venne a servire sino a tutto Dicembre passato non compresa la provisione che se le deve per detto tempo."

14. ASF Bartolommei 226, fol. 59r. "A dì 20 luglio 1653. A spese di lite f. [blank] buoni a Filippo Baldinucci nostro computista in conto a parte di sue fatiche straordinarie, e sono per sue fatiche di haver fatto un calculo da libri dello scrittoio delle possessioni di S.A.S. di tutto le detrazioni da farsi dall'entrate e rendite della possessione di Monte Vettolini per anni sette cioè dal 1643 a 1649 inclusive per ridursi e purificarsi la loro annua rendita qual calculo ha fatto in detto scrittoio in tempo di circa un mese e mezzo, e più per haver fatto un calculo del resto de resti con S.A.S. quale ha rifatto in altra forma altra volta, ad istanza del Sig. Gio. Federighi, tutto per venirsi al finale aggiustamento e valutazione di detta possessione, gli calculi da detto Baldinucci di nostra parola sono stati consegnati al Sig. Gio. Ant. Borromei ministro generale di detta Altezza, e questo oltre alle fatiche di più sessioni con detto Sig. Gio. Ant. e altri ministri e altro che va facendo in detta causa per haversi in considerazione a suo tempo."

15. Baldinucci refers to pictures seen in the house of Carlo Ginori "da me più volte veduti in occasione d'essere da esso signore per negozi." ASF Med. Princ. 1530, 24 July 1685, F.B. to Apollonio Bassetti (SPES 192).

In the *Diario*, the Alessandri are cited on p. 25 and the Pucci on p. 24. On p. 71 of the *Diario* Baldinucci refers to a call at San Silvestro, "per suoi bisogni del monasterio." Considering the location of the Valori properties, it is highly likely that his acquaintance with Alessandro Valori had a professional base. *Vita di F.B.*, p. 13. On p. 110 of the *Diario* is an unclear reference to "il legato del Valori." In *Paragone*, 331 (September 1977), p. 63, G. Corti publishes a reference from the *Giornale dell'Opera di Santa Croce* to monies "pagatici contanti li figlioli del già Sig. Taddeo del Sen. Giovanni Taddei, per le mani di Filippo Baldinucci."

16. In the *Diario*, Marcialla and Solucci are cited on p. 37, the Albizi and the della Gherardesca on p. 38, and the Frescobaldi on pp. 92 and 95.

17. Filippo's son Gian Filippo Baldinucci refers to "la casa paterna in Via Larga." Luigi Rosa, *Lettere inedite del Beato Antonio Baldinucci* (Prato, 1899), p. 147. See n. 183 below. In his Notizie di Bartolommeo Ammannati" (2, pp. 358–61), Filippo notes that, of the group of three houses designed by Ammannati for the Arte della Lana, he personally occupies the one facing Via della Pergola. These buildings still exist.

18. *Vita di F.B.*, p. 4. In ASF/CDA XXI, insert eighteen, fol. 286 is an undated rough draft of an enquiry concerning art objects in the possession of the Alberti family in Borgo San Sepolcro. Written in the left margin is "Aless.o Baldinucci / Vic.o del Borgo a S. Sep.o." The heading "Il P. Leopoldo saluta" is cancelled and "Filippo Baldinucci" written in. In ASF Misc. Med. 368, fol. 421 Filippo cites self-portraits by Giovanni and Cherubino Alberti, which he saw "coll'occasione di portarmi al Borgo a S. Sepolcro, lor patria, per visitare Alessandro Baldinucci mio cugino, che morì in quel governo." There is "il Capitano mio cugino" to whom Filippo refers several times in the *Diario*, pp. 37, 64, and 81. There is a brief letter from Alessandro Baldinucci to Leo-

poldo, discussing his evaluation of an estate. ASF Med. Princ. 5529, fol. 1233, 22 August 1657.

19. In the *Vita di F.B.* Francesco Saverio refers to "la gloriosa memoria del Gran Duca Cosimo III" (p. 17), dating the work after Cosimo's death in 1723.

20. *Notizie* 4, p. 86.

21. Ibid., 4, p. 97.

22. Ibid., 3, p. 658.

23. Ibid., 5, p. 35.

24. Ibid., 5, p. 31.

25. Ibid., 4, p. 623.

26. *Vita di F.B.*, p. 7.

27. *Notizie* 4, pp. 154–76.

28. Ibid., 4, p. 170.

29. Ibid., 5, p. 342.

30. Ibid., 5, p. 348.

31. Ibid., 4, p. 509.

32. Ibid., 5, p. 167.

33. Ibid., 5, p. 193.

34. Ibid., 5, p. 262.

35. Ibid., 5, pp. 207–19.

36. Ibid., 5, pp. 448, 452, 453, 463, 493.

37. Rosa, *Lettere*, p. 125. See n. 183 below. For Leonardo Buonarroti see U. Procacci, *La Casa Buonarroti* (Florence, 1965), pp. 19–21.

38. For Baldinucci's second collection of drawings, assembled after his sale of the first to Leopoldo de' Medici, see *Disegni fiorentini del Museo del Louvre dalla collezione di Filippo Baldinucci*, eds. R. Bacou and J. Bean ex. cat. (Rome, Gabinetto Nazionale di Stampe, 1959).

39. *Notizie* 3, p. 268.

40. Ibid., 3, pp. 662–63.

41. Ibid., 3, p. 722.

42. Ibid., 4, p. 419.

43. Ibid., 5, p. 177.

44. Ibid., 5, p. 32.

45. Ibid., 3, p. 63.

46. Ibid., 5, p. 460.

47. Ibid., 3, p. 727.

48. Ibid., 4, p. 628.

49. Ibid., 5, p. 228.

50. Ibid., 5, p. 348.

51. Ibid., 5, p. 345.

52. Ibid., 5, p. 86.

53. Ibid., 5, p. 249.

54. ASF Bartolommei 223, Debitori e Creditori della Fabbrica di Santo Stefano, fols. 7 and 14. In ASF Bartolommei 221 is a loose note to "Sig. Baldinucci" dated 25 August 1664.

55. ASF Bartolommei 231 is a thorough and precise inventory prepared in

1695, after the death of Marchese Mattias Maria Bartolommei. Included are the family palace in Via Lambertesca and the villas of Poggiale, Arcetri, and Montevettolini.

56. ASF Bartolommei 230, fol. 11ᵛ.

57. *Dizionario biografico degli italiani*, Vol. 6, pp. 789–91.

58. ASF Bartolommei 231. The very extensive library is inventoried on fols. 23–55, "Nella casa di Firenze vi sono gli appresso libri." On fol. 44ᵛ, col. two are listed the *"Notizie de' professori del disegno del Baldinucci*, Firenze 1681, *dal 1300 al 1400*, Firenze 1686, *dal 1550 al 1580*, Firenze 1688." On fol. 54ᵛ, col. two, are the *"Vita del Cavaliere Bernino* del Baldinucci, *Veglia di Sincero Veri, Vocabolario del disegno* del Baldinucci." On fol. 42ᵛ, col. one are the *"Lezione del Baldinucci*, Firenze 1692" and the *"Lettera dell'Ammannati*, Firenze 1687."

59. *Notizie* 5, pp. 268–69. Filippo owned a cartoon by B. Carducci and another by Macchietti that had previously belonged to the Valori. *Notizie* 3, pp. 474 and 508.

60. *Vita di F.B.*, p. 13. There was also a book of portrait drawings, largely copied from these, that Baldinucci kept at home. See Gabburri's description in Appendix II. At least a considerable portion of one set of Baldinucci's portrait drawings from the Valori circle is preserved in the Gabinetto di Disegni of the Uffizi, 5662–5694. Three other drawings by Baldinucci are Santerelli 15352–4. Giovanni Cinelli refers to Baldinucci's portrait drawings. See Chapter Four, n. 96.

61. *Notizie* 5, pp. 268–69. Baldinucci's drawing of Lorenzo Lippi is Uffizi 5687.

62. *Vita di F.B.*, p. 23 and Chapter Four.

63. *La Veglia: Dialogo di Sincero Veri* (Lucca, Iacinto Paci, 1684; Florence, 1690) SPES 181.

64. Filippo Baldinucci cites his eleven years of service to Cardinal Leopoldo in his appeal to Apollonio Bassetti of 9 December 1681, ASF Med. Princ. 1526, *Diversi* (SPES 177). Also in the author's preface to the *saggio* of the *Notizie* (*Notizie* 1, p. 10). It is well to note that Baldinucci uses the precise figure of eleven years, rather than a vaguer form (i.e., "about ten years"), in situations where it was to his advantage to maximize the length of his connection with Leopoldo. Since these references to "eleven years" tally with the documented 1664 Mantuan venture, I do not hesitate in accepting Baldinucci's statements at face value.

65. In 1662–1663 there were particularly grave conflicts with her brother-in-law Sigismondo, her husband's successor. See ASF Med. Princ. 5525 and 5180. In Med. Princ. 6357a there is an extensive block of documents concerning Anna de' Medici's financial struggles, including many of Tamburini's letters to the administration in Florence.

66. ASF Med. Princ. 5525, fol. 356, 14 September 1664, Giovanni Tamburini to Leopoldo. "Serenissimo Signore e Padrone Clementissimo / Quest'ordinario non ci sono novità, solo che la Serenissima Arciduchessa è stata (a causa di disgusti passati la settimana antecedente) un poco indisposta, ma hier-

matina si levò et questa matina sta assai bene et continua nella sua delibera-
zione di voler star qua ma non vol già trattare nullla del agiustamento de sua
interessi, se prima non vede l'esito del parentado d'Assia con il Signor Arciduca
che dovrà seguire pur alla fine questo, non io posso far altro che aspettare. Se
Vostra Altezza et il Serenissimo Gran Duca fussero ad una fenestra e vedessero
come passano le cose qua, son certo che quando la Serenissima volesse starci,
non vorebbono, e la farebbon tornare, ma come ho detto lei ha determinato di
volerci stare a tutti i patti, per l'amore che porta a queste Serenissime figliole,
è ben vero che quando sente qualche cosa, in quel primo moto la romperebbe
affatto, ma si procura di reprimerlo et con le raggioni et con dimostrarli (come
è verissimo) che queste povere principesse senza lei patirebbon d'ogni cosa,
perche qua bisogna che sinceramente li dica che non ci è amore, ne carità, ne
neanco convenienza. Si distesero i capitoli fra il Signore Arciduca e la Serenis-
sima Arciduchessa quali anco furno visti, et dal Signore Arciduca, et da
ministri, et negl'essenziali si concordava, si come credo si concorderà giachè il
Signore Conte di Chinensech, et alli giorni passati, et anco dua giorni sono,
mi ha detto, che il Signore Arciduca ogni volta che si vorà sottoscriverà detti
capitoli, che fermandosi in quella conformità non solo rimangono alla Serenis-
sima li sua beni di Mantova che anche rimane a sua dispositione il riveder i
conti a ministri per il tempo passato, et è negozio che pò essere di molto utile
alla Serenissima come a bocca rappresenterò a Vostra Altezza Serenissima è però
necessario che habbi persona e da bene et intendente, che vadia a Mantova, a
riveder detti conti, e per questo pregò me che li trovasse persona sufficiente,
che non seppi trovarli meglio, che il Signor Filippo Baldinucci, quale e per
bontà e per sapere non ha il pari in Firenze. Li scrissi però, se havesse volsuto
pigliar questo assunto, et dopo qualche difficoltà, finalmente a persuasione
mia, e del Signor Alessandro Vallori suo partialissimo, si contenta di venire
ogni volta che si vorà a Mantova per rivedere questi conti, ma perche ha nelle
mani alcune calculationi comesseli dal Serenissimo Gran Duca et alcune dal
Serenissimo Signore Cardinale Decano vorebbe però che li fosse comandato il
venire acciò si sapesse che non è sua mera volontà, ma necessità l'abbandonar
detti negozii, et che anco per quel tempo che starà fori che sarà un mese,
restassero sospesi detti negozi et la Serenissima mi ha fatto replicarli che si farà,
che però mi ha ordinato che scriva a Vostra Altezza Serenissima acciò in gratia
sua, vogli restar servita mandar per il detto Signor Filippo Baldinucci et ordi-
narli che venga pure a servire la Serenissima et domandarli che cosa desideri
che Vostra Altezza Serenissima operi, circa a negozi che ha nelle mani, et se-
condo che desidera, et habbi gusto che si facci, poiche vorrebbe che venise
quieto, e sodisfatto, quale maggiormente potesse senza pensieri operare, et la
detta Serenissima sommamente confida in Vostra Altezza Serenissima che habbi
da favorirla essendo negozio che li preme, et di molta consequenza, con rac-
comandar anco al detto Baldinucci i sua interessi, et a lui poi scriverò io quando
debba partire, giache la Serenissima vole che quando arriverà in Mantova vi sii
il Signor Conte Ferrari per poterlo instruire di molte cose, et al Vostra Altezza
Serenissima con ogni affetto bacio le vesti. / d'Inspruch li 14 settembre 1664 /

di Vostra Altezza Serenissima / Humilissimo et Obligatissimo Servitore / Gio. Tamburini."

On 22 September 1664 the Bali Gondi wrote Tamburini, "Ha veduto il Ser.mo Granduca quanto V.S. scrive al S.re P.npe Leopoldo in proposta delli effetti di Mantova et il med.o havrà cura di dignificare alla Ser.ma in qual grado si trovi il S.re Baldinucci." (ASF Med. Princ. 6357a, insert 10).

The correspondence between Tamburini and Leopoldo in ASF Med. Princ. 5525 is very lengthy and involved. On 5 October 1664 (fol. 360) Tamburini reminds Leopoldo to speak with Baldinucci. On 11 October (fol. 359), "La Serenissima ringrazia Vostra Altezza Serenissima della parlata fatta al Baldinucci et agiustate le cose si scriverà che parta." On 9 November (fol. 370), "In primo logo la Serenissima Arciduchessa prega Vostra Altezza Serenissima che venendo da lei il Baldinucci, che deve venire per lei a Mantova, operi che resti esaudito di quanto dirà a Vostra Altezza Serenissima circa alli sua negozi acciochè questo homo possi venir quieto, e di questa settimana si rimette il denaro, acciò parta al principio del venturo."

On 15 March 1665 (fol. 382) Tamburini was about to leave for Mantua and Florence and by 19 July had returned to Innsbruck (fol. 90, misnumbered sequence). Filippo executed a portrait drawing of Giovanni Tamburini, Uffizi 5672.

67. ASF Med. Princ. 5529, fol. 1151, 11 December 1664, Filippo Baldinucci to Leopoldo de' Medici. "Serenissimo Signore / Per satisfare in quanto mi è possibile al debito di divotissimo et obligatissimo suddito dell'Altezza Vostra Serenissima le do parte, come per gratia del Signore sono questa sera arrivato a Mantova. In questo luogo, dove spinto da cenni dell'Altezza Vostra Serenissima mi son portato per servire la Serenissima Arciduchessa, tengo a quel desiderio che devo vivissimo dell'honore de commandamenti di Vostra Altezza Serenissima, e per questo non meno, che per ogn' altro fine, non senza tema di troppo ardire le comparisco avanti con questa mia. Il Gallini, in casa del quale per commissione dell' istessa Serenissima sono alloggiato, sentito da me che si era degnata l'Altezza Vostra Serenissima nel licenziarmi che fece per la partenza di far memoria di sua persona, resto consolato, et insieme confuso della somma benignità di Vostra Altezza Serenissima a segno, ch'io non posso bastantamente esprimerlo et ad essa ne rendo infinitissime grazie. L'operatione, ch'io devo fare per la Serenissima cade sopra l'amministratione del medesimo Gallini tenuta per anni dodici in circa, e per quanto potuto riconoscere per una vista data per adesso cosi sommariamente (benche l'ordine dello scritturato mi paia ragionevolmente buono) penso però che sia per riuscire cosa alquanto più lunga dell'aspettato, volendo io come devo, e come è mio solito applicarmi ad operare con tutte le mie forze, acciò l'Altezza Serenissima resti più fruttuosamente servita, che mi sia possibile. Per questo dunque le gratie compartitemi dall'Altezza Vostra Serenissima e che mi andasse compartendo in avenire circa l'operare ch'io sia compatito per i negozi lasciati a Firenze, sono state e saranno a me et al medesimo servitio di detta Serenissima profittevoli e necessarie, che però non lascerò a tempo suo, et inquanto io veda il bisogno di tornar a supplicarnela, mentre per fine, con ogni più profonda umiltà all'Altezza Vostra

Serenissima fo reverenza. / Mantova li 11 Decembre 1664. Dell'Altezza Vostra Serenissima / Umilissimo e Devotissimo Suddito / Filippo Baldinucci."

68. ASF Med. Princ. 5529, fol. 1152, 20 January 1664/65, Baldinucci to Leopoldo. "Serenissimo Signore Padrone mio Colendissimo / Il negozio della Serenissima Arciduchessa Anna non solo è riuscito più lungo dell'aspettato ma vi si è aggiunto il dover io perdere del tempo, giache il computista di questa agenzia, per mala sanità, non trova la via a darmi per finite alcune poche mesate di scrittura senza li quali non posso concludere l'operatione (che già per altro ho a buonissimo termine) in modo di mia intera satisfazione, e buon servizio di Sua Altezza Serenissima e perche questo mi preme fino all'ultimo segno, et all'incontro fatto di qualche sinistro intorno a codesto mio avviamento, son forzato a ricorrere al favore dell'Altezza Vostra Serenissima supplicandola a degnarsi per mia sicurezza di far passare a suo nome nuovi, e se così li piace pronti offiti apresso di quelli solamente che troverà descritti nell'acclusa nota. Condoni l'Altezza Vostra Serenissima il soverchio ardire al vivo desiderio che tengo di servir bene la Serenissima et alla fiducia che ho nella somma benignità, con la quale l'Altezza Vostra Serenissima si è compiaciuta di rendermi animoso a ricorrere alle sue gratie, mentre con ogni più profonda umiltà a Vostra Altezza Serenissima faccio reverenza / Dell'Altezza Vostra Serenissima / Mantova 20 Gennaio 1664 / Umilissimo e Devotissimo Suddito / Filippo Baldinucci."

69. ASF Med. Princ. 5529, fol. 1153, 23 March 1664/65, Baldinucci to Leopoldo. "Serenissimo Signor Principe / Questa è per humilissimamente reverire l'Altezza Vostra Serenissima dandole parte del mio ritorno a Fiorenza sequito questo giorno, dopo havere con l'aiuto del Signor Dio terminato il negozio dall'Altezza Vostra Serenissima comandatomi in servitio della Serenissima Arciduchessa Anna. Nel licenziarmi dai Serenissimi di Mantova ho ricevuto ordini da tutta quella Serenissima Casa molto stretti di passare in loro nome offitii di reverenza, non tanto con l'Altezza Vostra Serenissima quanto con tutte loro Altezze Serenissime e gia l'ho fatto col Serenissimo Cardinale Decano e lo farò col Serenissimo Principe Mattias, attendendo che dalla solita clemenza, usata sempre verso di me dall'Altezza Vostra Serenissima mi sia comandato, se tanto in ordine all'operatosi da me per la Serenissima Arciduchessa Anna quanto alli offiti impostimi da detti Serenissimi di Mantova deva portarmi alla Corte, o, si vero attender il ritorno dell'Altezze Loro Serenissime, per che sarò prontissimo all'uno e l'altro ad ogni minimo cenno dell'Altezza Vostra Serenissima allaquale per fine faccio profondissima riverenza. / Fiorenza li 23 Marzo 1664 / Dell'Altezza Vostra Serenissima / Divotissimo e humilissimo suddito / Filippo Baldinucci."

70. BNF II II 110, fols. 291–92. There are two copies of letters of thanks to Baldinucci, both dated 22 February 1685. (1) "Copia di lettera dell'Illustrissimo et Colendissimo D. Girolamo Bernardo Ferrari d'Occhieppio, Maggiordomo Maggiore della Serenissima Anna d'Austria a Filippo Baldinucci / Molto Illustre Signore / Mi è pervenuta la gratissima sua de 14 cadente insieme con le carte di Vostra Signoria inviatemi, le quali ho ricapitate alla Serenissima Arciduchessa mia Signora, che ne ha meco fatte dimostrazioni di pieno gradimento con rimanere Sua Altezza intieramente contenta di tale sua

operazione e fatica, che in realtà ne più aggiustata, ne con maggior chiarezza, e dilucidazione potevasi da chiunque desiderare, ne dalla lei manierosa penna, e giudicio estendersi. In somma Signor Baldinucci, io confesso il vero, ch'ammiro le sue virtù, e talenti con tanto impareggiabili ed infatti per me resto a tal misura sodisfatto delle premessa lei opera, con tanta modestia, e facilità descritta, che non ritrovo parole bastevoli per esprimerlo, avvenga che quella porta seco, e con ragione, tutte quelle lodi maggiori, che per ogni conto se li devono da ogni prudente lingua. Però l'Altezza Sua ne porterà a suo tempo in quest'affare i suoi precisi sensi e Vostra Signoria in mentre non lasci d'esercitare a tutta confidenza quella brama che in me si è nutrita di servir al merito, e valor suo, come di cuore ne la prego, non che a persuadersi, che in qualunque luogo e congiontura mi mostrerò sempre con effetti pari all'animo. / Inspruch li 22 Febbraio 1665 / Affettuosissimo et [particolarissimo?] Servitore / D.G.B. Ferrari d'Ochieppio." (2) "Copia di lettera della Serenissima Arciduchessa Anna d'Austria a Filippo Baldinucci / Diletto Nostro / Dalla vostra diligenza e valore non potevamo attendere operazioni più proprie in nostro servizio, toccante gli interessi, che habbiamo costì, di quelle che vediamo dalla grata vostra, e dalle scritture trasmesseci, trovando in esse adempito pienamente il nostro desiderio circa la notizia delle cose passate e di quello, che possa farsi in avvenire. Circa il saldo delli conti doverete contenervi secondo l'instruzione, che riceverete dal Dottore Tamburini, accortandovi in tanto, che come habbiamo molto gradita l'opera che havete impiegata sin hora in questo affare, così seguirà di tutto quello, che opererete fino alla totale ultimazione di esso, e resteremo con desiderio d'haver l'occasione di mostrarvelo con gl'effetti, impiegandoci nell'occorrenze di vostro avvantaggio e Nostro Signore vi guardi. / Insprugg 22 febbraio 1665 / Vostra Anna."

71. *Vita di F.B.*, p. 11.

72. *Notizie* 5, p. 406.

73. ASF Misc. Med. 368, fol. 421 (SPES 161).

74. ASF Med. Princ. 1526, *Diversi*, 28 January 1680/81, Filippo Baldinucci to Apollonio Bassetti SPES 157).

75. See n. 69 above.

76. *Vita di F.B.*, p. 12.

77. In his *Lettera a Lorenzo Gualtieri* of 19 January 1681/82 (SPES 156), speaking of Raphael Baldinucci refers to "la cognizione che io ho potuto avere delle opere sue in Roma, in Firenze, per la Lombardia e per altre provincie et città d'Italia." The word "cognizione" is open to interpretation and the phrase is rhetorical in flavor.

78. *Notizie* 1, p. 10, "L'autore a chi legge."

79. The phrase is taken from Lodovico de' Vecchi's letter to Leopoldo de' Medici, ASF/CDA IX, insert nineteen, fol. 297, 25 August 1661. See n. 173 in Chapter One.

80. See Chapter One.

81. There is a set of notes in Baldinucci's hand laying out a scheme of division for the *autoritratti*, partially in the form of a genealogical tree. ASF Misc. Med. 368, fols. 422–24 (SPES 139). The date of this document is unclear,

though there is a reference to the self-portraits being "nella raccolta del Serenissimo Gran Duca," implying a time after Leopoldo's death.

82. See Goldberg, *Patterns*, chap. 1.

83. It is clear that Filippo Baldinucci achieved his greatest influence towards the end of Leopoldo's life. However, it is also well to remember that the documentation might be unbalanced. The accumulation of late signed letters from Baldinucci in ASF/CDA XXI, insert eighteen was probably left in the secretariat at the time of Leopoldo's death and thus preserved.

84. See preceding chapter. The date of the installation of the self-portrait gallery in Leopoldo's apartment remains to be established, as does its specific location. It is not cited in Marmi's description of his apartment from 1666–1667 (BNCF II I 284), when there were few self-portraits in any case. Until 1670 much of Leopoldo's time was spent in Rome and his efforts directed to his new responsibilities as cardinal.

85. ASF/CDA XIII, fols. 516–19 (SPES 61).

86. *Listra de' nomi de' pittori di mano de' quali si hanno disegni* . . . (8 September 1673). There is an annotated copy of the *Listra* from within the cardinal's administration in BNCF Post. 97 (SPES 52). Giovanni Cinelli, Baldinucci's most passionate enemy, attributes the *Listra* to him twice in his *Biblioteca volante*, implicitly in *scanzia* 4, p. 56 (Naples, 1682) and explicitly in *scanzia* 18, pp. 60–61 (Ferrara, 1716).

87. The monthly stipend of twelve *scudi* is cited in ASF Med. Princ. 5560, fol. 279, "Provvisionati ogni mese."

88. ASF/CDA XVIII, insert three, fol. 168, "Ricordi al Sig.re Can.co Cecini." In SPES 92, the draft is published without the above heading. For Natali see Goldberg, *Patterns*, pp. 28 and 260–61.

89. ASF/CDA XIV, fol. 722 (SPES 109).

90. ASF/CDA XXI, insert eighteen, fols. 270, 271–72, 281–82, 283, 284, 285, May through October 1675. (SPES 114, 126, 133, 134, 136, 137). The quote is from fols. 271–72, 9 August 1675.

91. *Vita di F.B.*, pp. 14–15. Francesco Saverio also retells a story concerning his father's attribution of a painting for Vittoria della Rovere, pp. 15–16.

92. Lorenzo Gualtieri is cited in several lists of Leopoldo's household in ASF Med. Princ. 5560, for example, fols. 381; 384 "Ruolo delle persone che devon venire a Roma a servire il Ser.mo S. Card.le de Medici" as *staffiere*; 279, "Provvisionati ogni mese," with a salary of 5 *scudi* 5 *soldi*.

93. ASF/CDA XXI, insert eighteen, fols. 274, 269; 25 April 1675, 9 May 1675; Baldinucci to Lorenzo Gualtieri (SPES 102, 113).

94. For Gualtieri see Gaeta Bertelà, "Testimonianze documentarie," p. 115; W. Prinz, *Selbstbildnisse*, Doc. 51; G. Chiarini, *Paragone* 387 (May 1982), pp. 79–80. For the *Lettera a Lorenzo Gualtieri* (SPES 156) see the following chapter.

95. See Goldberg, *Patterns*, pp. 28–29. An important document in the history of the emergence of the amateur connoisseur is Filippo Baldinucci's own *Lettera a Vincenzo Capponi* (Rome, 1681) (SPES 174), discussed in Chapter Three.

96. ASF/CDA XX, fol. 366 (SPES 93). ASF/CDA XIV, fols. 722, 723 (SPES 109, 110), memos between Leopoldo's administration and Baldassare Franceschini.

97. ASF/CDA XX, fol. 6, attached to letter to Leopoldo from G. M. Casarenghi dated 24 July 1671.

98. ASF/CDA XX, fols. 33–34.

99. ASF/CDA XX, fols. 43–44.

100. ASF/CDA XX, fol. 49.

101. ASF/CDA XX, fol. 45.

102. ASF/CDA XX, fol. 48 (SPES XXVIII). A clean copy of this is in ASF/CDA XIII, fol. 110.

103. ASF/CDA XX, fol. 51 (SPES 27).

104. ASF/CDA XX, fol. 42, 12 December 1671, Leopoldo de' Medici to G. M. Casarenghi (rough draft) SPES 28.

105. ASF/CDA XX, fol. 50, 12 December 1671, Leopoldo de' Medici to G. M. Casarenghi. (SPES 27).

106. ASF/CDA XIII, fols. 109–10.

107. ASF/CDA XX, fol. 53.

108. ASF/CDA XIII, fol. 106. "Il Beccadelli è un gentilhuomo da bene si, ma nell'interesse suo è peggio di un Genoese."

109. ASF/CDA XIII, fol. 106, 6 February 1672, Annibale Ranuzzi to Leopoldo.

110. See n. 106 above.

111. ASF/CDA XIII, fols. 122 and 123.

112. ASF/CDA XX, fols. 71–72. (SPES 30). The *"feti-odori"* pun centers on the word *fetore*, meaning "stench."

113. *Notizie* 1, pp. 10–13.

114. See the Introduction.

115. ASF/CDA XIV, fol. 594, 22 May 1674, Leopoldo to Annibale Ranuzzi (rough draft) SPES 75.

116. ASF/CDA XIV, fol. 713 (SPES 97).

117. BNCF Magl. II II 110, fol. 283. The date of the list is uncertain. The latest book cited is Boschini's *Ricche Minere* (1664).

118. ASF/CDA XXI, insert eighteen, fol. 270 (undated, 1675), Baldinucci to F. Cecini, (SPES 114). The books referred to are A. Masini's *Bologna perlustrata* (1650) and Montalbani's *Minervalia Bononiensia* (1641).

119. ASF/CDA XXI, insert eighteen, fols. 281–282 and 285. 27 September and 12 October 1675, Baldinucci to F. Cecini (SPES 133 and 137).

120. ASF/CDA XXI, insert eighteen, fols. 281–82, 27 September 1675, Baldinucci to F. Cecini (SPES 133). ASF/CDA XI, fol. 455, 12 October 1675, Ottavio Falconieri to Leopoldo de' Medici (SPES 138).

121. ASF/CDA XIV, fol. 738 (undated, April 1675), "Al Signor Conte Malvasia" (SPES 103).

122. ASF/CDA XXI, insert eighteen, fol. 273 (undated, by April of 1675) SPES 101.

123. ASF/CDA XVIII, insert two, fol. 394, 18 May 1675, Marco Boschini to Leopoldo de' Medici; and fols. 395–423 (SPES 117).

124. ASF/CDA XIV, fols. 748–50, 18 May 1675, Annibale Ranuzzi to Leopoldo and fol. 751 (SPES 118).

125. ASF/CDA XXI, insert nineteen, fol. 295, 9 July 1675, Francesco Oddi to Leopoldo de' Medici.

126. ASF/CDA XIV, fol. 97, 12 July 1675, Angelo Maria Ranuzzi, archbishop of Damiata, to Leopoldo (SPES 124) and fol. 98, 21 July.

127. This Neapolitan material is found in BNCF II II 110, fols. 125–27 (SPES 123). Renato Ruotolo traced the source of this information to Pietro Andrea Andreini, a Tuscan businessman and classical antiquarian. See R. Ruotolo, "Mercanti—collezionisti fiamminghi a Napoli: Gaspare Roomer e i Vandeynden," in *Ricerche sul '600 napoletano* (Naples, 1983), esp. pp. 9–10 and nn. 23–29. The letters from Andreini to Leopoldo de' Medici and his secretary Fabrizio Cecini, primarily on antiquarian matters, are in ASF/CDA XXI. Ruotolo identifies Andreini as the author of the Biblioteca Nazionale material on the basis of a reference in Andreini's letter of 20 September 1675 to Leopoldo de' Medici in Florence (ASF/CDA XXI, fols. 170–71), "Si compiace Vostra Altezza Reverendissima vedere ciocchè distinguo in un foglio, che mando al Baldinucci per conto della nota de Pittori, Scultori et Architettori. . . ." In fact, we know only that Andreini transmitted the information, not that he composed it. On 20 September 1675 (ASF/CDA XXI, fol. 172) Andreini also wrote a letter to Fabrizio Cecini with this postscript, "Favorisca dire al Signore Baldinucci, che oggi stimavo di mandarli le notizie, che desidera, però quel Pittore m'hà mancato di parola, e con mia estrema mortificazione sebbene mene avesse assicurato con replicate promesse. Gli accudirò in queste due feste e sicuramente verranno con le lettere di martedì."

128. ASF/CDA X, fol. 443, 13 April 1675, Ottavio Falconieri to Leopoldo. "Le notizie desiderate da Vostra Altezza circa i Pittori, Scultori e Architetti che son stati qua in qualche riputazione dal 1642 si procureranno da me con tutta la diligenza possibile non solo con i mezzi accennatimi da Vostra Altezza ma anche per tutti l'altre vie li quali giudicherò opportune ad ottenere l'intento."

129. See Chapter One.

130. See n. 86 above.

131. ASF/CDA XXI, insert six, fols. 89–90, 24 October 1673, Leopoldo de' Medici to Flaminio Borghesi (SPES 58).

132. "Nota de' Libri de disegni tanto grandi, che mezzani, con la distinzione di quanti ne sono attaccati per libro . . . ," ASF Guardaroba 779, insert nine. There is no indication that Filippo Baldinucci was involved in preparing the 1687 list, and indeed, a retrospective reference is made to his former work.

133. Gaeta Bertelà offers this in the appendix to her article, "Testimonianze documentarie," pp. 128–45.

134. *Vita di F.B.*, p. 18.

135. ASF Med. Princ. 1526, *Diversi.* 20 July 1681, Baldinucci to A. Bassetti (SPES 176).

136. For the relations between the Medici and the Cospi-Ranuzzi family with which Malvasia was connected see Goldberg, *Patterns*, chap. 2.

137. For biographical information on Malvasia see Adrianna Arfelli's introduction to her edition of Malvasia's *Vite di pittori bolognesi (appunti inediti)* (Bologna, 1961).

138. For a rudimentary "oeuvre catalogue" by A. Masini, see the "Aggiunta" to the *Bologna perlustrata* in *L'Archiginnasio*, 52 (1957), p. 212.

139. Giovanni Fantuzzi, in his *Notizie degli scrittori bolognesi*, Vol. 5, pp. 146–47, describes Malvasia, "Nacque egli a' 18 di Dicembre del 1616 e fu figliuolo d'Anton-Galeazzo, Patrizio, e Conte, e di una Catarina, Femmina di bassa condizione, ma legittima Moglie." Fantuzzi cites the baptismal record that records her as "Catharina eius Uxoris." In any case, we are dealing with a situation of considerable social delicacy.

Some further light is shed on Carlo Cesare's origins and his connections with the Malvasia and Cospi families by P. Dolfi in his *Cronologia di famiglie nobili di Bologna* (Bologna, 1670). In regard to his questionable parentage, the silence on his mother's identity can be contrasted with the explicit statement concerning his half-brother Gioseffo. Dolfi, p. 488, on Malvasia family: "1596—Conte Antonio Galeazzo [Malvasia] . . . fu marito di Christina Cospi. . . ." "1629—Conte Carlo di Cesare del Conte Antonio Galeazzo è Canonico di San Pietro e Doctore di Legge. . . ." "1651—Conte Gioseffo del Conte Antonio Galeazzo e della Cospi, Cavaliere di Fiorenza e senatore vivente, fu marito di Vicenza Bianchini."

140. ASF/CDA XVI, fol. 373, 6 September 1663, Ferdinandi Cospi to Leopoldo. "Fu errore chi che scrisse sul disegno mandato dal Sirano a V.A. essendo egli impedito dalla gotta poi che doveva dir Zoppo e non Gobbo. V.A. lo puol far aggiustare havendo certezza che è cosi havendone fatto tutta la diligenza in presenza del istesso Sirano che subito confessò l'equivoco, et vi è stato il S. Co. Carlo Cesar Malvagia Canonico intelligente di questa professione, antiquario, et che è quello che sequita [in] oggi a scriver le Vite de Pittori per darle alla stampa, e da esso ho havuto l'inclusa notizia che V.A. puole incontrare."

141. Giovanni Mitelli, *Vita e opere di Agostino Mitelli*, Bologna, Biblioteca Communale, MS. 3575, fol. 71ᵛ. Cited by Arfelli in Malvasia, *Vite*, p. i. On p. xxiv of her useful and interesting study she offers a list of various other trips undertaken by Malvasia in the 1660s.

142. ASF/CDA XVI, fol. 391, 13 April 1666, Cospi to Leopoldo. "Humilissime grazie rendo a V. A. per il recapito fatto dare alla mia per il Sig. Conte Rannuzzi. Così ha supplicato perche è passato due giorni sono di qui per Roma il Canonico Conte Carlo Cesare Malvagia. Fa la strada per Loreto e dopo Pasqua ritorna per quella di Firenze. Sarà a baciar la veste a V.A.S. con una mia. Questo è quel suggetto che con V. A. già ne parlai intelligentissimo de disegni e ne ha de bellissimi. Egli scrive l'aggiunta delle Vite de Pittori e raccoglie di questi le più belle opere, che però V.A. [le grazie sa] che pigli una nota le sue per descriverle. Mi persuado certo il V. A. S. sia per haver gusto trattare seco che però io l'hò esortato à trattenersi in Firenze quanti giorni V. A. comanderà. Questo è Canonico del Duomo, il meglio e più accreditato dottor legista di questo studio con [grosso stipendio], e bel ingegno poeta nel bernesco in particolare il meglio di questo paese ma non vuol componer più. È fratello natu-

rale [però] del Quaranta Malvagia mio nipote e sta in sua casa trattandolo da fratello per le sue virtù. Lo descrivo a V. A. per che sappia le sue qualità, che se le piaceranno come credo sarà buono a servire V. A. S. più d'ogni altro in questo paese nelle materie di sua intelligenza. . . ."

On his arrival in Florence Malvasia presented Leopoldo with a brief letter of introduction from Cospi. ASF/CDA XVI, fol. 392, 5 May 1666 "Ser.mo Sig.e et P.rone Col.mo / Presenterà questa mia a V.A.S. col baciarle la vesta il Sig. Canonico Conte Carlo Cesare Malvagia mio parente. Supplico humilissima-mente l'A.V. per farmi grazia vederlo volentieri col favorirlo di farli vedere le sue bellissime pitture e disegni, che in ciò V.A. riconoscerà i sua talenti, come anco nelle altre virtù che lo rendono in questa patria riguardevole, egli si sti-merà fortunato in dichiararsi servo humilissimo et haver occasione di poter meritar la sua protezione col servirla, et io annumererò anco questa obligazione al infinitissime che le devo, le quale tutte le rassegno con me stesso profonda-mente inchinato col baciarle la veste / di Bologna li 5 Maggio 1666 / Di V.A. Ser.ma / Humilissimo Servitore /Ferd.o Cospi."

On 1 June 1666 (ASF/CDA XVI, fol. 394) Cospi noted, "Due favoritissime di V.A.S. ricevò con questo procaccio che passa a Venezia, in una sento con mio estremo contento che essendo arrivato il S. Canonico Malvagia che a della sua servitù sodisfazione a V.A.S. come certo mi credevo, per che è persona erudita, e di molte virtù versata, ha ingegno et è modesto, e goderò nel suo ritorno nel sentire il racconto delle belle cose vedute da V.A.S. delli favori che al mede-simo Conte si compiace farli per sua immensa benignità glie ne rendo humilis-sime grazie."

143. Malvasia maintained a limited direct correspondence with Leopoldo. Malvasia's letters are preserved in ASF/CDA XVIII, insert four. The earliest known letter from Malvasia to Leopoldo was written on 8 June 1666. "Altezza Serenissima / Son gionto in Bologna, ove il dolce amore della patria cede di gran longa alla soave memoria delle tante belle cose costà vedute, si come elleno mi hanno sempre accompagnato nel viaggio, rappresentandomisi distin-tamente e sempre più meravigliose, e facendomi via più comparire maggiori le obbligazioni, che dovrò sempre alle grazie compartitemi in tanta abbondanza dalla somma benignità, e clemenza dell' Altezza Vostra Serenissima. Darò mano alla nota, che mi onorò commettermi, e cercherò che sia precisa, e pun-tuale al possibile. La supplico in tanto reverentemente ad essercitare sovra di me tutti gl'atti della sua da me riverita padronanza, perche io possa sempre più avanzarmi nella sua da me adorata grazia con qualche merito di effettiva ser-vitù, e riverente mi piegò a baciarle le vesti. / di Bologna li 8 giugno 1666 / Dell'Altezza Vostra Serenissima / Um.mo Dev.mo Obblig.mo Serv.re / Carlo Malvasia."

144. ASF/CDA XIII, fol. 507, 16 December 1673, Ranuzzi to Leopoldo. (SPES 63).

145. ASF/CDA XII, fol. 130, 30 May 1665, Ranuzzi to Leopoldo. "Il Signor Bianco Negri ha una mano di dissegni in vendita e gle ne sono state offerte cento doble, e io vorrei pure, che ne mandasse almeno parte a V. A., a fine che gli vedesse, ma non posso farlo risolvere, e la mattina lo persuado, e la sera lo

trovo disuaso, poiche quelli che gli vorrebbono che sono certi sensali per ca-
nonico Malvasia gli sono alle corte tutto il giorno, e gli mettono in capo mille
sospetti."

146. ASF/CDA XII, fol. 132, 13 June 1665, Ranuzzi to Leopoldo. "Circa i
dissegni non posso far bene, e dò in certi cervelli pazzi, pazzi, pazzi. Il Signor
Bianco Negri la mattina si contenta di mandarne qualche d'uno, la sera no, ma
quando si viene a concludere di mandargli in quel punto che dice di conten-
tarsi, subito si pente e il si diventa no, e mi dispiace, perche crederei che
qualche cosa vi fosse per V.A."

147. ASF/CDA XVIII, insert 4, 15 June 1666, Malvasia to Leopoldo. "L'in-
clusa è la nota de' disegni, che nel viaggio e nella mia racolta ho potuto osser-
var, e che l'Altezza Vostra Serenissima si degnò comandarmi. Ella è ristretta,
ma tale che può dare lume sufficiente a chi con l'ocular ispezione dovrà poi
sodisfarsi in suo servizio."

In 1671 Ferdinando Cospi arranged the loan to Malvasia from Leopoldo's
collection of a portrait of Alessandro Tiarini, to serve as model for an engraving
in his *Felsina pittrice* (Bologna, 1678). Malvasia cites this favor in Vol. 2, p.
203. His letter of thanks to Leopoldo, dated 12 October 1671, is in ASF/CDA
XVIII, insert four.

148. ASF/CDA XVIII, insert four, fol. 162, 8 August 1673, Malvasia to Leo-
poldo (SPES 49).

149. ASF/CDA XIV, fols. 596–98 and fol. 599, 24 and 29 May 1674, Ra-
nuzzi to Leopoldo. (SPES 76 and 77).

150. ASF/CDA XXI, insert eighteen, fol. 273 (SPES 101).

151. ASF/CDA XXI, insert eighteen, fol. 274, 25 April 1675, Filippo Bal-
dinucci to Lorenzo Gualtieri (SPES 102).

152. ASF/CDA XIV, fol. 738 (SPES 103 and 104). On this folio a paragraph
was drafted "Al Signor Conte Malvasia." This was crossed out and another
written along side of it, "Al Signor Conte Ranuzzi."

153. ASF/CDA XIV, fol. 733, 27 April 1675, Leopoldo to Ranuzzi (SPES
106).

154. ASF/CDA XIV, fols. 725–27, 30 April 1675, Ranuzzi to Leopoldo (SPES
107).

155. ASF/CDA XIV, fol. 728 (SPES 108).

156. M. Oretti, *Opuscoli diversi pittoreschi*, Biblioteca Communale di Bo-
logna, MS. B. 148 n. 1. Cited by Arfelli in Malvasia, *Vite*, pp. xxviii–xxix.

157. ASF/CDA XIV, fols. 739f. 4 May 1675, Leopoldo to Ranuzzi (SPES 111).

158. ASF/CDA XIV, fols. 742f. 7 May 1675, Ranuzzi to Leopoldo (SPES 112).

159. ASF/CDA XIV, fol. 746, 11 May 1675, Ranuzzi to Leopoldo (SPES 15).

160. ASF/CDA XIV, fol. 755, 14 May 1675, Leopoldo to Ranuzzi (SPES 116).

161. ASF/CDA XIV, fols. 748–50, 18 May 1675, Ranuzzi to Leopoldo (SPES
118).

162. ASF/CDA XIV, fol. 751, memorandum headed "Nota di pittori presenti
dal '42 in qua, data dal signor Conte Malvasia." (SPES 118).

163. ASF/CDA XIV, fols. 756–57, 21 May 1675, Ranuzzi to Leopoldo (SPES
119).

164. ASF/CDA XIV, fol. 758, 25 May 1675, Ranuzzi to Leopoldo (SPES 120).

165. ASF/CDA XVIII, insert four, fol. 759, 6 August 1675, Malvasia to Leopoldo (SPES 125).

166. ASF/CDA XXI, fols. 304–5 (SPES 129).

167. ASF/CDA XVI, fols. 424–25, 3 September 1675, Cospi to Leopoldo. There is a copy of this letter in ASF/CDA XXI, insert nineteen, fols. 302–3, which is published in SPES 130.

168. ASF/CDA XXI, insert eighteen, fols. 281–82, 27 September 1675, Baldinucci to Fabrizio Cecini (SPES 133).

169. Baldinucci refers to the initiation of the diary several weeks later, in his entry of 7 October 1669. *Diario*, p. 12.

170. Ibid., p. 3, 15 September 1669.

171. Ibid., pp. 4–5, 15 September 1669.

172. Ibid., pp. 5–6, 15 September 1669.

173. Ibid., pp. 9–10, 21 September 1669.

174. Ibid., pp. 3–10.

175. Ibid., p. 9, 21 September 1669.

176. Ibid.

177. For example, ibid., p. 95, 20 September 1686.

178. Ibid., p. 212, 13 May 1694.

179. Ibid., p. 51, 19 August 1674.

180. Ibid., p. 82 [1684–86?].

181. Ibid., pp. 15–16, 26 December 1672.

182. Ibid., p. 48, 18 May 1674.

183. Filippo Baldinucci speaks most openly about his experience with the seeress in his deposition of 25 December 1680, in relation to his son Antonio's application to the Jesuits. This document was later incorporated into the *Sommario* of the cause for Antonio's beatification and also published by Rosa in *Lettere*, pp. 124–32. Filippo dates his association with the nun from 1667, notes her noble birth, and his discovery that she was "parente dei parenti di mia moglie." She is cited in the *Diario* until Filippo's death.

Filippo also sought advice from an esteemed though evidently less mystically potent nun in the Convent of San Silvestro in Borgo Pinti. It is often difficult to determine which of these two nuns Filippo is discussing. He had business dealings with both convents (See *Diario*, p. 71 and Rosa, *Lettere*, p. 127), and at that time Santa Maria Maddalena de' Pazzi and San Silvestro were adjoining (O. Fantozzi Micali and P. Roselli, *Le Soppressioni dei conventi a Firenze* (Firenze, 1980), pp. 200–201 and 248–49). The nun of Santa Maria Maddalena de' Pazzi is often referred to as "la Maddalena," a standard appellation for members of that community. In the *Diario* he also uses the shorthand reference of M.C. (p. 200) and "la Madre. C." (p. 192). The nun of San Silvestro is called "la Madre Sorella O.S." (p. 194), "la Molto Reverenda Madre sor. Or." (p. 201), perhaps indicating "Suor Orsola"; and in most abbreviated form, S.O.S. in S.S. (p. 155). In the *Diario* on 30 January 1694 (p. 201), Filippo recorded, "Narrando alla Molto Reverenda Madre sor. Or. la gran perplessità in che mi teneva il vedere ch'ella dissimulasse tante mie miserie senza conso-

larmi, sapendo d'avermi per il passato per tant'anni date tante speranze di bene, mi diede una pronta e sapientissima risposta, cioè non disse e disse, 'Dite un poco; non mi diceste voi una volta che voi avevi un'obbedienza dal vostro Padre spirituale di credergli? In quanto a me, io mi quieterei qui. Or, non avete voi quell'altra dico la Maddalena, che anchessa vi dà animo a sperare? E'l vostro Padre Spirituale?' "

184. Rosa, *Lettere*, p. 127.

185. Ibid., p. 36, 7 November 1673.

186. Ibid., pp. 58–62, 12 June 1675.

187. Ibid., pp. 62–63.

188. Ibid., p. 63, [?] September 1675.

189. Ibid., pp. 65–66. [?] September 1675.

190. Ibid., pp. 41–43, 25 March 1674.

191. Ibid., pp. 43–44, 25 March 1675.

192. Ibid., p. 49, 1 June 1675.

193. Ibid., pp. 49–50, 1 June 1675.

194. Ibid., p. 19, 29 December 1674.

195. Ibid.

196. Ibid., p. 20, 29 December 1674.

197. Ibid., pp. 20–22, 29 December 1674.

198. Ibid., p. 22, 29 December 1674.

199. Ibid., pp. 22–23, 29 December 1674.

200. Ibid., pp. 23–24, 29 December 1674. On 9 February 1675/76 (ibid., p. 68), Baldinucci describes a series of mystical apparitions experienced by the visionary nun, demonstrating the role of Saints Primitive and Cosimo as his special protectors.

201. Ibid., pp. 25–27, 4 August 1675.

202. *Notizie* 3, pp. 407 and 456.

203. *Notizie* 1, pp. 115–16. See also Ugo Procacci's "Una lettera del Baldinucci e antiche immagini della Beata Umiliana de' Cerchi," *Antichità viva* 15, No. 3 (1976), pp. 3–10. Filippo Baldinucci's contemporary antagonist Giovanni Cinelli sarcastically commented about him, "Io l'ho sempre conosciuto per abbachista, e computista, doppo aver l'arte di copista esercitata . . . ," BNCF Magl. XVII, 22, fol. 67ᵛ. In 1679 Baldinucci advised Apollonio Bassetti on the problems of executing copies, ASF Med. Princ. 1525, *Diversi*, 27 July, 2 August, 24 August, 27 August, 27 September, and 3 October (SPES 146, 147, 148, 149, 150, and 151). He discusses the considerations involved in making copies in his *Lettera a Vincenzo Capponi*. For Alessandro de' Cerchi (1625–1708) see S. Salvini, *Fasti consolari dell'Accademia Fiorentina* (Florence, 1717), pp. 581–84.

204. Moreniana 382 AB, insert 32, 19 May 1673, F. Baldinucci to Senator Alessandro de' Cerchi. "Illustrissimo Signore e Padrone Colendissimo / Le ceremonie ch'io feci nel ringraziare Vostra Signoria Illustrissima del favore che con troppa liberalità si compiacque farmi nel regalo di 50 esemplari della imagine con altretanti hinni. Sono state contro mie intenzione le ceremonie di mona onesta, perche mi è convenuto il distribuirne tante a diverse religiose di San

Francesco e famiglie spirituali e devote che fino a questo giorno son quasi rimasto con niuna, e restono tuttavia altri che so che s'approfitterebbono di questa devozione mentre ne potessi avere altre. Questa mia non è per chiedergliene di vantaggio, ma se bene per porli in considerazione, che quando a Vostra Signoria Illustrissima sia riuscito il far delle restanti quello che è riuscito il fare delle donatemi da Vostra Signoria Illustrissima sarebbe bene farne tirare alcune altre per appagare la brama di molti divoti, e senza più incomodarla resto al solito / Di Vostra Signoria Illustrissima / Di casa 19 Maggio 1673 / Devotissimo e Obligatissimo Servitore / Filippo Baldinucci."

205. ASF/CDA VII, fol. 292, 17 October 1671, Paolo del Sera to Leopoldo (Goldberg, *Patterns*, p. 280).

206. Moreniana 382 AB, insert 32, 4 January 1671 (1672?), F. Baldinucci to Lorenzo Panciatichi. "Illustrissimo Signore e Padrone mio Colendissimo / Devo rendere avvisata Vostra Signoria Illustrissima come questa mattina mi è pervenuta lettera di risposta alla mia inviata a Pisa insieme con quella mia operetta dell'Imagine della Santissima Nonziata per Sua Altezza Reverendissima, et è che sia stata di tutto gusto di Sua Altezza quale subito l'istessa sera la mandò a venetia dove era destinata, si che non occorrerà che Vostra Signoria Illustrissima se pigli incomodo di scrivere cosa alcuna a Sua Altezza e mentre io le rendo infinite gratie della cortessissima esibizione resto / di Vostra Signoria Illustrissima / di Casa li 4 Gennaio 1671/ Divotissimo et Obligatissimo Servitore Vero/ Filippo Baldinucci."

207. *Vita di F.B.*, p. 14.

208. *Notizie* 5, pp. 345–46, 362. Justus Sustermans also executed a replica for the Jesuits at Innsbruck. Anna and Leopoldo de' Medici's travel diary of 1646 notes, "Li vidde ancora in questo luoga la Chiesa delle Giesuite, che è molto bella per l'architettura e di grandissima devozione per conservarsi in essa quantità di reliquie, et una Nunziata di mano di Giusto copiata diligentemente con ogni misura di'quella miracolosissima di Fiorenza" (ASF Med. Princ. 6381, insert one, fol. 29). In a letter from Innsbruck of 25 October 1665, Giovanni Tamburini cites a gift "al Conte Lambergh Camarier maggiore . . . la Nunziata che ha mandato il Ser.mo Prencipe Leopoldo ultimamente" ASF Med. Princ. 6357a, former insert six (inscription cancelled).

209. *Diario*, p. 24, after 15 May 1675.

210. *Notizie* 5, p. 229.

211. Ibid., 5, pp. 239 and 248.

212. *Diario*, pp. 68–69, 9 February 1675/76, and p. 78, 24 October 1680.

213. *Notizie* 5, p. 260.

214. A recurring theme in the *Notizie* is the tradition of moral art and Christian artists emanating from the studio of Matteo Rosselli. See particularly *Notizie* 4, pp. 154–76.

215. The Jesuit connection was clearly an important one. At times of crisis Filippo and his sons made retreats to undertake the Spiritual Exercises of Saint Ignatius (*Vita di F.B.*, p. 8 and *Diario*, p.80). His spiritual advisors were such Jesuits as Giovanni Angelo de Benedictis, Emilio Savignani, Innocenzio Innocenzi, and José Maria Sotomayor. However, Filippo also showed an interest

in the Oratorian order founded by his patron saint, Filippo Neri. It was for the Oratorians of San Firenze that he composed the *Lazzi contadineschi*. Filippo Baldinucci's place in Florentine religious life is a topic of the greatest possible interest and importance, as is the content of his visual imagination. A rigorous investigation of these questions would have involved writing a whole other book, so I allude to them only in this fleeting and unsatisfactory way.

216. *Vita di F.B.* and Chapter Five.

217. *Notizie* 2, pp. 358–61 and 3, pp. 748–49.

218. For the republication of the *Lettera del Ammannati*, see Chapter Five.

219. *Vita di F.B.*, pp. 31–32 and Chapter Five.

CHAPTER THREE

1. Before 1681 Baldinucci had issued only a printed handlist of Leopoldo's drawings, the *Listra de' nomi de' pittori*, dated 8 September 1673 (SPES 52).

2. *Diario*, pp. 53–56, 19 January 1676.

3. Ibid., p. 68, 9 February 1676.

4. In a letter to Apollonio Bassetti of 24 July 1685, Baldinucci discusses a self-portrait by Rosso Fiorentino suitable for the granducal gallery. ASF Med. Princ. 1530, *Diversi* (SPES 192). This is the latest reference that I have found to Baldinucci's activities in the self-portrait collection.

5. ASF Med. Princ. 1526, *Diversi*, 12 February 1681, Baldinucci to Bassetti (SPES 159).

6. ASF Med. Princ. 1526, *Diversi*, 9 December 1681, Baldinucci to Bassetti (SPES 177). See Chapter Two for the role of Lorenzo Gualtieri. The "stanza al capo al palazzo" presumably refers to Leopoldo's former Stanza dei Bronzi on the mezzanine level of his apartment, as described in Chapter One.

7. See Chapter Two.

8. Regale de' Cerchi, Alessandro's sister, was married to Baldassare Suares, who was probably related to Bishop Giuseppe Maria. See Giuseppe Maria Brocchi, *Vite de Santi e Beati fiorentini* (Florence, 1752), Vol. 1, p. 235. "Regale, moglie del Balì Baldassar Suarez, n. 23 Nov. 1637, m. 25 Giugno 1700 fu aia della Seren. Elettrice Palatina e del Sereniss. Gio. Gastone settimo Granduca. / Alessandro Sen. e Cav., n. 8 Luglio 1625, m. 8 Aprile 1708. Segr. e Soprintendente alla segreteria alla Sereniss. Granduchessa Vittoria. Sua moglie Caterina di Giacinto Galli, spos. 7 Giugno 1663, m. 20 Gennaio 1716."

9. Suares was a founding member of Christina's academy in 1674. (J. Arckenholtz, *Mémoires concernant Christine reine de Suède* [Amsterdam-Leipzig, 1751–60], Vol. 2, p. 139.) Giovanni Cinelli left several notes on Giuseppe Maria Suarez, "romito di Monte Senario," in BNCF Magl. IX 67, fol. 932 and BNCF IX 75, fol. 1073.

10. BNCF Magl. II II 110, fol. 275 (SPES 141).

11. BNCF Magl. II II 110, fol. 274. "Copia di Capitolo di Lettera scritta al S. Sen.re Cerchi dal Padre Porta. Roma 23 maggio 1676 / Ho presentato questa mattina la lettera che V.S. Ill.ma m'inviò per Mons. Suares, il quale leggendola in presenza mia mostrava singolar godimento nell'intendere l'espli-

cazione del vero nome di Giotto. Quando poi arrivò a quel particolare nel qual V.S. Ill.ma gli rappresentava il desiderio che à il Sig. Filippo Baldinucci di tener corrispondenza di lettere con lui si protestò che non solamente volentieri l'haveria ricevuta ma di più haverebbe riputatala per sommo favore."

12. BNCF Magl. II II I 10, fol. 274, 11 July 1676, Suares to Baldinucci (SPES 142).

13. BNCF Magl. VIII IV III, fol. 90, 28 June 1677, (SPES 144).

14. The gathering consists of sixteen pages. The title page, printed in red and black, reads "Epistolae tres / ad picturae pictorumque historiam pertinentes / Authoribus / Illustrissimo et Reverendissimo Domino / D. Ios. Maria Suaresio / Episc. Olim. Vasionen. / et / D. Antonio Maria Salvino / In Florent. Acad. Publ. Graeca Linguae Profes. / Eminentis. Ac. Reverendis Principi / Francisco / S.R.E. Presb. Cardinali / Nerlio / Archiep. Florent. / [Nerli's arms are here inserted] / Florentiae Ex Typographia sub signo STELLAE sup. Permissu. MDCLXXVII."

This publication, entirely in Latin, includes a dedication to Nerli by Jacopo Sabatini, a letter from Suares to Cardinal Francesco Barberini on Giotto's mosaic of the *navicella* in Saint Peter's, the letter from Suares to Baldinucci, and a letter from Antonio Maria Salvini to Lorenzo Adriani praising Baldinucci and citing his forthcoming work. I consulted the copy of this publication in the Biblioteca Riccardiana-Moreniana, Misc. 138, no. 2.

Among the Moreniana manuscripts (382 AB insert 32) is a block of correspondence from Filippo Baldinucci to Alessandro de' Cerchi. These letters allow us to follow closely the development of this publication. On 15 May 1677 Filippo Baldinucci wrote Alessandro de' Cerchi: "Illustrissimo Signore e Padrone mio Colendissimo / Quanto si vadino ogni giorno agumentando le mie obligazioni verso di Vostra Signoria Illustrissima lo riconoscerà ella dall'inclusa copia d'epistola scrittami dall'Illustrissimo Monsignor Suares e mandatami insieme con un esemplare dell'altra epistola fatta intorno alla navicella di Giotto, della quale per avanti ero pure stato da Vostra Signoria Illustrissima favorito fino a questo segno dunque son gionti gli onori che per mera benignità Vostra Signoria Illustrissima ha fatti godere alla mia povera operetta e da me medesimo. Resto ora che avendo Vostra Signoria Illustrissima fin qui operato tanto si compiaccia ancora pigliarsi alcuno incommodo di più, mentre io per supplicarnela spedisco persona a posta. La prego dunque a favorirmi d'una minuta di lettera di ringradimento a Sua Signoria Illustrissima volgare in quella forma che usano oggi in segreteria che è stile molto diverso dallo storico, della quale desidero io servirmi per mostrare qualche segno di gratitudine verso un tanto mio benefattore. Oltre ai ringraziamenti e risposte che Vostra Signoria Illustrissima stimerà essere necessarie alla proposta desiderei mettervi due cose, una è che mi parebbe che la parola *in qua praecellebas* si potesse alquanto moderare, perche è vero che io fin dalla prima età ho atteso molto al disegno, ma alla pittura l'ho fatto quanto basta per operare ordinariamente attesoche i colori portino grand'imbarazzo e perdita di quel tempo che mi è stato necessario per l'occupazioni della professione. La seconda è ch'io desiderei d'interrogare quel Signore con bella maniera di quello ch'io deva al presente fare intorno a essa

lettera perche la vedo sottoscritta originalmente con l'imprimatur, e con la firma del Capoquichi Maestro del Sacro Palazzo che però posso dubitare se esso Monsignore l'habbia già data alle stampe, nel qual caso non è luogo a mutar nulla, o se voglia che si dia qua, nel qual caso non so chi possa fare questa parte in un'opera d'altra persona, ne a me conviene il farlo. Secondo una lettera che mi scrive a mesi passati il Padre Baldigiani pare che si deva stampare da detto Monsignore e senza accompagnatura di sua lettera di avviso, mi lascia in questi dubbi. Spero che Vostra Signoria Illustrissima come molto perita in cose simili potrà sapere quel che io deva intendere e fare, però compiacendosi ella di farmi questo nuovo favore facci la minuta a modo suo interamente ed eserciti la sua umiltà e bontà in compatire un pare mio, che piglia tanto ardire e sicurtà con un pare suo, dandomi qualche occasione di quella poca corrispondenza che si puole aspettare da me per governo di Vostra Signoria Illustrissima gl'invio copia della lettera del Padre Baldigiani. Quella dell'epistola di Monsignore è alquanto male scritta che si degnerà compatire l'imperizia di chi l'ha copiata che è un mio piccolo figliolo e per fine con ogni più vera riverenza e affetto mi offro / Di Vostra Signoria Illustrissima / Vico Pisano li 15 Maggio 1677 / Devotissimo Servitore Obligatissimo / Filippo Baldinucci."

On 27 May 1677 Filippo Baldinucci wrote Alessandro de' Cerchi: "Illustrissimo mio Signore e Padrone Colendissimo / In questo presente ricevo la benignissima di Vostra Signoria Illustrissima scrittami fino il di 21 del corrente e non saprei come esplicare i sentimenti che quelle ha mossi nella mia imaginativa, se non con dire ch'io conosco sempre più che dove è Dio, è la carità ardente, e operante verso il prossimo, e Vostra Signoria Illustrissima che è tutto bontà e spirito non sa pigliarsi a petto le cure, e i bisogni de prossimi se non nel modo che ha fatto il mio che è stato tale, che io non sapevo ne desiderare ne pensare più, attesochè Vostra Signoria Illustrissima nel consigliarmi in cosa tanto importante quanto è il negoziare bene con Monsignore Illustrissimo Suarez ha pensato a quello che a me non sarebbe mai sovvenuto, ed harei fatta una bella filza di spropositi. Inoltre Vostra Signoria Illustrissima con tanta carità si degna offrirsi come ella dice a cavar la lepre del bosco con procurare per mezzo del Padre Porta o d'altri d'intendere qual sia la volontà di Monsignore, intorno al fare o no stampare l'opera a Roma che non posso dirli quanto mi è stato caro, e di qual pensiero io mi veda scarico. Io approvo da me a sommo tutto il contenuto di essa cortesissima lettera di Vostra Signoria Illustrissima e la supplico a farmi pure l'onore che mi offrisce per sua benignità, e non dubito punto che il terzo oggetto accennatomi dal Padre Baldigiani d'impinguare l'epistola con qualche altra notizia, ed il far citare in fonte il Boccaccio non tornassi molto a proposito accio l'opera si rendesse più voluminosa e per consequenza più curiosa, e desiderabile, ma il considerare che Monsignore è vecchio assai e assai occupato, e che è già un anno che Sua Signoria Illustrissima applicava per farmi quest'onore, e che quale gravi occupazioni non l'ha potuto effettuare se non adesso mi farebbe risolvere a pigliarla così, con parermi anco un gran che per un mio pare. Queste grazie io renda e mi conosca tenuto a rendere a Vostra Signoria Illustrissima non gliele posso esplicare, piace al Signore Dio remunerarla del molto aiuto che mi da. Io non sarò più lungo per

che sento che Vostra Signoria sia uno che parta di Bientina a 21 ore, ed ora son 20 ore e se posso fare che sia a tempo me ne voglio ingegnare Nostro Signore la riempia di tutte quelle felicità che ella sa mai desiderare / Vico Pisano li 27 Maggio 1677 / Di Vostra Signoria Illustrissima / Devotissimo ed Obligatissimo Servitore / Filippo Baldinucci."

On 30 May 1677 Filippo Baldinucci wrote Alessandro de' Cerchi: "Illustrissimo mio Signore e Padrone Colendissimo / Non mi si è ancor presentata occasione d'inviare la risposta data alla gentilissima di Vostra Signoria Illustrissima avuta a giorni passati quando mi trovo di nuovo favorito d'un altra di Vostra Signoria Illustrissima al Padre Porta, e con l'eruditissimo parere del Signor Salvini intorno alla parola *Iconografias*. Le resoluzioni prese da Vostra Signoria Illustrissima per farmi arrivare al godimento di un favore tanto stimabile di Monsignore Illustrissimo Suares son tanto adattate al bisogno e desiderio mio, ch'io non posso rappresentarli quanto io me ne trovi consolato, e lo stimo effetto della Divina providenza. Attenderemo quanto ne avviserà il Padre Porta, e poi sarà luogo a Vostra Signoria Illustrissima di farmi di nuovo godere gli effetti della sua moltissima carità, ed io fra tanto desideroso sempre più di corrisponderle in qualche parte le fo umilissima reverenza / Vico Pisano / li 30 Maggio 1677 / Di Vostra Signoria Illustrissima / Divotissimo Servitore Obligatissimo / Filippo Baldinucci."

On 8 June 1677 Filippo Baldinucci wrote Alessandro de' Cerchi, "Illustrissimo mio Signore, Signore e Padrone mio Colendissimo / Ricevo le nuove grazie di Vostra Signoria Illustrissima con la sua compitissima lettera delli 5 e lasciando i ringraziamenti per meno tediare Vostra Signoria Illustrissima (che troppi doverebbero essere) dico che la risposta del Padre Porta non poteva essere ne più puntuale ne più chiara per il nostro bisogno, e veramente ho ammirata la premura di diligenza con che ha favorito Vostra Signoria Illustrissima approvo con tutta la mia volontà, che Vostra Signoria Illustrissima habbi conferito col mio riveritissimo Padre Cionacci che tanto benefica le mie povere fatiche, e non solo acconsento, ma desidero vivamente che si stampino le due opere di Monsignor Suares, e già che Vostra Signoria Illustrissima si degna di offrirmi l'onore di prestarmi il nome le dico che non bramo altro per fare tal cosa che lei perche questo sarà di somma onorevolezza non dico a me che non la merito ma a Monsignore medesimo. Vorrei ben pigliare sicurtà di proporre un mio contrario parere intorno all'altre cose che hanno discorso insieme loro Signori ed è questo. Primieramente quanto al fare comporre altra operetta per impinguare il corpo, io non lo farei per queste ragioni, in primo luogo dubiterei che lo stampare in simile idioma e materia, cosa d'altri benche conspicuo letterato fussi un far paragone, o almeno potersi parere a Monsignore et anco quel mescolare l'opere d'huomo che già tiene il primo luogo con altre opere fusse potuto riuscire di dubitoso evento appresso esso Monsignore, oltre all'apprenderla io per cosa più lunga ma questo per altro poco importerebbe. Alla piccolezza del corpo mi pare che si rimedierà col far stampare le due epistole in foglio nobilissimo a proporzione, con carattere molto grande e gran margini, insomma alla nobile affatto, e costi quello che vuole, per che la spesa non mi da un pensiero al mondo. Assai sarà se la benignità di Vostra Signoria

Illustrissima si degnerà prestarmi il nome con apparir lei nel farlo stampare. Sta benissimo il farne stampare 100 o 150 al più per le prudentissime ragioni di loro Signori. Lasciai di dire, che vi sarebbe stato un altro rimedio per fare il corpo maggiore, ma sarebbe cosa lunga, quando che Vostra Signoria Illustrissima o il Padre Cionacci ne volessero fare una versione Toscana, e stampare l'uno e l'altra insieme, perche sarebbe di doppio gusto a forestieri, et a Monsignore medesimo, e in questo caso metterebbe conto farne tirare moltissime. Resta la dedicazione, ancor qui mi farò lecito dire il mio sentimento. Io non potrei haver cosa più cara che acquistare qualche poco di merito coll'Eminentissimo Signor Cardinale Arcivescovo. Ma considero che essendosi il Serenissimo Gran Duca dirò così interessato in questa mia opera, per havermene parlato e fatto parlare più volte, e per havermi quando era a Pisa mandato a Vico Pisano un libro fiammingo fattomi venire aposta di tutto negoziato suo d'Amsterdam, e per sapere egli che questa fatica deve essere dedicata alla Casa Serenissima mi pareva non solo conveniente ma utile per me che le prime cose che uscivano fuori dove l'opera e tanto più la mia persona fusse nominata dovessero essere dedicato a lui. Dico utile per me, perche ho aspettata a gloria quest'occasione perche ho sperato che quando ella sarà sotto l'occhio di Sua Altezza come cosa propria, Sua Altezza Serenissima s'invoglierà più della medesima e più mi favorirà che mi occorressero per l'opera e mentre non sia di diverso parere Vostra Signoria Illustrissima con mia saputa, acciò mi potesse fruttare il buon affetto e protezione ch'io desidero. Ora Signore Illustrissimo gia che ella ha preso a favorirmi tanto la supplico a fare conto ch'io non sia al mondo e con il Padre Cionacci deliberare quanto li piace, e ardisco di più di pregarla a non aspettare il mio ritorno, ma quando habbi deliberato, a chiamare quello stampatore che li piace fare assistere a chi li piace, e insomma tirare a fine questo negozio, con questo però che Vostra Signoria Illustrissima non habbi se non il nome, voglio dire che la spesa (sia pur grande quanto vuole che si stampi nobilmente) sia tutta sopra di me, che in altro modo facendo sarei necessito di privarmi di un onore tanto desiderato, quanto è che questa opera si dia fuori da un par suo. Per tal effetto le mando congiunta un altra copia della medesima epistola diretta a me, alquanto meglio scritta. Similmente l'opera stampata della Navicella e la lettera del Padre Porta della quale mi sono lasciata copia. Gli invio ancora la lettera di risposta a Monsignor Suares aperta supplicandola ad inviargliela con quell'accompagnatura che parrà alla somma prudenza sua. E necessario ch'io le dica come ho stimato bene il rendere avvisato con una mia brevissima lettera il Signor Magliabechi come è comparsa la detta desiderata epistola di Monsignore e questo ho fatto, perche avendone egli mostrato per amore mio desiderio grande, non mi par bene che lo deva sapere da altri prima che da me, il quale ho molto bisogno di lui materia di libri e gli ho soggiunto che avendomi Vostra Signoria Illustrissima fatto il favore di ottenermi questa entratura non sono lontano da sperare che Vostra Signoria Illustrissima sia anco per honorarmi di farla stampare. La lettera la mando inclusa perche se Vostra Signoria Illustrissima havesse minima difficoltà in quanto io scrivo a esso Signor Magliabechi, la possa stracciare e con pregarla di scusa di tanti e tanti incomodi resto pregandoli da dovere dal Signore Dio il

colmo di ogni desiderata felicità. / Vico Pisano / Li 8 Giugno / Di Vostra Signoria Illustrissima / Divotissimo Servitore Obligatissimo / Filippo Baldinucci."

On 22 June 1677 Filippo Baldinucci wrote Alessandro de' Cerchi: "Illustrissimo Signore e Padrone mio Colendissimo / Io non finisco mai di commettere mancamenti con Vostra Signoria Illustrissima ed ella all'incontro sempre mi accresce l'obbligazioni. Confesso la mia stolidezza che fu di non intendere bene l'offerta che mi fece Vostra Signoria Illustrissima di volermi aiutare nel fare stampare l'epistola di Monsignor Suares, si come ho fatto col rileggere la lettera di Vostra Signoria Illustrissima dopo ricevuta l'altra de 15 per mezzo della quale, e per il parere trasmessomi dal Padre Cionacci, ho fermato l'animo che si stampino coll'aiuto che mi darà Vostra Signoria Illustrissima, insieme con l'epistola da farsi dal Signor Salvini et il farla dedicare a Monsignor Arcivescovo atteso il bel pensiero venuto a Vostra Signoria Illustrissima quale non sapevo per avanti, cioè di descrivere in essa l'assunto del mio operare mi sarà caro all'ultimo segno per molte ragioni. Io scrivo a Firenze per ottenere di portarmene per brevi giorni, e così haverò tempo di ricevere le grazie di Vostra Signoria Illustrissima in persona, fra tanto la supplico a compiacersi di fare col Signor Salvini quelle parti che stima necessarie per ottenermi da lui il favore desiderato di detta epistola ed a questo effetto ho distesa così presto presto l'alligata informazione per Sua Signoria della quale potrà Vostra Signoria Illustrissima valersi se così stima bene fatto, e per non tediarla di vantaggio finivo rendendoli infinite grazie e pregandola a scusare la mia debolezza e importunità, col farle umilissima reverenza / Vico Pisano / li 22 Giugno 1677 / Di Vostra Signoria Illustrissima / Devotissimo Servitore Obligatissimo / Filippo Baldinucci."

15. See Chapter Two.

16. See the "L'Autore a chi legge" in Baldinucci's *Vocabolario toscano dell'arte del disegno* (Florence, 1681). In the second volume of *Teatro di grazia e di giustizia, o vero, Formulario de rescritti a tutte le cariche che conferisce il Ser.mo G. Duca di Toscana per via dell'Ufizio delle tratte* (the dedication is dated 19 February 1705/6), Niccolò Arrighi notes, "Vico Pisano, Vicario / Ha di provvisione scudi 1800 in sei mesi. / Tiene un giudice e un cavaliere." ASF Misc. Med. 414, fol. 181 verso. Leopoldo de' Medici owned a *fattoria* at Vico Pisano which passed to Francesco Maria.

17. On copying pictures, see Baldinucci's letters to Bassetti of 27 July and 2 and 27 August 1679. ASF Med. Princ. 1525, *Diversi* (SPES 146, 147, and 148).

18. See Baldinucci, *Vocabolario*, "L'Autore a chi legge."

19. ASF Med. Princ. 1525, *Diversi*, 21 September 1679, Baldinucci to Bassetti (SPES 149).

20. ASF Med. Princ. 1525, *Diversi*, 27 September 1679, Baldinucci to Bassetti (SPES 150).

21. *Diario*, p. 76, 24 October 1680. In the spiritual diary it seems clear that references to *"l'opera"* signify *"l'opera cronologica."*

22. *Vita di F.B.*, p. 24.

23. *Notizie* 1, p. 15.

24. *Diario*, p. 69, 5 March 1676.

25. Ibid., p. 71, 22 August 1676.

26. For his relatives in the Marche see *Vita di F.B.*, p. 4. Baldinucci's "Notizie di Antonio Calcagni" might well include researches that he carried out on the spot in Loreto. *Notizie* 3, pp. 101–25, esp. pp. 112 and 124. The Florentine and Marchigiano branches of the Baldinucci family kept in touch with each other. In his letters Antonio Baldinucci makes repeated reference to his cousins in Macerata (Rosa, *Lettere*, for example, nos. 8 and 63). In a letter to Francesco Saverio of 7 March 1697 (62), Antonio describes a visit with Signora Angela Baldinucci in Macerata.

27. *Vita di F.B.*, p. 20.

28. *Diario*, pp. 36 and 49. *Vita di F.B.*, p. 33. On 24 November 1681 Baldinucci wrote Bassetti a lengthy, highly emotional, and barely legible letter (ASF Med. Princ. 1526, *Diversi*). "Illustrissimo Signore e Padrone Colendissimo / In tempo appunto che io dopo una lunga sofferenza d'anni stavo sospeso d'animo e quasi fra le dua, se io dovevo far ricorso al Padre Cardinale Arcivescovo o pure al Padrone Serenissimo a cagione de cativissimi termini che à usato e usa tuttavia il Padre di Botinaccio, con me, col mio, e con chi fa i fatti mia. Sento che egli (che è il più astuto uomo che io conoscessi mai) o da per se o per altra via ch'io non so, mi abbia fatto pervenire al Padrone Serenissimo. / Questa nuova mi è stata una saetta all'anima, per le gran consequenze che ella è per portare, e perche (siccome è noto a Sua Altezza per altri casi occorsimi agli anni a dietro io non ò da fare, con i soli preti di quel luogo. All'incontro io che non posso andare in villa mai ò necessità di tenere un uomo, e non ò mai trovato che facci i fatti mia da persona da bene, se non questo che vi è al presente, che è un povero contadino ma soldato del Serenissimo Gran Duca, che però è guardingo dell'onore suo nel quale è sempre perseguitato {onde . . . *cancelled*} e per fare bene i fatti mia è stato veramente martire, a cagione di questo sacerdote, il quale è diventato fattore di quasi tutti i vicini e corre come si suole dire il parere per suo. Io per non perdere la pace ò sopportato e sopportavo ogni affronto, in me e nella persona del fattore, il quale so certo che à impedito più volte a mia lavoratori il ricorso a Monsignor Arcivescovo, ed ora sente quello che io sento, con pericolo abbia effetto, il desiderio, che vantamente che à fatto per il parere lo stesso Prete di farmelo levare di li in ogni maniera dal che nascerà l'ultimo esterminio alla povera e disastrata casa mia, e sarà necessario ch'io vada in persona a tenere cura di quelle quattro miserabili cose che ove si raccoglie ò condannato me stesso a perdere quel poco ch'io vi ò quando un poco e quando un altro o lasciarmi tirannegiare a questa creatura, se la bontà del Padrone Serenissimo non ripara al quale so essere noto quanto furono necessarie le sue grazie e del Serenissimo Signor Cardinale per ch'io colassù non fussi oppresso a tempo d'un antecessore di questo al quale non so se in gastigo, o per mia totale liberazione per allora il Signor Dio mandò poi la morte nel più bello degli anni suoi. / Io supplico dunque Vostra Signoria Illustrissima a porgere al Padrone Serenissimo questi mia sentimenti supplendo ora per me finch'io mi porti in persona a prostrarmi a' piedi di S. A. e sup-

plicandolo a sospendere ogni credenza e credere all'incontro che io sono il maltrattato e fratanto acciò che Sua Altezza subordori alquanto le qualità di questo sacerdote a fare sentire da Vostra Signoria Illustrissima Giovanni Toni mio contadino uomo semplice e grossolano che dirà naturalmente il vero e per a buon conto intenderà gli strapazzi che gli a fatto ed al suo ordine anche a mio figlio facci abboccare con Vostra Signoria Illustrissima lo stesso mio fattore e io poi metterò in carta ogni cosa a fine che la bontà di Sua Altezza Serenissima si degni rimettere la cognizione della verità a qualcheduno e poi la facci la giustizia. Mi duole bene fino all'anima che s'abbia a fare ricorso alla bontà, anzi santità di un tal Padrone quale è il nostro Serenissimo per godere gli effetti della di lui carità ed insiememente raccontare cose tanto lontane dal vero e per fine di levarsi d'attorno chi fa l'ofizio suo, e non permette che altri faccia affronti e l'oppressi alla sua famiglia e persone subordinate come fa quel povero uomo di mio fattore. Finisco per non più tediare Vostra Signoria Illustrissima offrendomi per altro prontissimo ad ogni cenno del Serenissimo Padrone quale spero che si degnerà di sentire le discolpe di quel povero suo suddito e fedelissimo soldato e resto per fine di Vostra Signoria Illustrissima / Firenze li 24 Novembre 1681 / Divotissimo Servitore Obligatissimo / Filippo Baldinucci / Scrivo questa lettera subito dopo avere avuto l'avviso in cambio di desinare per posso spedire a posta mio figlio e dopo scritto à portato la disgrazia che la medesima resti imbrattata di alcuni scorbi e perche non ò tempo di ricopiarla la supplico a perdonare non avendola nemeno potuto rileggerla."

29. *Diario*, pp. 75–76 and 78, 24 October 1680.

30. *Vita di F.B.*, p. 20. *Diario*, pp. 76–81, 24 October, 7 November, and 21 December 1680. Filippo describes these events in his deposition of 25 December 1680 (Rosa, *Lettere*, pp. 130–31). For Gian Filippo Baldinucci's account see Rosa, pp. 146–48.

31. *Diario*, p. 81, 21 December 1680.

32. In ASF Med. Princ. 3661, Bassetti to Mancini; ASF Med. Princ. 3947, Mancini to Bassetti; and ASF Med. Princ. 1526, *Diversi*, Gualtieri to Bassetti. Also ASF Auditore delle Riformagioni 55, fol. 3 and ASF Pratica Segreta di Firenze 194, fol. 18 (Proibizione a librai di stampare l'opere di Filippo Baldinucci).

Baldinucci's formal appeal for Florentine copyright privileges is found in ASF Auditore delle Riformagioni 55, fol. 3. "Ser.mo Gran Duca / Filippo Baldinucci Fiorentino suddito humilissimo di V.ra A. havendo con molto suo dispendio di fatica, di tempo e di denaro, in grazia degli Amatori del buon disegno e benefizio della posterità gettato i fondamenti d'un'opera che sarà piena di notizie, e di lumi istorici intorno a' professori del medesimo Disegno, colla quale intende dimostrare come, e da chi, le belle arti della pittura, scultura et architettura da Cimabue in qua lasciata l'imperfezione de secoli barbari siansi nel presente ridotto all'antica loro eccellenza, la quall'opera porterà seco ancora un Vocabolario attenente alla pratica delle stesse arti, ma non potrà uscire alla luce delle stampe, se non divisa in più volumi et in diversi tempi sotto varii titoli, e frontispizii, secondo le materie che comprenderanno, relative alla professione dell'Arti sudette, et potendo facilmente avvenire che coll'avanzarsi del tempo, e dell'opera, convenga pur accrescere, diminuire o

variare i trattati, supplica l'autore accioche non vengano ristampati in qualche luogo, con pregiudizio di quell'ordine e perfezione, che egli brama di darli, che gli sia concesso privilegio, col quale, si proibisca a qualunque persona per tutti li stati di vostra A.S. durante il corso di venti anni compresa anche la città, contadi, e montagna di Pistoia e qualunque altro luogo quantunque magg.te privilegiato che havesse bisogno di speciale, et individua menzione, non solo la ristampa, e la vendita di quella parte, che l'autore sarà per pubblicare presentemente dell'opera sud.a in uno o più volumi ma ancora dell'altre che consecutivamente andrà stampando spettanti alla stessa materia, et storia del disegno, sia che per il corso di venti anni dal tempo che ciascuna parte dell'opera medesima uscirà alla luce, non sia lecito ad alcuno il ristamparla o il venderla senza espressa licenza in scriptis dell'autore, o de suoi eredi sotto le pene che all'arbitrio che a V.ra A. parrà d'imporre a i trasgressori per tutto il suo felicissimo dominio qua deus." Beneath this is written: "L'Aut.re delle Riformagioni informi Emilio Luci, 22 Marzo 1680 / Serenissimo Gran Duca / Per informazione reverentemente si rappresenta a V.A.S. come ò solito non denegare simili privilegi per le stampe dell'opere nuove, e concedendolo V.A. al supplicante per il tempo d'anni venti, come domanda, se li distendeva dall'offizio delle Riformagioni il privilegio nella forma consueta, con pena di f. 25 a chi contravenisse, e perdita de libri d'applicarsi per un quarto al fisco, e Gran Camera Ducale, per un quarto all'Accusatore segreto o palese, e per un quarto al Magistrato o rettore che condennerà o risquoterà, et per l'altro quarto al Supplicante, e con obbligo di consegnare a quest'offizio delle Riformagioni uno di detti libri stampati e di pagare al Monte un fiorino d'oro. Il comandamento sta all'A.V.S., alla quale bacio umilissimamente le vesti. / di Firenze / 22 marzo 1680 / dell'Alt. V. Ser.ma / humilissimo servitore / Antonio de' Ricci." Beneath this is written: "Concedersi come si propone / Emilio Luci / 13 aprile 1681."

In regard to the question of administration fees, see n. 35 below.

33. ASF Med. princ. 3661, 14 January 1681, "Memoriale di Filippo Baldinucci" (SPES 155).

34. See n. 32 above.

35. ASF Med. Princ. 3661, insert three, 10 December 1680, Mancini to Bassetti. "Mentre il breve del privilegio per il Sig. Baldinucci non possa aversi a più lungo tempo di nove anni bisognerà pigliarlo nella forma che si costuma concederlo." Innocent XI's privilege in the 1681 edition in fact specifies the period of a decade. There is the following exchange in regard to the administrative expenses. ASF Med. Princ. 3661, insert four, 21 February 1681, Bassetti to Mancini. "V'è ricevuto il Breve per il Sig. Baldinucci, a cui Sua Altezza avendo prestato la sua interress.ma non credo che vorrà far gliene sentir la spese, ma sopra questo punto dirò a V.S. Ill.ma il positivo un'altra volta." On 24 February Bassetti adds, "Intende l'Altezza Serenissima che vada a proprio conto la spesa del Breve cavatosi per il Sig. Baldinucci, a mia comanda stasera di farlo sapere a V.S. Illustrissima."

36. ASF Med. Princ. 1526, *Diversi*, 28 January 1681, Baldinucci to Bassetti (SPES 157). In his letter to Bassetti of 12 February 1681, Lorenzo Gualtieri

refers as well to Baldinucci's desire for the privileges of Parma. ASF Med. Princ. 1526, Gualtieri (cited in note to SPES 159).

37. ASF Med. Princ. 1526, *Diversi*, 2 February 1681, Baldinucci to Bassetti (SPES 158).

38. The inventory of the self-portraits, dated 12 February 1680/81, is in ASF Misc. Med. 368, fol. 420 (SPES 160). Baldinucci's cover letter to Bassetti, dated 15 February 1680/81, is in ASF Med. Princ. 1526, *Diversi* (SPES 162).

39. ASF Med. Princ. 1526, *Diversi*, 10 March 1681, Baldinucci to Bassetti (SPES 165).

40. ASF Med. Princ. 1526, *Diversi*, 20 and 29 March and 5 April 1681, Baldinucci to Bassetti (SPES 167, 168, and 169). Also Lorenzo Gualtieri refers to Baldinucci's activity in his letters to Bassetti of 19 and 24 March 1681 in ASF Med. Princ. 1526, Gualtieri (quoted in the note to SPES 167).

41. ASF Med. Princ. 3661, 5 April 1681, Baldinucci to Bassetti (SPES 170). Later in this chapter I postulate that Paolo Falconieri might have been Filippo's intended host.

42. ASF Med. Princ. 3661, 8 April 1681, Baldinucci to Mancini (quoted in note to SPES 170).

43. ASF Med. Princ. 1526, *Diversi*, 8 April 1681, Baldinucci to Bassetti (SPES 171).

44. "Al Serenissimo Cosimo Terzo Granduca di Toscana," as published in the first installment of the *Notizie* (1681).

45. ASF Med. Princ. 1525, *Diversi*, 11 April 1681, Baldinucci to Bassetti (SPES 173). The letter is dated "11 Aprile 1680" twice, though the content clearly refers to events of the following year. Since the letter was written only eighteen days after the New Year, a brief lapse from force of habit is plausible. The grand duke objected to Baldinucci's calculatedly modest reference to the "mediocrità del lavoro." See also n. 116 below.

46. ASF Med. Princ. 3947, 19 April 1681, Mancini to Bassetti (quoted in note to SPES 172).

47. ASF Med. Princ. 3661, 8 April 1681, Bassetti to Mancini (SPES 172).

48. ASF Med. Princ. 3947, 12 April 1681, Mancini to Bassetti (quoted in note to SPES 172).

49. *Vita di F.B.*, p. 22. Giovanni Cinelli, Filippo Baldinucci's most vehement adversary, gives him credit for three papal audiences. "Andò a Roma, scrisse tante bugie, ch'una sola per tutte basti: Incontri di carrozze, esser da' Cardinali corteggiato furon la grazie minori; ma l'esser egli solo in otto giorni più volte col Cardinale [name omitted] e tre e non altri all'audienza del Pontefice ammesso fece a più d'uno che per prima l'amava venir il latte a' testicoli." BNCF Magl. XVII, 22 fol. 68ʳ.

50. See Chapter Two.

51. Goldberg, *Patterns*, pp. 200–204.

52. "Poi che ella è divenuta invisibile et io immobile, per esseguire due comandamenti fattimi dal P.rone Ser.mo piglio la libertà di significarglieli con questo biglietto, il quale [starei] aspettandola dove ella si rende visibile. Sua Altezza condescendo benignamente a fare al Baldinucci la grazia della quale

l'ha supplicata nell'aggiunto biglietto scritto a me, e di più dell'opera di un certo Malvasia che egli presoppone dovere uscire dentro a questa settimana da i torchi di Bologna contenente notizie di molti pittori Lombardi, e mi ha comandato che ella ne scriva al Sig. Ab. Goti et al Sig. Balì Cospi." ASF Med. Princ. 3943, 6 November 1677, Paolo Falconieri.

53. "Trovandomi settimana sono per altro dal Sig. Conte Carlo Cesare Malvasia Canonico di questa Metropolitana mi mostrò il suo bel libro delle vite de' pittori fornito, solo mancava un residuo della tavola che faceva e dissemi che per certa risposta datali da un Senatore haveva voltato vela di non dedicarlo più a questo Senato ma era resoluto dedicarlo al Rè di Francia, e me ne lesse la dedicatoria che però conviene attendere le risposte di colà che non doverebbero tardar molto, e subito lo darò fuori con sua sodisfazione per che da' Francesi era stato richiesto della matrice per stamparlo colà a loro spese, e donarglene copie, ma la brama che haveva come ho detto dedicarlo al reggimento di Bologna lo ritirò d'applicare a questa cortesia, e doppo speso tanto ha fatto nuova resoluzione. Ho fatto a V. S. Ill.ma questo racconto per che se alcuno gl'havesse dover presto uscire alla luce sappia la causa del ritardo. Vedrò il detto Sig. Conte per stare alle velette quando si possa havere. Tanto mi comanda il Sig. Marchese mio Signore al cenno datoli per parte di V.S. Ill.ma del comando di S.A." ASF Med. Princ. 3943, insert Cospi-Bondoni, 13 November 1677.

54. "Il Sig. Conte Malvasia ha fornito il libro e subito che ne haverà astradati per Parigi il primo sarà per il Ser.mo G. Duca come gia haveva destinato per la servitù che acquistò col Ser.mo Sig. Pr.pe Card. Leopoldo, tanto nominato nell'opera, et haverà a sommo onore servirne S.A.S. che sarà verso la metà del venturo mese facendo legare quelli per S.M." ASF Med. Princ. 3943, insert Cospi-Bondoni, 23 November 1677.

55. Malvasia, *Felsina pittrice*, p. 9.

56. The notorious *"boccalaio"* is one of the best examples of Malvasia's tendency towards explosive overreaction. The author's real grudge was not against Raphael but rather against the habit of evaluating the Carracci in terms of Raphael, usually to Lodovico's detriment. The myth of Annibale as the second Raphael reached its culmination in Bellori's *Vite*, most particularly in his description of Annibale's funeral in the Pantheon (*Vite*, pp. 76–80). Malvasia's attitude to Annibale is highly ambivalent. He tends to attack Annibale if he is praised by others, especially when this comes at the expense of the more faithfully "Bolognese" Lodovico. Malvasia, however, can also rally to Annibale's defense if he seems threatened.

The *"boccalaio"* is itself a direct response to Bellori's discussion of the relationship between painting and poetry in the Camerino and Galleria Farnese (*Vite*, pp. 32–66). While paralleling Raphael and Annibale as outstanding practitioners of "painted poetry," Bellori specifies only Annibale's reliance on the literary inventions of others (*Vite*, p. 32). Malvasia took this as a slight to Annibale. In the *Felsina pittrice* the *"boccalaio"* appears in a description of the interaction between artists and writers at the Carracci academy. After echoing Bellori's discussion of the use of "anachronism" in history painting (*Vite*, pp. 42–43), he observes in regard to Raphael's pictorial themes, "I will never be-

lieve that such elevated and assured inspiration could have chanced to enter into the petty not to say humble imagination of an Urbino mug maker" (*Felsina*, p. 471).

In his vehement critique of the *Felsina*, Vicente Victoria recognizes the connection between the two passages in the *Vite* and the *Felsina* (*Osservazioni sopra il libro della Felsina pittrice* [Rome, 1703], pp. 40–41). Malvasia's infamous references to Correggio as a "lady painter" (*Felsina*, p. 368) and to Raphael's *Saint Cecilia Altarpiece* (p. 365) both appear in the context of the Carracci polemic.

57. In 1844 the Parmesan bibliophile Angelo Pezzana published a leaflet discussing this matter. He observed that first states of the *Felsina* fetched higher prices and that of the five copies in the public library in Parma, only one was a prized "esemplario del boccalaio" (Angelo Pezzana, *Osservazioni bibliografiche intorno alla Felsina pittrice del Malvasia impresa nel 1678* [Parma, 1844]). We can deduce a terminus post quem of May 1682 for the reissue of the *Felsina* since Malvasia cites the second portrait that Louis XIV sent him after the first was stolen in transit. See also n. 82 below.

58. As we saw in the preceding chapter, Malvasia claims to have disregarded the primitives until 1675, when Baldinucci repeatedly approached him for information relevant to this issue. In this period the aesthetic values of the primitives were remote from contemporary artistic concerns. The nearest point of contact came in occasional references to old and revered devotional images. In the seventeenth century, researches on the primitives were directed especially at establishing the "nobility" of a particular school through its antiquity.

59. *Notizie* I, pp. 21–32. "Proemio dell'opera con le notizie di Cimabue pittor fiorentino, il primo che desse miglioramento all'arte del disegno, ed alla maniera del dipingere, che i moderni greci, ed altri loro imitatori ne' suoi tempi tenevano."

60. Baldinucci's attention to these points reflects particular concerns of that time. Vasari's questionable claim of Cimabue's noble birth and the date of construction of the Gondi Chapel at Santa Maria Novelli were soon to figure in Florentine controversies. See Chapter Four.

61. *Notizie* I, pp. 35–71. The apology comprised twenty-two pages in the 1681 edition. "La Ristaurazione dell'arte del disegno da chi promossa. Apologia a pro delle glorie della Toscana per l'assertiva di Giorgio Vasari aretino, ed onore di Cimabue e Giotto fiorentini."

62. Ibid., I, p. 36.

63. In fact, Malvasia makes a special point of his own "homespun and popular language" and his familiarity with studio usage and tradition (*Felsina pittrice*, "Prefazione"). In Florence there was a raging controversy that sprang from a complex set of motives and involved Filippo Baldinucci, Giovanni Cinelli, and Ferdinando Leopoldo del Migliore. Whatever the fundamental issues might have been, a standard tactic was undercutting one's opponent by demonstrating that he had no right to treat such matters. See particularly Baldinucci, *La Veglia*; Giovanni Cinelli, *Lettera dell'Anonimo d'Utopia a Filalete* (MS., BNCF Magl. XVII 22), Ferdinando Leopoldo del Migliore, *Reflessioni e aggiunte*

alle Vite de pittori di Giorgio Vasari (MS., BNCF II IV 218). Aspects of this controversy are discussed in Chapter Four. In the *Lettera a Vincenzo Capponi* Baldinucci is conspicuously unable to decide whether he wishes to present himself as a scholar or a *"professore."*

64. *Notizie* I, p. 37.

65. Since recorded assessments of Baldinucci tended to be highly partisan, it is difficult to evaluate the more general response to his methods. Giovanni Cinelli, who is very far from an objective observer, offers an intriguing reference to "questa sua odiosissima Apologia nella quale oltre l'aver replicato mille volte le cose medesime fa una spantacata che la sa fare ogni asino, mentre veggendo ciò ch'anno detto i comentatori di Dante nel MS. di S. Lorenzo che son tutti insieme, puo chi che sia con la sola copia far lo stesso fracasso, per esser da gli scimuniti, ma non da chi ha sale, dotto tenuto." BNCF Magl. XVII 22, fol. 12ʳ.

66. In the various copies of the 1681 *saggio* of the *Notizie* that I have seen, the presswork has been notably sloppy. However, it is somewhat premature to generalize about the whole press run. The physical characteristics of the major art historiographic publications have been largely ignored in favor of purely textual concerns. Considering such factors could shed much light on their circumstances and patronage.

67. *Notizie* I, pp. 9–10.

68. *Notizie* I, p. 17.

69. The *Lettera a Vincenzo Capponi* is republished in SPES 174, pp. 461–85.

70. For Vincenzo Capponi (1605–1688) see *Dizionario biografico degli italiani*, Vol. 19, pp. 99–100. Also *Notizie . . . intorno agli uomini illustri della Accademia Fiorentina* (no author [Florence, 1700]), pp. 346–49 and S. Salvini, *Fasti consolari dell'Accademia Fiorentina* (Florence, 1717), pp. 491–97.

71. SPES 174, p. 462.

72. SPES 174, pp. 462–63.

73. SPES 174, p. 463.

74. SPES 174, p. 467.

75. SPES 174, pp. 463–64. In regard to the activity of professional artists as connoisseurs, see Chapter One and Goldberg, *Patterns*, pp. 28–30.

76. SPES 174, p. 470–71.

77. SPES 174, p. 476.

78. *Notizie* 3, p. 346. This section of the *Notizie* was published posthumously in 1702.

79. For Bellori's interpretation of Annibale as the second Raphael, see n. 56 above.

80. Goldberg, *Patterns*, pp. 118–22.

81. See Chapter Two and the letters in ASF/CDA XXI, 27 September 1675, Baldinucci to Cecini (SPES 133) and ASF/CDA XI, fol. 455, 12 October 1675, Ottavio Falconieri to Leopoldo de' Medici (SPES 138). The mosaics in Santa Maria in Trastevere are specifically cited. There is no indication of a response from Bellori.

82. G. Campori, *Lettere artistiche inedite* (Modena, 1866), p. 130. Three

years later, when the controversy over the primitives was further complicated by the involvement of the Florentines Giovanni Cinelli and Ferdinando Leopoldo del Migliore, Bellori singled out Baldinucci for somewhat warmer praise, though he carefully avoided taking sides. See Bellori's letter to Magliabechi of 13 May 1684 and Chapter Five.

83. Goldberg, *Patterns*, pp. 93–96.

84. *Notizie* 5, pp. 581–82. In his dedication to Francesco Marucelli of the *Cominciamento e progresso dell'arte dell'intagliare in rame* (Florence, 1686), Baldinucci specifically states that he "betook himself to Rome in order to thank Her Majesty for such a favor" as this commission.

85. In his *Listra* Baldinucci cites nine drawings by Bernini in Leopoldo's collection (SPES 52). Many of Bernini's major projects were widely known from prints. His *Bust of Costanza Bonarelli* had been in the granducal collection since 1645. Baldinucci is also likely to have seen the Chigi commissions in Siena Cathedral, including the Saint Jerome, the Saint Mary Magdalen and the memorial statue of Alexander VII (executed by Raggi). There was some minor architectural work for the Rospigliosi in the Pistoiese. In 1674 Leopoldo de' Medici acquired a painted self-portrait of Bernini through the auspices of Paolo Falconieri. See W. Prinz, *Selbstbildnisse*, p. 177 (docs. 45 and 46).

86. There is a lingering uncertainty regarding the identity of the author of the libretto of *L'Honestà negli amori*. This is probably due to a late seventeenth-century typographical error. The libretto was published under the pseudonym of "Felice Parnasso." In his *L'Istoria della volgar poesia* (Rome, 1698), Giovanni Mario Crescimbeni credits the work to "Gio. Filippo Bernini Romano, Prelato di molta dottrina" (Vol. 5, p. 162) and cites the copy annotated by Queen Christina. Though this Gio. Filippo Bernini is often credited as author, the biographical description in fact fits Pierfilippo. Also "Felice Parnasso" sounds much like a play on "Pierfilippo." Dr. F. W. Sternfeld at Oxford very kindly assisted me with Scarlatti bibliography.

87. *Notizie* 5, p. 608.

88. On 21 February 1682 Gian Pietro Bellori in Rome wrote Antonio Magliabechi in Florence, "di vostro desiderio saper qualcosa della Vita che si stampa costà del Cav. Bernino, in Roma s'intaglia il ritratto che Mons. Bernino manderà per la stampa." BNCF Magl. VIII 435, fol. 9ᵛ.

89. *Notizie* 4, p. 280.

90. Ibid., 5, pp. 312–13. Also the dedication to Marucelli of Baldinucci's *Arte dell'intagliare in rame*. Antonio Baldinucci called on Abbot Marucelli in Rome in late August of 1691. See Antonio's letter to Francesco Saverio of 1 September 1691 (Rosa, *Lettere*, no. 5).

91. Goldberg, *Patterns*, chaps. 4, 7 and 9.

92. ASF Med. Princ. 3944, 24 September 1678, Paolo Falconieri to Bassetti. "Questa sera mando i due disegni di Polidoro e di Guido, e so dal Baldinucci potesse aggiungere qualche riprova all'antichità de caratteri che vi sono, per la quale si potesse essere più sicuri che sia veramente il ritratto di quel gran uomo." There is some question as to whether "*caratteri*" is to be taken as "characters" or "characteristics."

93. ASF Med. Princ. 3947, 19 April 1681, P. Falconieri to Bassetti. "Secondo quello, che mi è stato scritto di costà il Sig. Filippo Baldinucci dovrebbe giungere questa sera. Non posso sapere se sia giunto, perche non so dove vadia a smontare. Ma non molto indugio a saperlo, e saputolo non lascerò d'offerirmegli, dalla spollacatura, et ad ogni altra cosa, parendomi un uomo che meriti cortesia. Ella non però avergli invidia della spollacatura, perche non ne ha bisogno essendo spollaccata benissimo."

94. ASF Med. Princ. 3947, 26 April 1681, P. Falconieri to Bassetti. "La Domenica mattina viddi il Sig. Baldinucci nella Chiesa Nuova, cominciai a servirlo allora, e continuo a farlo quanto mi permettono molte cose, che bisogna ch'io sbrighi prima di partire."

95. For Falconieri's departure for Florence see Goldberg, *Patterns*, p. 212. Baldinucci cites Paolo Falconieri's collection in Rome in *Notizie* 5, pp. 458 and 538. According to Francesco Saverio, Paolo Falconieri undertook the publication in Rome of Filippo's "Albero" after his death. Falconieri's own death thwarted this initiative. *Vita di F.B.*, p. 19.

96. *Notizie* 5, p. 466.

97. Ibid., 5, pp. 313–14. After Filippo's return to Florence, dal Pozzo sent him information on Pietro Testa.

98. Ibid., 5, p. 373. Filippo brought works by Keilhau back to Florence and also received from him information about Rembrandt.

99. ASF Misc. Med. 368, fols. 457–58, 11 June 1681, Baldinucci to Bassetti (SPES 175).

100. Ibid.

101. ASF Med. Princ. 1526, *Diversi*, 20 July 1681, Baldinucci to Bassetti (SPES 176).

102. For the background to Filippo Baldinucci's *Vocabolario toscano dell'arte del disegno* (Florence, 1681), see Severina Parodi's critical essay appended to the recent undated photographic reproduction of this work issued by the Studio per Edizioni Scelte in Florence.

103. Baldinucci, *Vocabolario*, p. vii.

104. Parodi in Baldinucci *Vocabolario*, p. iii. Francesco Redi, *Arciconsolo* of the Crusca, wrote Baldinucci a letter of congratulation on 13 January 1682. F. Redi, *Opere* (Milan, 1809–1810), Vol. 7, pp. 267–68.

105. *Vita di F.B.*, pp. 19–20.

106. This description is offered on the title page of the *Vocabolario*.

107. Parodi in Baldinucci's *Vocabolario*, pp. xxvii–xxviii.

108. Baldinucci, *Vocabolario*, pp. ix–x.

109. Parodi in Baldinucci's *Vocabolario*, p. ix. It is interesting to note that Baldinucci's work is listed in the table of abbreviations in the third edition of the *Vocabolario della Crusca* (1691), even though this work is never cited.

110. F. Baldinucci, *Lezione nell'Accademia della Crusca intorno alli pittori greci e latini* (Florence, Matini, 1692), reprinted in SPES 199. See Baldinucci's references to the Accademia and Gian Gastone de' Medici in his letter to Apollonio Bassetti of 13 June 1690. ASF Med. Princ. 1533, *Diversi* (SPES 198).

111. This picture is in the possession of the Accademia della Crusca at Villa

di Castello. Francesco Saverio Baldinucci describes it in his biography of Piero Dandini (*Zibaldone baldinucciano*, Vol. 2 [Florence, 1981], p. 331).

112. ASF Med. Princ. 1526, *Diversi*, 9 December 1681, Baldinucci to Bassetti (SPES 177).

113. ASF Med. Princ. 1526, *Diversi*, 20 July 1681, Baldinucci to Apollonio Bassetti (SPES 176).

114. See n. 28 above.

115. ASF Med. Princ. 1526, *Diversi*, 19 December 1681, Baldinucci to Bassetti (SPES 178).

116. ASF Med. Princ. 1526, *Diversi*, 30 December 1681, Baldinucci to Bassetti. "Ill.mo Sig.re, Sig.re e P.rone mio Col.mo / Quando ebbi a condurre a Roma quel mio Angioletto per vestir l'abito della Compagnia lo condusse dal P.rone Ser.mo il quale gli comandò che nel pigliare il santo abito porgesse al Signore preghiere particulari per la persona sua. Fecelo egli e per debito di suddito e per il comando autone e per obbedire ancora a me, che strettamente e sopra d'ogni altra cosa glielo ingiunsi. Penso io ora che non dispiacerà a S.A.S. che io faccia partecipare all'A.S. le ottime nuove, che oltre a quello che ò avute sempre di esso mio figlio, sono stato mandato qua a questi Padri dal Padre Maestro di Novizi con l'ultimo ordinario, e sono queste, tolte ad verbum dalla propria lettera. / 'Il fratello Baldinucci alza grido fra questi novizi di uno Beato Stanislao, certo che compunge chiunque lo vede, strigato e pronto nelle sue cose, senza alcuno discioglimento, senza alzare un occhio, accorto in tutto. Dicono che parla coi compagni in modo, che infervora tutti, ed il suo esempio è di gran giovamento a tutti. Se si averà una mezza dozina di simili, benche il noviziato sia pienissimo, ed aviamo carestia di camere, ognuno farà loro volentiere luogo nella sua.' / Con questo auguro a V.S. Ill.ma buon principio d'anno ringraziandola del recapito della lettera al S. Tomansi laquale sorte il suo effetto e resto al solito. / Di V.S. Ill.ma / Firenze li 30 Dicembre 1681 / Divot.mo Serv.re Oblig.mo / Filippo Baldinucci."

117. ASF Med. Princ. 1527, *Diversi*, 6 February 1682, Baldinucci to Bassetti (SPES 179). The memorandum to which Baldinucci refers is no longer attached to the letter.

118. ASF Med. Princ. 1527, *Diversi*, 27 February 1682, Baldinucci to Bassetti (SPES 180).

119. See n. 117 above. The portrait was engraved by Arnould van Westerhout after Gaulli.

120. See n. 88 above.

121. The *Lettera di Filippo Baldinucci a Lorenzo Gualtieri fiorentino* was first published in 1765 in the *Raccolta di alcuni opuscoli . . . da Filippo Baldinucci* (Florence), pp. 97–104 and republished most recently in SPES 156. The *Lettera* is dated "19 gennaio 1681," which according to the old Florentine usage implies 1682 Roman style. Baldinucci refers to the works by Raphael that he saw in Rome and cites his "*Vocabolario dell'arte del disegno* dedicato a questa nostra Accademia della Crusca." Baldinucci did not arrange to dedicate the *Vocabolario* to the Crusca until July 1681. See n. 101 above.

122. *Notizie* 5, pp. 662–63.

123. The letter is published, undated, in Arckenholtz, *Mémoires concernant Christine reine de Suède*, Vol. 4, pp. 39–40.

124. *Diario*, p. 39, 4 April 1684. The repetition "e non altro e non altro e non altro" is expressed in the text.

CHAPTER FOUR

1. *La Veglia*. There was evidently some degree of official tolerance for pamphlets and other minor publications of an unthreatening nature. However, Filippo Baldinucci published the second edition of his *Veglia* in Florence (Piero Matini, 1690) with full formal approval. Also he discarded any pretence of anonymity, signing the initials F.B. at the conclusion of the text. In the Biblioteca Riccardiana-Moreniana in Florence is an annotated copy of the 1684 *Veglia* (DD12567). Many of the typographical errors of the first edition are corrected and a number of literary changes proposed. These correspond almost entirely with the textual variants in the 1690 edition. Some of Filippo's personal papers entered the Riccardiana, and the *Veglia* in DD12567 is most probably his personal, annotated copy. Baldinucci told Ruberto Pandolfini that he published the *Veglia* in Lucca to save expense. It is possible, however, that Filippo had the work printed outside the grand dukedom of Tuscany in order to avoid official formalities and save time, which was clearly of some importance to so topical a piece. It is clear, in any case, that in 1684 Baldinucci had an informal imprimatur from the granducal administration. Filippo acknowledges his authorship of the *Veglia* in the second installment of the *Notizie* (1686 edition, p. 55) and in the index under "Compagnia di San Luca."

2. The most easily accessible edition of the *Veglia*, and the one which I cite below, is found in SPES 181 (pp. 498–542).

3. *Notizie* 5, pp. 268–69. Baldinucci's drawing of Lippi is Uffizi 5687.

4. SPES 181, p. 500.

5. Ibid., p. 502.

6. Ibid., p. 506.

7. Ibid., p. 506.

8. *Vita di F.B.*, p. 23. The texts of five of Baldinucci's "*scherzi scenici*," written in a variety of hands, are preserved in the Biblioteca Riccardiana (3471, fols. 354–405). These texts are evidently close to the author's working copies, and often include the names of the performers as well as many specific references to the setting. In the Biblioteca Marucelliana (A176, fols. 44–61) is a very clean version of the third Riccardiana "*scherzo scenico*." These pieces were published a number of times in the nineteenth century in local Florentine journals and as occasional pamphlets to mark festive occasions.

These *scherzi scenici*, or *lazzi contadineschi*, as they are often called, merit further study for their literary, cultural, and religious content. Filippo's connection with both the Jesuits and Oratorians is interesting, considering the different philosophies of the two orders. The specificity of Baldinucci's stage directions would seem to indicate that he was personally involved in these retreats. Each of the pieces is headed "Da recitarsi in sul prato, e davanti alla

Villa de' Molto Reverendi Padri della Congregazione di San Filippo Neri posta a San Francesco al Monte, dai secolari nel giorno della ricreazione."

The third Riccardiana *scherzo* (and the Marucelliana piece) offers this carefully considered stage direction: "Si raguni la gente nel luogo solito ove si rappresentano simili cose in tal giorno; ossia si faccia tal ragunata in modo che nessun creda d'esser giuvi a tal effetto condotto, ossia ad ogni altra fine, fingendosi di portare, o tavola, o cosa simile per altro qualsiasi trattenimento, o di musica, o di suono, e mentre la gente aspetta a sedere in giro ogn'altra cosa, che tale rappresentazione, dalla scalina, che di verso le croce porta in sul prato, salga il contadino, che deve operare il primo, e salita la scala, si volti addietro fingendo di parlare con un suo ragazzo, che sia giù basso poco lontano, e con voce alta, che possa esser ben sentita dai ragunati, come sopra, dica. . . ."

It remains to be determined when Filippo composed these pieces and whether he wrote others as well. The names of the performers might offer some leads. In the third *scherzo* participants included Giuseppe Maria Bernardi, Filippo Maria Bernardi, Niccolò del Frate, Giuseppe Caselli, and Dionisio Franceschi. In the fourth the *interlocutori* are listed as Giuseppe Maria Bernardi, Bartolomeo Vanni, Anton Giani, Pier Luigi Carlieri, Filippo della Nave, Anton Morelli, Filippo Maria Bernardi, Giuseppe Maria Chiari, and Santi Grassi. Dionisio Franceschi's name is cancelled. Also cited in this text are Alessandro Valloni, Francesco Luci, Donato Logni, and Francesco di Rossellino. The following appeared in the fifth: Giuseppe Maria Bernardi, Filippo Maria Bernardi, Niccolò del Frate, Pier Luigi Carlieri, and Filippo della Nave.

9. SPES 181, pp. 514–16.

10. SPES 181, p. 517.

11. SPES 181, p. 526.

12. SPES 181, p. 527.

13. See Chapter Five for the republication of Ammannati's 1582 letter to the Accademia.

14. This "survival theory" for the Gondi Chapel has received some acceptance, for example, R. Diaccini, *La Basilica di S. Maria Novella* (Florence, 1920). In *The Dominican Church of Santa Maria Novella at Florence* (Edinburgh, 1902), J. Wood Brown discusses the matter at some length and concludes that the Cimabue story is in fact possible. Reverend Brown was evidently unaware of the seventeenth-century controversy on this point. More recent scholarship upholds a relatively early date for the choir chapels. W. and E. Paatz, *Die Kirchen von Florenz*, Vol. 3, pp. 663–845, present these chapels as the oldest portion of the present church, built between 1246 and 1279. The extant ceiling frescoes are dated around 1270 (p. 711).

15. SPES 181, p. 536.

16. Ibid., pp. 538–40.

17. This was the *Vita di Ammannati*, discussed in Chapter Five. See Baldinucci's letters to Bassetti in ASF Med. Princ. 1528, *Diversi*, 25 December 1683 and ASF Med. Princ. 1529, *Diversi*, 14 January, 1 February, 23 March, and 30 June 1684 (SPES 183, 184, 185, 186, and 187).

18. ASF Med. Princ. 1529, fol. 199, 22 January 1683/84, Ruberto Pandol-

fini in Florence to Apollonio Bassetti in Pisa). "Si compiace V.S. Ill.ma dar notizia a S.A.S. del pagamento seguito a Suor Maria Benedetta Zati delli ducatoni 100 pagatili a conto di quello deve la Ser.ma Casa alla redita della Sig.ra Contessa Zati, legatura di Madama Ser.ma Duchessa di Mantova, et insieme rappresentarli come gli eredi della predetta Sig.a Cont.a voglion risquotere il restante del credito, e rinvestirlo in luoghi di monte del sale, e di pietà, per la cauzione da noi chiesta, si che penso di far saldar il conto da Filippo Baldinucci, e ricognosciuto il resto del nostro debito darne parte a S.A. acciò ella si degni cometterne il pagamento al Sig.re Depositario Generale." Bassetti replies on 24 January (fol. 200, draft). "Aspetterò ora l'A.S. di sentire da V.S. Ill.ma quanto manchi doppo che il Sig.re Filippo Baldinucci havrà saldato il conto." On 29 January (fol. 201) Pandolfini notes, "Il Sig.re Baldinucci verrà a riconoscere il conto della Sig.ra Contessa Maria Zati, cosi contentandosi S.A."

19. Biblioteca degli Uffizi, MS. 264, March 1684, F. Baldinucci to Ruberto Pandolfini (SPES 182).

20. ASF Med. Princ. 1529, *Diversi*, 23 March 1683/84, Baldinucci to Bassetti (SPES 186). In Baldinucci's letter the name "co' MIGLIORI" is capitalized and underlined to emphasize the pun.

21. ASF Med. Princ. 1525, *Diversi*, 21 September 1679, Baldinucci to Bassetti (SPES 149).

22. Salvini, *Fasti consolari*, pp. 625–29. For Cosimo's brother Ferdinando della Rena, pp. 615–19. It is not clear from Salvini's entry which grand duke appointed Cosimo *Soprintendente* of the archives nor precisely what this position involved. Giovanni Cinelli describes the residence of Cosimo della Rena in his *Le Bellezze di Firenze* (Florence, 1677) pp. 276–88.

23. *Notizie* 1, p. 122.

24. Ferdinando Leopoldo del Migliore, *Firenze città nobilissima illustrata*, (Florence, della Stella, 1684), pp. 3 and 378.

25. C. della Rena, *Della serie degli antichi duchi e marchesi di Toscana. . . .* (Florence, 1690). He refers on p. xiii to "il sempre lodato Filippo Baldinucci," on p. 13 to "il diligente Filippo Baldinucci," and on p. 58 to "l'attento e studioso Filippo Baldinucci." Della Rena on p. 14 cites "Ferdinando Leopoldo del Migliore, illustrator indefesso delle memorie della patria, le quali porta tuttavia con molto aggradimento alla stampa." The implication here is that del Migliore still intended to publish further volumes of the *Firenze illustrata*.

26. There is a good deal of genealogical material on the del Migliore family in ASF Carle Sebregondi 3561–3567 (Famiglia del Migliore). On 3567 it is stated, "Vengano da Fiesole trovandosi il loro stipite così, Migliore di Giunta di Gianni di Fantinello Fiesolano. / Il ramo di Firenze si spense in Ms. Filippo di Antonio che era stato canonico fiorentino e che di poi prese moglie e lasciò una sua unica figliola chiamata Angelica e maritata nel 1618 a Agnolo Ginori. / Ne sono in Napoli i quali per due decreti del Magistrato dei Consiglieri, che uno del 1642 e l'altro del 1701 sono stati dichiarati di questa stessa famiglia del Migliore che ha goduto il Priorato procedenti dallo stesso stipite del detto Ms. Filippo di Antonio."

On folder eight the following summary is offered, "Nel cittadinario detti *Migliori* / Cittadini fiorentini, San Giovanni-Drago. / 5 priori di Libertà dal 1394 al 1440. / 6 dei XII Buonuomini dal 1348 al 1466 / 8 dei XVI di Compagnia dal 1384 al 1449. / 1 dei XVI di Compagnia 1529 / Dichiarato degli antichi. / Estinti nel 1618—eredi i Ginori—Patrizi Fiorentini."

In his *Genealogia e storia della famiglia Ginori* (Florence, 1876), L. Passerini shows on table nine, "Angiolo (1587–1644) m. 1618 Angelica di Filippo del Migliore erede di sua casa."

Amidst the hundred forty volumes of historical material left behind by Ferdinando Leopoldo del Migliore and his nephew Giovanni Battista is a family tree extending till the mid-eighteenth century. Ferdinando Leopoldo's descent from the Neapolitan branch is clearly expressed. His great-grandfather was Antonio, his grandfather Francesco, his parents Giovanni Battista del Migliore and Caterina Vanni. He had a brother Giuliano (the father of his collaborator Giovanni Battista) and other evidently unmarried siblings, Abbot Francesco Maria, Anna, Claudia, and Margherita. Ferdinando Leopoldo is succinctly described as "scrittore fiorentino" and no dates are offered. In his generation the preponderance of Medicean names is conspicuous. BNCF XXV 397, fol. 19.

27. While discussing Baldinucci's numerous failings, Giovanni Cinelli refers to "Quel suo commilitone, e fidissimo Acate Migliori non del Migliore, che si vuole questo cognome d'una spenta famiglia usurpare." *Lettera dell'Anonimo d'Utopia a Filalete*, BNCF Magl. XVII 22, fol. 24ʳ. In his discussion of Ferdinando Leopoldo in his *Scrittori toscani* (or *Toscana letterata*) Cinelli notes, "Intorno alle famiglie senza voler sapere s'è sia Migliori or del Migliore, avvenga che questa è molti anni sono spenta, e la lor casa in Via Larga, che per decreto del Magistrato Supremo, fu l'anno 1646 venduto al Cavaliere Guidacci, ov'era quella famosa Pomona del Pontormo, che si li fu levata, e nella Casa Sani in via del Cocomero trasportata." For Cinelli's *Toscana letterata*, see n. 83.

28. Giovanni Cinelli elaborates his description of del Migliore as "senza lettere." "Dico senza lettere, perche usando il Migliore la veste e tonsura clericale, non è mai potuto per non averne principio, arrivare a gl'ordini sagri. Se però non vi fussi giunto doppo la mia partenza dalla patria che fu ne 8 Maggio 1683." BNCF Magl. IX 66, fol. 447.

29. In BNCF Magl. XXVI 147, fol. 85 is a document dated 6 October 1664 granting the Chapel of Saints Thomas Aquinas and Lucy to "R.D. Ferdinandi Leopoldi del Migliore clerici nob. floren." See also fol. 89.

30. Del Migliore left a long and detailed description of the Florentine Church of San Jacopo sopr'Arno in manuscript. BNCF Magl. XXV 403, fols. 153–182. He refers to the church in third-person plural possessive forms ("ours," "to us," "we hope") and demonstrates a close knowledge of the chapter's customs, patrons, and prerogatives. In BNCF Magl. XXVI 147, fol. 84 is a document dated 16 April 1701 referring to a suit between Giovanni Battista del Migliore and the fathers of San Jacopo in the archepiscopal court in Florence. It concerned "la cappella della natività posta nella loro chiesa posseduta

già dal Signore Ferdinando Leopoldo del Migliore suo zio, contro del quale per detto conto vanno creditori di gran somma."

31. Del Migliore signs the errata sheet to his *Firenze illustrata* as "Accademico Apatista." The errata sheet was probably not printed before 1685, and it is somewhat surprising that he fails to cite this academic distinction on the *Firenze illustrata*'s 1684 title page or elsewhere in the book that I have seen.

32. *Senatori fiorentini raccolti da Ferdinando Leopoldo del Migliore*, published in Florence by the "Stamperia di Sua Altezza Serenissima" in 1665. This ninety-page ottavo volume has some pretensions in format and presentation. There is an etched frontispiece featuring the Niccolini arms and a dedication to Filippo Niccolini, Marchese di Ponsacco. Otherwise there is no text, only one hundred forty-nine coats of arms of the senatorial families and lists of the senators with their dates of election.

33. This massive collection of material is in the Florentine Biblioteca Nazionale, where they keep an inventory in the manuscript room (catalogue nineteen, *Spoglio degli zibaldoni del Migliore*).

34. In BNCF Magl. XXVI 147, fol. 93ff. are a variety of undated rough drafts of appeals to "Sua Altezza Reale," probably Cosimo III or even Gian Gastone. Giovanni Battista del Migliore requests patronage positions and describes the hardships he incurs in professing "l'arte dell'antiquario."

35. BNCF Magl. XXVI 147, fol. 1 is headed "Illustrazione alli studienti antiquarii sopra i libri della Gabbella de' Contratti di Ferdinando Leopoldo del Migliore fatta l'anno 1697." On fol. 3 he offers a very rare statement about himself, "Io Ferdinando Leopoldo del Migliore dopo aver veduto quasi tutti gli Archivi Publici di Firenze e Privati di monache e frati e particolarmente quello delle riformagioni importantissimo mediante per esservi notati tutti i decreti della Signoria ed ogni altra cosa appartenente alla Republica che è la Nuova legge municipale, li stetti gran tempo eccetuato questo della Gabella non trova dove appagara la mia curiosità in ordine a queste materie, dove sono dimorato, intervendovi mattina e sera più di dieci anni."

36. Del Migliore, *Firenze illustrata*. The title page is dated 1684 and the dedication to Francesco Maria de'Medici is dated 24 December 1684. The *approvazioni* are undated.

37. Ibid., p. 2.

38. In addition to the evident guidebook format of the *Firenze illustrata*, Giovanni Cinelli cites its connection with the *Bellezze di Firenze*. See n. 98 below.

39. For the important genre of nobility literature see G. Previtali's, "La Controversia seicentesca sui primitivi," *Paragone* 10 (November 1959), esp. pp. 6–7. For the Tuscan context Diaz, *Il granducato di Toscana*, pp. 199–229 and pp. 422–63.

40. Del Migliore, *Firenze illustrata*, p. 327.

41. Ibid., "Origine di Firenze e sue qualità," first page of unnumbered preface.

42. Ibid.

43. Ibid., "Origine," fourth page and p. 423.

44. Ibid., p. 18.

45. Ibid., pp. 414–15.

46. Ibid., pp. 415–16.

47. Ibid., p. 416.

48. Ibid., p. 417.

49. BNCF Magl. XVII 22, fol. 8r. Cinelli notes in regard to Baldinucci's statement in the *Apologia* (*Notizie* 1, p. 36) about applying to experts for assistance, "Confesso anch'io questo axioma, e non risponderei *nec verbum quidem*, se non si fussi il Baldinucci andato vantando, che quanto alle cose istoriche ne sapeva più di me: come il suo fedelissimo Migliori che dice ch'a scriver d'antichità tocca a lui che n'è maestro, e gli altri non se n'intrighino: Questo si sa per i boccali che per non saper leggere benche vesta di lungo, non è mai alla dignità sacerdotale potuto giugnere, e quanto alle materie istoriche confesso esserne del tutto ignorante, perche non le leggo, ma scorrendole non vi à necessità di filosofia per intenderle, ed avendo un po di memoria presto presto pratico di esse si doventa."

50. Diaz, *Il granducato di Toscana*, pp. 363–71.

51. Del Migliore, *Firenze illustrata*, p. 506.

52. Ibid., pp. 157–87, Collegiata di San Lorenzo, and pp. 198–205, Palazzo Medici. Among the inglorious episodes of Medici history, del Migliore describes on p. 25 the victory of Cosimo I "contro a' suoi propri cittadini rebelli," p. 42 the "congiura dei Pazzi," and pp. 201–2, the sack of the Palazzo Medici by the French under Charles VIII.

53. ASF Med. Princ. 1530, fol. 137v, 25 May 1685, Ruberto Pandolfini to Apollonio Bassetti: "Dissi a questi giorni a V.S. Ill.ma, ch'averei desiderato di sentire i sua prudentissimi sentimenti circa il passare o non passare alcune espressioni, che si fanno da chi mette alla stampa. Venendo adesso al particolare, resti V.S. Ill.ma informata, ch'il S.re Ferdinando del Migliore manda alla stampa, anzi ha mandato dice lui, con permissione del S.re Mercatti, un opera intitolata *Firenze Illustrata*, nella quale, doppo avergli fatto levare alcune cose notoriamente non tollerabili, sto in dubbio, se anco queste, che li mando, vadino rimosse; Parendomi, quanto alla prima va apposta senza necessità, et in tempi incongrui rinfrescando la memoria del poco rispetto, portato dalla pazzia del popolo, agl'antenati della Serenissima Casa, massime constituiti in quella sublimità di stato sacrosanto. Quanto alla seconda, se bene l'azioni espresse sono sommamente plausibili, e portate anco con ogni decoro, a me non pare, che quelle del Ser.mo P.rone si ristringhino a termini così angusti, e che la reverenza e ammirazione dell'operazioni del principe regnante, resti meglio conciliata, et impresa negl'animi, senza restringersi a particolari, massime quando se ne parla come passaggio, parendo, che l'inclusioni di questi, sin una tacita esclusione degl'altri, che a mio giudizio sono più segnalati, e degni di mandarsi ad eterna memoria. Sottopongo queste mie osservazioni al suo prudentissimo giudizio, protestandomi di voler quello onninamente seguitare, e perciò la supplico del suo purissimo sentimento."

The name of "Matteo Mercati Avvocato di Sua Altezza Serenissima" fre-

quently appears among the *"approvazioni"* of books printed in Florence. Giovanni Cinelli acknowledges his assistance on p. 21 of the *Bellezze di Firenze*.

54. See n. 25 above.

55. Del Migliore was still alive in 1697 (see n. 35 above). Though Ferdinando Leopoldo might have turned his chapel over to his nephew during his own lifetime, the document of 16 April 1701 (n. 30 above) is more likely to refer to the settlement of his estate.

56. The *Reflessioni e aggiunte alle "Vite de' pittori" di Giorgio Vasari* (BNCF II IV 218) presents a collection of material in varying degrees of completion and legibility, ranging from rough drafts to random notes on slips of paper. In the library of the Uffizi (MS. 55) is a compendium of material that Luigi Scotti collated from del Migliore's manuscript in 1835. Scotti describes his undertaking on pp. 128–29. Paola Barocchi discusses the *Reflessioni* in "Le Postille di del Migliore alle *Vite* vasariane," in *Il Vasari Storiografo e Artista* (Atti del Congresso internazionale del IV centenario della morte) (Florence, 1974), pp. 439–47.

57. Del Migliore, *Reflessioni*, BNCF II IV 218, fols. 2v–3r (misbound) "Gli è vero che l'imperio Romano declinò, ma non venne meno affatto si che il dir che venisse meno di forze tali da sommercer in tutto e per tutto ogni buon arte è un assurdio intollerabile. Il danno dell'oscurare la pittura, la scultura e l'architettura non derivò dalla declinazione dello Imperio, e chi lo dice erra indignosso mostrando di non sapere la scienza radicata in un popolo in un sol caso potersene oscurar l'eccelenza e ridursi all'estremo e questo è quando in'un paese subentra gente di diverso costume che eziandio, sto per dire, le leggi nuove sovertendo le vecchie danno in ogni faclutà e scienza soversione notabile si che apoco apoco ogni cosa si riduce uniforme all'uso che corre e si pratica: fino alla venuta dei Goti in Italia l'arti di cui parliamo stettero nel suo essere senza contaminazione veruna. Ma dipoi variatosi del tutto i costumi, i riti e le leggi, ed ogni cosa divenendo diversa da quella de Romani convenne che anche l'arte, il disegno, e'l modo del dipignere, dello scolpire e del fabbricare si riducesse alla fine allo stile tenuto da quella barbara nazione che fu molto alieno dal nostro e di questo non occorre dubitare, persistano ancora le fabbriche lequali fatte ne' tempi de' Goti e Longobardi non sono in verun conto da lodarsi diversificando in tutto e per tutto dalle buone regole antiche de' Romani e così la scultura e la pittura patirono il medesimo naufragio. Con tutto ciò un modo di dipignere, di scolpire e di architettare sempre perseverò e stette in Italia e massime nelle città principali come fu per dire il vero in Firenze sempre stata madre e nutrice d'ogni buon arte. Che questo stile e [modo] dipignere e scolpire fosse cattivo, barbaro e deforme, non si può negare sul evidenza dell'operazioni antiche che persistono ancor oggi, basta il far conoscere a chi legge che la nostra maniera non è greca ne dalla grecia s'è ripigliato il modo del dipignere e dello scolpire ne meno dell'architettare declinato lo imperio Romano superato e vinto da' Goti e Longobardi."

58. Ibid., fol. 15r. "Dove puol aver veduto il Vasari un decreto della Signoria di Firenze per cui si deliberasse di chiamare pittori greci a dipignere in Firenze. L'avrà sentito dire e cavò la novella che la nonna racconta al nipote la

sera a veglia. Le scritture delle Riformagioni per lequali si vede giù giù per ordine ogni atto fermato per decreto del senato non passava l'anno 12[o]2 incirca, di dove dunque e da qual testo più autentico lo puol aver egli cavato? E se si trovasse puol egli mai dire per rimettere in Firenze la pittura piutosto perduta che smarrita? Avrebbe più del verosimile se ciò fosse seguito per capriccio e non per necessità avutoli, piacendo tal volta più l'opere de' forestieri che quelle de' propri cittadini, essendosi veduto a' nostri tempi un Pietro da Cortona, un Giordano da Napoli e moltissimi altri essere chiamati a dipignere in Firenze, in tempo che la città abbondava di professori eccelenti."

59. Ibid., fols. 6–9. This sequence of thought, passing from *San Bartolommeo inter dipintores* to the academy, is clearly a response to Carlo Cesare Malvasia's derogatory comment on pp. 14–15 of *Le Pitture di Bologna* (Bologna, 1686), which Malvasia follows with an exposition of the historic nobility of this art in Bologna. In fact del Migliore makes a gracious reference to Bologna at his point of transition. "Qual sarà la nostra consequenza se non questa, che in tempo così scarso di pittori Firenze come madre ben si meritasse quel titolo, che oggi porta Bologna con tanta acclamazione nutrice degli studi di Florencia docet nella pittura . . ." (fol. 6v).

60. Ibid., fol. 53r. "Per la scrittura citata di sopra et altre publiche ancora Bondone padre di Giotto fu figlio d'un Francesco da Vespignano, castello già situato nel contado di Firenze il quale havendo prodotto molte famiglie nobili e generose e fra esse il Conte Stefano nato d'un altro Conte Stefano, che forse è l'antico ascendente alla famiglia de Bruni di [Ser Santi], non sarebbe gran fatto che Giotto fosse uscito da una di queste schiatte, tutto diverso il suo natale, da quel che se le figura l'autore, da Bondone contadino guardian di pecore vilissimo che par favola. Concedo che ogni spirito non nato nobile possa divenire generoso, abile a poter far gran cose, ma per lo più l'adattarvisi con vantaggio proporzionato segue in quegli che tragon l'origine da sangue dirozzato e di lunga mano aggentilito, a quali non è gran fatto divenire eccellenti, che ne' suggetti nati di bassa condizione si reputa maraviglia." Del Migliore continues to describe a document of 1220, citing Giotto's father as *preclaro*, a title not given to peasants.

61. Biblioteca degli Uffizi, MS. 264, March 1684, F. Baldinucci to Ruberto Pandolfini (SPES 182).

62. See n. 27 above.

63. See n. 49 above.

64. Giovanni Cinelli often carried his mother's family name of Calvoli; thus he is sometimes listed as Giovanni Cinelli Calvoli or even Giovanni Calvoli. The principal body of information on him is the entry by G. Benzoni, "Giovanni Cinelli Calvoli," in *Dizionario biografico degli italiani* (Rome 1981), Vol. 25, pp. 583–89. Dionigio Sancassani included a biography of Cinelli in his cumulative edition of the *Biblioteca volante* (Venice, Albrizzi, 1734–1735), pp. ciii–cxliii. The various *scanzie* of Cinelli's *Biblioteca volante* contain a good deal of autobiographical commentary. Cinelli lists himself in the *Toscana letterata*, BNCF Magl. IX 66, pp. 719–26.

65. Cinelli, *Biblioteca volante*, Sancassani ed. (1734–1735), p. civ (see n. 64 above).

66. Cinelli was married twice, first to Giulia Gucci in Pisa in 1651, who died in 1656 after bearing four children, and then to Eufrasia Carsughi, who bore him others. Among the various scandals that attached themselves to Cinelli's name was that of being a neglectful and abusive husband and father. When he fled Florence in 1683, he is held to have abandoned a paralyzed wife and seven or eight children, the exact number of which he was himself uncertain. Benzoni, "Giovanni Cinelli Calvoli."

67. Cinelli's movements are often difficult to ascertain. Even in the two decades that he was apparently based in Florence from sometime in the 1660s to 1683, it is not clear that he resided there without interruption.

68. Benzoni, "Giovanni Cinelli Calvoli," pp. 583–84.

69. In ASF Bartolommei 226, fol. 230v are records of payments "al Signore Dottor Cinelli" dated 16 September 1662 and 22 January 1663/64. In ASF Bartolommei 229, fol. 65v are thirteen payments between 15 January 1665/66 and 27 April 1667. There are six more payments recorded on fol. 98v, from 14 May 1667 to 26 October 1667.

70. Benzoni, "Giovanni Cinelli Calvoli," pp. 584–85.

71. Cinelli claimed that the manuscript of Bruni's *Vite* was in his own library. The Malatesti *Polifemo* belonged to Antonio Magliabechi.

72. Leopoldo de' Medici entrusted Paolo Minucci with the preparation of an authorized first edition of the *Malmantile*, which did not appear until 1688. In his 1676 edition Cinelli discusses the opposition he encountered, which resulted in the destruction of most of the first printing. Ferdinando Leopoldo del Migliore and Filippo Baldinucci's objections to the *Bellezze di Firenze* are discussed below. It is interesting to note that Cinelli's first edition of Bruni's *Vita di Dante* (Perugia, 1671) was followed the next year by an edition published in Florence.

73. The *Vita di Dante* (1671) was published in Perugia, the second edition (1678) of *Bellezze di Firenze* in Pistoia, and the third (1685) and fourth (1682) *scanzie* of the *Biblioteca volante* in Naples.

74. This description appeared on the title page of both the 1591 and 1677–1678 editions.

75. See n. 73 above.

76. Cinelli, *Bellezze di Firenze*, p. 30.

77. Ibid., author's preface.

78. Ibid., p. 493.

79. In *scanzia* 7 of the *Biblioteca volante* (Parma, 1692), pp. 31–34, Cinelli offers a full description of Magliabechi's position in response to Domenico Guglielmini's *Illustr. et Cl. Viro Antonio Magliabechio Sereniss. Magn. Ducis Etruria Bibliothecario dicata* (Bologna, 1684): "Il titolo di Bibliothecario del Gran Duca di Toscana che ha il Sig. Magliabechi, è stato in un certo scartafaccio per non dir peggio, dicendo suo vero nome (stampato alla macchia, perche in alcun modo non sarie stato permesso), contrastato e messogli in forse con tali parole: 'Redde nomen hoc cui debetur Illustrissimo scilicet clarissimoq;

viro satis nunquam laudato'; Quanto di livore sia in queste parole ben lo conosce chi legge; Io non so chi meriti più il titolo di *satis nunquam laudato*, se quello di cui il nome non è mai uscito dalla propria casa, o di quell'altro a cui, oltre la notizia che si ha di lui per tutta Europa, son stati dedicati tanti libri, come altrove ho detto, che se ne può di que' soli fare una ben copiosa libreria; ma favellando del Titolo controverso, vede ogni giorno il Gran Duca esser questo replicato, nelle soprascritte delle lettere, de' fagotti, e d'ogni altra cosa indritta, a quel grand Uomo, oltre il vederlo stampato ne' frontispizi di tanti libri, ed in tanti componimenti che ogni dì gli piovono, per così dire a casa; Ha di più S.A. incominciata la sua vaga e copiosissima Libreria, tanto d'Arabi libri ricca, sotto la direzione e sopraintendenza del medesimo Signor Magliabechi; esso ne ha le chiavi, e niuno senza di lui, toltone il solo guardaroba ha facultà di potervi entrare, ne senza la sua assistenza si mostrano le Pandette, che sono in Guardaroba di palazzo vecchio. Ha il Sig. Magliabechi le stanze per la sua abitazione sopra la medesima Libreria nel Real palagio, dalle quali per le scale segrete penetra nelle camere di S.A. senza altro portiere ed il medesimo Sig. Antonio è assegnato uno staffiere del Padron Serenissimo, che di continuo gli assiste senza obbligo di far altro; Ha l'annuo stipendio dalla camera di S.A. che lo dichiara tale, Or chi è dunque il Bibliotecario? Mandi un poco chi pretende tal titolo, a veder la libreria qualche forestiero, e vedrà se senza il Magliabechi li sarà permesso." Cinelli also includes a sonnet addressed to Magliabechi by a Signor Benotti.

80. BNCF Magl. VIII 636, fol. 4. This draft, which is found among Cinelli's letters to Magliabechi, is laid out like a letter and bears the semilegible salutation "R.mo P.re [space] [Aldini?]." It is undated. In my translation the paragraph indentations are arbitrary, though I think in keeping with the very clipped, highly mannered "stoical" tone of the piece. See n. 97 below for a possible reference to this Aldini.

"Eccomi a servirla di quelle notizie che de' nostri viventi parmi si possino dire, e prima

Antonio Magliabechi Bibliotecario, ecc., viva miniera d'erudizione e di fioritissima dottrina: Poiche oggi giorno que pochi che studiano in queste nostre parti che sono rarissimi e per lo più non anno che una semplice orpellatura o per accumular monete o per giugnere ad onori bramati il fanno, cosa che nel Magliabechi non è perche non solamente non brama, e non cerca cariche, ma lo stipendio che da S.A. riceve, oltre le proprie entrate tutto in merce letteraria spende e consuma ogn'altra spesa come superflua regettando: Egli si può dir vero letterato, per che d'altra materia non favella giammai, e tutta la coltura della persona e de comodi agli altri lasciando tanto gode e trionfa quanto scartabellando libri perpetuamente fra gli studi sepolto rimane: Feste non l'allettano, spettacoli non lo tirano, novità fuori che letterarie non lo muovono; Ad esso come miniera inesausta ed abisso profondo di scienza tutte le penne de' letterati d'Europa e per consiglio e per erudizioni, e per notizie e per censure ricorrono: Oh quanto in questo proposito io che gli sono intrinseco servitore dir potrei, se la reverenza e'l rispetto dovuto a chi di sue fatiche talor si veste non m'annodasse la lingua: Un solo libro ch'è sotto il torchio ha ricevuto da

esso sessanta fogli di correzzioni e addizzioni e queste currenti calamo scritte. Quaranta fogli di censure ad un libro che nominar non mi lece, riceve in otto giorni un porporato, e queste oltre l'esser extemporanee fino in cento volendo d'accrescer promesse: Un gran letterato mandò a S.A. un libro per che riveder il facesse, come dandolo al Magliabechi fece acciò l'ammendasse, al quale diss'egli: Serenissimo quanti errori vuol V.A. che io trovi cento, duecento, mille? Non rispose il Padrone cento bastano, e questi in due soli fogli esser mostrogli, ancorche il libro o sia uscito, o sia per uscire alla luce senza maggior correzzione; Ha più scritto egli solo, ancorche ne pure un periodo vada sotto suo nome alle stampe, che non an fatto la metà de gli scrittori fiorentini e amico de veri amici, ed a porger benigni uffici per altri sempre dispostissimo: Non ambizioso o vano, ond'è che molte volte dal Coltellini, dal P. Boselli, dal Dr. Toppi e da molti altri, ha d'esser nominato nelle loro opere rifiutato e ricusato. Molti scritti d'uomini dotti anno per mezzo suo gli benefici delle stampe goduto, e benche egli non abbia stampato darà di [qualsivoglia materia] in un sol giorno un trattato."

81. Apart from a few frequently repeated anecdotes, there is remarkably little information in print about this very important figure. See Diaz, *Il granducato di Toscana*, pp. 507–10, and E. Cochrane, *Florence in the Forgotten Centuries* (Chicago, 1973), pp. 267–68, 539–40.

82. For Magliabechi's personal interest in the *Biblioteca volante* and the *Toscana letterata*, see n. 135 below.

83. Cinelli's *Toscana letterata* fills three large codices in the Florentine Biblioteca Nazionale. The authors are arranged in alphabetical order by first name. The first two volumes (Magl. IX 66 and 67) cover Florentine writers and the third (Magl. IX 68), those from elsewhere in Tuscany. Anton Maria Biscioni added fourteen "supplementary" volumes and an index (Magl. IX 69–83). In 1979 a very useful *Indice onomastico* was published by Giovanni Presa (Milan, Università Cattolica) in the series "Vita e Pensiero".

84. Cinelli, *Biblioteca volante, scanzia* 18, p. 143.

85. Cinelli, *Biblioteca volante*, Sancassani, ed. (1734–1735), p. cvi.

86. Cinelli, *Biblioteca volante, scanzia* 16, pp. 8–9.

87. Cinelli, *Biblioteca volante, scanzia* 1, p. 7.

88. In fact, the fourth *scanzia* was printed in Naples in 1682 and the third also in Naples, but three years later in 1685. There are many intriguing questions about Cinelli's publication practices, including why he issued the *scanzie* of the *Biblioteca volante* in so many different cities. This might have been part of a scheme to call himself to the attention of publishers all over Italy. Also, considering his limited financial resources, he might have printed his works wherever he could make a special deal. The Biblioteca Riccardiana-Moreniana in Florence has a very nearly complete set (missing only the third *scanzia*) of the eighteen evidently compiled by Cinelli himself. These are annotated by Anton Maria Salvini, often with well-informed and very topical comments.

89. Cinelli used the *Biblioteca volante* in a very free and very personal way. In fact, Dionigio Sancassani took Cinelli's first-person statements there as a principal source for his biography.

90. In a copy of the fourth *scanzia* in the Biblioteca Riccardiana-Moreniana is the following note by Anton Maria Salvini, "Delle venti scansie componenti la presente raccolta è questa la quarta ed è la più rara per essere stata come libello infamatorio bruciata in Firenze per man del Boia nel Palazzo del Bargello a suon di campana sotto il Governo del G.D. Cosimo III."

91. Cinelli, *Biblioteca volante, scanzia* 4, pp. 14–15. The bewildering verse reads, "Da poi che non sete ito nell'Avello / Ser Pippo mio e l'alma avete ancora / Che tien troppo a disaggio Farfarello."

92. Cinelli, *Biblioteca volante, scanzia* 4, pp. 56–57. The ostensible point of contention is the correctness of the word *listra* rather than *lista*.

93. *Notizie* 1, pp. 74–75.

94. Three distinct works are mixed together in the eighty-five leaves of BNCF Magl. XVII 22. There are two complete and one partial draft of Cinelli's *Lettera dell'Anonimo d'Utopia a Filalete*. This is a direct response to the *saggio* of Baldinucci's *Notizie*. In the second draft (fol. 32ᵛ) Cinelli refers to "questo anno 1681." See n. 123 below.

On fols. 64–73 is a draft of another piece, primarily answering Baldinucci's *Vita del Bernino* of 1682. There is a reference on fol. 65ʳ to "alcune indecentissime righe scritte in un tale scartabello in carattere silvio," presumably a garbled allusion to Baldinucci's *La Veglia: Dialogo di Sincero Veri* of early 1684, Silvio being a more expected pseudonym than Sincero. On fol. 67ʳ, Cinelli refers to del Migliore's *Firenze illustrata* that "egli compone ora." The most reasonable assumption is that the first (and as it happened, only) volume was yet to appear. The *Firenze illustrata* is dated 1684 on the title page, but in the spring of 1685 the censorship problems had yet to be resolved. In fact we don't know precisely when the *Firenze illustrata* was first distributed. There is also the possibility that the work appeared already and the reference "egli compone ora" was meant to indicate the volumes yet to come. Since Cinelli fled Florence in May of 1683, his information might not be absolutely current.

On fols. 74 and 75 is a draft of a highly defensive genealogical discourse on the Cinelli family. This is quite probably a reply to Bertolini's *Io. Cinelli et . . . Magliabechi vitae*, published in Siena in 1684.

95. Prospero Bernardi was a prolific scholar and author, particularly on subjects relevant to the Servite order. He was also a major patron of the Santissima Annunziata in Florence. His benefactions are described in *Il santuario della Santissima Annunziata di Firenze* (Florence, 1876), written "da un religioso dei Servi di Maria," see esp. p. 73 for his adornment of the choir, p. 119 for his rebuilding of the Cappella dell'Assunta, and p. 122 for his decoration of the Cappella del Beato Giovacchino Piccolomini.

Cinelli lists Prospero Bernardi in his *Toscana letterata* (BNCF Magl. IX 67, fol. 1533): "*Prospero Bernardi* servita teologo e buon uomo, ma perche nelle *Bellezze* nel nominar più d'una volta, ed egli se l'ebbe per male, si vendicò meco, perche citando le *Bellezze* disse dell'edizione del 1591 nella sua *Apologia* stampata in Pisa." The *Apologia* to which Cinelli refers might well have been the motive for their visit to Baldinucci. Cinelli cites the work as "Apologia contro l'opinione di quelli che dicono l'immagine della Nunziata di Firenze

essere stata dipinta da seguaci di Giotto, fra quali fu Pietro Cavallini. Pisa 1679, in foglio, il cui compendio è ristampato in Roma nel Giornale terzo de letterati per il Tinassi." Bernardi is cited in *scanzie* 7 and 16 of the *Biblioteca volante*.

96. BNCF Magl. XVII 22, fols. 65ᵛ–66ʳ. "Sono oltre 22 anni che praticando la casa d'un Cavaliere imparai a conoscer Filippo Baldinucci, computista e ris-quotitor di quella come di molte altre, e lo tenni sempre, e l'ho tenuto fin'ora nella mia mente in concetto d'amico e di buon uomo, quantunque poi l'oper-azione e la riprova m'abbin mostrato il contrario, e lo stimai mio confidente allora, che per suo diporto volle fare il mio ritratto a matita rossa e nera, per metterlo con alcuni altri ch'egli avea fatti di vari personaggi cogniti della città, che appresso di se per istudio conserva, ond'io vedendomi favorito, cercai giusta mia possa rendergli qualche dimostranza di dovuta corrispondenza nelle mie Giunte alle Bellezze p. 493 con la moglie nominandolo. Ma questa fatica ha riportato per premio molti nemici fra' quali uno è stato il Baldinucci e principai ad accorgermene allora, che andato a casa sua col P. Mro. Prospero Bernardi Servita, che domandava alcune notizie intorno alla Nunziata, cavato egli fuori uno scartafaccio di indigesta materia dell'opera delle Notizie che compilava, e lettoci pochi versi, perch'io con confidenza volsi pur l'occhio su lo scartafaccio che ci masticava, coperse con una mano lo scritto perch'io non potessi leggere, dalla quale azzione la diffidenza di lui compresi e ritirandomi indietro altro di suo mai più veder volli. Nel tempo ch'io stampava Le Bellezze mi sovviene che meco discorrendo sopra di ciò m'essagerava et esortava a non dar giudizio, e questo perche con esso che si tien per lo più intendente uomo del mondo nelle cose di pittura io non mi consigliava, e molto bene n'avea giusta cagione, avendo lo sempre tenuto per computista, facitor di conti, e soprintendente dell'altrui azienda in case particolari, non per pittore o scultore, ne' quali casi a' professori più intendenti mi sono appoggiato."

97. BNCF Magl. XVII 22, fols. 66ᵛ–67ʳ. "Stampava il Baldinucci le Notizie de' Professori del Disegno, ed il giorno avanti ch'uscisse l'opera, che vastissima e' chiama, alla luce, mi fa domandar da persona sua confidente, come quello che sapeva il velenoso cuore e ch'a guisa del serpe avea due lingue, se era vero ch'io gli scrivessi contro, al questo in questa forma risposi: Bisogna Signor mio confessare che fra la gente vi è de' maligni, e de' seminatori di discordie, non solo io non farei tal opera, ma ne meno mi è mai nella mente tal concetto caduto. Stimo il Baldinucci amico, me gli confesso anzi obbligato, che non scrive materia dalla mia opera degli scrittori differente, questa come più uni-versale non ha di che invidiar la sua nella nobiltà, andrà la mia forse per tutta Europa o almeno Italia, la sua non uscirà di Toscana, e quando sopra la stessa materia scrivesse ogn'uno s'aiuti. Io non sono il Migliori che va borbottando, e lamentandosi ch'io gli ho guastato l'opera, quand'io ho ristampato un libro composto più di cento anni prima ch'e' nascesse ed egli compone ora. [*In margin*: Dico più di cento anni perche nella libreria Strozzi ho trovato due MS. d'incerto intitolati le Bellezze di Firenze, ed avanti il Bocchi, l'avea P.re Francesco Albertini ad instanza del Papa date alla luce sotto nome di Bellezze e Magnificenze di Firenze nel 1510 in quarto.] Anche il dottissimo Padre Aldini

Giesuita compone un'opera simile alla mia, ed io gli partecipò i miei scritti, e gli somministrò di questa città le notizie." This Padre Aldini might be the recipient of Cinelli's encomium of Magliabechi. See n. 80 above. Albertini's book is in fact *Memoriale di molte statue e pitture nella città di Firenze*.

98. In his "Introduzione fatta al Priorista del Buini" (BNCF Magl. XXVI 144, fols. 128ᵛ–129ʳ) del Migliore wrote, "Ma se alcuno leggendo questo nostro discorso intitolato [le bellezze di firenze—*cancelled*] [firenze illustrata—*written in*] applicherà la considerazione a quelle cose che in essa si raccontano."

In the *Toscana letterata* (BNCF Magl. IX 66, fols. 447–54) Cinelli begins his entry, "*Ferdinando Leopoldo del Migliore*: Scrittore d'antichità moderna e moderno antiquario di nostro secolo col quale in questo luogo peroche dalla sua lingua e penna quanto è trafitto voglio alquanto discorrere. Feci ristampar nel 1677 le Bellezze di Firenze del Bocchi alle quali posi alcune giunte di cose, o dall'autore non dette, o state erette dopo lui. Componeva il Migliori la sua Firenze illustrata e n'aveva affisso il titolo MS. per tutti i chiapuoli due o tre anni prima ch'io ristampassi. Andavo questo esagerando per tutte le botteghe, e con chiunque, favellava che le Bellezze di Firenze le faceva lui, e non io. Queste sue Bellezze non ne sono ch'io sappia vedute ancora, e talmente s'affaticava, e riscaldava in questa sua ipocondria che fino una mattina me ne fece sfacciatamente una smargiassata sotto al condotto in testa allo stradone delle stalle ove si giuoca al maglio che se non eramo separati, ancor ch'io fussi senz'arme venivamo alle mani. Io ristampavo un libro impresso cento anni prima con quel titolo, ne l'alterai un iota, solo giungendosi, *da me ampliate ed accrescuite*, e che impaccio davo io alla sua operazione da questi argumenti chi ha discretezza ciocchè si può giudicare."

99. BNCF Magl. XVII 22, fol. 67ʳ–67ᵛ. "Il giorno seguente uscè il libro ed a pena è fuori che tre amici m'avvisano che v'è la mia stafilata: Io nol credetti però fin tanto, che con gli occhi propri da per me stesso non lessi e riscontrai le proprie parole portate da esso a bello studio in differente carattere. Stordii di sua temerità, del modo sfacciatissimo di trattare, e dell'ardimento ch'e' si piglia da cattivi consiglieri esortato a favellar in tal forma. E se prima l'ebbi in materia di disegno in qualche concetto, conobbi che m'ero grandemente ingannato, perche difendendo tal figura, o lo fa perche del corpo umano la proporzione non intende o per pretta cavillazione la verità impugnando."

100. BNCF Magl. XVII 22, fol. 67ᵛ. "Vorrei che mi dicesse da quando in qua e' sia Censor pubblico della Città, e chi l'induce a questa arrogante necessità che gli bisogni correggere. Io l'ho sempre conosciuto per abbachista, e computista, dopo aver l'arte di copista esercitata, e non ho mai saputo ch'e' sapessi leggere non che farsi letterato, e ben si vede ch'e' non è tale."

101. BNCF Magl. XVII 22, fols. 67ᵛ–68ʳ. "Esser non può scortese un che sia dotto. Quali son quelle prerogative che cosi arrogante ed insolente lo fanno? Qual università, qual principe gli da l'autorità ch'e' s'ascrive che gli bisogni correggere? Corregga egli se stesso che sarà un grand'uomo se saprà farlo, e non cerchi corregger gli altrui bruscali senza veder il suo trave. Io sono stato dal 1645 al 1650 scolar del Collegio Ducale in Pisa, e benche abbia gettato via il tempo, son però contro ogni mio merito in quella celebre università graduato,

e dichiarato Maestro, che tanto suona la Laurea Dottorale. E come dunque egli che non è per ancora stato scolare ardisce qui mi bisogna correggere? Non si correggono gli maestri almeno per reverenza dell'esser loro, se non da altri più dotti maestri: sfacciataggine troppo ardita e parole da mentecatti son queste mentre i Maestri o Dottore che dir vogliamo anno faclutà di vestir la toga, insegnare in cattedra, ed interpretare i detti de' savi ed egli non ha ne men come scolare facoltà di comparir nelle scuole non che di correggere, non potendo veramente in rigore gli scolari de' studi comparir in esse se prima matricolati non sieno: Come gli bisogna correggere? Ma tralasciando da banda questo odioso discorso venghiam di grazia al caso per lo quale ho presa la penna. Andavasi questo omicciuolo a guisa di quel malvagio che gloriabatur in malizie in ogn cantone vantando d'avermi con alcuni altri aggiustato, onde di non saperlo fingendo, non è però che non mi desse nel naso una si fatta arroganza."

102. *Notizie* 1, p. 56. Baldinucci incorrectly dates the *Bellezze di Firenze* 1600, rather than 1591.

103. SPES 156 and Chapter Three. The *Lettera a Lorenzo Gualtieri* of 19 January 1682 addresses the question of whether Raphael or Andrea del Sarto was the greatest painter of the sixteenth century. Strictly speaking, the comments on Andrea del Sarto to which Baldinucci refers were written by Bocchi, not Cinelli, and first appeared in the 1591 version of the *Bellezze di Firenze*. Nonetheless, Baldinucci's insulting dismissal of Cinelli's contribution represents a serious and carefully considered discourtesy. See n. 95 above for another similar slight to Cinelli's additions to the *Bellezze*.

104. For the dating of this section of BNCF Magl. XVII 22, fols. 64–73 see n. 94 above.

105. BNCF Magl. XVII 22, fol. 53ʳ–53ᵛ. "E comparsa quell'opera tanta decantata di Filippo Baldinucci, intitolata *Notizie de' Professori di Disegno* . . . alla gran fama ch'era sparsa di quest'opera io m'aspettava un voluminoso Calepino per non dire una Bibliotheca Patrum, quando mi veggo giugnere alle mani uno scartabello d'otto infelici fogli, e conosco ch'è vero che *minuit presentia famam*.

Leggo il frontispizio e da esso riconosco esser vero quel che già mi fu scritto cioè che questo non è letterato ma di professione computista, o facitor d'abbacchi e ragioni, mestiero ch'anticamente 140 anni sono si chiamava volgarmente cavalocchio cioè risquotitore dell'altrui azienda, o crediti, benche oggi questo titolo cohonestato rimanga da un altro nome che gli danno, e questo si è di tener le scritture, e per che egli stesso par che di questo esercizio anzi vergogna che altro gli paia di ritrarne, per ciò dice ch'è di differente professione non ispiegando di quale, come pur pare che la bisogna richiedesse. Egli però vanta questa sua arte per assai confacente alla sua civiltà e onorevolissima, ma sia qual'ella voglia il tener i conti altrui non è arte da Cavaliero; Dico questo perch'egli debbe aver cattivi vicini molto da per se stesso lodandosi, ed in modo tale che s'un'altro l'avesse a lodare non direbbe tanto ad un gran pezzo se non volesse essere adulatore, dicendo ch'il Serenissimo Cardinale Leopoldo s'è servito di sua direzzione nell'ordinare i disegni, come che in Firenze non fussero

altri uomini accreditati nella pittura, e dandosi del buono istorico, cose tutte che chi non è come Narciso dell'opere proprie innamorato debbe a gli altri e non per se lasciarle dire, poiche vi è gran differenza da piantare una partita in un libro Debitori e Creditori dallo scrivere storie. Sento ch'egli debbe esser un buono homicciatto, e nella sua professione valente, e ch'abbia buona pratica delle maniere de' disegni e delle pitture per essersi dilettato di ritrar con matita rossa e nera, ma senza però adoprar mai il pennello e particolarmente ne' colori a olio, ma ch'e' sia letterato non si crede da chi legge il frontispicio della sua opera. . . ."

106. BNCF Magl. XVII 22, fol. 3ʳ. "Venne trè di sono dalla nuova città di Prato ove al presente due suoi più stretti parenti l'uno del tintore, l'altra del fornaio l'onorevol professione esercita."

107. BNCF Magl. XVII 22, fol. 3ᵛ. "S'avesse detto buon computista pur pure, ancorche un'altro di suo mestiere dica ch'e' non sa dove e' s'abbia la testa ne perciò una Compagnia di Religiosi da lor servigio il licenziarono, e perche prudentissimi ed esemplarissimi non licenzia mai niuno senza demerito, ma per aver dato di se sospeto per la troppa stretta confidenza co' fattori delle possessioni."

108. BNCF Magl. XVII 22, fol. 2ᵛ. "Non vi è altro di buono, ch'aver lasciato uno spazioso margine, acciocche in esso comodamente gli spropositi che son moltissimi notar si possano."

109. BNCF Magl. XVII 22, fol. 4ᵛ. "Il consiglio datogli di propalar questo principio è stato prudentissimo e d'uomo di coscienza, perch'è meglio restar burlato a comprar una leggenda d'otto fogli, che gettar via molti paoli per la *vastissima opera* che era giusto ch'uscisse presto alla luce in questi tempi melancolici, per dileguar le nebbie di ipocondria, e suscitar ne' petti la morta risa."

110. BNCF Magl. XVII 22, fol. 6ʳ. "Si vede finalmente che questo è un di quelli ch'i suoi compatrioti chiamano affannoni, che fan l'uffizio delle mensole mostrando far gran cose, e non operano nulla, perche e' poteva risparmiar la briga a tre potentati col non chiedere il privilegio, promettendogli che non si troverà stampator così goffo che a proprio costo la ristampi per non essere condannato nelle spese, il che esso medesimo coll'esperienza conosce, e piangendo se ne duole non trovando cane che la fiuti quand'e' credeva arrichire."

111. Francesco Saverio Baldinucci describes his father as "di statura piccola assai ma ben formato di vita." *Vita di F.B.*, p. 29.

112. BNCF Magl. XVII 22, fol. 10ᵛ.

113. BNCF Magl. XVII 22, fol. 31ᵛ. "Quando scrisse quelle poche parole, ed anche in bisogno alla correzzione di tutta l'opera, era sicuro la settimana santa, o qualch'altra solennità, nel qual tempo questo bacchettoncino faceva l'esame della coscienza, perch'oltre il conoscer veramente il bisogno d'esser corretta questa sua *vastissima opera*, non ha registrato in essa maggior verità di questa."

114. BNCF Magl. XVII 22, fol. 1ᵛ. "Or riconosco esser vero ciò che mi fu scritto, e ch'io credevo malignità, cioè ch'e' non fussi letterato, e osservo nel titolo una manifesta contradizione nelle parole, *lasciata la rozzezza delle maniere greca e gotica, si sieno questi secoli ridotte all'antica loro perfezzione* e parmi che se la pittura e scultura anticamente erano in perfezzione, non possano aver rozzezza,

perch'una volta che l'arte è giunta al sommo di sua perfezzione, non so come quella più perder possa, e di perfetta torna ad esser rozza, tanto più, che dalle statue e fabbriche, che più durevoli sono della pittura, e delle quali alcune antiche molto, in piedi ancora conservansi, il buon modo d'operare ricavar puossi, avendo le statue il rilievo e'l tondo non tanto difficili ad imitarsi; E se il detto di Quintiliano è vero come è verissimo *non est perfectum quicquam quò melius est aliud*, non avendo le statue de' Greci chi per dire l'arrivi, non che l'avanzi, il sol Michelagnolo eccettuandone, dunque ne la scultura ha perduta mai l'antica sua perfezzione ne gli nostri tempi a quella sono arrivati, di che le statue greche sopra tutte bellissime dell'eccellenza de' lor maestri fan pur troppo ampia fede; E se nel tempo di Giovanni di Cimabue vennero a Firenze pittori greci grossolani e rozzi per lo poco saper loro, non perciò ne segue che l'arte abbia punto suo pregio, o diminuito o perduto. . . ."

115. BNCF Magl. XVII 22, fol. 33r–33v. "Vegnendo all'architettura gotica da esso *rozza* chiamata, per confutar sua asserzione alcuni pochi esempi per gli molti ch'addur potrei basteranno. L'uno è il Campanile di Santa Maria del Fiore bellissimo e nobile quanto mai bramar si possa: Il secondo il maraviglioso Duomo di Milano: Terzo la fabbrica della stessa Santa Maria del Fiore, tutte e tre opere d'architettura gotica ma bellissima, e che non anno ne per pensiero menomissima rozzezza, ma bensi, tutte quelle parti, che la buona architettura richiede, come a chi che sia intendente disappassionato considerare, e giudicare io lascio. Aggiungo il quarto esempio: Desiderio ultimo Re de Longobardi in Italia fu da Carlo Magno superato e vinto circa l'anno 800, ed in que' tempi appunto le tirannie di quella barbara nazione le buon'arti tutte dissipate aveano. Con tutto ciò fece lo stesso Carlo la Chiesa de Santi Apostoli in Firenze fabbricare, non con maniera gotica, ma con ordine d'architettura Corinto, dalla cui fabbrica come ch'ella fusse in quel genere il Regolo di Policleto, tutti gli artefici migliori il modo di ben'operare in architettura d'avere apparato confessarono come Filippo di Ser Brunellesco, Bramante, il Buonarruoti, e molti altri."

116. BNCF Magl. XVII 22, fol. 3v. "A voler esser chiamato *buono istorico* vi vuole molto, e per meritar tal titolo vi voglion prima l'opera, e poi lasciarlo dire a gli altri, per che *laus in ore proprio sordescit*."

117. BNCF Magl. XVII 22, fol. 12r. "E per non romper la testa di vantaggio con questa sua odiosissima apologia nella quale oltre l'aver replicato mille volte le cose medesime, fa una spantacata che la sa fare ogni asino, mentre veggendo cio ch'anno detto i comentatori di Dante nel MS. di San Lorenzo che son tutti insieme puo chi che sia con la sola copia far lo stesso fracasso, per esser da gli scimuniti, ma non da chi ha sale, dotto tenuto."

118. BNCF Magl. XVII 22, fol. 31v. "E di poi più che certo, che questa serie de' pittori non è nuova, avendola prima fatta il Vasari, gli scolari più cogniti e ragguardevoli d'ogni artefice di cui scrisse la vita nominando. E per far da grand'autore, benche e' sia omicciatto, e da letteratone, ha nel nome di divisione Livio e'l Machiavelli imitato, *l'opera vastissima* in secoli e decennali dividendo. Ed è certo ch'in comparazione di questa sua, quella de dottissimi e

celeberrimi Enschenio e Papebrochio grandissima, al suo dire leggenda diven-
terà."

119. BNCF Magl. XVII 22, fol. 31ʳ. "L'unire i disegni per l'ordine de' tempi
non fu suo concetto per quanto intesi, ma ben si del Volterrano e del Lippi,
ancorche fastosamente pretenda d'aver egli solo *un intera cognizione di tutto
quell'ordine*. . . . Siccome il concetto *dell' albero è chiara dimostrazione*, che egli
smillanta, si sa pubblicamente ch'e' fu del Lippi autor del Malmantile, da cui
fu tal fatica non solo incominciata, ma a buon segno condotta, e cavati egli gli
scritti di mano agli eredi perocche pupilli a guida di donne, con finissima
politica, l'ha a se stesso appropriata." Cinelli rather surprises us by failing to
cite Vasari's famous books of drawings.

120. For Leopoldo de' Medici's involvement in earlier schemes to bring Va-
sari up to date see the Introduction.

121. *Notizie* 1, p. 17.

122. See n. 124 below.

123. BNCF Magl. XVII 22, fol. 5ʳ. "Quand pur fusse vero che *la memoria
giocondissima del Cardinale Leopoldo l'avesse stimolato*, non perciò la discretezza di
quel principe l'averebbe necessitato a farsi burlare, ma perche i morti non pos-
son rispondere, ci facciam lecito dir di loro cio che ci piace."

124. BNCF Magl. XVII 22, fol. 32ʳ–32ᵛ. "*Stimolato anche a ciò fare da molti
nobilissimi ed eruditissimi ingegni di mia patria e fuori*. Bugie senza fine! E chi sarà
mai stato quel letterato se pur ha visto l'opera ch'a darla fuori l'abbia consig-
liato? E poi era veramente dovere, ch'ognuno lo stimolasse alla stampa perche
le fatiche di questo novello Livio in malora non andassero. De patrioti se pur è
vero non l'averà stimolato se non qualche letterato si sua riga, per ambizione
d'essere nomminato; de' forestieri non credo, perche se bene noi abbiamo in
Parnaso due spedali de' Pazzerelli, e la sua nazione non ve n'ha ne meno uno,
con tutto ciò, non daremmo e niun galantuomo gli darebbe si pernicioso con-
siglio. Or vegga per grazia che millanteria è questa, ch'è seguitata poi da una
bugia maggiore ed è *fra quali fa numero molto grande il singolarissimo Antonio
Magliabechi*: bisognava dire dall'ambizione di farsi tener letterato, per la quale
con alcuni regaluzzi, e con tranellerie e trappole s'è fatto scrivere, e nominare
per tale in alcune leggende, ch'ha con molta cautela nella patria occultate, e
fuori sparse a chi nol conosce, per comprar con si fatte arguzie, e nome e fama,
e nominando qualche letterato, o scrivendogli, accio dalla corrispondenza ne-
cessitato gli abbia a render la pariglia nominandolo. Politiche finissime da al-
cuni moderni scaltriti, in ragunate di mosche adusate, dando lode a certi bab-
bicassi perche di loro parlino con lode, e perche per lo più dove la merce
letteraria è bandita pochi leggono interamente l'opera, per non si far burlar dal
comune, e non si vituperar nel paese, con finissima mozzineria nell'indice i
nomi taccino, perche come oscuri non così facilmente si trovino, e per
ch'avendo il volgo di lor poca letteratura pienissima cognizione da gli autori
per vari fini lusingati e solleticati con tal furtanza non restin que' che scrivono
tanto alla scoperta, e cosi tosto derisi. So poi benissimo che l'esortazione ch'e'
vanta fattagli dall'eruditissimo e dottissimo Antonio Magliabechi gloria di sua
patria in questo secolo è pretta bugia poiche poco avanti Pasqua di questo anno

1681 ho dello stesso Magliabechi una lettera veduta in risposta ad un'amico, che di questa *vastissima opera* notizie cercava, nella quale perche è sincerissimo con queste formali parole all'inchiesta risponde: *Circa l'opera del Baldinucci non le ne posso dir cosa veruna, tenendola egli con molta cautela e gelosia all'altrui occhio nascosa: So bene che si va con gran fretta stampando, e me n'ha letto un foglio di già tirato, dal quale non si può raccapezzar cosa che m'induca a darne giudizio, ma bisogna vederla tutta* [underlined in text]. Onde non avendola il Magliabechi veduta, egli non per altro che per accreditarla sotto l'ombra di quel purgatissimo e prodigiosissimo ingegno, smillanta d'esser stato esortato, a darla all luce, quando se l'avesse veduta, e considerata certo certissimo che l'averebbe a darla all'acciughe persuaso." Presumably the *saggio* of the *Notizie* is to be given to the anchovies as wrapping paper. In the two earlier drafts, Cinelli suggests that it be given "al caviale."

125. BNCF Magl. XVII 22, fols. 5v and 55v.

126. BNCF Magl. XVII 22, fol. 5r. There is a somewhat more fully developed version of this discussion on fol. 32r–32v. See n. 124 above.

127. See Chapter Three.

128. See Chapter Three.

129. BNCF Magl. XVII 22, fol. 1r. "Dopp'aver tre anni interi con affanno aspettato comparsa finalmente alla luce quell'opera tanta decantata di Filippo Baldinucci, ed alla gran fama che n'era sparsa essendosi egli fatto nominar nel Giornale de' Letterati. . . ."

130. BNCF Magl. XVII 22, fol. 33r. "Io non mi piglio la briga di censurare i vocaboli impropri non Toscani ne Fiorentini da esso adoperato, per che troppo averei che fare, ma lasciandone a suoi Zelanti Cruscanti l'assunto, vuò che mi basti solo dir, ch'è vergogna troppo grande, ch'i fiorentini che per gli maestri della lingua Toscana si spacciano, lascin con lor rossore certi vocabolacci andar fuori, per dover poi con vilipendio esser da noi altri Lombardi beffati e ripresi. Gli lor censori che fanno? Ch'alle parole *Dilettante Decoroso* e simile latinismi non badano, da niun buono autore di tosca lingua adusate giammai."

131. A letter of 21 October 1687, from Cinelli in Bertinoro to Magliabechi in Florence, is divided between two volumes. BNCF Magl. VIII 1356, fol. 21 concludes, "Di costà come gli ho" [*catch words*: detto ho]. Magl. VIII 636, fol. 20 begins, "detto ho fatto il pianto andai, su la Cupola il dì di Pasqua a dir a Dio alla Patria, e baciai cordialmente le mura del Torrione della Porta a Pinti, perche partii da vero e non scherzai, e ritornando mi mostrerei troppo debole. Ho il petto di pietra, e non mi piego per poco, e sono in luoghi ove vivo, e son lasciato vivere per grazia di Dio."

132. *Io Cinelli et . . . Magliabechi vitae.* This was composed by Niccolò Francesco Bertolini with the assistance of Giovanni Andrea Moniglia and printed in Siena by Vincenzo Vangelisti. It was issued anonymously with a false place of publication, "Fori Vibiorum."

133. ASF Serie Manoscritti 68 contains a wide range of letters to Bernardo Benvenuti, prior of Santa Felicità in Florence. In the insert marked "Magliabechi" is an undated letter from the granducal librarian. "Perche mi preme anche riparare la mia riputazione dalle calumnie, e così diaboliche, dette in

voce, sapendo che continovamente ne sparge nella corte del Serenissimo Principe di Toscana, dove io non ho conoscenza, o servitù alcuna la prego [per] le viscere di Giesu Cristo Signore Nostro, a degnarsi con qualche occasione di rappresentare, si al Serenissimo Signor Principe, come al Signor Marchese degli Albizzi, *che io mi sottoscriverò al gastigo di esser decapitato, ogni volta che si trovi ch'io abbia mandata materia al Signor Cinelli da fare una sola riga* [underlined in text] della sua scrittura, o ci abbia parte in alcun altra materia."

In ASF Serie Manoscritti 68, insert Baldinucci is a single letter of 21 September 1687 in which Baldinucci refers to his arrangements for the execution of copies of pictures. Another letter from Baldinucci to Prior Benvenuti is in the Biblioteca Riccardiana-Moreniana, MS. Moreniana Autografi 91 (618). On 3 November 1688 Baldinucci asks the prior for the loan of his *sepultuario*.

134. Two letters written on the same bifolio in BNCF Magl. VIII 636, fols. 9–10 give an impression of the close reliance between Cinelli and Magliabechi. On fol. 9 is a brief note, "Illustrissimo Signore mio Signore e Padrone Colendissimo / Ho posto il piè fuor di carcere, grazie a Dio, e sono a pregarla di purgar da ogni puntura la terza scanzia, e di ciò ch'ella leva da essa farne fare una copia, e favorirmi d'inviarmela avanti di farla stampare, e questo per non battere in nuovi scogli. Intanto la supplico de suoi comandamenti e mi rassegno di Vostra Signoria Illustrissima / Servitore Devotissimo Obligatissimo / Gio. Cinelli." On fol. 10 is a letter from Magliabechi to an unidentified recipient, evidently the printer in Naples or someone else closely involved with the publication of the third *scanzia* of the *Biblioteca volante*. "Illustrissimo Signore mio e Padrone Colendissimo / Benche io sia senza lettere di Vostra Signoria Illustrissima, non posso far di meno di non iscriverle, per avvisarle una nuova che so che le sarà gratissima, ed è che'l nostro Signore Dottor Cinelli, è escito, con giubbilo universale, di carcere. Conserva i medesimi sensi verso i suoi amici, e gli studi, e l'istessa venerazzione verso'l gran merito di Vostra Signoria Illustrissima. / Adesso per tanto potrà ella fare stampare la scanzia, ma con le seguenti condizioni, cioè / Che si degni levare ogni puntura che sia in essa, contro di chi che sia. / Che faccia notare tutto quello che leva in essa, e mandi qua scritto diligentemente il tutto. / Per servirla come era mio obbligo, mi son fatto mandare un catalogo della insigne Biblioteca Heinsiana per la posta, e tra due o tre giorni che partirà un amico mio per Roma, lo manderò per Vostra Signoria Illustrissima, al Abate Raffaello Fabretti. Potrà ella per tanto, o scrivere al suddetto Signore Abate in che maniera le lo dovrà mandar costà, o ordinare a qualche sui amico che sia da esso a farselo e le lo invii a Napoli subito. È necessario che l'abbia senza indugio alcuno, perche sono in esso molti libri che Vostra Signoria Illustrissima non troverà mai. Fra tanto Vostra Signoria Illustrissima anche prima d'aver l'indice, scriva pure, chiedendo tutti i libri che brama, per essere a tempo, perche certo che la maggior parte vi saranno. Può scrivere a dirittura, all'eruditissimo Signor Carlo Crucio, parente strettissimo del Signor Heinsio, che mi manda qua i cataloghi, o al mercante di libri Gio. de Vive, appresso del quale è stampato il catalogo, e si venderanno i libri. Che Vostra Signoria Illustrissima non abbia amicizia alcuna con essi, poco importa, oltre che già ho informato l'eruditissimo Signor Carlo Crucio, del

gran merito di Vostra Signoria Illustrissima. / Con che supplicandola dell'onore de' suoi da me, e bramatissimi et stimatissimi comandamenti, la riverisco, e mi riconfermo di Vostra Signoria Illustrissima / Firenze li 14 Aprile 1683 / Umilissimo ed Obligatissimo Servitore vero / Antonio Magliabechi."

On fleeing Florence Cinelli left some of his papers with Magliabechi, as is noted in a letter to the granducal librarian of 17 July 1690 (BNCF Magl. VIII 635, fol. 3). "Sentii in Urbino da un nostro Fiorentino la morte del Volterrano. Se questo è, manca un uomo da bene alla professione de' Pittori. . . . Penso in partendo di qui andar in luogo dove è la stampa, ove con settanta scudi potrò stampar la mia opera degli scrittori, ed in questa mi servirò del prezzo che si caverà da cotesti libri, se però mi riuscirà, come spero in dio. intanto la supplico a mandarmi il catalogo ms. de gli scrittori per ordine alfabetico di mia mano che in foglio è fra le mie scritture per non avere a rifarlo e questo può far consegnare al procaccio d'ancona."

135. Giovanni Cinelli's letters to Antonio Magliabechi are found in BNCF Magl. VIII 634, 635, 636, 637, and 1356.

136. The posthumous *Biblioteca volante, scanzia* 17 (Modena, 1715) includes a letter from Cinelli "al Leggitore Amico" describing these misadventures. "Era questa scanzia stata compilata da me anni sono, con alcune altre; ma per che mi fu da una buona limosina affogata sotto specie di carità, la IX è stata dieci anni prima di stamparsi, la X s'è smarrita fra revisori, e stampatori: la XV castrata e diformata con miglaia d'errori sotto il torchio. Un'altra ch'era per la XVI destinata buttata via, e poi da me, con moltissimo stento, racapezzata, sicche poi quando, e come Dio ha voluto, è poi uscita alla luce. Io mi era abbandonato senza voler piu duran fatica per impoverire, e intisichire la rabbia, veggendo cotali straniezze. Ma poi lo stimolo continuo de' letterati amici mi ha finalmente spinto a ripigliare le fatiche." In his note to the same *scanzia*, the publisher Soliani recounts the fate of Cinelli's papers and unpublished works after his death. "Lasciato di vivere Gio. Cinelli in Loreto, dov'era Medico Stipendiato, colà capitasse un libraio, che fatto l'acquisto di tutta la supellitile letterata di quell'uomo erudito, tenesse buon conto delle due manoscritti, XVII e XVIII, le quali bozzate in quinternetti slegati, e pieni di molte cassature."

137. *scanzie* 1 and 2 of the *Biblioteca volante* appeared in Florence in 1677, 3 in Naples in 1685, 4 in Naples in 1682, 5 in Parma in 1686, 6 in Rome in 1689, 7 and 8 in Parma in 1692, 9 in Venice in 1700, 10 in Venice in 1705, 11 in Modena in 1695, 12 and 13 in Rome in 1697, 14 in Venice in 1699, 15 in Padova in 1722, 16 in Venice in 1726, 17 in Modena in 1715, and 18 in Ferrara in 1716.

138. These academic affiliations are credited to Cinelli on the title pages of various numbers of the *Biblioteca volante*. For Cinelli's disruptive presence in the Accademia degli Apatisti see E. Benvenuti, *Agostino Coltellini e l'Accademia degli Apatisti a Firenze nel secolo XVII* (Pistoia, 1910).

139. BNCF Magl. VIII 636, fol. 7. This letter to Magliabechi seems to fit in with those written by Cinelli when he was in Bertinoro (near Forlì) around 1688. A *scanzia* was not in fact published in Padova until long after his death.

An elegy by Fellero (published in Liepzig in 1687) is cited on p. 61 of the eighth *scanzia* (Parma, 1692). "Illustrissimo Signore mio Signore e Padrone Colendissimo / Mi rende il Signor Cavaliere la sua umanissima con l'elegia stampata del Signor Fellero, e le notizie di che tutto la ringrazio. A me pare che di questa elegia ella me ne desse notizia, e d'averla messa nella scanzia ch'è ita a Padova a stamparsi; se non vi sarà l'inserirò nella prima che andrà fuori, che doverebbe esser presto, avendone due pronte, ne vi mancando altro che le dedicatorie per lequali aspetto le notizie da' Mecenati, e non altro mi ritarda. Attendo anche le notizie da lei per quella del Crasso che subito vi darò mano, e glie l'invierò in due o tre plichi per far meno involgio, e la copierò stretta al possibile. Quanto al far queste d'una sola materia è quasi impossibile a me dove sono, perche non vi ho libri, e qui non son altre librerie che le vigne. Attendono questi signori alla campagna, e si lamentano di me, che sono interessato perche non regalo questi primati, gli quali vorrebbon mangiar le costole a' forestieri. Io non posso farlo, perche son finiti tre mesi che non ho guadagnato quanto vale un capo di spillo, di dicembre guadagnai 16 giuli, settembre, ottobre e novembre 4 giuli, e viva l'amore, quando mi dettero a credere che vi sarebbon stati d'incerti 50 doble, onde fra l'aria che m'ha smosso tutti i denti, e'l non vedere modo d'avanzar altro che i piè fuor del letto, mi son licenziato per alla fine di giugno che finisce l'anno. Ora se sarò a tempo domando Fossombrone, onde se lei mi può favorir di qualche raccomandazione per mezzo di qualche Cardinale per quella città mi sarà gran favore, ma vuol'esser favorir presto e con silenzio perche di costà non venisse qualche bella informazione. Lo stipendio è di [1]oo doble onde spererei d'avanzare qualcosa per le mie necessità. Ho scritto al Casanatta, quale non m'ha fin qui risposto. La città è nello stato d'Urbino per sua informazione et il Legato sarebbe buonissimo ma io non so chi sia. Se non otterrò qui me n'andrò dove Dio mi guiderà. Eseguirò il suo comandamento in iscrivere al Patino. Circa il tralasciar gli opuscoli moderni non ho inteso così ma è vero ch'io vi ho inserito de gli antichi per riempire, non avendo più cosa di rimarco ne'miei spogli, onde se Vostra Signoria Illustrissima non me ne va somministrando, bisogna ch'io faccia come posso. So bene che le novità piacciano, ma quando non ne ho non ne posso dar notizia. Ho veduto nell'elegia del Fellero, com'ella vi è nominata, ma accoppiata male, di che dirò qualcosa. La scanzia ch'è ita fuori penso che sarà la più copiosa di tutte, e questo ho fatto per che non mi tocca à spendere. Credo che il P. Fontana la dedichi al Co. S. Vitale. Il nome del P. Capassi l'aveva di già ritrovato, siccome dell'autor del Poemetto de' Maccheroni. Rimando la lettera dell'Hopfler, e l'ho ringraziato nella scanzia come vedrà. Tutti le notizie ch'ella m'ha favorito, che son rimaste indietro per aver qualche mese prima cominciate le due scanzie che ho ora finite, le rimetterò in altra che vado ora tessendo, poiche è quasi impossibile che non ne scappi qualcheduna e bisognandomi fare ogni cosa da me per non aver ne aiuti, ne danari da farmi aiutare se vi fussero persone alte, mi si rende assai dificile. Circa il replicar gli opuscoli, io tengo sempre a mano le scanzie stampate, e le fatte, ma quella che è fuori non posso ora vederla, e però si piglia degli errori, ed a ritenersene la copia vi vorrebbe doppia fatica. Manderò la nota de' libri perche si ripeschino, e si vendino,

eccettuandone alcuni pochi, come anche la nota delle mie polize di presto ormai perdute, per riavere i resti, e potermi valer de' quattrini. Sento che l'Ateo sta bene e chi attaccorno i [Veneziani?] e diederò un botton di fuoco per che dormiva, per saggio di quello che proverà dell'Inferno. Sento che Terenzio vive, e pure mi fu detto ch'era morto; La supplico a comandarmi e le fo reverenza di Vostra Signoria Illustrissima / Devotissimo Obligatissimo Servitore vero / Gio. Cinelli." On the outside of the sheet is the inscription, "All'Illustrissimo mio Signore e Padrone Colendissimo il Signore Antonio Magliabechi Bibliotecario del Serenissimo Gran Duca di Toscana / Firenze."

CHAPTER FIVE

1. BNCF Magl. XVII 22, fol. 23r. "Gran rabbia ha questo omicciulo per quanto si vede col Conte Carlo Cesare Malvasia, ch'è un gran letterato, e scrive con sodezza e dottrina, e questo nasce per aver mostrato chiaramente il Malvasia nella sua dottissima opera ch'oltre 100 anni prima di Cimabue in Bologna dipignevasi, laquale asserzione come provata non è d'uopo qui replicare. A questo fondamento che tutta la fatica Baldinuccesca intorno a Cimabue mette in conquasso non ha egli in contrario adotto nec verbum quidem, tal che ha molto ben conosciuto quel purgatissimo ingegno che le chiacchiere del Baldinucci sono un ronzar di moscone che null'altro concludono se non far cacchioni."

2. Cinelli and Bocchi, *Bellezze di Firenze*, p. 256. This passage was added by Cinelli to Bocchi's text.

3. BNCF Magl. XVII 22, fol. 7r–7v. "Se il *Vasari è degnissimo scrittore* per ch'ardisce correggerlo, forse per mostrarsegli superiore? chiamarlo degnissimo e sferfarlo, dir bene e operar male, è azzione da simulatore non da sincero, e pretendendo annihilarlo ed avvilirlo, non solo l'esalta, ma la propria ambizione da altrui a conscere."

4. On 12 August 1683 Carlo Malvasia wrote Apollonio Bassetti (ASF Med. Princ. 3949, *Diversi*), "Illustrissimo Signore mio Padrone Singolarissimo / Al libro che il Signore Marchese Cospi mi favorisce di far benignamente gradirsi dal Serenissimo nostro Padrone il Gran Duca per mezzo di Vostra Signoria Illustrissima ho preso l'ardire animatovi anche dal suo consiglio, ad aggiungerne uno legato per lo Signore Abate Gondi, al quale conservo tante obligazioni, e tre, che non si è stato in tempo di far legato, per Vostra Signoria Illustrissima, Signor Padre Noris, e Magliabechi, come dalle ingionte mie lettere a ciascuno di essi, che vivamente la prego non isdegnare la briga di far loro tenere. Servirà quest'occasione per dedicarmi servitore a Vostra Signoria Illustrissima e pregarla de' suoi comandamenti, acciò io possa correspondere a que' favori, che in tal guisa io vengo a ricevere prima quasi d'averne la supplicata, e degnandosi di condonare al debito dell'animo mio grato verso il Signor Colbert la necessità di cosi debile e diffettuosa composizione, mi rassegno e per l'avvenire e per sempre. / Da Vostra Signoria Illustrissima / Divotissimo Servitore parzialissimo / Carlo Cesare Malvasia."

The work in question is the *Aelia Laelia Crispes* (Bologna, 1683). On 14

August 1683 Teodoro Bondoni, secretary to Marchese Ferdinando Cospi, wrote Apollonio Bassetti (ASF Med. Princ. 3949, Cospi), "L'altra lettera è del Signor Conte Carlo Cesare Malvasia quale si compiacerà presentarla come è in sue mani un libro che presentemente ha posto alla luce, essendo in un fagotto che verrà con i specchi e sopravi il nome di Sua Altezza Serenissima. E ve ne è una copia anco per Vostra Signoria Illustrissima che vien pregato da detto Signor Conte della distribuzione di altre anessevi." On 28 August 1683 Bondoni again wrote Bassetti; "Illustrissima Signore Padrone Colendissimo / Da già che Vostra Signoria Illustrissima mi da la libertà del dare o no la lettera al Signor Conte Carlo Cesare Malvasia, ancorche ella gl'accenni nella sua di mandarglela con le prime. Le dico d'haver visto una risposta del Serenissimo Gran Duca Padrone de 22 Gennaio 1671 che gli da del Molto Illustre e che gli fece havere il Signor Marchese Cospi mio Signore anzi al medesimo Signor Conte Malvasia. Ho detto che farsi detta risposta la manderanno al Signor Marchese da farglela havere. / Se è sconcerto Vostra Signoria Illustrissima non habbia alcuno scrupolo con sudetta si pregia della risposta comunque si sia per la stima, devozione e ossequio che porta a cotesta casa come credo si sarà scoperto (per dirla a Vostra Signoria Illustrissima in tutta confidenza) in una risposta data al Dottor Cinelli [*in margin*: ora le scritture tenute dalla giustizia] quando da esso venne ricercato di scrivere contro a certo libro, non volendo nemeno amicizia di chi non gode la grazia de' Padroni Serenissimi di cotesta casa. / Si dichiara a Vostra Signoria Illustrissima più che obligato e per la gentilissima risposta datali, et per l'incomodo presosi, però parla di lei con ogni dovuta stima. / Io poi sono quel servitore suo antico, et inutilissimo per che buono a nulla, ma conservo sempre il desiderio di farmi conoscere / di Vostra Signoria Illustrissima / Bologna 28 agosto 1683 / Umilissimo Servitore Obligatissimo / Teodoro Bondoni."

Bondoni does not specify the book against which Cinelli wished Malvasia to write. Under the circumstances, however, their most obvious shared antagonist was Baldinucci and, more specifically, his *saggio* of the *Notizie*. On 4 September 1683 Bondoni informed Bassetti, "Al Signor Conte Malvasia ho portato la lettera del Serenissimo Gran Duca Padrone per parte del Signor Marchese mio Signore."

5. BNCF Magl. VIII 435, fol. 7^r–7^v. 13 May 1684, G. Bellori to Magliabechi. The letter is published in G. Campori, *Lettere artistiche inedite* (Modena, 1866), p. 131. On 21 February 1682 Bellori already established contact with Cinelli through Magliabechi (fol. 5^v). "Io sono desideroso di meritar qualche cosa appresso il Signor Cinelli, a cui mi dedico buon servitore, supplicando Vostra Signoria Illustrissima ad avvalorare appresso di esse questo mio uffizio. Di vostro desiderio saper qualche nuova della Vita che si stampa costà del Cavaliere Bernino in Roma s'intaglia il ritratto che Monsignor Bernino manderà per la stampa." Here we see Bellori maintaining a parallel interest in the activities of Cinelli and Baldinucci.

6. BNCF Magl. VIII 435, fol. 8^r, 25 August 1685, Bellori to Magliabechi. "In questo tempo ricevo ancora di modana la Giustificazione del Signor Dottore Cinelli, e non havendo veduto altro di suo, lo riconosco gran soggetto di

spirito, d'erudizione, e di dottrina, le quali virtù mi fanno altrettanto dolere le sue disgrazie, e prego Dio a sollevarlo. Quello che io desideravo sapere de' suoi scritti e sentimenti, era solamente intorno la pittura e l'ho pregato a rendermene informato."

7. Vasari, *Vite* (1550), Vol. 1, p. 85.

8. *Notizie* 1, pp. 27–28.

9. In the *Bellezze di Firenze*, neither Bocchi nor Cinelli refer to the Borgo Allegri incident either in their discussion of that quarter or of the Madonna Rucellai in Santa Maria Novella. The *Lettera dell' Anonimo d'Utopia a Filalete* states in BNCF Magl. XVII 22, fol. 7ᵛ, "Non è però vero che Borgo Allegri abbia dall'allegrezza della tavola di Cimabue preso il nome, ma bensì dalla famiglia Allegri assai più moderna, come molte altre strade di Firenze anno per lo numero de gli abitatori d'una sola famiglia ritenuto, oltre che non so veramente, se questa strada allora fusse fuori di Firenze, e grandemente ne dubito, oltre che sarebbe debolezza credere che dalla già detta tavola la strada il nome prendesse."

10. See Chapter Three, n. 56 in that chapter.

11. See Chapter Three and nn. 56 and 57 in that chapter.

12. Bellori, *Vite* (1976), p. 633. The *Vita di Carlo Maratti* was first published in 1732.

13. The index to the first edition of the *Felsina pittrice* offers a striking impression of this aspect of Malvasia's approach, especially the very extensive entries under such sensational headings as "malignità," "malizia," "gelosia," "disgusti," "minaccie," and "opposizioni." Writing some years after the appearance of the *Felsina*, Vicente Victoria offers the clearest and most emphatically "academic" response. In his *Osservazioni* he takes Malvasia severely to task for failing to provide clear lessons on correct artistic style and appropriate public behavior.

14. In 1683 he published the *Aelia Laelia Crispes*, an ingenious interpretation of a troublesome inscription, and in 1690 the *Marmora Felsinea*.

15. See Chapter Two, n. 139.

16. ASF Med. Princ. 3949, Cospi, 28 August 1683, Teodoro Bondoni to Apollonio Bassetti. See n. 4 above.

17. For Bellori see K. Donahue's entry, "Giovanni Pietro Bellori," in *Dizionario biografico degli italiani*, vol. 7 (Rome, 1965), pp. 781–89; A. Pallucchini, "Per una situazione storica di Giovan Pietro Bellori," *Storia dell'arte* 9/10, 1971, pp. 285–95; Previtale's introduction to Bellori's *Vite* (1976); and Goldberg, *Patterns*, pp. 81–122.

18. ASF Med. Princ. 3949, *Diversi*, 12 August 1683, Carlo Malvasia to Apollonio Bassetti. See n. 4 above. The gift of the portrait miniature is described in the prefatory material in the second state of the first edition of the *Felsina pittrice*.

19. See Chapter Three, nn. 53 and 54.

20. For the general background to Malvasia's *Le Pitture di Bologna* (Bologna, 1686) see G. Perini, "Storiografia artistica a Bologna e il collezionismo privato," *Annali della Scuola Normale di Pisa*, Vol. 1, 1981, pp. 181–243.

21. BNCF Magl. II II 110, fol. 290, 1 April 1687, Carlo Malvasia to Antonio Magliabechi (SPES 193).

22. Malvasia, *Pitture di Bologna*, p. 2. In fact this is an ironic pastiche of quotes from Vasari's *Vite*.

23. Ibid., p. 3.

24. Ibid., p. 4. The passage is taken from *Notizie* 1, p. 36.

25. Ibid., p. 4. The reference is to del Migliore's *Firenze Illustrata*, p. 417.

26. Ibid., pp. 14–15.

27. Ibid., p. 15.

28. Ibid., p. 33.

29. See n. 21 above.

30. BNCF Magl. VIII 1177, fol. 87ᵛ, 7 July 1691, Malvasia to Magliabechi. "Ma sento riconvenirmi dal mio compitissimo Signor Antonio come? un nuovo libro dunque da te ultimamente stampato e a me non transmesso? Io per dirla, ho bensi fatto la fatica, ma non gia la spesa, quale come tutta si è addossata il P.M. Gaudenzio, così tante poche copie ha volsuto lasciarmene, che tutte le poche toccatemi sono restate in mano degli amici in Bologna e de Padroni in Roma, non essendomene restate ne pure un paio da mandare a Parigi a miei fautori. Mi assicurò tuttavia il Padre, ch'ella l'avrebbe veduto, ed io poi anche poco mi curo che costì se n'abbia notizia troppo sgraziato in codesto paese con le mie produzioni, com'ella ben m'intende, senza che più mi allarghi. Ma portando il libro in fronte una Felsina, sedente mesta su varie quisquilie marmoree, con sopra un arco rotto quel famoso per noi elogio di Plinio, 'Bononia Felsina vocitat cum Etrureai princeps esset,' qual rumore non se ne leverebbe costì? Massime che l'eruditissimo Carlo Dati, dopo ogn'altro Toscano ha avuto a credere, o fingere di credere, e scrivere nelle sue Vite de' Pittori, aver inteso Plinio di codesta Etruria (che a que' tempi non fù ne pure in idea) ed a quella, come a scuola dell'universo, aver mandato i Romani la sua gioventù ad istudiare i riti sagri e le cerimonie a que' tempi? l'assai, che non aggionse anche per corroborozione gli squisiti vini, che costì si fanno, giacche vuol Livio lib. 1 decad. 5 che i Galli Boi *dulcedino vini apprime capti*; calando l'Alpi cacciassero da questa antica lor sede gl'Etruschi sudetti che poi da Galli Boi chiamavano Felsina Bononia constituendola capo e metropoli delle loro 112 tribu, come prima ella era delle dodici città che allora componevano la Etruria (oggi Gallia Cisalpina) Princeps come dice Plinio."

31. See Chapter Four, n. 56.

32. Del Migliore, *Reflessioni*, BNCF II IV 218, fol. 3ᵛ. "Cio si riconosce per verissimo per la fama, che à portato in ogni ogni parte il nome dell'uno e dell'altro, e massime di Giotto, celebrato da tutti gli scrittori antichi e moderni con epiteti eccellentissimi, bastando solo il dire che Dante autor gravissimo lo commemorasse dicendo: *Credette Cimabue nella pittura tener lo campo, et ora a Giotto il grido*; per consequenza non è mai stato nessuno che sia opposto alla corrente di tanta voce: e benche Bologna avesse avuto anch'ella ne' medesimi tempi Uomini valenti nella Pittura nulla di meno ella cede e confessa e per lei oggi il Conte Carlo Cesare Malvasia Bolognese Scrittore di tal materia dottamente distesa, il quale nella prefazione della sua ultim'opera stampata, dice

apertamente di non aver mai negato, che a Cimabue e Giotto non si deva il primo onore per esser stata da loro ricolocata la Pittura in miglior stato caduta e non spenta in que' tempi, e che se il Vasari se la figurata spenta abbia errato per che in tutte le città d'Italia s'è sempre dipinto e sempre s'e professata la pittura come s'è detto di sopra."

33. Ibid., fol. 16ʳ–16ᵛ. "Sentendo che si dà a Giotto titolo di eccellentissimo, di valentissimo, di sovrano e di altri simili avantagiamenti, è facile ch'e [hole] induca a credere che l'opere di Giotto siano state molto superiori a quelle de Guido Reni, de Caracci, de Tintoretto, de Correggio, de Borgognone e di tanti, e tanti altri maestri eccellentissimi de nostri secoli, e pure la diferenza è tanto grande quanto quella che passa tra il sole alle tenebre. Oggi le pitture di Giotto si riguardano ma non s'ammirano o se l'ammirazione vi s'induce, accade in ordine al gran progresso che à fatto l'arte che, indottasi da un così tenuo principio, si sea poi sollevata così. L'uomo non resta capace come Giotto si meritasse tanta lode. Si deve stimar Giotto ut princeps et reductor artis e confessarlo per onore che molto s'avvantaggia a favore di Firenze per avere avuto un uomo che sapesse prima d'ogni altro ridurre in migliore stato sì bell'arte. Non è mai stato veruno, che abbia detto o scritto in contrario, ultimamente il Conte Carlo Cesar Malvasia s'è sottoscritto a questa verità, convenutogli toccar questo punto nel suo dottissimo libro de Pittori Bolognesi e ben che le sue parole sian molto larghe e significanti sono state non ostante glosate e interpretate in diverso senso, e s'è ridotto questo tale con una lunga filastrocca d'autori a provare Giotto essere stato nominato per il primo maestro, che abbia avuto il mondo, tutta fatica di schiena buttata via per che il Conte Malvasia non à mai scritto ne detto tal cosa, l'articolo suo negativo è che avanti a Cimabue e molto più a Giotto, in tutte le parti e in tutti i luoghi d'Italia eran Pittori, che dipignevano, onde, che nessun di loro si possa chiamare resucitatore ne inventore della Pittura. Queste si domandano sacenterie pregiudiciali, massime quando la difesa non è presa per il suo diritto, che male si intenda il senso di quel che si piglia a difendere o non con ragioni equivalenti da riportarne onore a se e alla patria. Anche un altro prese a difendere la nobiltà di Firenze e disse cose dell'altro mondo, invece di toccare la ragione principale, ch'ella à d'independente, in cambio di riportarne applauso appresso alle persone intendenti di tal materia ne riportò biasimo, sostenendo che per mezza del traffico e dell'arte fosse sublimata."

34. Baldinucci, *Lezione all'Accademia della Crusca*, SPES 199, pp. 382–83.

35. Del Migliore, *Reflessioni*, BNCF II IV 218, fol. 3ᵛ. "Onde mostra e con ragione di dolersi di una certa apologia fattagli contro con qualche livore da un che non avendo inteso il suo detto mette in essa una lunga filastrocca di autori, che anno con epiteti eccellentissimi lodati l'eccellenza di Giotto, il tutto buttato via per la ragione detta di non essersi mai negato questo da lui anzi apertamente confessato."

36. Ibid., fols. 5–7.

37. Del Migliore, *Firenze illustrata*, p. 417.

38. Del Migliore, *Reflessioni*, fol. 12ʳ–12ᵛ. "Tocco in sorte a Giorgio Vasari Aretino, il quale non mediocremente, anzi superando molti suoi coetani nella

Pittura e trovandosi in tempo in cui l'animo di un principe fosse in florido di volontà benissimo disposto in porger volentieri la mano ad ogni spirito nobile potette come seguì dargli tant aiuto, che ad impresa di tanto studio e di tanta applicazione egli felicemente conducesse a fine; Bene è vero che in tutte le parti e in tutti que'requisiti; che si ricercavano necessari per compimento d'una tant'opera, non potette come è credibile farlo da se solo, e massime in quel che s'appartiene alla erudizione dell'Istoria, della lindura della bella lingua Toscana perfezionata l'una e l'altra come si richiede in cimento di stampa. Non controverto che un pittore non possa avere anche egli questi adornamenti, ma dico bene che questo si darà di rado o, se si darà, manchevole e difettoso, e defatti si riconosce vero, che dove e' tratta di pittura, non può forse arguirsi d'errore, aggiustato in darne precetti e regole salutevoli. Ma nell'istoria e ne' fatti legati, chi ben gli va disaminando, malamente corrispondono, non ostante che io creda egli essersi rapportato a qualcheduno e che anche egli, mal informato, non con tanto studio e intelligenza che fosse sufficiente, restasse ingannato in molte cose degne di correzione. In materia di lingua però non corre la medesima conseguenza, essendo distessa benissimo con periodi ben aggiustati, con vocaboli bonissimi e buona gramatica. Mediante, che anche in questo riconoscendosi il Vasari insufficiente fece capitale, non di Mon. Vincenzo Borghini famoso indagatore delle cose antiche come anno creduto molti, ma bensi del Abbate D. Silvano Razzi monaco camaldolense, discepolo del Varchi. È quelli che dette alla luce molte opere e particolarmente le Vite de' Santi e Beati Toscani, corrispondenti nel metodo e in quella bella locuzione in cui si vedono distese le Vite de' Pittori."

39. *Notizie* 1, p. 36.

40. *Lettera a Vincenzo Capponi.* See Chapter Three.

41. See Chapter One.

42. Giovanni Cinelli refers to del Migliore with evident sarcasm as "Scrittore d'antichità moderna e moderno antiquario di nostro secolo" in his *Toscana letterata.* See n. 98 to Chapter Four.

43. For example, the elaborate exposition of Giotto's lineage, *Notizie* 1, pp. 127–32.

44. *Vita di F.B.*, p. 24.

45. Rosa, *Lettere.*

46. Ibid., letter XXXII, 12 December 1693, Antonio Baldinucci in Rome to Isidoro Baldinucci in Florence.

47. Ibid., letter LVI, 24 December 1695, Antonio Baldinucci in Rome to Francesco Saverio Baldinucci in Florence.

48. Ibid., letter XCIV, 15 July 1705, Antonio Baldinucci in Frascati to Isidoro Baldinucci in Florence. The preceding letter (XCIII) of 25 June 1705 is much in the same vein.

49. The last entry in the *Diario* is dated 22 November 1696. The clairvoyant nun survived Filippo. Antonio probably refers to her in his letter of 28 July 1697 (Rosa, *Lettere*, letter LXIV), "Di più la prego di rinnovar l'istanze a quella Serva di Dio Maddalena ed alla sua penitente."

50. *Diario*, pp. 230–31.

51. See Chapter Three.

52. *Diario*, p. 150.

53. Ibid., p. 224, 30 November 1694.

54. Ibid., p. 250. There is no further indication of the identity of this picture.

55. Ibid., p. 221.

56. See Filippo's letter of 20 July 1681 to Apollonio Bassetti. ASF Med. Princ. 1526, *Diversi* (SPES 176).

57. *Vita di F.B.*, p. 23 and Appendix Two.

58. *Disegni fiorentini* Bacou and Bean, eds. The authors demonstrate the imprecision of Baldinucci's attributions according to the standards of present-day connoisseurship. By the second quarter of the eighteenth century, Gabburri already felt the need to make excuses. See Appendix Two.

59. For the *Lettera a Vincenzo Capponi* see Chapter Three. The 1687 edition was published by Piero Matini in Florence.

60. The *Veglia* (Florence, Matini, 1690) carries the initials F.B. at the conclusion of the text. See Chapter Four, n. 1. The *Veglia* is cited twice in the 1686 volume of the *Notizie*. The index lists, "Veglia, Dialogo, composizione dell'Autore di quest'opera, p. 55, si vede stampata in Lucca l'anno 1684 sotto nome di Sincero Veri."

61. Baldinucci, *Lezione nell'Accademia della Crusca*. The *approvazioni* carry dates from March of 1692. See Baldinucci's letter of 13 June 1690 to Apollonio Bassetti, informing him of Gian Gastone's election as *protettore* of the Accademia della Crusca. ASF Med. Princ. 1533, *Diversi* (SPES 198).

62. The *saggio* of the *Notizie* and the *Vocabolario*, both of 1681, were printed by Santi Franchi in Florence. The *Vita del Bernino* (1682) was printed in Florence by Vincenzio Vangelisti. The arrangements for this edition, sponsored by Queen Christina of Sweden, are not known, and Filippo might not have chosen the printer. All subsequent works printed by Filippo during his lifetime were undertaken by "Piero Matini all'insegna del Lion D'Oro" in Florence.

63. *Notizie*, Vol. 2 (Florence, Matini, 1686), preface, "L'Autore a chi legge."

64. *Notizie* 1, p. 13.

65. *Vita di F.B.*, pp. 18–19. Paolo Falconieri died in 1704.

66. Cinelli, *Biblioteca volante, scanzia* 16, pp. 8–9.

67. Cinelli undertook two megalomaniacal projects, the *Biblioteca volante* and the *Toscana letterata*. Del Migliore's *Firenze illustrata* would have been equally awe inspiring, if he covered the entire city with the thoroughness he demonstrated in the first volume. Del Migliore's archival *Spoglio* (Florence, Biblioteca Nazionale) runs to one hundred forty volumes. It was never brought near to publishable form, but still represents an obsessional body of work.

68. As we discuss in the present introduction, Lionardo Dati's scheme of 1646 to bring Vasari's *Vite* up to date would have involved a collaborative project among the Accademici del Disegno in Florence and included the use of standardized questionnaires. In Chapters One and Two we noted Leopoldo's reliance on information from various agents and the gradual emergence of Bal-

dinucci's role. There is no evidence that Leopoldo specifically set Baldinucci to writing full artists' lives. Rather, his project for the *Notizie* took clear shape after the prince's death. At the beginning of his "Notizie di Annibale Carracci," Baldinucci discusses his method of combining original researches with material extracted from other authors (*Notizie* 3, p. 329).

69. The *"approvazioni"* for the second volume of the *Notizie* were granted in February and March of 1686. The *"approvazioni"* for the *Arte dell'intagliare in rame* were issued in September of 1686 and the dedication to Marucelli dated 20 December of that year.

70. The Marucelli were one of the principal senatorial families that were assuming control of the Tuscan government. Abbot Filippo Marucelli was one of the alternating "First Secretaries" installed by Ferdinando II in 1664 and was confirmed by Cosimo III in 1670.

71. In the *Vite* in *capitolo* XIX of his introduction "Della Pittura," Vasari discusses "Del niello, e come per quello abbiamo le stampe di rame." At the beginning of the "Vite di Marcantonio Bolognese," pt. 3, p. 294 (1568) Vasari notes, "Il principio dunque dell'intagliare stampe venne da Maso Finiguerri fiorentino circa gl'anni di nostra salute 1460."

72. Malvasia, *Felsina pittrice*, Vol. 1, p. 63.

73. Ibid., p. 63.

74. The next great Italian "encyclopedia" of art was Lanzi's *Storia pittorica dell'Italia* (1789), which was restricted to Italian production. In Italy there was probably some circulation of northern books in relatively accessible languages, such as the 1683 Latin edition of Sandrart's *Teutschen academie* and Descamps's *La vie des peintres flamands, allemands, et hollandais* (1753–1764).

75. *Notizie* 5, pp. 558–71.

76. BNCF Magl. II II, fol. 334, Giovanni Vangeldri to Giusto Sustermans, 22 June 1675 (SPES 121) and Giusto Sustermans to Filippo Baldinucci, 17 August 1675 (SPES 127). The timing of Van Gelder's letter is highly suggestive, since it coincides with the requests for information sent out in Leopoldo's name in late April of 1675. See Chapter Two, nn. 123–28. This and the reference to the interest of "Sua Altezza Serenissima" make the connection with Leopoldo virtually certain. In 1677, through the auspices of Cosimo III, Baldinucci obtained "un libro fiammingo fattomi venire aposta di tutto negoziato suo d'Amsterdam." See Chapter Three, n. 14.

77. Baldinucci, *Arte dell'intagliare in rame*, p. 83.

78. Ibid., p. 79. For Baldinucci's biography of Rembrandt see S. Slive, *Rembrandt and His Critics* (The Hague, 1953), pp. 104–15.

79. In his *Notizie* on Sustermans (4, pp. 473–511) Baldinucci discusses their relationship in the warmest terms.

80. Baldinucci, *Arte dell'intagliare in rame*, p. 62.

81. Ibid., p. 102.

82. Filippo Baldinucci never composed *Notizie* on Brunelleschi and Michelangelo. See the publisher's preface to Vol. 3 of the *Notizie*, published in 1728.

83. *Notizie* 2, pp. 358–61 and 3, pp. 748–49.

84. Goldberg, *Patterns*, p. 205.

85. Cinelli, *Biblioteca volante, scanzia* 4, pp. 14–15.

86. ASF Med. Princ. 1529, *Diversi*, 25 December 1683, Baldinucci to Bassetti (SPES 183).

87. I have not seen a copy of Baldinucci's 1687 reprint of Ammannati's *Lettera*. J. Schlosser Magnino cites it, *Letteratura artistica*, p. 431. In the inventory of the Bartolommei library (1695) a copy is listed. ASF Bartolommei 231, fol. 42ᵛ (see Chapter Two, note 58). Since the Ammannati letter was issued separately only a year before its appearance in the 1688 installment of the *Notizie*, it might well represent only an extended run of these pages from the larger work. In the 1688 *Notizie* (pp. 36–42) the letter fills seven pages, which could have fit on a single bifolio in quarto. For Cosimo III's attitude to sexual decorum in the arts, see Ulrich Middeldorf, "Vestire gli ignudi," in *Kunst des Barock in der Toscana* (Munich, 1976), pp. 33–37.

88. *Diario*, p. 142.

89. *Notizie* 4, pp. 191–278.

90. For Annibale Carracci see *Notizie* 3, p. 340, and for Agostino *Notizie* 3, pp. 325 and 328. Lodovico is presented as the only Carracci of sound discretion in his choice of subject matter. Indeed, Baldinucci's notices on Annibale (pp. 329–49) are characterized by pauses, hesitations, and mental reservations, occasioned most notably by his efforts to steer a middle course between the interpretations of Bellori and Malvasia.

91. *Vita di F.B.*, pp. 31–32.

92. *Vita di F.B.*, pp. 27–28.

93. Gabburri cites Filippo Baldinucci's burial in San Pancrazio (Appendix II). This church has been closed for restoration for as long as I can remember, and I have not attempted to locate his specific resting place.

94. *Notizie* 5, p. 348.

95. *Vita di F.B.*, pp. 8–9.

96. *Vita di F.B.*, p. 9.

97. *Vita di F.B.*, p. 9. Filippo's concern for Ignazio in Spain is expressed several times in his *Diario* in 1686, pp. 86, 94, and 99. Ignazio was dead by January of 1688 (p. 111).

98. S. Samek Ludovici, "Francesco Saverio Baldinucci," in *Dizionario biografico degli italiani* (Rome, 1963), Vol. 5, pp. 498–99.

99. *Vita di F.B.*, p. 9.

100. The literature on the Blessed Antonio Baldinucci is extensive, much of it associated with his cause and eventual beatification. A useful bibliography is found in A. Merola, "Antonio Baldinucci," in *Dizionario biografico degli italiani* (Rome, 1963), Vol. 5, p. 495. Particularly informative are F. M. Galluzzi, *Vita del Padre Antonio Baldinucci* (Rome, 1722); P. Vannucci, *Vita del Beato Antonio Baldinucci* (Rome, 1893); and most especially, Rosa, *Lettere*.

101. Rosa, *Lettere*, letter V, 1 September 1691, Antonio Baldinucci in Rome to Francesco Saverio Baldinucci in Florence.

102. Ibid., letter IV, 16 June 1691, Antonio Baldinucci in Rome to Francesco Saverio Baldinucci in Florence. The reference is tantalizing and probably

referred to Lodovico David, who was so controversial a figure in the Roman Academy.

103. Ibid., letter XXVIII, 25 April 1693, Antonio Baldinucci in Rome to Francesco Saverio Baldinucci in Florence. Father Andrea Pozzo was at work in Sant'Ignazio in Rome. Also letter XXX, 4 July 1693.

104. Ibid., letter XXXIX, 4 and 5 April 1693, Antonio Baldinucci in Rome to Filippo Baldinucci in Florence, and letter XXXII, 12 December 1693, Antonio Baldinucci in Rome to Isidoro Baldinucci in Florence.

105. Ibid., letter VIII, 17 November 1691, Antonio Baldinucci in Rome to Francesco Saverio Baldinucci in Florence.

106. Ibid., letter LV, 2 November 1695, Antonio Baldinucci in Rome to Francesco Saverio Baldinucci in Florence.

107. Ibid., letter CVII, 16 March 1709, Antonio Baldinucci in Livorno to Isidoro Baldinucci in Florence.

108. In his entry in the *Diario* for 2 March 1691, p. 150, Filippo discusses how Francesco Saverio obtained the assistantship to Ruberto Pandolfini without help from the grand duke. In a letter to Apollonio Bassetti from December of 1689, Baldinucci requests for Francesco Saverio "l'uffizio dell'archivio o della Parte" (SPES 195). Also 3 February 1690 (SPES 196). On 10 February 1690 Filippo informs Bassetti that Francesco Saverio has received the post in the *Pratica Segreta*. On 31 August Filippo receives "il magistrato de' Nove e quello dell'Arte della Seta" (*Diario*, pp. 25–26).

109. ASF Med. Princ. 1533, *Diversi*, 10 February 1690, Filippo Baldinucci to Apollonio Bassetti (SPES 197).

110. Biblioteca degli Uffizi, MS. 264, March 1684, Filippo Baldinucci to Ruberto Pandolfini (SPES 182).

111. *Vita di F.B.*, p. 26 and Appendix Two.

112. *Notizie*, 1702 (Florence, Manni all'insegno di San Giovanni di Dio), pp. v–vii. "Lo Stampatore a' cortesi lettori." Ferrante Maria Capponi (1682–1752) became a member of the Crusca in 1702 (G. M. Mecatti, *Storia genealogica della nobiltà fiorentina* [Naples, 1754], pp. 167–68).

113. The 1728 *Notizie* (Vols. 3 and 6) were published in Florence "nella stamperia di S.A.R. per li Tartini e Franchi."

114. These are in BNCF Palatini 565 and principally deal with recent artists, particularly those who reached their maturity after Filippo's death. Francesco Saverio did, however, write up a life of Brunelleschi from his father's notes. Francesco Saverio Baldinucci's *Notizie* were published by the Studio per edizioni scelte in Florence as the second volume of the *Zibaldone baldinucciano*, ed. B. Santi (1981).

115. This is described in the publisher's preface in Vol. 3 of the *Notizie* (1728).

116. This is described in Gabburri's own biography of Filippo Baldinucci. See Appendix II.

117. Fabia Boroni Salvadori, "Francesco Maria Niccolò Gabburri e gli artisti contemporanei," *Annali della Scuola Normale di Pisa*, 1974, pp. 1503–64.

Among those who frequented Gabburri's house, Boroni Salvadori cites Pandolfo Pandolfini and Anton Maria Salvini (p. 1504).

118. Gabburri wrote the *Vita di Filippo Baldinucci* after the death of Francesco Saverio in 1738, that is to say, more than forty years after Filippo's death. Gabburri was certainly confused when he stated that Filippo executed Bernini's portrait from life, since he only went to Rome a year after the subject's death. Gabburri lived from 1676 to 1742.

119. Anton Maria Salvini (1653–1729) was a prolific author and a very active member of the Accademia della Crusca, where he held a number of high offices. Severina Parodi, *Catalogo degli Accademici della Crusca dalla fondazione* (Florence, 1983), p. 126. Francesco Saverio cites him in the *Vita di F.B.*, p. 21. A letter of commendation from Salvini was included in Baldinucci's 1677 gathering of occasional pieces. See Chapter Three, n. 14.

120. Antonio Maria Biscioni (1674–1742) was a priest, theologian, and archivist. He served as librarian of the Laurenziana for many years under difficult circumstances. *Dizionario biografico degli italiani*, Vol. 10, pp. 668–71.

121. The *Vita di F.B.*, p. 17 contains a reference to "la gloriosa memoria del Gran Duca Cosimo III" and was thus written after his death in 1723.

Bibliography

CORRESPONDENCE AND DOCUMENTARY SOURCES

Florence, Archivio di Stato (ASF)
 Auditore delle Riformagioni: 47, 55, 58
 Carteggio degli Artisti (ASF/CDA): V, VI, VII, VIII, IX, X, XI, XII, XIII, XIV, XVI, XVIII, XIX, XX, XI
 Carte Pucci: II
 Carte Sebregondi: 3561, 3562, 3563, 3564, 3565, 3566, 3567
 Carte Strozziane: V, 1121
 Fondo Bartolommei: 221, 223, 224, 226, 229, 230, 231
 Guardaroba: 779, 826
 Medici del Principato (ASF Med. Princ.): 1016, 1525, 1526, 1527, 1528, 1529, 1530, 1533, 3034, 3661, 3941, 3943, 3944, 3947, 3949, 5180, 5379, 5396, 5496, 5508, 5511, 5521, 5525, 5529, 5539, 5560, 5563, 5565, 5567, 5575a, 5869a, 6357a, 6381, 6388
 Miscellanea Medicea (ASF Misc. Med.): 3, 94, 201, 368, 414
 Pratica Segreta di Firenze: 194
 Serie Manoscritti: 68
Florence, Biblioteca Marucelliana
 A176
Florence, Biblioteca Nazionale Centrale (BNCF)
 Manoscritti Magliabechi (BNCF Magl.): VIII 22, VIII 435, VIII 634, VIII 635, VIII 636, VIII 637, VIII 1177, VIII 1356, XXV 397, XXV 403, XXVI 144, XXVI 147, II I 284, II II 110, II III 500, VIII IV III
 Manoscritti Palatini: 1031
 Manoscritti Tordi: 540.7
 Postillati (BNCF Post.): 97
Florence, Biblioteca Riccardiana-Moreniana
 Manoscritti Moreni: 382 AB
 Manoscritti Moreni Autografi: 91
Florence, Biblioteca degli Uffizi
 55, 264

WORKS IN MANUSCRIPT

Baldinucci, Filippo, *Diario*, Florence, Biblioteca Riccardiana, MS. Moreni 18.
—— *Scherzi scenici*, Florence, Biblioteca Riccardiana, MS. 3471, fols. 354–405.

Baldinucci, Francesco Saverio, *Vite di artisti* (including "Notizie della vita di Filippo Baldinucci"), BNCF Palatini 565.

Cinelli, Giovanni, *Lettera dell'Anonimo d'Utopia a Filalete*, BNCF Magl. XVII 22.

—— *Toscana letterata*, BNCF Magl. IX 66–68 (Additions by Anton Maria Biscioni, Magl. IX 69–83).

Gabburri, Francesco Niccolò Maria, *Vite dei pittori*, BNCF Palatini E.B. 9.5.

del Migliore, Ferdinando Leopoldo, *Reflessioni e aggiunte alle "Vite de' pittori" di Giorgio Vasari aretino*, BNCF II IV 218.

Ricci, Giovanni Battista, *Diario*, ASF Serie Manoscritti 160.

PRINTED SOURCES

Accademia del Cimento, *Saggi di naturali esperienze*, ed. Lorenzo Magalotti. Florence, Cocchini, 1667.

Arckenholtz, J., *Mémoires concernant Christine reine de Suède*, 4 vols. Amsterdam-Leipzig, 1751–1760.

Arfelli, Adrianna, see Malvasia, C.

Aschengreen Piacenti, K., "Le Opere di Balthasar Stockamer durante i suoi anni romani," *Bollettino d'arte* 48 (January–June 1963), pp. 99–110.

—— *Il Museo degli Argenti*. Florence, 1967.

Bacou, R., and Bean, J., *Disegni fiorentini del Museo del Louvre dalla collezione di Filippo Baldinucci*, ex. cat. Rome, Gabinetto Nazionale di Stampe, 1959.

Baldinucci, Antonio, see Rosa, L.

Baldinucci, Filippo, *Cominciamento e progresso dell'arte dell'intagliare in rame*. Florence, 1686.

—— *Diario spirituale di Filippo Baldinucci*, in *Zibaldone baldinucciano*, Vol. 1, ed. B. Santi. Florence, Studio per Edizioni Scelte, 1981.

—— *Lettera di Filippo Baldinucci a Lorenzo Gualtieri fiorentino*. Reprinted in SPES 156.

—— *Lettera di Filippo Baldinucci . . . all'illustrissimo . . . Vincenzio Capponi*. Rome, Tinassi Press, 1681. Reprinted in SPES 174.

—— *Lettera di Filippo Baldinucci . . . all'illustrissimo . . . Marchese Vincenzio Capponi*. Rome and Florence, Matini, 1687.

—— *Lezione all'Accademia della Crusca intorno alli pittori greci e latini*. Florence, Matini, 1692. Reprinted in SPES 199.

—— *Notizie de' professori del disegno*. . . . Vol. 1, Florence, Franchi, 1681; Vol. 2, Florence, Matini, 1686; Vol. 3, Florence, Tartini and Franchi, 1728; Vol. 4, Florence, Matini, 1688; Vol. 5, Florence, Manni, 1702; Vol. 6, Florence, Tartini and Franchi, 1728.

—— *Notizie de' professori del disegno*. . . . Florence, 1974–1975, reissue of 1845–1847 Ranalli edition, 5 vols.; vol. 6, Baldinucci correspondence; vol. 7, Index, A. Boschetti.

—— *La Veglia: Dialogo di Sincero Veri*. Lucca, 1684. Reprinted in SPES 181.

—— *Vocabolario toscano dell'arte del disegno*. Florence, 1681.

—— *Vocabolario toscano dell'arte del disegno*, ed. S. Parodi. Florence, Studio per Edizioni Scelte, n.d.

Baldinucci, Francesco Saverio, "Notizie della vita di Filippo Baldinucci," in *Zibaldone baldinucciano*, Vol. 2, ed. B. Santi. Florence, Studio per Edizioni Scelte, 1980, pp. 3–35.

Bandera, S., "Un corrispodente cremonese di Leopoldo de' Medici: Giovan Battista Natali e la provenienza dei disegni cremonesi degli Uffizi," *Paragone* 30 (January 1979), pp. 34–55.

Barocchi, P., "Le Postille di del Migliore alle *Vite* vasariane," in *Il Vasari storiografo e artista* (Atti del Congresso internazionale del IV centenario della morte), Florence, 1974, pp. 439–47.

—— "Il registro de' disegni degli Uffizi di Filippo Baldinucci," in *Scritti di storia dell'arte in onore de Ugo Procacci*, Vol. 2, Florence, 1977, pp. 571–78.

Barzman, K., *The "Compagnia ed Accademia del Disegno"*. Ph.D. thesis, Johns Hopkins University, 1985.

—— "The Florentine *Accademia del Disegno*: Liberal Education and the Renaissance Artist," *Leids kunsthistorisch jaarboek*, Leiden, 1986.

Bellori, G., *Le Vite de' pittori, scultori, ed architetti moderni*. Rome, 1672.

—— *Le Vite de' pittori, scultori, ed architetti moderni*, eds. E. Borea and G. Previtali. Turin, 1976.

Bencivenni-Pelli, Giuseppe, *Saggio istorico della Real Galleria di Firenze*. Florence, 1779.

Benvenuti, E., *Agostino Coltellini e l'Accademia degli Apatisti a Firenze nel secolo XVII*. Pistoia, 1910.

Benzoni, G., "Giovanni Cinelli Calvoli," in *Dizionario biografico degli italiani*, Vol. 25, Rome, 1981, pp. 583–89.

Boase, T.S.R., *Giorgio Vasari: The Man and the Book*. Princeton, 1979.

Bocchi, Francesco, *Le Bellezze di Fiorenza*. Florence, 1591.

Bocchi, Francesco, and Cinelli, Giovanni, *Le Bellezze di Firenze*. Florence, 1677.

Borea, E., *Caravaggio e caravaggeschi nelle gallerie di Firenze*, ex. cat. Florence, Uffizi, 1970.

—— *Pittori bolognesi del seicento nelle gallerie di Firenze*, ex. cat. Florence, Uffizi, 1975.

Boroni Salvadori, Fabia, "Francesco Maria Niccolò Gabburri e gli artisti contemporanei," *Annali della Scuola Normale di Pisa*, Series 3, Vol. 4, 1974, pp. 1503–64.

Brocchi, Giuseppe Maria, *Vite de' Santi e Beati fiorentini*, 3 vols. Florence, 1742–1761.

Brook, A., "Rediscovered Works of Ferdinando Tacca for the Former High Altar of S. Stefano al Ponte Vecchio," *Mitteilungen des Kunsthistorischen Institutes in Florenz* 29, No. 1 (1985), pp. 111–28.

Campbell, M., *Pietro da Cortona at the Pitti Palace*. Princeton, 1977.

Campori, G., *Lettere artistiche inedite*. Modena, 1866.

Capecchi, Gabriella, "La Collezione d'antichità del Cardinal Leopoldo de' Medici: I Marmi," *Atti e memorie dell'Accademia "La Colombaria"* 44 (1979), pp. 125–45.

Casarosa, M. R., "Collezioni di gemme e il Cardinale Leopoldo de' Medici," *Antichità viva* 15, No. 4 (1976), pp. 56–64.

Cinelli, Giovanni, *Biblioteca volante, scanzie* 1–18, various places in Italy, 1677–1716.

—— *Biblioteca volante*, ed. D. A. Sancassani. Venice, Albrizzi, 1734–1747.

—— *Le Bellezze*, see Bocchi.

Cochrane, E., *Florence in the Forgotten Centuries*, Chicago, 1973.

Cox Rearick, J., *Dynasty and Destiny in Medici Art*. Princeton, 1984.

Crescimbeni, Giovanni Mario, *L'Istoria della volgar poesia*. Rome, 1698.

—— *Dell'Istoria della volgar poesia*, 2d ed., 6 vols., Venice, 1730–1731.

Dati, C., *Vite de' pittori antichi*. Florence, 1667.

Dempsey, C., *Annibale Carracci and the Beginnings of Baroque Style*. Glückstadt, 1977.

Diaz, F., *Il granducato di Toscana: I Medici*. Turin, 1976.

Disegni fiorentini del Museo del Louvre dalla collezione di Filippo Baldinucci, eds. R. Bacou and J. Bean, ex. cat., Rome, Gabinetto Nazionale di Stampe, 1959.

Dolfi, P., *Cronologia di famiglie nobili di Bologna*. Bologna, 1670.

Donahue, K., "Giovanni Pietro Bellori," in *Dizionario biografico degli italiani*, Vol. 7, Rome, 1965, pp. 781–89.

Fabroni, Angelo, ed., *Lettere inedite di uomini illustri*, 2 vols. Florence, 1773–1775.

Fantozzi Micali, O., and Roselli, P., *Le Soppressioni dei conventi a Firenze*. Florence, 1980.

Fantuzzi, Giovanni, *Notizie degli scrittori bolognesi*, 9 vols. Bologna, 1786.

Firenze e la Toscana dei Medici nell'Europa del cinquecento, ex. cat. Florence, 1980.

Gaeta Bertelà, G., "Testimonianze documentarie sul fondo dei disegni di galleria," in *Gli Uffizi: Convegno internazionale*, Florence, 1982, pp. 107–45.

Galluzzi, F. M., *Vita del Padre Antonio Baldinucci*. Rome, 1722.

Giglioli, O. H., "Due sculture in avorio inedite di Baldassare Stockamer," *L'Arte* 16 (1912), pp. 451–64.

Giovannini, Laura, *Lettere di Ottavio Falconieri a Leopoldo de' Medici nel Carteggio d'Artisti*. Florence, 1984.

Goldberg, E., *Patterns in Late Medici Art Patronage*. Princeton, 1983.

Haskell, F., *Patrons and Painters: A Study in the Relations between Italian Art and Society in the Age of the Baroque*. London, 1963.

Howarth, David, *Lord Arundel and His Circle*. New Haven, 1985.

Langedijk, K., "Een Van de Velde—aankoop door Kardinaal Leopoldo de' Medici in het jaar 1672," *Oud Holland* 76, No. 1 (1961), pp. 97–106.

——— *The Portraits of the Medici*, 2 vols. Florence, 1981.

Lunadoro, G., *Relatione della corte di Roma*. Venice, 1671.

Mahon, D., *Studies in Seicento Art and Theory*, London, 1947.

Malvasia, Carlo Cesare, *Aelia Laelia Crispes*. Bologna, 1683.

——— *Felsina pittrice*, 2 vols. Bologna, 1678.

——— *Marmora Felsinea*, Bologna, 1690.

——— *Le Pitture di Bologna*. Bologna, 1686.

——— *Vite di pittori bolognesi (appunti inediti)*, ed. Adrianna Arfelli. Bologna, 1961.

Mansuelli, G., *Uffizi: Le Sculture*. Rome, 1958.

Mascalchi, S., "Anticipazioni sul mecenatismo del Cardinale Giovan Carlo de' Medici," in *Gli Uffizi: Convegno internazionale*, Florence, 1982, pp. 41–82.

Masini, A., *"Bologna perlustrata* (aggiunta)," *L'Archiginnasio* 52 (1957), p. 212.

Mecatti, G. M., *Storia genealogica della nobiltà fiorentina*. Naples, 1754.

Meloni Trkulja, S., "I due primi cataloghi di mostre fiorentine," in *Scritti di Storia dell'arte in onore di Ugo Procacci*, Vol. 2, Florence, 1977, pp. 579–85.

Merola, A., "Antonio Baldinucci," in *Dizionario biografico degli italiani*, Vol. 5, Rome, 1963, p. 495.

Middeldorf, Ulrich, "Vestire gli ignudi," in *Kunst des Barock in der Toskana*, Munich, 1976, pp. 33–37.

Middelton, W.E.K., "A Cardinalate for Prince Leopoldo de' Medici," *Studi seicenteschi* 11 (1970), pp. 167–80.

——— *The Experimenters: A Study of the Accademia del Cimento*. Baltimore, 1971.

del Migliore, Ferdinando Leopoldo, *Firenze città nobilissima illustrata*. Florence, della Stella, 1684.

——— *Senatori fiorentini raccolti da Ferdinando Leopoldo del Migliore*. Florence, 1665.

Mitchell, B., *The Patron of the Arts in Giorgio Vasari's "Lives."* Ph.D. thesis, Indiana University, 1975.

Notizie . . . intorno agli uomini illustri della Accademia Fiorentina (no author). Florence, 1700.

Omaggio a Leopoldo de' Medici, 2 vols., ex. cat. Florence, Uffizi, 1975.

Pallucchini, A., "Per una situazione storica di Giovan Pietro Bellori," *Storia dell'arte* 9/10, 1971, pp. 285–95.

Parodi, S., *Accademia della Crusca: Inventario delle Carte Leopoldiane*, Florence, 1975.

——— *Catalogo degli Accademici della Crusca dalla fondazione*. Florence, 1983.

Pastor, L., *La Storia dei papi dalla fine del medio evo*. Rome, 1925–1963.

Perini, G., "Storiografia artistica a Bologna e il collezionismo privato," *Annali della Scuola Normale di Pisa*, Series 3, Vol. 11, 1981, pp. 181–243.

Pezzana, Angelo, *Osservazioni bibliografiche intorno alla Felsina pittrice del Malvasia impresa nel 1678*. Parma, 1844.

Pieraccini, G., *La Stirpe de' Medici di Cafaggiolo*, 3 vols. Florence, 1924.

Previtali, G., "La Controversia seicentesca sui primitivi," *Paragone* 10 (November 1959), pp. 3–28.

—— *La Fortuna dei primitivi: Dal Vasari ai neoclassici*. Turin, 1964.

Prinz, W., *Die Sammlung der Selbstbildnisse in den Uffizien*. Berlin, 1971.

Procacci, L. and U., "Carteggio di Marco Boschini dal Cardinal Leopoldo de' Medici," *Saggi e memorie di storia dell'arte*, Vol. 4, 1964, pp. 85–114.

Procacci, U., "Una lettera del Baldinucci e antiche immagini della Beata Umiliana de' Cerchi," *Antichità viva* 15, No. 3 (1976), pp. 3–10.

Ragghianti Collobi, L., *Il libro de' disegni del Vasari*. Florence, 1974.

Redi, F., *Opere*, 9 vols. Milan, 1809–1811.

della Rena, C., *Della serie degli antichi duchi e marchesi di Toscana. . . .* Florence, 1690.

Righini Bonelli, M. L., *Il Museo di Storia della Scienza*. Florence, 1968.

Rosa, Luigi, *Lettere inedite del Beato Antonio Baldinucci*. Prato, 1899.

Ruotolo, R., "Mercanti—collezionisti fiamminghi a Napoli: Gaspare Roomer e i Vandeynden," in *Ricerche sul '600 napoletano*, Naples, 1983.

Salvini, S., *Fasti consolari dell'Accademia Fiorentina*. Florence, 1717.

Samek Ludovici, S., "Filippo Baldinucci," in *Dizionario biografico degli italiani*, Vol. 5, Rome, 1963, pp. 495–98.

—— "Francesco Saverio Baldinucci," in *Dizionario biografico degli italiani*, vol. 5, Rome, 1963, pp. 498–99.

Schlosser Magnino, J., *La Letteratura artistica*. Florence, 1977.

Sestini, F., *Maestro di camera*. Venice, 1671.

Slive, S., *Rembrandt and His Critics*. The Hague, 1953.

Soprani, R., *Le Vite de' pittori, scultori, ed architetti genovesi*. Genoa, 1674.

Sustermans: Sessant'anni alla corte dei Medici, ex. cat. Florence, Palazzo Pitti, 1983.

Vannucci, P., *Vita del Beato Antonio Baldinucci*. Rome, 1893.

Vasari, G., *Le Vite de' più eccellenti architetti, pittori, et scultori italiani*, 2 vols. Florence, 1550.

Vasari, G., *Le Vile de' più eccellenti pittori, scultori, e architettori*. Florence, 1568.

Victoria, Vicente, *Osservazioni sopra il libro della Felsina pittrice*. Rome, 1703.

Vita di Filippo Baldinucci, see Baldinucci, Francesco Saverio.

Index

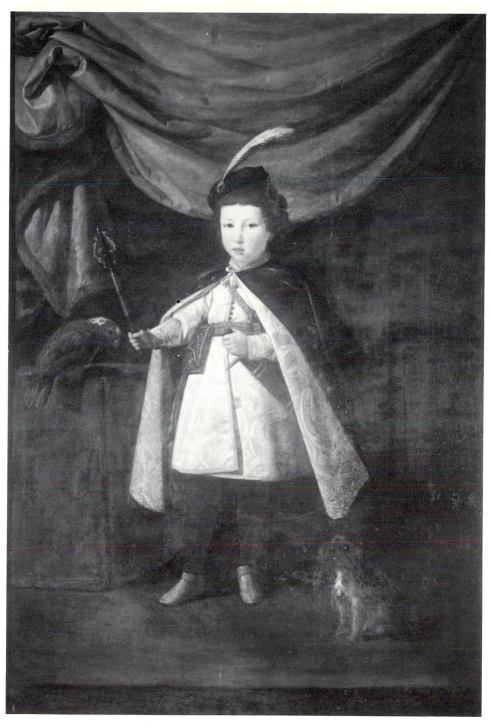

1. Justus Sustermans: *Prince Leopoldo de' Medici,
at Age Four, in Polish Costume.*

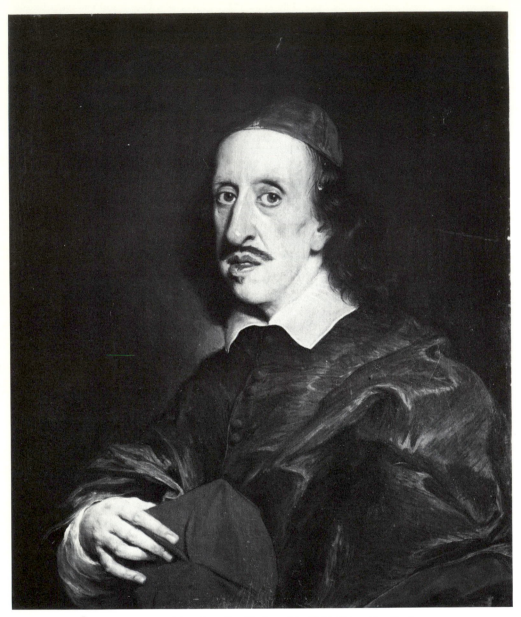

2. Giovanni Battista Gaulli: *Leopoldo de' Medici as Cardinal*.

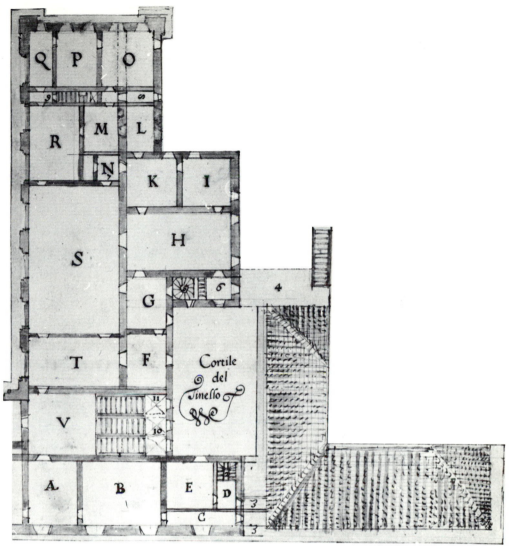

3. The main floor of Leopoldo's principal apartment in Palazzo Pitti.

F = Prima Anticamera (Camera de' Portieri)
G = Seconda Anticamera (Anticamera de' Gentiluomini)
H = Stanza degli Appimondi (Salotto del Appartamento)
I = Stanza dell'Audienza (Camera d'Audienza)
K = Camera di Sua Altezza . . . dove dormiva (Camera di Riposo)
L = Logetta
M = Camera Buia (Camera della Cappella . . . che serve per galleria di quadri)
N = Cappella (Cappella)
O = *probably* Stanza de' Pittori (Camera . . . che serve per galleria)
P = *probably* Camera detta del Satiro (Galleria di vari quadri dipinti in figure piccole)
Q = Anditino (Andito o camerino . . . che serve per galleria . . . di quadri)
R = Stanza del Buonaccord (Stanza . . . che serve per galleria di paesi e statue)
S = Salone de' Quadri (Salone grande detto delle guerre, oggi galleria famossissima di quadri e statue)
The first description dates from 1675 (ASF Guardaroba 826), the second from 1666–1667 (BNCF II I 284).

5. Justus Sustermans: *Leopoldo de' Medici as a Young Man.*

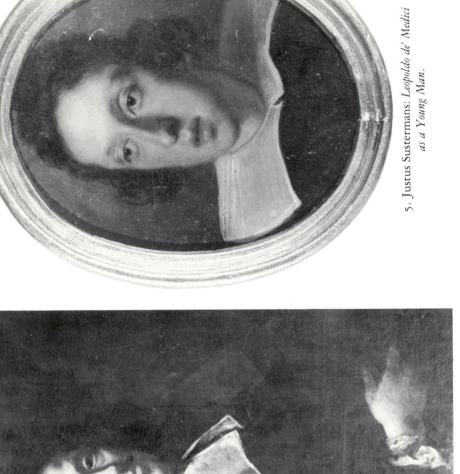

4. Justus Sustermans: *Self-Portrait* from Leopoldo's
Galleria di Autoritratti

6. Plan for the "museum" of Sustermans's paintings, arranged around 1678 in Leopoldo's former Camera d'Audienza in the Palazzo Pitti.

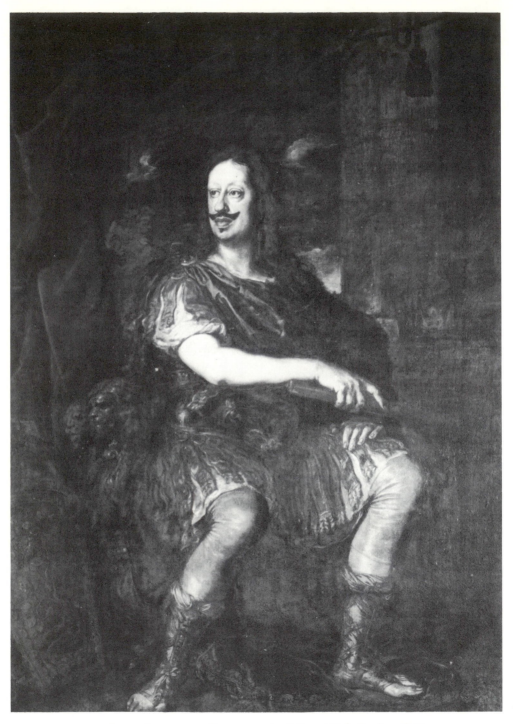

7. Justus Sustermans: State portrait of *Grand Duke Ferdinando II*
from his brother Leopoldo's Camera d'Audienza.

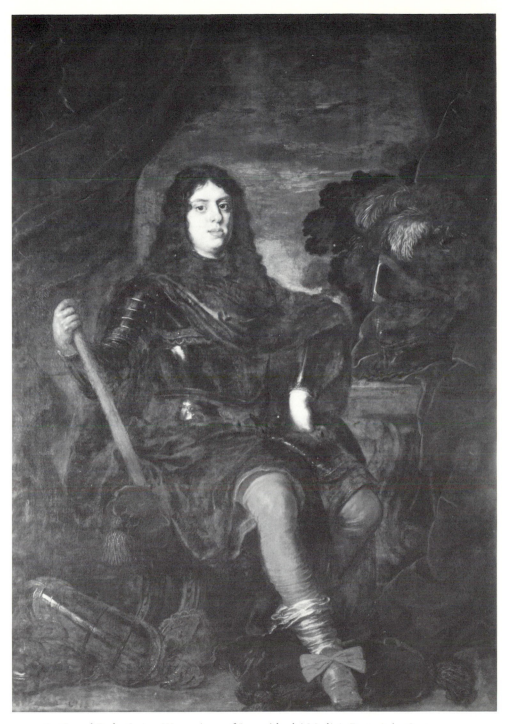

8. *Grand Duke Cosimo III*, nephew of Leopoldo de' Medici. Portrait by Sustermans, of the type that hung in the Cardinal's Camera d'Audienza.

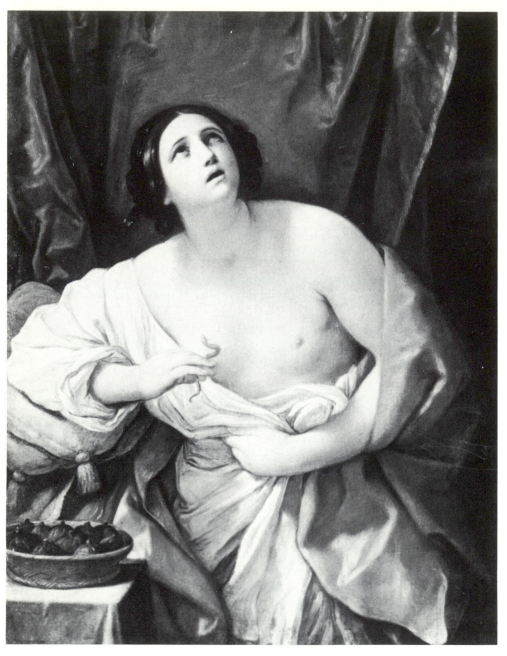

9. Guido Reni's *Cleopatra*, one of the most celebrated pictures
in Leopoldo's Salone de' Quadri.

10 (at right). *The Venus of the Casa Palmieri-Bolognini*, the most prized
classical sculpture in Leopoldo's Salone de' Quadri.

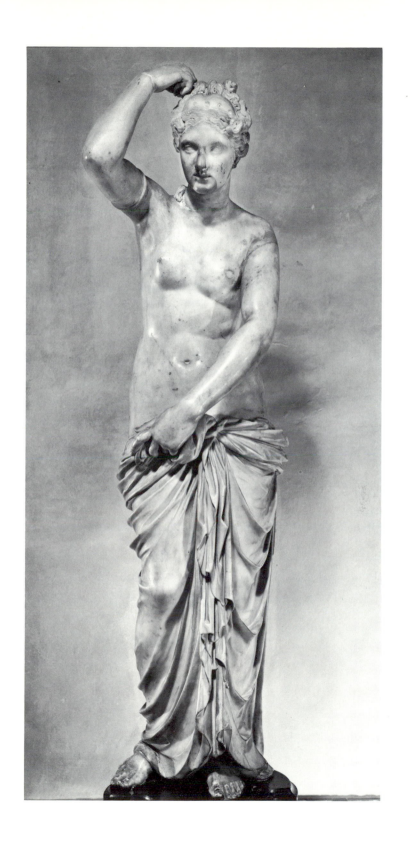

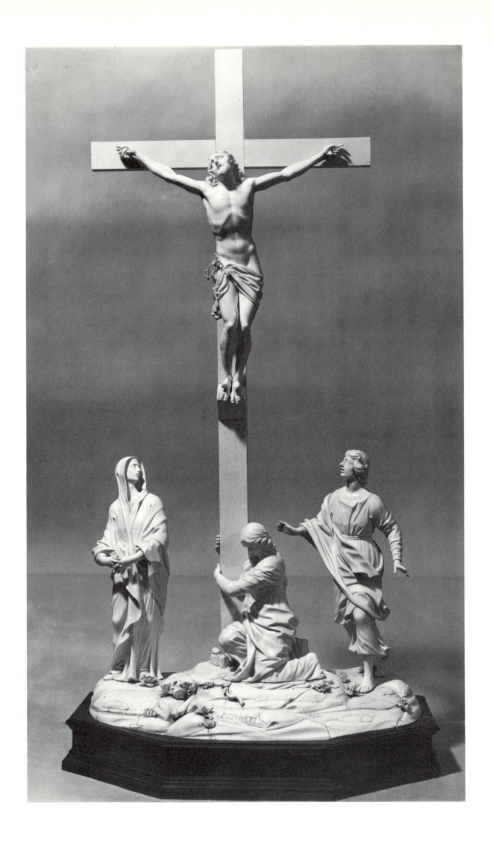

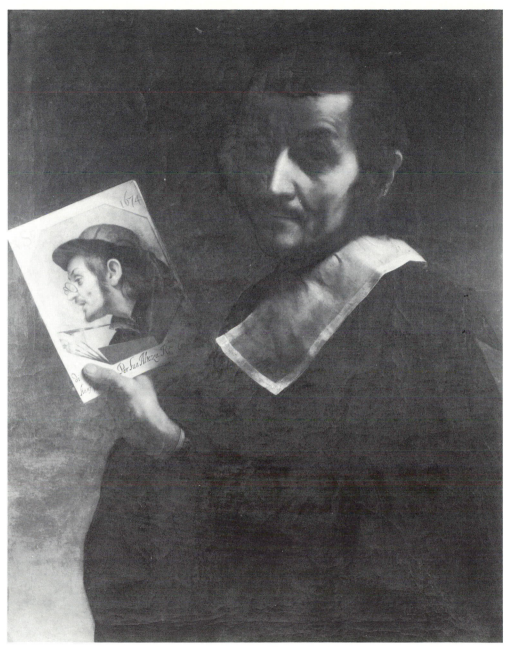

12 (above). Carlo Dolci's *Self-Portrait*, from Leopoldo's Galleria di Autoritratti.

11 (at left). Balthasar Stockamer's great ivory *Crucifixion* group, sculpted for Leopoldo de' Medici after a drawing by Pietro da Cortona.

13. A landscape drawing and the draft of a poetic composition by Leopoldo de' Medici.

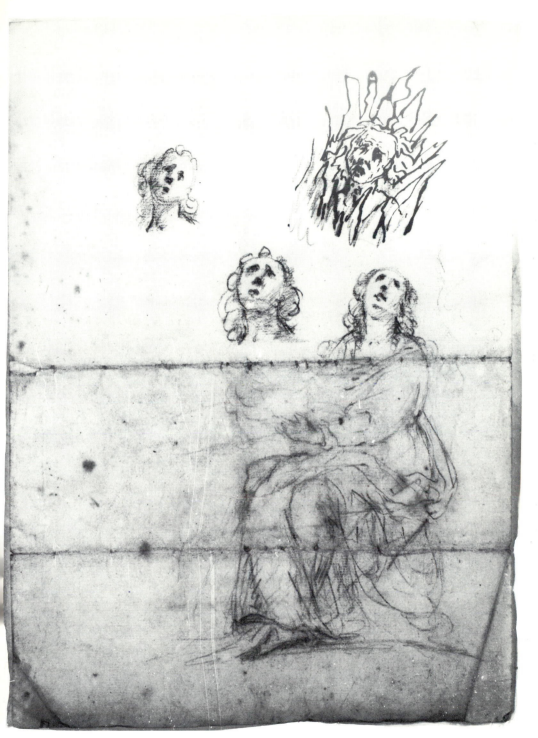

14. Figure studies by Leopoldo de' Medici.

15. Leopoldo de' Medici: Sketches of a scientific instrument and the planet Saturn.

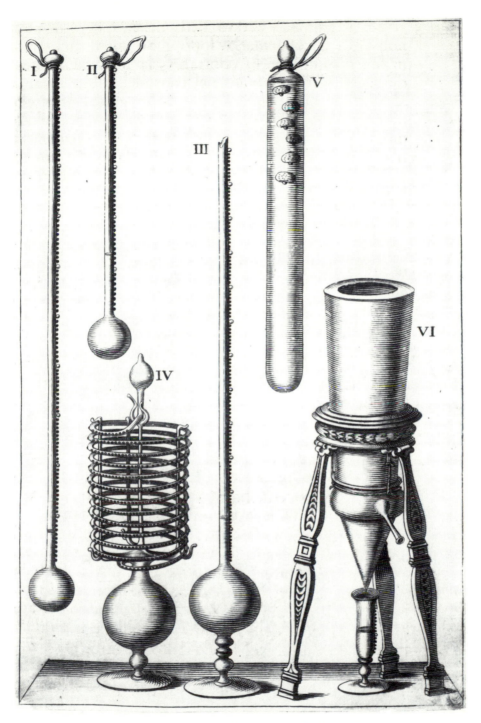

16. Scientific instruments used by the Accademia del Cimento.

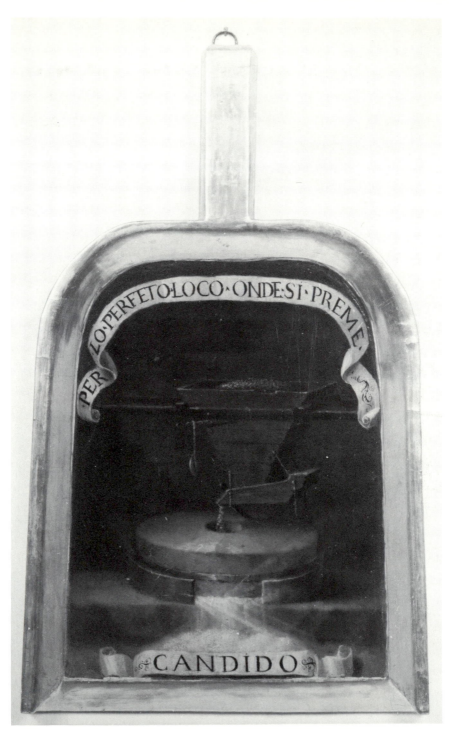

PER LO·PERFETO·LOCO·ONDE·SI·PREME

CANDIDO

17. Leopoldo de' Medici's *pala* or emblematic grain shovel
from the Accademia della Crusca, describing
his academic persona of "Il Candido."

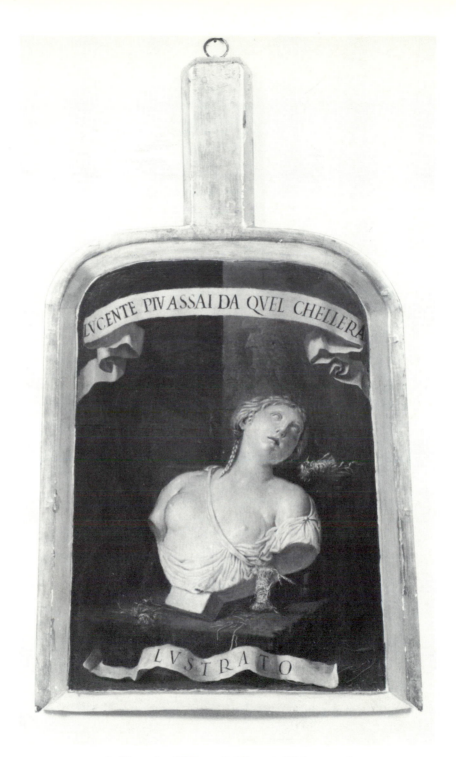

18. The *pala* of Filippo Baldinucci, "Il Lustrato."

 ISTRA de' Nomi de' Pittori, di mano de' quali si hanno Diſegni, & il primo numero denota quello de' Diſegni, e l'altro denota quello, nel quale, ò fiorirono, ò morirono i medeſimi Pittori, e tutto fino al preſente giorno 8. Settembre 1673. andandoſi ſempre agumentando la raccolta de' medeſimi, & accreſcendo le notizie de' tempi, & eſſendo fatta queſta per ſemplice memoria, ne eſſer meſſi per anco i tempi a tutti; non ſi è oſſeruato ordine alcuno nel metterli in nota, ſe non quello dell'Alfabeto.

A.

Andrea Orgagni.	num.	1.	
Alfonſo Boſchi.	num.	2.	nel 1649.
Antonio Viuiani d. il Sordo da Vrbino.	num.	10.	1605.
Antonio di Stefano.	num.	1.	
Angelini da Siena.	num.	1.	
Algardi.	num.	4.3.	1654.
Angelo Caroſelli.	num.	1.	
Albano Bologneſe.	num.	10.2.	1640.
Altiſſimo.	num.	6.	1575.
Antonio Campi.	num.	5.24.	
Andrea Vicentino.	num.	2.	1616.
Altobello da Mellone Cremoneſe.	num.	2.4.	
Aurelio Lomi.	num.	1.	1608.
Ariſtotile da S. Gallo.	num.	1.	1557.
Aleſſandro Vittoria.	num.	1.	1570.
Andrea di Coſimo da Peltro.	num.	1.	
Andrea Taſi.	num.	2.	1290.
Agnolo di Donnino.	num.	2.	
Aleſſo Baldouinetti.	num.	2.	1447.
Andrea dal Caſtagno.	num.	7.	1478.
Antonello da Meſſina.	num.	1.	
Andrea del Sarto.	num.	194.17.	1530.
Andrea Boſcoli.	num.	44.64.	1608.
Agoſtino Caracci.	num.	38.56	1596.
Andrea Lilli d'Ancona	A num.	2.	Anto-
Antonio Borgherini	nº	2.	
Auanzini	nº	2.	
Adamo	nº	1.	
Alfonſo Parigi	nº	9.	
Andrea Parigi	nº	2.	

19. Filippo Baldinucci's handlist of Leopoldo's drawing collection, compiled in September 1673 and updated in August 1675.

Nota per aver le cognizioni, che si richieggono nel descrivere le vite de
S.ri Pittori, della quale sono pos'a fare più copie p darle a q; e quello

Intorno alla Nascita	Intorno alla Vita	Intorno alla Morte
Bisogna	Progresso	Quando segue
Il Ritratto	Fanca fantasia	dove
Patria	Studi maestri	di che età mori
d'altri Maestri detti pa.	Accidenti della vita	dove sepolto, come
Anno, mese, e giorno	Stravaganze, facezie, burle	se v'è epitaffio
Nome, casato, e sopranome	detto, o fatto da lui o da altri	se fece testam.to
suo stato, e qualità de	da lui a lui	se lasciò roba
nascita	Maniera di dipingere	se gl'allievi — sopradi;
qualità di tempi	Disegni	
	opere, dove, quando	
	se publiche, segnate	
	se da giovane e da vecchio	
	se fu Accademico	
	se fu scapigliato, o ritirato	
	so sano, se ammalato, o allegro	
	so malinconico, o liberale	
	o scientito d'altro che d'una	
	sola professione	
	se si conosceri, o possederi suo	
	gl'amici, le conversazioni	
	se ebbe moglie e chi	
	se ebbe figliol	
	se lasciò roba	
	se fu secolare, o eccl.o	
	dove abito, suoi viaggi	
	se ebbe servitù di Prencipi	
	suoi Allievi	

E simili altri Particolari, i quali sovvengono col pensarvi

20. "Note for Obtaining Information Required for Describing the Lives of the
Painters": A questionnaire or memorandum associated with Baldinucci's researches.

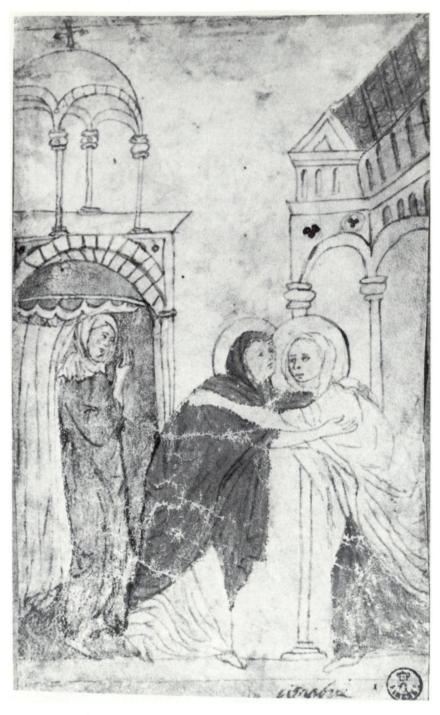

21. *The Visitation*, Florentine, circa 1300: A drawing attributed
to Cimabue in Leopoldo's collection.

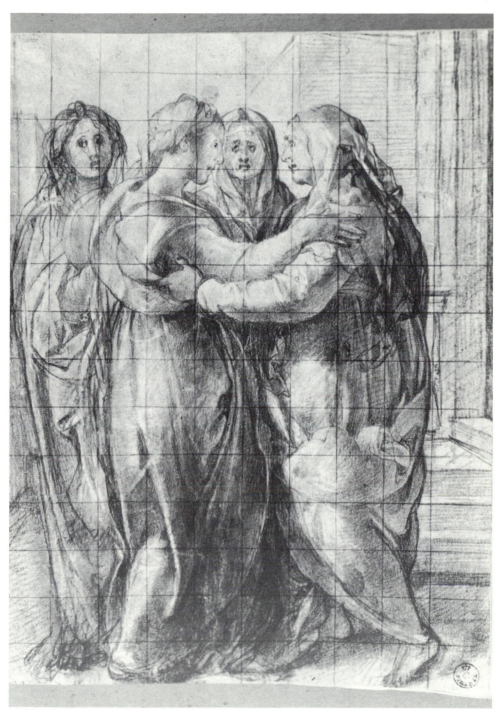

22. Jacopo Pontormo, *The Visitation*: A drawing from Leopoldo's collection.

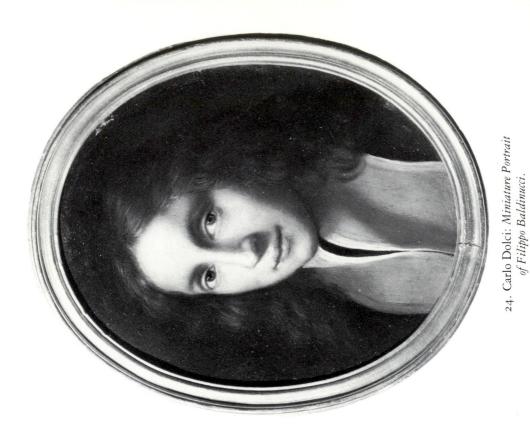

24. Carlo Dolci: *Miniature Portrait of Filippo Baldinucci.*

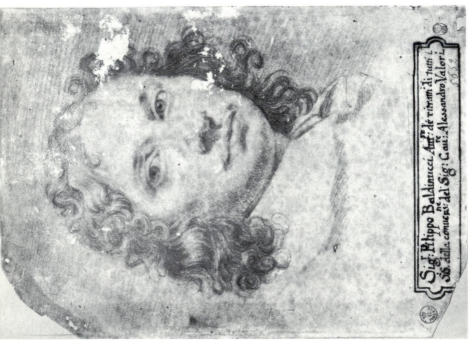

23. Filippo Baldinucci: *Self-Portrait* in red and black chalk.

25. Florence, intersection of *Via degli Alfani* and *Via della Pergola*. On the left is a block of three houses designed by Bartolomeo Ammannati, including the residence of the Baldinucci family.

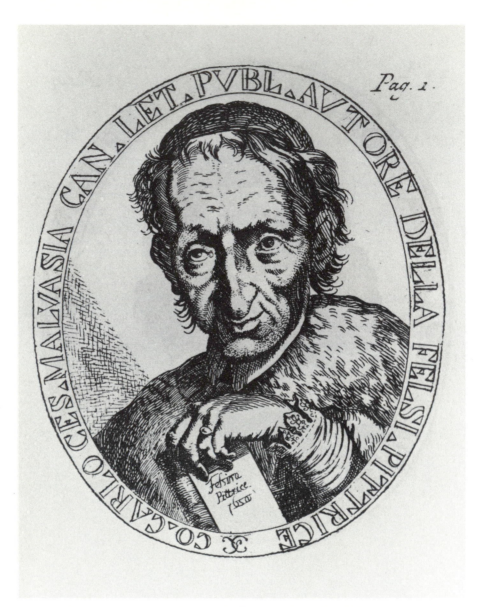

26. *Conte Canonico Carlo Cesare Malvasia*, author of the *Felsina pittrice*.

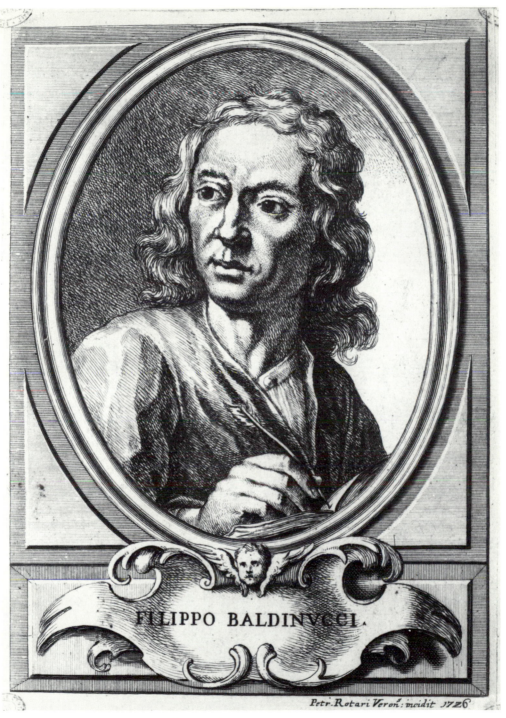

Petr.Rotari Veron: incidit 1726

FILIPPO BALDINVCCI.

27. Portrait of Filippo Baldinucci from the last installment of the
Notizie de' professori del disegno, 1728.

NOTIZIE
DE' PROFESSORI
DEL DISEGNO
DA CIMABVE IN QVA,

PER LE QVALI SI DIMOSTRA COME, E PER CHI
le bell'Arti di Pittura, Scultura, e Architettura lafciata la rozzezza
delle maniere Greca, e Gottica, fi fiano in quefti secoli
ridotte all'antica loro perfezione.

OPERA

DI FILIPPO BALDINVCCI FIORENTINO
diftinta in Secoli, e Decennali.

AL SERENISSIMO

COSIMO III.
GRANDVCA DI TOSCANA.

IN FIRENZE, per Santi Franchi. 1681. Con lic. de' Super.E PRIVILEGI

28. Baldinucci's *Notizie de' professori del disegno*: Title page
of the 1681 prospectus.

ALBERO DELL'OPERA.

PER QVANTO CONTENGONO
i quattro Decennali del preſente Volume.

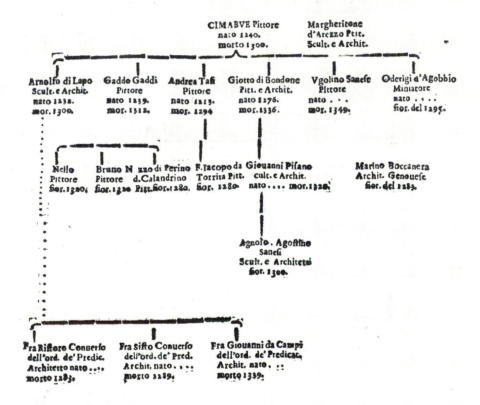

CIMABVE Pittore
nato 1240.
morto 1300.

Margheritone
d'Arezzo Pitt.
Scult. e Archit.

Arnolfo di Lapo
Scult. e Archit.
nato 1232.
mor. 1300.

Gaddo Gaddi
Pittore
nato 1239.
mor. 1312.

Andrea Tafi
Pittore
nato 1213.
mor. 1294

Giotto di Bondone
Pitt. e Archit.
nato 1276.
mor. 1336.

Vgolino Saneſe
Pittore
nato . . .
mor. 1349.

Oderigi d'Agobbio
Miniatore
nato
fior. del 1295.

Nello
Pittore
fior. 1320.

Bruno N... zzo di Perino
Pittore d.Calandrino
fior. 1320 Pitt. fior. 1280.

F. Iacopo da
Torrita Pitt.
fior. 1280.

Giouanni Piſano
cult. e Archit.
nato mor. 1320.

Marino Boccanera
Archit. Genoueſe
fior. del 1283.

Agnolo , Agoſtino
Saneſi
Scult. e Architetti
fior. 1300.

Fra Riſtoro Conuerſo
dell'ord. de' Predic.
Architetto nato
morto 1283.

Fra Siſto Conuerſo
dell'ord. de' Pred.
Archit. nato
morto 1289.

Fra Giouanni da Campi
dell'ord. de' Predicat.
Archit. nato
morto 1339.

29. First branch of Baldinucci's genealogical tree, showing the descent of the art of design from Cimabue.

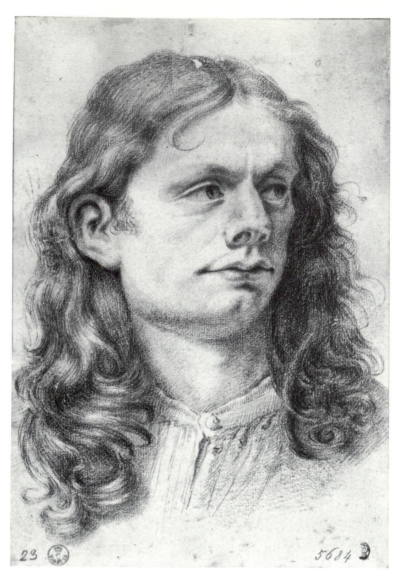

30. *Giovanni Cinelli*: Portrait by Filippo Baldinucci.

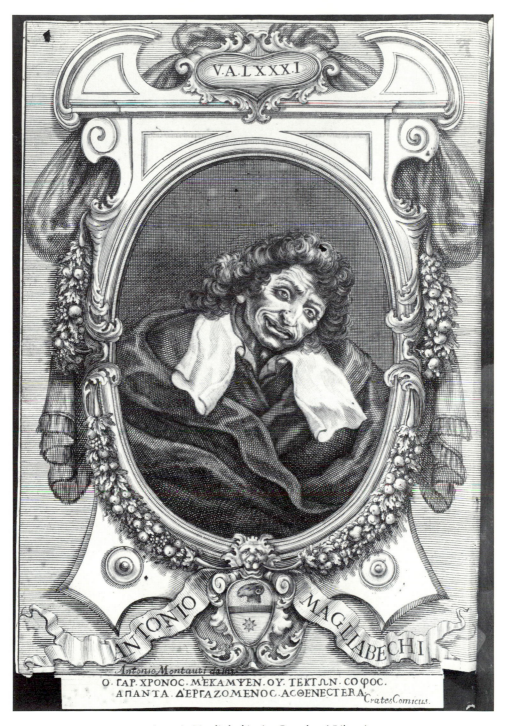

V·A·L·XXX·I

Antonio Montauti del.

O· ΓΑΡ· ΧΡΟΝΟΣ· Μ·ΈΚΑΜΨΕΝ· ΟΥ· ΤΕΚΤΩΝ· ΣΟΦΟΣ·
ΑΠΑΝΤΑ· Δ·ΈΡΓΑΖΟΜΕΝΟΣ· ΑΣΘΕΝΕΣΤΕΡΑ·

Crates Comicus.

31. *Antonio Magliabechi*, the Granducal Librarian.

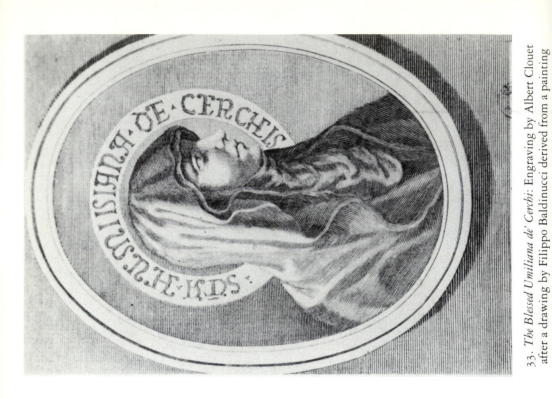

33. *The Blessed Umiliana de' Cerchi:* Engraving by Albert Clouet after a drawing by Filippo Baldinucci derived from a painting

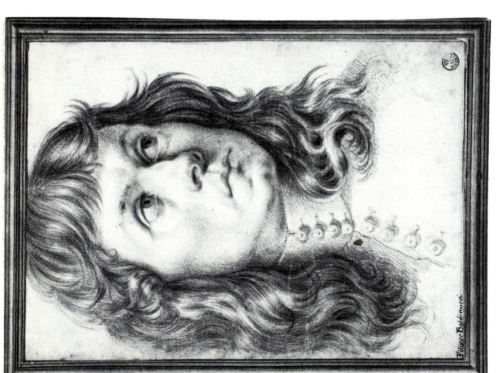

32. *Antonio Baldinucci in Clerical Dress,* portrayed by his father Filippo.

34. A page from Filippo Baldinucci's spiritual diary, describing a mystical experience with the remains of Saint Primitive.

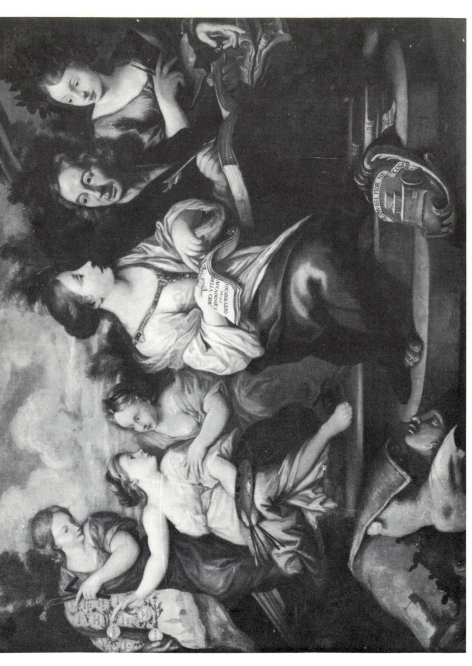

35. Piero Dandini: *Filippo Baldinucci*, with personifications of the Accademia della Crusca and the Accademia del Disegno.